Markings on pg. 246
GSPLD
10·20·15

P9-BIY-316

Markings on pg. 246
GSPLD
10·20·15

P9-BIY-316

MODELS OF INFLUENCE

MODELS OF INFLUENCE

50 Women Who Reset the Course of Fashion

Nigel Barker

HARPER DESIGN

An Imprint of HarperCollinsPublishers

MODELS OF INFLUENCE

Copyright © 2015 by Nigel Barker

All rights reserved. No part of this book may be used or reproduced in any manner whatsoever without written permission except in the case of brief quotations embodied in critical articles and reviews. For information address Harper Design, 195 Broadway, New York, NY 10007.

HarperCollins books may be purchased for educational, business, or sales promotional use. For information please e-mail the Special Markets Department at SPsales@harpercollins.com.

First published in 2015 by
Harper Design
An Imprint of HarperCollins*Publishers*

195 Broadway
New York, NY 10007
Tel: (212) 207-7000
Fax: (855) 746-6023
www.hc.com
harperdesign@harpercollins.com

Distributed throughout the world by
HarperCollins*Publishers*
195 Broadway
New York, NY 10007

ISBN 978-0-06-234584-4

Library of Congress Control Number: 2014930210

Art director: Lynne Yeamans
Book designer: Christine Heslin
Photography editor: Claudia Lebenthal

Printed in China
First Printing, 2015

With love to the models who influenced my life:
Thank you, Ma, Crissy, and Jazz.

CONTENTS

INTRODUCTION

I grew up with a model in the house, which explains a few things about me. My mother, who is half English and half Sri Lankan, was almost crowned Miss Sri Lanka in 1960 at seventeen. When another contestant complained that my mother was biracial and should not be able to enter the competition—my grandmother had been cast out from her own family for marrying an Englishman—she was disqualified. Undeterred, my mother went on to build a successful career modeling in her native country and abroad, and it was very hard won. At eighteen, she used the money she earned from posing for Pakistan International Airlines and *Ceylon Woman* magazine, from swimsuit modeling, and from acting in films such as *The Bridge on the River Kwai* to bring her mother and sister over to England with her when she emigrated in 1961.

In London, where she felt her opportunities would be more abundant, my mother modeled for calendars, sang on television, and volunteered for any other kind of entertainment work she could pick up when there was call for an ethnic model. By doing so, she could support my aunt and my grandmother. Even after my mother married her first husband, the nephew of the Marquess of Huntly, and had two children, she continued to work. That marriage ended and she entered into a second one, to an Englishman, and had my sister and me; she still modeled off and on until I was two years old.

The world saw my mother as a beautiful woman, and I certainly did too, but I also saw the hard work and dedication it takes to maintain a career as a model, especially while raising a family. My mother was passionate about what she did and very driven. She was also kind to the people she worked with as well as to those around her—and remains so to this day. The same effortless beauty she showed in pictures extended to her life off camera, so I grew up with a strong under-standing of the power of grace and charm and a belief that modeling could be a valuable endeavor, as well as a good opportunity for me. I didn't yet understand how her work affected others out there in the world, but her influence over me, and my appreciation of her career, was certainly profound.

In 1989, when I was seventeen, my mother enrolled me in a televised modeling search called *The Clothes Show*. At the time I was working my way toward a place in premed studies at Guy's Hospital in Central London, but my mother saw an opportunity for me. I performed so gingerly in the contest, it was no surprise I failed to win it, but there was a scout in the audience from the Models One agency who thought my exotic look could work in 1980s London. With my mother's full encouragement and support, I decided to take a year's sabbatical before starting school, to test my luck and perhaps see a bit of the world.

My luck was pretty good and a year grew into several. By 1991, I moved over to Select Models, where I had some early success. What I experienced in those first few years in the business was life-changing.

As a young man growing up with both Sri Lankan and British blood, I suffered an identity crisis that anyone that age from an ethnically mixed background knows only too well. There was only one other kid in my neighborhood who was like me. The community of Sri Lankan immigrants in London was tightly knit and didn't mix much with outsiders, which we were, even if the community was proud of my mother's success. I was always asked by English kids where I was from and why I looked different, and it was only in working as a model that I found a more tolerant and diverse community who didn't think I was weird just because I didn't look like everyone else. In fact, they celebrated it.

The creative people I came into contact with in my work as a model—whether photographers or stylists, the hair and makeup team or my fellow models—were from all over the planet, and many of them were outcasts in their hometowns, as I often felt I was. In the small but international community of fashion, we all felt at home, some of us for the first time in our lives. There was no way I was going to give up that sense of belonging to return to school. I transitioned from modeling to photography when the waif look came along in the early 1990s and big, well-built guys like me were no longer in vogue. But as I've continued my work in the industry, both shooting for my own clients and on television in *America's Next Top Model* and *The Face*, I've witnessed time and again the sense of homecoming that so many young models feel when they start to work in the industry.

In my job as a photographer, I'm inspired not so much by other photographers or art directors as by the models themselves. These young women, when they're starting out, are most often of a tender age and still have a childlike innocence as they put the world and its desires on their shoulders. When a model is asked to really be herself for the first time in front of the camera, what you see as a photographer comes straight from her heart. In their guilelessness and honesty, models give us an immediate reflection of the here and now. These irreplaceable moments are why, even in spite of the fashion industry's elitist tendencies and its predilection for drama, which is not always fun, I continue to find it a fascinating and rewarding field in which to work.

Our culture often puts fashion down as phony, materialist, and shallow—is it a coincidence that people would denigrate a business mostly run by and catering to women? But in the everyday experience of the majority of the people in the world, fashion is anything but insignificant. It's not just a multibillion-dollar business, employing people on an international level. It's also a means of self-expression, for designers and models, certainly, but also for everyone who wakes up and gets dressed in the morning. Fashion designers and fashion media send out millions of messages a year, across countless platforms, from runways to newsstands to billboards to cyberspace, and models

act as their primary human communicators. Models are with us, consciously or unconsciously, every time we open our closets.

Of course the fashion industry is not without its own problems. It is a part of a flawed larger world, and sometimes it replicates that world's intolerance and closed-mindedness. In its endless search for inspiration and novelty, fashion can be predatory and ruthless, chewing up and spitting out those who don't have the stamina and self-possession to withstand an extremely demanding environment. But when fashion and the fashion media sensationalize what most people consider scandalous, they help to highlight larger social issues. With every whitewashed runway presentation, every controversial advertising campaign, and every time a designer is accused of glorifying disordered eating or drug use, fashion becomes an arena for us all to confront the demons that continue to plague us as a society. Because its messages circulate so widely, fashion has a unique power, whether by good intention or insensitive misstep, to get people talking about the things that matter to them. That's why fashion is never entirely frivolous and certainly never "just clothes."

Politics, war, religion, and social movements have profound impacts on our world—but it is individuals who breathe life into mass events. Like world leaders, activists, and entertainers, models have stood as personifications and symbols of their times, avatars of the zeitgeist in which they work. Sometimes they have been the shapers of it, too. *Models of Influence* takes a close look at fifty of the most influential and impactful women in the history of the fashion business from the 1940s to the present. It profiles those models whose creativity, talent, and ability to tell a story without words have pushed society and its standards of beauty ever forward. None of these standards changed because someone on high decided it would be nice; at every step of the way, models were at the vanguard, putting themselves on the line, where, more often than not, they were mocked, insulted, exploited, or downright rejected before ultimately prevailing—connecting with their clients and, in many cases, the world at large.

The post–World War II era is a natural starting point for this book, as that is when fashion and fashion photography were reborn out of the ashes of the war. Through the work of pioneering photographers like Richard Avedon and Irving Penn, followers of fashion embraced couture models of the late 1940s and 1950s as exemplars of the magnificent opulence that fashion was capable of once again and as vehicles for the dreams of a world that had just endured hard and graceless times. The mass media, through the booming magazine industry and the newly ascendant medium of television, was there to capture all of it.

The perfection of the 1950s started to feel ossified and false as the 1960s arrived, a time of great global change and often messy social progress. The personal freedom, offbeat style, and diverse racial makeup of the groundbreaking models of this era inspired legions of

women to cut or grow their hair, to open their minds, and to dress and behave in daring new ways.

In the 1970s, as the women's movement was sweeping through the West, there was a need for strong, polished, sophisticated women to carry off fashion that was not only increasingly daring and sexy but also created to dress a world that was enjoying its first taste of hedonism on a large scale. Photographers turned to bold and brave models who created shocking and sometimes salacious images as powerful American advertisers, recognizing the strength of their ability to sell products, signed them to record-breaking contracts. The models of this period served as beacons to women who were waking up to their own need for respect and fair pay.

In the 1980s, as society jerked itself out of the bacchanal and started to sober up, wholesome-looking women helped consumers celebrate health and wealth, and designer fashion started to become more widely available. As the decade wore on, fashion shows started to become media spectacles, and soon a pack of women emerged whom the industry has since dubbed the supermodels, who enlivened fashion through personality and verve and helped attract the eyes of the world, which haven't looked away since.

If the fashion of the late 1980s and early 1990s was overindulgent, then the waifs and the grunge girls who came on the heels of the supermodels represented a kind of apology for all the excess. With their unique, sometimes even strange, looks, they helped popular

culture, which had by now thoroughly embraced fashion, take a great leap forward into an appreciation of authenticity and diversity. Meanwhile, the world outside of the United States and Western Europe was shaking off decades of dictators. As fashion sought new customers in the former Soviet Bloc, Latin America, and China, those regions became prime sources for new models, too, who could both appeal to audiences in their home countries and represent for the rest of the world the global village that we were becoming.

Today, as we arrive at a new era of social sharing through technology, joining the world through a twenty-four-hour loop of nonstop visual communication, models are once again in the middle of it. They are reality TV stars, obsessively followed on Instagram and Twitter, moment by moment providing us with new images and new ideas, satisfying our growing curiosity about who they are and what they do. Models have always worked by reaching out and touching the public, inspiring us all to dream of a more adventurous or satisfying life. It's just that today, they do it more directly and intimately than, say, the models of the 1950s could ever have imagined.

Above all, models have moved us over the years to think and see the world differently. They hold up a mirror to society and show us where we are and where we still have room to grow. What is considered beautiful evolves, but it's very often through models and fashion that we come to understand beauty in the context of our time and, by extension, within ourselves.

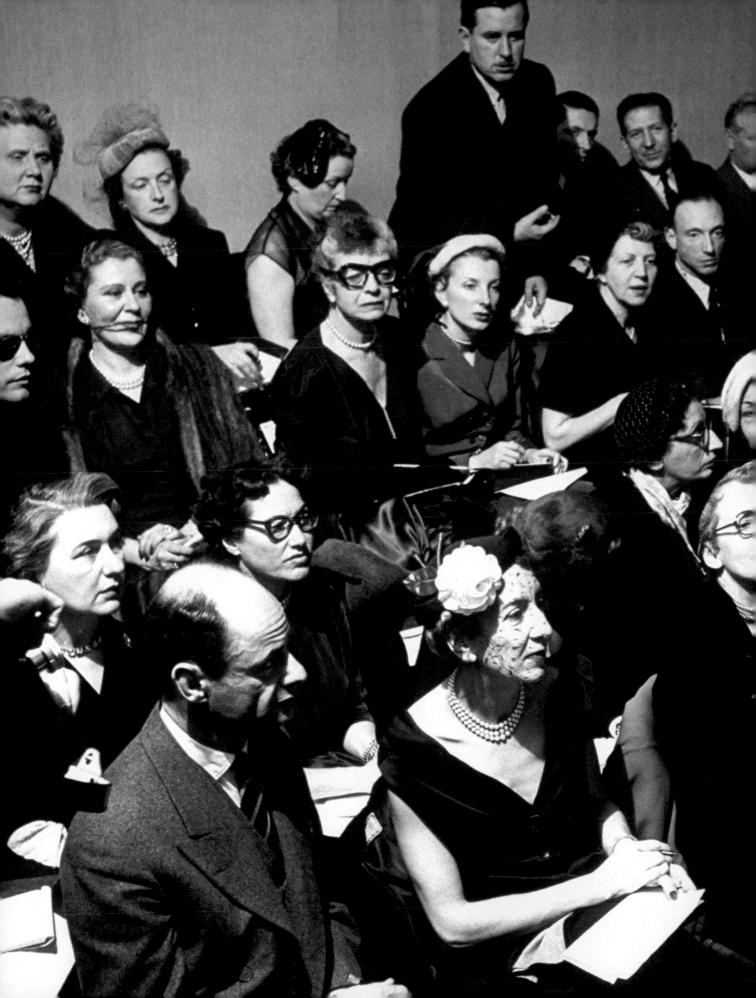

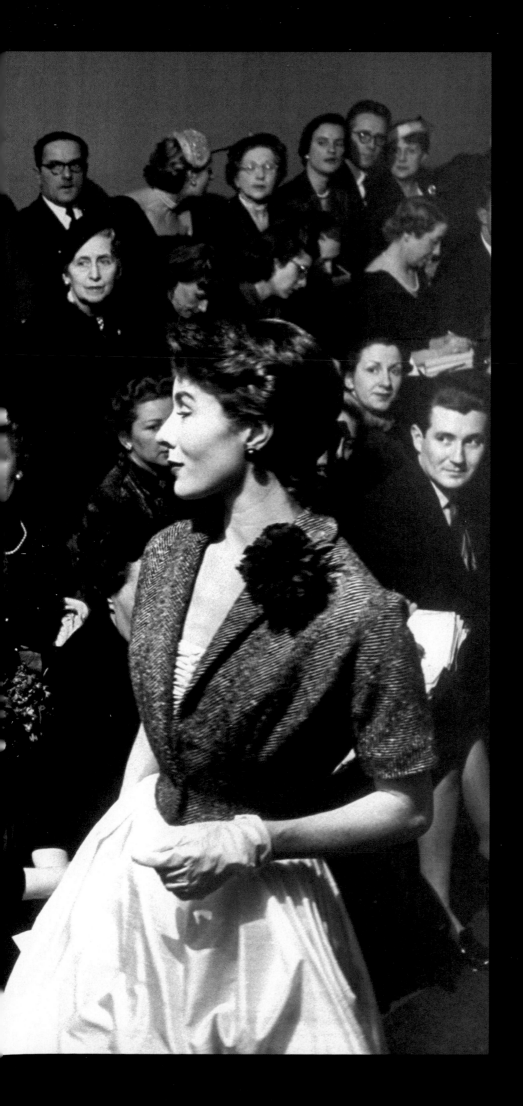

I.

THE GOLDEN AGE

INCE THERE HAVE BEEN ARTISTS, women have posed for them. But the business of modeling, the organized supply of living subjects to be drawn or photographed, only took form in 1923, when a former actor named John Robert Powers opened an eponymous school and agency in New York City. There were already magazines and fashion designers at that time, but the advertising industry was evolving rapidly, which resulted in a growing demand for real people, especially women, to sell products. The Depression provided an unexpected boost to models' ranks when "good" families, feeling a pinch in their bank accounts, sent out their debutante daughters to pose in lovely dresses to make extra income.

During the Depression and World War II, commercial photography continued to develop, yet Europe, the headquarters of high fashion, was devastated by a nonfunctioning economy. The bombs may not have fallen on Paris, the capital of haute couture, during the war, but the city was under Nazi siege and occupation for four years, and businesses suffered greatly. Not surprisingly, many couturiers shut down their operations. Even after peace was declared in 1945, strict rationing was the order of the day, not just for food but for luxury fabrics, too.

When the austerity of the war's immediate aftermath began to lift, there was an exuberant return to glamour all over the world, nowhere more so than in Paris. The medium of photography had been pushed to new heights during the war, and artists like Richard Avedon and

Irving Penn were beginning to emerge, taking pictures to new technological and expressive places. With such visual artists free to turn their lenses to a proliferation of beautiful women in beautiful clothes, the conditions were in place for a perfect fashion moment. Even with the rapid pace of technology today, that dovetailing of an evolving medium and subject matter doesn't happen all that often. But at the end of the war, long-bottled-up creativity was unleashed all over the world.

Designers like Jacques Fath and Christian Dior led the way, creating the hourglass silhouettes and decadent volumes that defined the fashion of the late 1940s and 1950s. As photography gained ground over illustration, the models, ever at the designers' sides, both as dress forms and muses, began to achieve their own recognition and power. Here and there, magazines started running the names of models next to their pictures, and the gossip press followed the romantic exploits of the most successful ones. Though most models were still beholden to the photographers who often wanted the unwritten right to shoot them exclusively, they were becoming players in the game of fashion. In a sense, they became the first supermodels.

Today, the term "supermodel" has become so overused that it's lost almost all its meaning. The word should really only be employed in cases when a model has transcended the limitations of her field and crossed over into new territories, both in the business and at large, through her influence upon contemporary standards of beauty. By that definition, the first supermodels arose in the period after World War II. It's for this reason that this period is often referred to as modeling's golden age.

Pages 12–13:
Press show, Hubert
de Givenchy, 1952.
Photograph by
Nat Farbman.

Lisa Fonssagrives-Penn

Lisa Fonssagrives-Penn was an artist. Raised in Sweden, she was the first model to both sit for the fine artists of her day and star in advertising campaigns targeted to the masses. Her upbringing in Sweden, a country with more relaxed standards around nudity, and her training as a ballet dancer contributed to her comfort in her own skin, which included a rare willingness to work in the nude. In 1936, when Horst P. Horst took the first test shots of her for *Vogue*—clothed, by the way—the reigning aesthetic of the era was still quite staged and fairly modest.

Fonssagrives, who emigrated to New York City in 1939 but continued to work all over the world into her forties, saw her job as helping to make art—no matter who the client was. Unsure of herself in her early years, especially about what to do with her hands, she would pass afternoons at the Louvre studying sculpture for inspiration.

Whether engaged in more commercial advertising jobs or in studies for photographers including Man Ray, she created dramatic shapes with her body without ever allowing it to overshadow her face, with its high, arched eyebrows and pouting, very purposeful lips. Her jawline was severe,

and was often an important feature in the composition of the pictures she sat for. You can see this quite clearly in Irving Penn's famous 1947 picture for *Vogue*, called *Twelve Beauties*, in which he put Lisa at the exact center of the image because he was so moved by her. Penn and Lisa became romantically involved and wed three years later, after she divorced photographer Fernand Fonssagrives. They are one of fashion's great love stories, and remained together until Lisa's death in 1992 at the age of eighty.

Penn, who died in 2009, is largely considered one of the medium's greatest masters, and he established many of the most recognizable codes of modernist photography—graphic minimalism, high contrast, abstraction of the human form—across Lisa's face. Using simple sets and striking lighting—in keeping with the severe and unadorned architecture and design of the times—Penn shot photographs that brought a laserlike focus to his subject. As he sought to create images that did not distract from the model with elaborate decoration and froufrou, he sought captivating models to hold the viewer's undivided attention. Some of his fashion pictures with Lisa are so intimate, despite the stunning dresses, as to be unsettling.

Opposite:
Photograph by Irving Penn, *Vogue*, 1949.

Page 18:
Photograph by Irving Penn, *Vogue*, 1950.

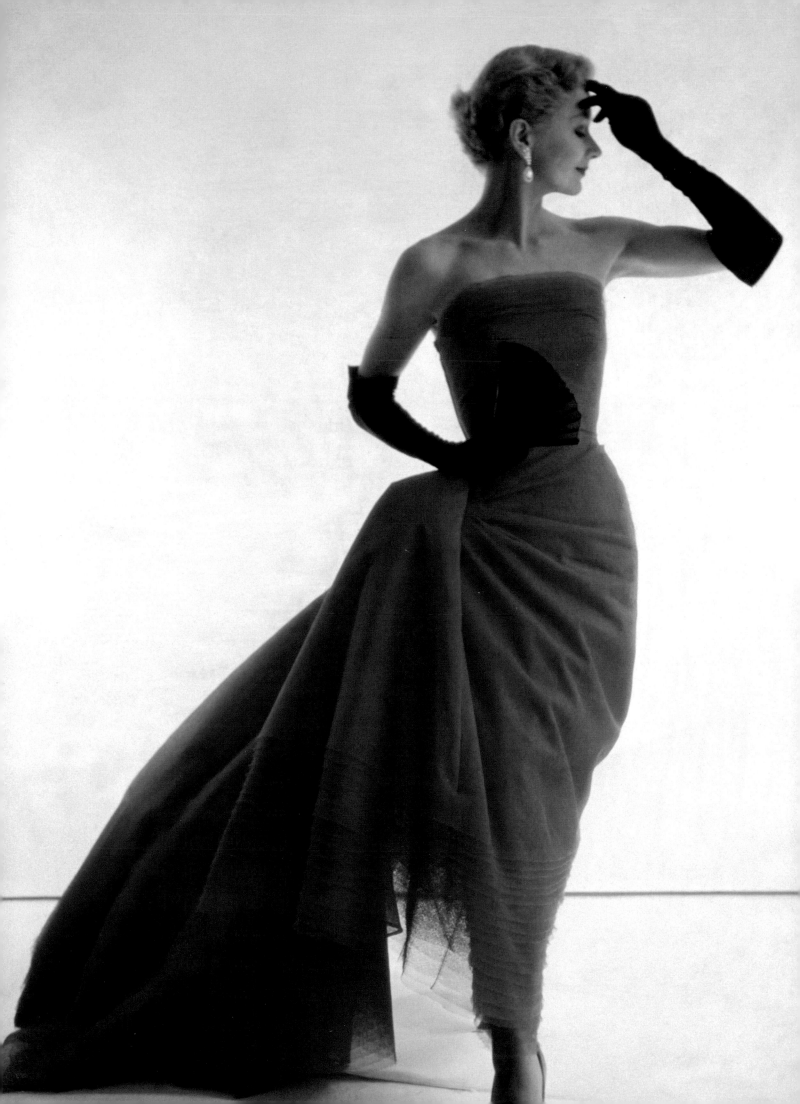

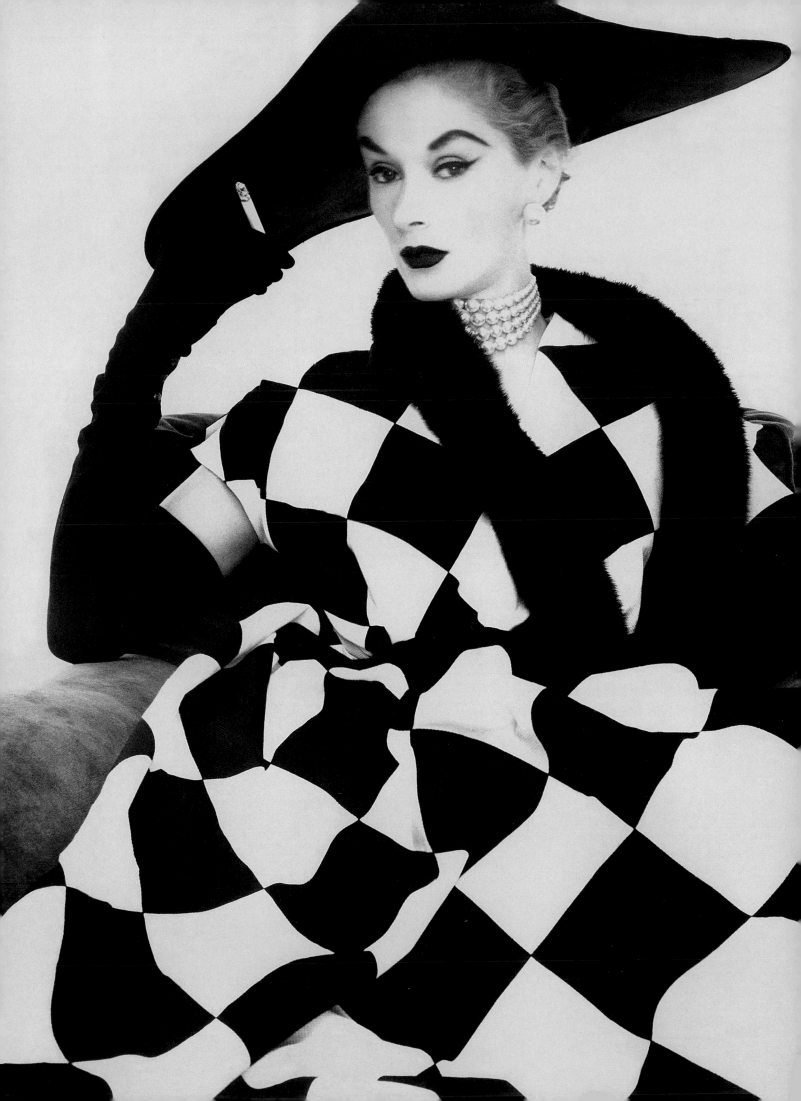

"I WOULD STAND BEFORE THE CAMERA ON A SET AND CONCENTRATE MY ENERGY UNTIL I COULD SENSE IT RADIATE INTO THE LENS AND FEEL THE PHOTOGRAPHER HAD THE PICTURE."

—LISA FONSSAGRIVES-PENN, from "Lisa Fonssagrives-Penn," by David Seidner, *BOMB*, Spring 1985

Lisa never lost her sense of comportment, but the way that she looks into the camera as if through it, like in a portrait from the January 1952 issue of *Vogue* in which she wears a towel on her head—it almost feels as if you're spying on a domestic scene, albeit in a setting of grandeur. Of Penn's many important subjects, from jazz greats to film legends to Lisa's model peers, she was the only one who could truly be called his muse.

Of course, it wasn't just Penn's love that made Lisa shine. She is often called the first supermodel because of the incredible range of her bookings, from art photography to editorials to advertisements for hair dye, household appliances, and cosmetics. Her face and manner were regal exemplars of the no-hair-out-of-place postwar woman—no matter that in real life she flew planes and raced around in convertibles. She had a classic appeal that clients who were looking to reach truly mass audiences knew was a sure thing. So illustrious was she that she was featured on a 1947 cover of *Time* as part of a

story on the growing power of the modeling business. That image of Lisa, with a faraway look in her eye, bears the cover line, "Do Illusions Also Sell Refrigerators?," a statement that feels innocent today, when we know that the answer is an emphatic yes. But before Lisa, this kind of category-jumping ubiquity just didn't occur in modeling, and it did only in exceptional cases for decades after. The artist, the client, and the designer were usually bigger than the girl. Lisa was different, and that's why she was able to earn forty dollars an hour at the height of her career in the late 1940s, when other models were usually earning less than half that.

When Lisa stopped modeling, well into her forties, with more than two hundred *Vogue* covers to her name, she took up fashion design and photography. By the 1960s, she was concentrating on sculpture. It's odd to think that she arrived at that fitting pursuit relatively late in her life because of how beautifully and movingly she was able to sculpt herself.

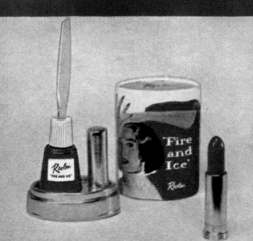

for you who love to flirt with fire…

who dare to skate on thin ice…

Revlon's 'Fire and Ice'

for lips and matching fingertips. A lush-and-passionate scarlet

…like flaming diamonds dancing on the moon!

"Indelible-Creme" Lipstick…Regular Lipstick
Frosted Nail Enamel…
Improved-Formula Nail Enamel

COSTUME: ROVE OF SOPF SCHOOL
PHOTO: AVEDON · HAIR: JOHN R. JOHN

Dorian Leigh

Dorian Leigh became a model almost by accident. She was short, standing just five feet, five inches, and started her career at the relatively older age of twenty-seven. She brought an incredible emotional richness and a smoldering quality to her work, no doubt because she had already lived such a full life and knew how to access her emotional experiences at a moment's notice for the camera. This ability won her international success and fame, and her life remained fascinating, if turbulent, until its end in 2008.

By the time Dorian thought to have pictures done, she had already been married once, had two children, worked for the telephone company, gotten an engineering degree in night school, helped design airplane wings for Eastern Airlines, and served as a copywriter for Republic Pictures. It was on this last job, in an industry fully cognizant of the power of beautiful women, that her boss suggested she try modeling. In 1944, Dorian contacted the agent Harry Conover, who sent her to see Diana Vreeland, then editor at *Harper's Bazaar*, after reviewing her only test shoot. Vreeland, who fell for Dorian's sharply angled dark eyebrows, didn't care

how old she was; she just knew she wanted more. She booked Dorian for the magazine's September cover the next day.

For a single mother of two during wartime, this was an unusual situation in which to find oneself. Dorian was doing everything she possibly could to make a living, which put her in a difficult bind, as she was also expected to play the lady for her upstanding Texas family. When she began her modeling career, she even dropped her last name, Parker, so as not to offend her parents, as modeling was still not considered a suitable career for proper women. By the time Dorian got two of her three younger sisters, Florian and Suzy, into the business in 1948—Suzy, of course, would go on to be a major star in her own right—the family had grown to accept it.

How could they not, when Dorian's soaring career trajectory ultimately earned her as much as $300,000 in one year (she claimed) at a time when the average American man was earning less than one-hundredth that amount? Dorian worked nonstop, even doing lingerie modeling, a job that most couture models wouldn't dare take on, as it was seen as one step away from pornography.

Opposite:
Revlon Fire and Ice advertisement, 1952. Photograph by Richard Avedon.

"SHE HAD SO MUCH ESTROGEN, LIKE SOME MEN ARE JUST FULL OF TESTOTERONE. DORIAN WAS JUST SO SEXY WITHOUT SAYING A WORD."

—CARMEN DELL'OREFICE, from "Everyone Fell for Suzy," by Laura Jacobs, *Vanity Fair*, May 2006

In 1946, she was on the cover of *Vogue* seven times: more than half the year. That's never happened again at any single magazine.

For her versatility, her daring personality, and her magnificent poise, Dorian was popular among all the great photographers of her day, including Irving Penn. She became a go-to girl for Richard Avedon, who shot her for her most famous ad campaign, Revlon's Fire & Ice cosmetics collection, in 1952. "For you who love to flirt with fire . . . who dare to skate on thin ice," read the tagline. Dorian's saucy, open expression and the sexiness of her gaze, direct and challenging, took the campaign beyond what could have been a one-dimensional femme fatale message to a mass sensation and made her a star. Because of her veneer of upper-class breeding and her ability to turn on the sex when she needed to but downplay it when she didn't, Dorian really did combine naughty and nice, appealing to men and women equally—a rare ability indeed. In subsequent editorials, Avedon so evocatively captured her spontaneity that their loose, seemingly improvisational pictures together created a new avenue for fashion photography.

Dorian was ambitious and had some visionary business ideas, but she didn't always see them through in the best way. In the late 1940s, to better manage her own bookings and those of a few other models, she opened her own agency in New York. She set up a voucher system to advance girls money when clients took too long to pay, which was novel, but the agency stayed open only briefly and ended up in debt. So Dorian put her bookings in the hands of the ex-model Eileen Ford, who used the same voucher system Dorian did, and who would end up becoming one of the powerhouses of the modeling industry. After a string of unhappy love affairs, some that produced children, Dorian relocated to Paris and reopened her agency there in 1957. It was the first legal one in France, in fact helping to launch Veruschka's career, among others. But despite her talent for picking faces, Dorian couldn't sustain her second coming in the face of French employment laws, and she ended up needing a bailout. That came from Eileen Ford again, and Dorian transformed her business into a satellite of Ford's, though they would eventually have a difficult falling-out over money.

A renaissance woman with no secure income other than her own, Dorian wasn't ready or able to stop working after her agency fizzled. She went on to open a restaurant, write two cookbooks, and, in 1980, with her most tumultuous years behind her, pen her autobiography, *The Girl Who Had Everything*. Dorian used the title somewhat ironically, but during much of her life, it was also arguably true. Her confidence and dynamism as well as her versatility and sophistication helped set a new template for women in business during an age when they were very much still in society's backseat.

Opposite: Photograph by Genevieve Naylor, 1952.

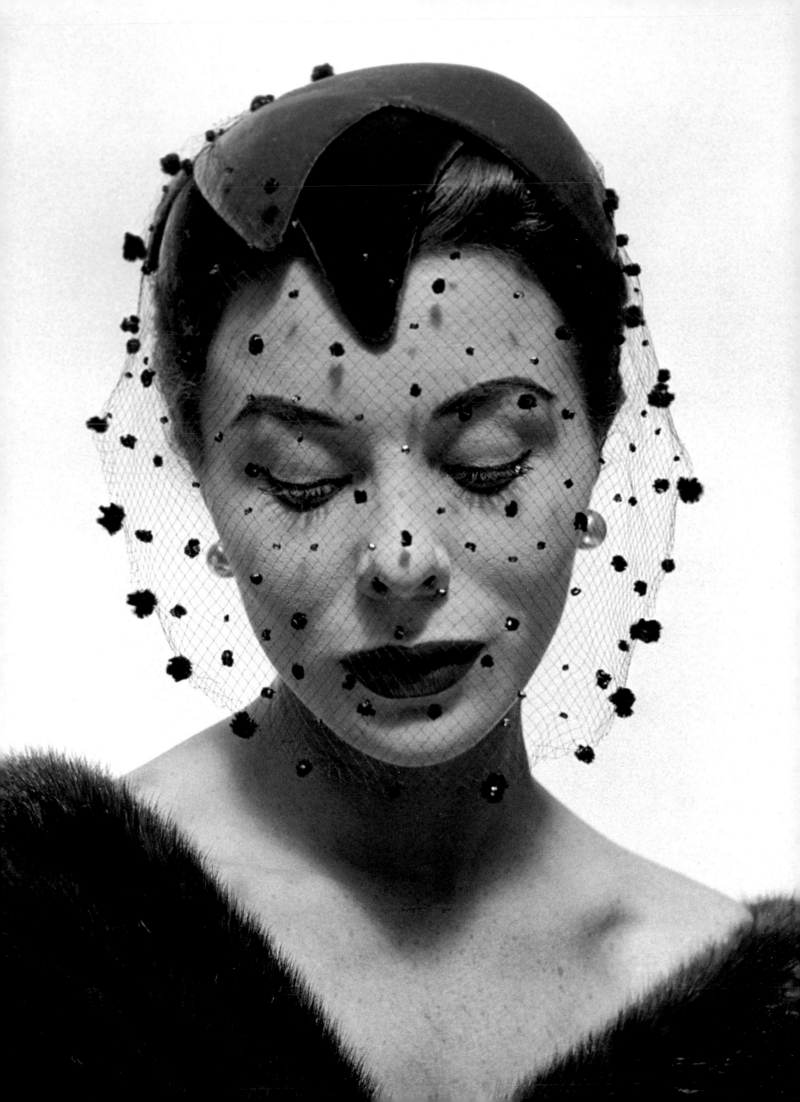

Bettina Graziani

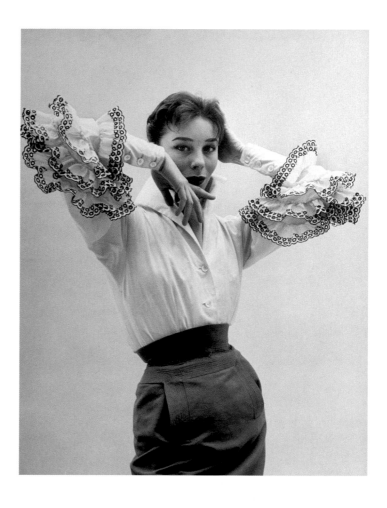

Opposite:
Photograph by
Georges Dambier,
1953.

Above:
Photograph by
Nat Farbman, 1952.

Gamine, with a freshness that broke through the aristocratic mold, Bettina Graziani had a rock-solid connection to some of the most influential designers of the age. With her long, swanlike neck, tiny waist, broad, full mouth, and sharply defined profile, she was built for the graphic, sculptural couture and high-drama black-and-white photography of the 1950s. She was a study in contrasts, which made her especially compelling, with her boyish, cropped hair and open expression that was a beautiful counterpoint to the opulent, glamorous designs of Jacques Fath, the French couture

house where she first made her mark exclusively as part of an in-house team of fit and runway models. Among the small group of European models who enjoyed both runway and editorial success, Bettina was the queen.

The daughter of a teacher, Bettina was raised in Normandy and began her career in the 1940s, modeling hats. Meeting Fath in 1947 changed everything for her. He not only gave Bettina her "name" (she was still going by her given name, Simone); he also gave her her trademark look. After she had worked for him for a few years, Fath suggested she cut her long red hair into the

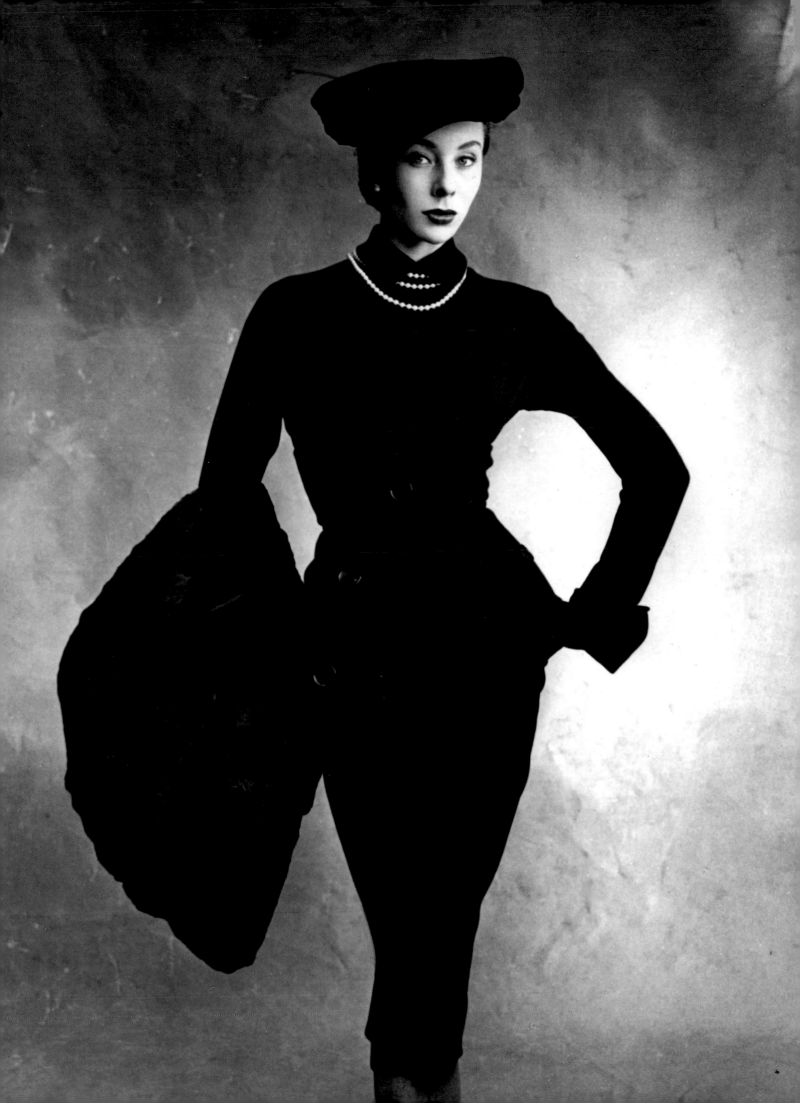

short cut that would spawn a thousand imitators, Audrey Hepburn included.

Where Christian Dior produced romantic, achingly elegant clothes under-girded by crinolines and corsets, Fath's couture had a touch of the bombshell, with accentuated hourglass curves and extra-low necklines. In Bettina he had someone who showed the world that remarkable clothes should never overshadow the woman who wears them. And unlike the willowy ideal that was emerging at the time, Bettina was small, and she had punch.

That punch was what distinguished her from other models of the day, effectively making her career. Even as Bettina could strike very stylized poses when she sat for photographers like Irving Penn at American *Vogue*, she often contrasted her stylized body position with a natural expression that brimmed over with mischievousness and joie de vivre. She might hunch her shoulders or twist her limbs, but she did it with a twinkle in her eye and an insouciant sense of fun that makes even the most archly sophisticated images feel warm. Bettina draws you in without a lot of pomp and ceremony; when you look at her pictures, it's as if she's emoting just for you. Even when her eyes are closed, you can feel her energy, almost as if you could hear her thoughts. Sometimes, despite the dramatic lighting and architectural dresses, her images look almost candid.

In 1952, Bettina went to work as a muse and press agent for a former lieutenant designer to Fath, Hubert de Givenchy, at his new company. There she continued to make an impact, especially in the design atelier. Givenchy's Bettina blouse, created as part of an entire debut collection that bore her name, helped put the designer on the map. In the shirt you can see the same harmony of op-posites that made Bettina herself so chic: the garment is a men's-style button-down with a pointed upturned collar and exaggerated, ruffled bolero sleeves. Under her influence, Givenchy sent models out onto the runway barefoot, and emphasized separates, which allowed women to mix and match. When the designer traveled to New York in 1952 and was interviewed by Edward R. Murrow, it was Bettina who sat by his side, the perfect embodiment of his brand of sporty elegance.

"I CAN'T SAY I WAS THE MOST BEAUTIFUL. IT'S NOT A QUESTION OF BEAUTY. YOU HAVE TO HAVE A PERSONALITY."

—BETTINA GRAZIANI, from "Questionnaire: Bettina, Model and Muse," *Interview*, December 2008

As fashion designers and magazines enjoyed newfound power in the early 1950s, Bettina is often credited with defining what it meant to be a cover girl. *Vogue*, *Elle*, and *Harper's Bazaar* couldn't get enough of her. Though Bettina retired from modeling in 1955, she remained a figure of interest for the society press. She took up with Aly Khan, the playboy former husband of Rita Hayworth, in 1955, and after losing him to a fatal car accident in 1960, returned to Paris to rejoin its jet set. Bettina modeled one last time, for Chanel, before going to work as a press agent and couture director for Emanuel Ungaro during the house's heyday in the mid-1970s, and she remains a respected figure in fashion today.

Opposite:
Photograph by Irving Penn, *Vogue*, 1950.

Dovima

Opposite:
Dovima with
the elephants,
evening dress by Dior,
Cirque d'Hiver,
Paris, August 1955.
Photograph by
Richard Avedon.

One of the reasons fashion imagery from the 1950s is so visually compelling is that it's very different from what's in magazines today. In those days, high fashion was neat, structured, formal, and exceedingly glamorous, far from the daily life of most women. The looks were extreme—constricting pencil skirts, gowns with room for multiple petticoats—as was the makeup, which favored sharply lined eyes and graphic eyebrows. Coordination was key, accessorizing down to the last detail a must. Some models, like Bettina Graziani, worked against convention by employing a gamine charm. Others, like Dovima, a tall, slim, aristocratic-looking brunette, became the epitome of its elegance.

Dovima brought a kind of perfection to the feminine ideal that wouldn't survive into the 1960s. But for one decade at least, she was fashion's highest-paid sittings model. Dovima herself never thought she was all that beautiful, and she actually had a broken front tooth when an editor at *Vogue* discovered her on a New York City street. In her first *Vogue* shoot, which happened to be with Irving Penn, Dovima kept her mouth shut because of it, which gave her shots a *Mona Lisa*–like quality. In fact, that beatific, untouchable expression became her stock in trade.

When modeling, Dovima worked to emphasize her distinctive characteristics, making her seem otherworldly; her attenuated figure, with which she could make graphic shapes, was topped with raven hair and pale skin she made even paler through the thick pancake makeup she applied herself. That she was her own creation was highlighted by the fact that she was one of the first models to go by a single name, which she had con-figured from her given first names, Dorothy Virginia Margaret, as a moniker for an imaginary friend while she was sick with

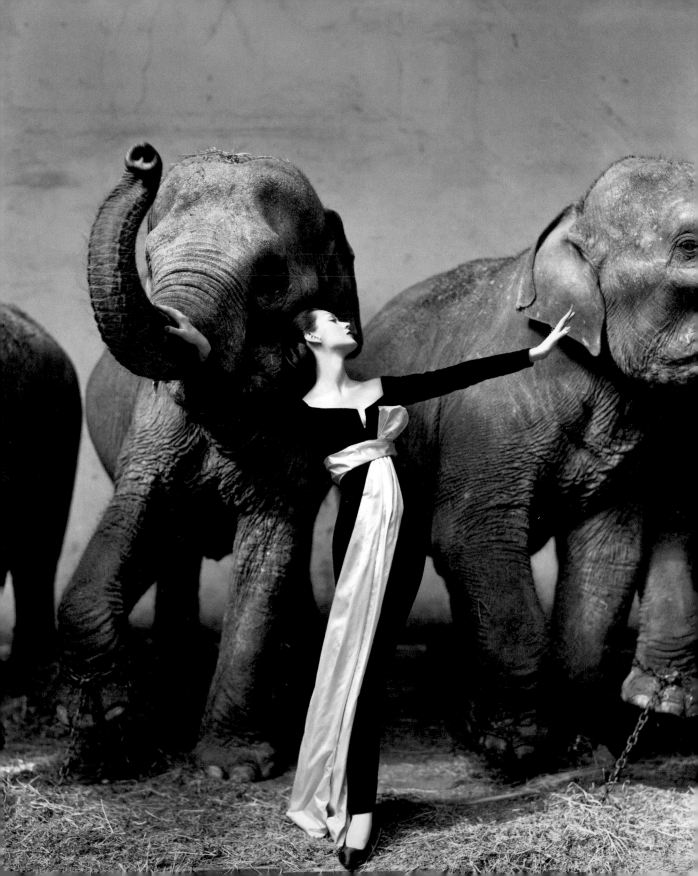

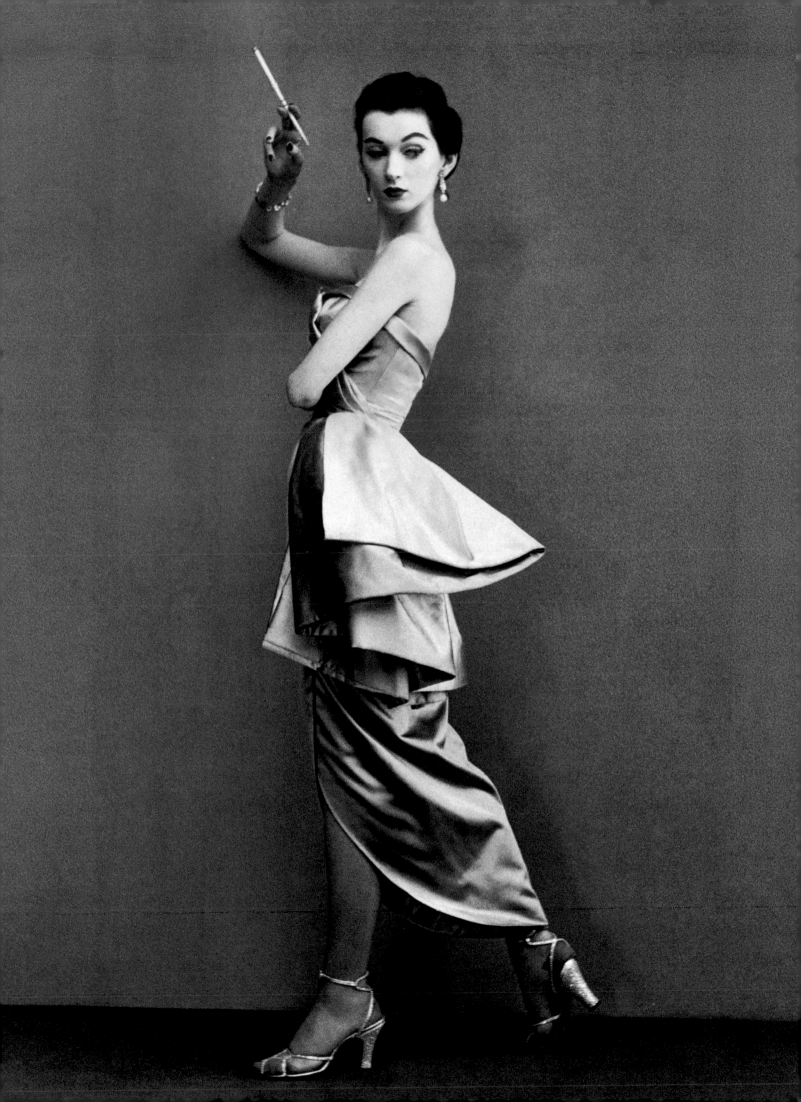

rheumatic fever as a girl. There was an electricity to her, and a flair for drama.

By the early 1950s, certain photographers had unofficial claim on certain models, and Dovima was Richard Avedon's girl. Avedon had come into his own as a leader, making naturalistic, dynamic images, and his 1955 picture *Dovima with the Elephants* is the most famous of all his fashion work—in fact, it's arguably the most famous fashion photograph of all time. The huge animals follow the movement of this witchy figure, as if she were pulling their strings, while she executes a classic 1950s pose, chin up, arms out to her sides. That harmony of opposites— wild animals and a thoroughly composed, perfectly soigné woman—is what makes the image so resonant. You can see a similar dynamic in another of Dovima's great photographs, *Dovima and Sacha*, also by Avedon, shot in 1955, where she sits, in an elegant ensemble, at a lunch counter next to a shaggy dog. Much of Dovima's work implies that chic women are not part of the natural world; they transcend it.

Off camera, Dovima had a very dreamy quality too, which helped her block out almost anything that was going on around her. She was famous for reading comic books, hauling a trunk full of them around behind her while on a shoot with Avedon in Egypt. But she was also capable of making fun of herself, as you can see in her small part in Stanley Donen's 1957 musical *Funny Face*. (Fred Astaire's character, the photographer Dick Avery, is said to have been inspired by Avedon himself, who served on the film

as visual consultant.) She speaks in an exaggerated outer-borough accent and plays the airhead to perfection, even whipping out a comic book in one scene.

But in *Funny Face* you also see the beginning of the end of Dovima, who cut short her own career at the dawn of the 1960s.

"SHE WAS THE SUPER-SOPHISTICATED MODEL IN A SOPHISTICATED TIME. DEFINITELY NOT THE GIRL NEXT DOOR."

—JERRY FORD, from "Dovima, a Regal Model of the 50's, Is Dead," by Bernadine Morris, *New York Times*, May 5, 1990

She was aware that the aesthetic rules were changing, moving toward a greater looseness and a more emotive style. Dovima knew herself well, and what she was capable of, and looseness and displays of great emotion were never in her tool kit. Recognizing that she didn't have it in her to change along with the times, she retired from posing to try acting. Sadly for her, Dovima didn't save or invest the considerable sums she made at the height of her success, and after her acting career failed to take off, she ended her days out of the limelight, in Fort Lauderdale, Florida.

Opposite:
Evening dress by Jacques Fath, Paris, August 1950. Photograph by Richard Avedon.

Carmen Dell'Orefice

Arguably the longest-working model in history, Carmen Dell'Orefice has luminous looks that have only grown stronger as she's aged. Although her seemingly eternal story in fashion is ultimately one of triumph, at its outset it was beset by some of the darker aspects of the business. In the late 1940s, when she began modeling, pay was so low that if you weren't booking advertising jobs, you could work steadily for *Vogue* and still not have enough to eat. Such was the case with Carmen, who took in sewing on the side, sometimes for *Vogue* shoots, while at the same time sitting for the likes of Norman Parkinson, Irving Penn, Horst P. Horst, Richard Avedon, and Cecil Beaton. Carmen, who was the sole breadwinner in her family, was so skinny that many wondered if she wasn't malnourished. And she didn't own

Opposite:
Photograph by John Rawlings, *Vogue*, 1955.

a phone: to book her, sittings editors had to visit her apartment in person, where she lived with her family.

There's a still-waters-run-deep quality to Carmen's composed early pictures, as she views her job as akin to acting. She drifted in and out of full-time modeling, mostly based on whether she had a husband (in this era, very few models worked once they married). She made one comeback in the early 1950s, returning for several years to sit for Lillian Bassman and Richard Avedon at *Harper's Bazaar*. And then she left and came back again, briefly, in the 1960s.

But it was only in the 1970s, after her hair started to turn white, that Carmen really became iconic. After running into Norman Parkinson at a party, she started working again—and with a vengeance,

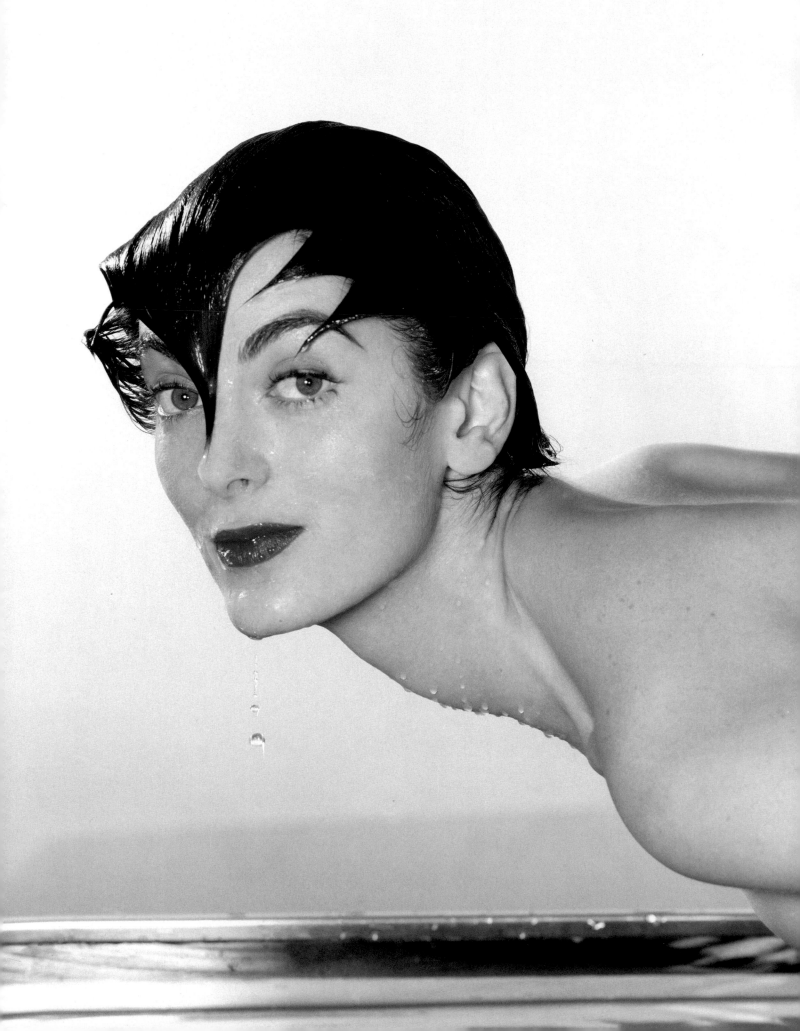

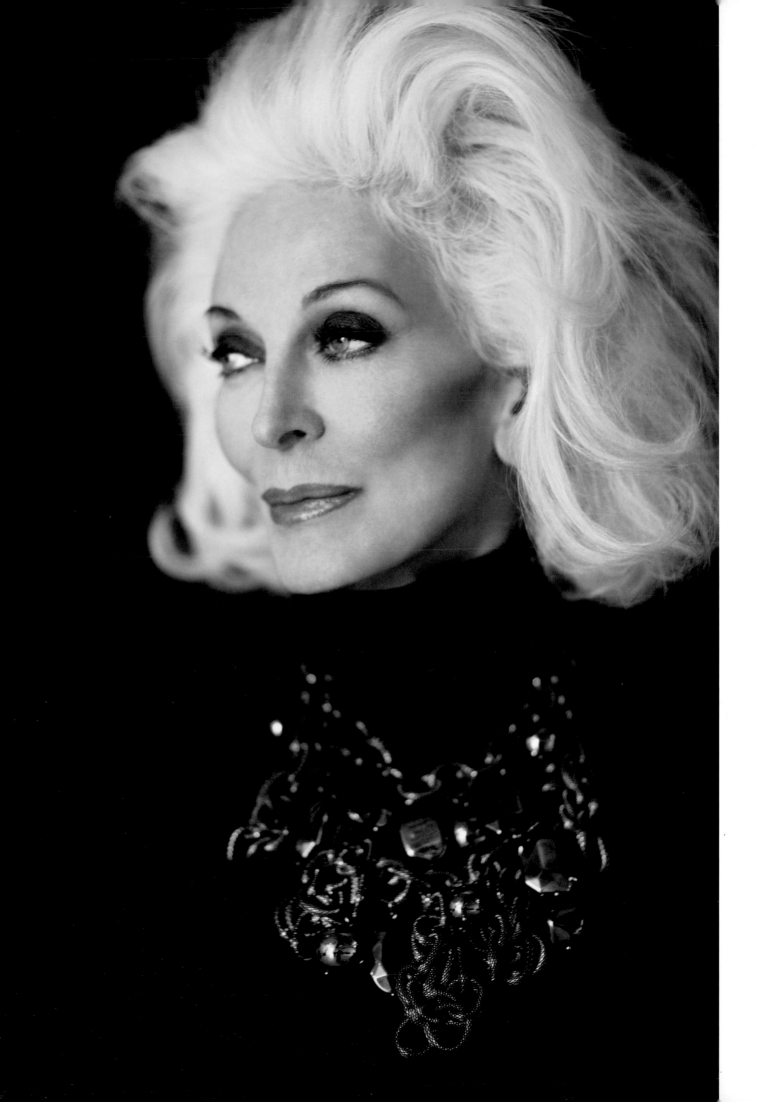

"IT TOOK ME HALF MY LIFE TO UNDERSTAND WHO I WAS. I AM ABLE TO BE TRUER AND TRUER WITH MYSELF THE OLDER I GET, BUT I AM STILL A WORK IN PROGRESS."

—CARMEN DELL'OREFICE, from "Carmen Dell'Orefice, the 82-Year-Old Model, Reveals the Secrets to Her Lasting Success," by Jane Mulkerrins, *Daily Mail*, July 6, 2013

posing nude at age fifty-one for James Moore and becoming the perfect avatar of aging beauty right at the time the world was first ready to enjoy it. Because of Carmen—one of the only senior models working on a high level in the 1980s, helping to expand the category steadily throughout the years—the dreams that models have always helped to create became visibly available, for the first time ever, to women of all ages.

There is a wisdom and humor to the pictures of Carmen taken in her later years, gained by difficult marriages and repeated financial setbacks, and a lot of good times, too. The rigorous 1950s poses she still strikes today show a level of craft that many younger models can only aspire to. Of course, Carmen's renaissance is due in part to her having stayed in incredible shape. Even today, she has reservoirs of energy. Though she is the first to admit to having had a bit of help here and there, her poise, electricity, charisma, and grace—all visible in her work—are hers alone. By her own admission, Carmen has done more covers in the last fifteen years than she ever did before that, and she's still regularly booking fashion editorials for major magazines and advertisements for companies such as Rolex and Missoni, and walking the runways, too.

Opposite: Photograph by Tim Petersen, *Madame*, 2010.

35

China Machado

Like a number of the models of her era who came to the business years later than most girls do today, China Machado had a lot of life experience before she ever walked a runway or sat for a photographer. The product of a biracial family that lost everything at the hands of the Japanese, she grew up in wartime Shanghai, where the only beautiful women she saw in pictures were white; it certainly never occurred to her to follow fashion, let alone work in the industry as a model. Today, to look at pictures of her, especially her work with Richard Avedon, her collaborator from 1958 until she stopped modeling full-time in 1962, it's impossible to imagine that a woman with those regal cheekbones, huge soulful eyes, and impeccable cool wouldn't have a chance for a modeling career. But beauty standards have a way of putting up road-blocks. Once she started in the business, though, China helped break them down.

When China was nineteen, then living in Lima, Peru, she was eager to see the world and got a job with Pan Am as a flight attendant. Her wish would come true, but not with the airline; three days after a chance meeting with the dashing Spanish bullfighter Luis Miguel Dominguín, she dropped everything and ran away with him to Mexico. Her actions ultimately alienated her from her family for more than a decade, although the relationship lasted only two years. At his side, traveling constantly, China ran with a seriously glamorous set, rubbing elbows with people like Pablo Picasso and Errol Flynn.

When the relationship ended—because Dominguín, a well-known rake, left her for Ava Gardner—China went to Paris and found her calling. Initially she went to stay with a girlfriend who happened to work for Jacques Fath; it didn't take long

Opposite:
Suit by Ben Zuckerman,
hair by Kenneth,
New York,
November 6, 1958.
Photograph by
Richard Avedon.

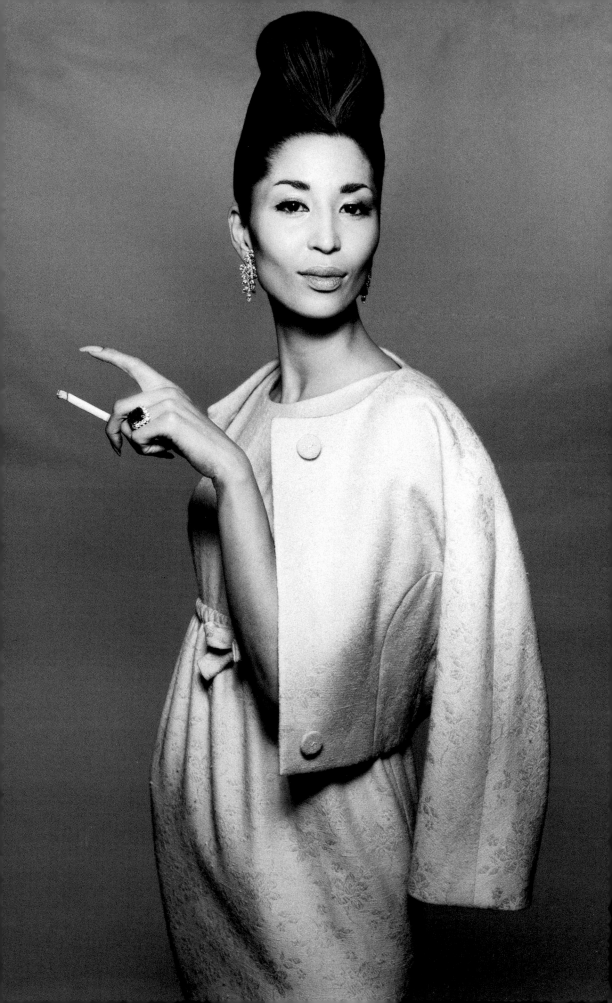

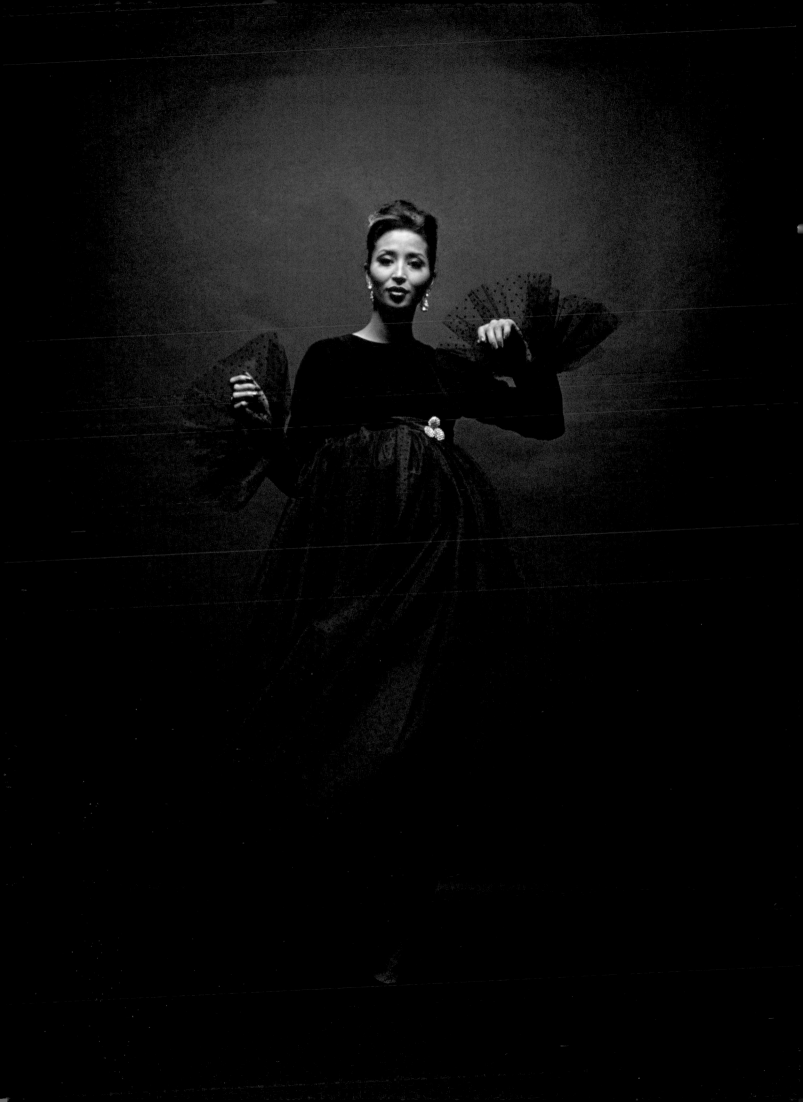

before China was hired as a house model at Givenchy. After changing her name to capitalize on her exoticism—"China," pronounced "cheena," was a common catcall on the streets of Lima—she became a sensation on the European runways, and at one point the highest-paid runway model of her time, earning $1,000 a day.

As a runway model, China didn't have much opportunity to meet photographers who did editorial work. But in 1958, when she was in New York walking in a show produced by Diana Vreeland, she met Avedon. He booked her for a sitting for *Harper's Bazaar* for the next day, and so began one of the most storied and studied collaborations in the history of fashion photography. In Avedon's hands, this exotic-looking woman wasn't forced into contrived poses. She exuded a relaxed confidence, making her foreign beauty feel familiar. China wouldn't learn until a few decades later that Avedon had to fight to get those first pictures published—the magazine feared it would lose subscribers if a nonwhite woman appeared on the cover—threatening not to renew his contract with Hearst unless they ran. The pictures did run, and in February 1959, China became the first woman of color to appear on the cover of a major fashion magazine.

By 1962, China was getting bored of posing, especially since big-money advertising jobs were not abundant for nonwhite models. She started styling for Avedon, then got a job at *Harper's Bazaar* as a fashion editor, a position she held for eleven years. She went on to produce fashion-related television shows and dabble in movie costume design, returning to magazines as a fashion editor for six years at *Lear's*. Ready for a change of scenery, she then left publishing and opened

"SHE'S THIS SORT OF SOIGNÉE, DEVIL-MAY-CARE WOMAN WHO'S ALL FIXED UP AND VERY PROPER, BUT SHE ALSO HAS THIS SLIGHT ATTITUDE, LIKE: YOU DON'T LIKE IT? TOUGH."

—CAROL SQUIERS, from "China Machado," by Bridget Foley, *W*, March 2010

a high-end catering and tableware boutique in Water Mill, New York, but fashion couldn't let her go. At the age of eighty-one, in 2011, China signed a two-year contract with IMG models, appearing in editorials for *W* magazine and in advertisements for Cole Haan and Barneys New York. She's not hired for these jobs simply because of her past glory, though people are certainly happy to see her again. China's engagement with the camera and her instinctive feel for clothes always come forward. In that sense, she remains truly ageless.

Opposite:
Photograph by Jerry
Schatzberg, 1960.

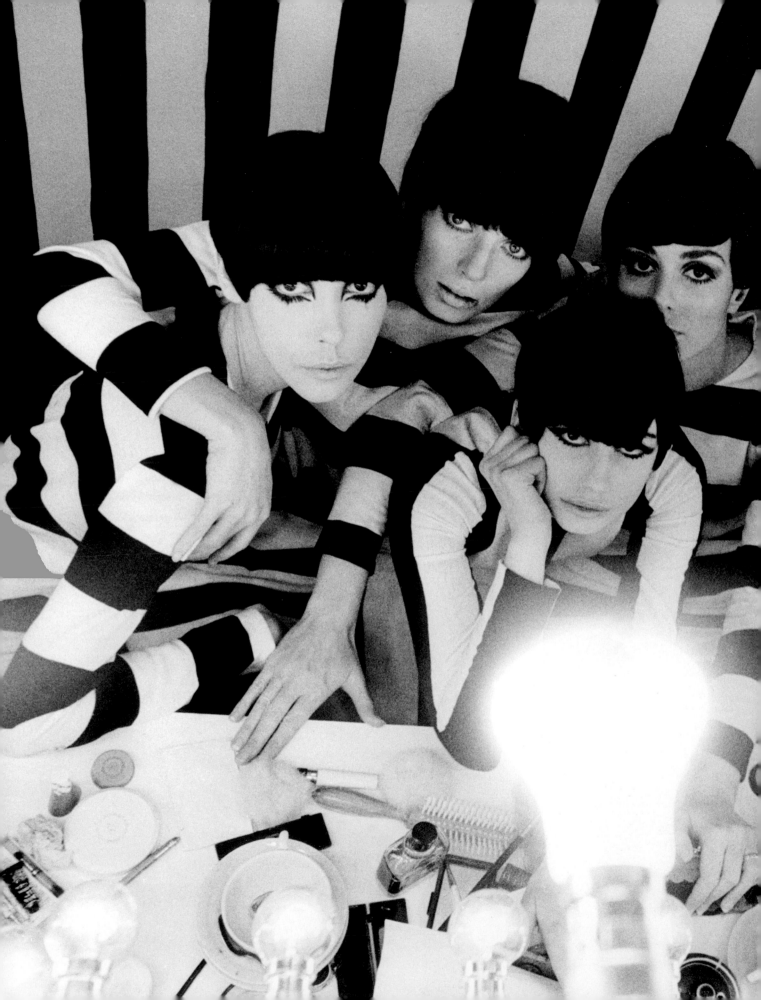

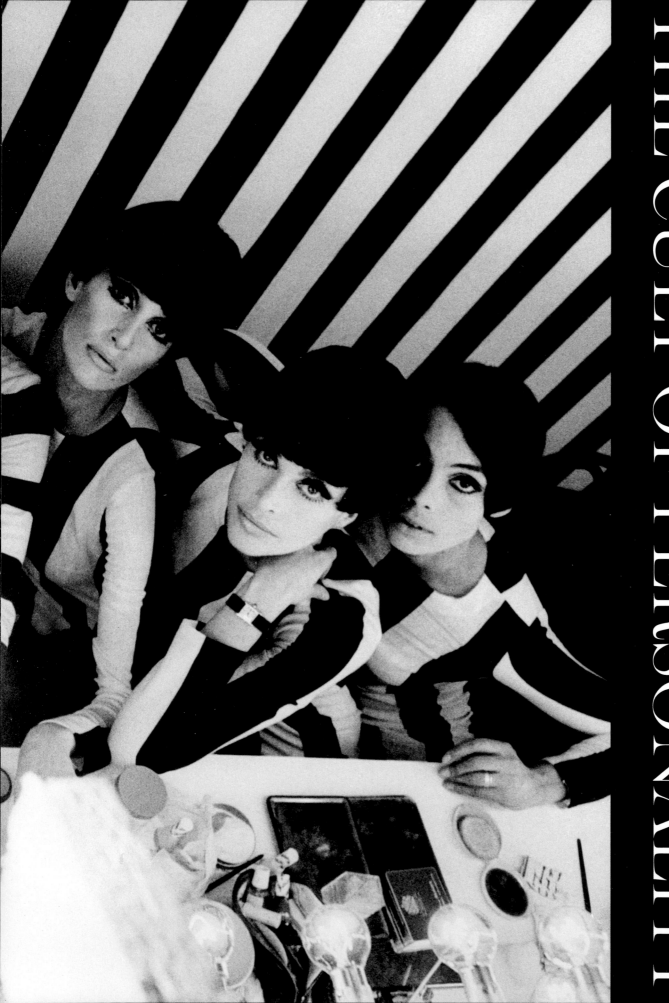

THE CULT OF PERSONALITY

BY THE 1960S, THE HORRORS OF
World War II were beginning to fade, and rationing was a dim
memory. As the world rode a wave of prosperity, the television
age began, giving a new immediacy and power to events
worldwide, including the Cold War and the spread of nuclear
warheads, ongoing movements for social change, and the
Dionysian musical form of rock and roll. For the first time,
masses of people in countries all over the globe were united in real
time, which made political and social developments more intense, both
terrifying and exhilarating, even for those who were watching on the sidelines.
Establishment power started to break down, and with protest movements arising in places from
Mexico to the United States to Western Europe to all over Africa, individuals had no choice
but to confront what was working and what wasn't in their own lives as well. Thus was born
the human potential movement, which gave rise to explorations of lifestyle, sexuality, and
creativity that seemed to wake up the whole world.

In America alone, seventy million teenagers came of age during this time, and more than
anything, they wanted the freedom to express themselves outside of the rigid norms of their
parents. Fashion heard their call, and the decade saw a new eclecticism, with designers as
diverse as Pierre Cardin, Rudi Gernreich, and André Courrèges, who celebrated the future
and fetishized modernity and its technological promise, and a bohemian brigade that included
Ossie Clark, Biba's Barbara Hulanicki, and Yves Saint Laurent, who sought to give women with
adventurous, less formal lifestyles sensuous clothes to play in. There also came a radical change

in beauty standards. Androgyny, imperfection, and eccentricity started to become accepted as characteristics of individual beauty rather than negative qualities that deviated from the norm. Hair became decorative and geometric. Or it became unstuck—wilder, bigger, longer. Makeup went to new heights of theatricality, too, as beauty itself became an interrogation rather than a declaration. Unusual faces and posing and blatant sexuality started to capture the interest of established American photographers like Richard Avedon, and such rising stars as Melvin Sokolsky, Bob Richardson, and the "terrible trio" of David Bailey, Terence Donovan, and Brian Duffy in London, who posed women in newly provocative ways, often in quotidian settings for greater shock value. Models who dominated this era, like Veruschka, were adventurous, both in defying modest norms and in posing in outlandish locations, sometimes at risk to their own safety.

The notion of celebrity also started to change in the 1960s. Paparazzi began to follow the famous as they lived their daily lives, giving a newly frank look at off-duty musicians, actors, and, in some cases, models. Models who took up with notable personalities—like Jean Shrimpton with Terence Stamp, Edie Sedgwick with Bob Dylan, and Peggy Lipton with Paul McCartney—drew new attention to their profession and occasioned fantasies about the glamour their job entailed. This in turn made more young girls see modeling as an attractive professional option rather than a shabby side career, and brought more aspirants into the fold. Some models, like Twiggy, became pop phenomena in their own right. Even if photographers and powerful fashion editors like Diana Vreeland, who left *Harper's Bazaar* in 1962 to take the reins at American *Vogue*, still held most of the power when it came to a model's fate, and would hold on to it until the middle of the next decade at least, the seeds of the model as superstar, bigger than her photographer, magazine, or advertising client, were first planted in this era, when fame on a mass scale was truly invented.

Pages 40–41:
On the set of
Who Are You, Polly Maggoo?, 1966.
Photograph by
William Klein.

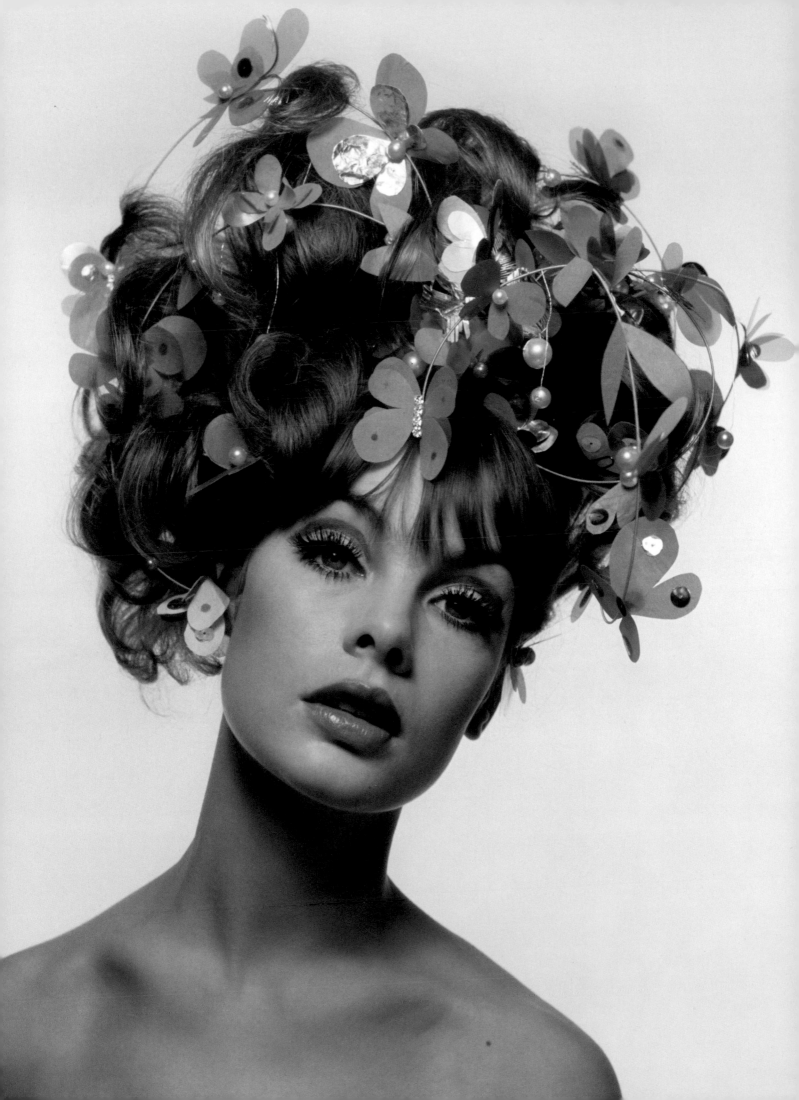

Jean Shrimpton

It is often impossible to date the moment when one era ends and another one begins, but in fashion, it could be said that the transition from the 1950s to the 1960s happened in a single meeting in 1960, when eighteen-year-old Jean Shrimpton was discovered by David Bailey while she was waiting in a studio for another photographer. Bailey, like his fellow working-class East Londoner photographers Terence Donovan and Brian Duffy, was a rough-and-tumble bad boy who developed a style of photography that was both blatantly sexual and infused with youthful pop energy. Unlike the 1950s work of Penn and Avedon, which presented seemingly flawless women in idealized or even sterile environments, the "terrible trio," as Bailey, Donovan, and Duffy were called, portrayed models in quotidian contexts. This made it easier for the young women reading the magazines to identify with the clothes and products they saw—and they readily did.

The coltish, aristocratic Jean Shrimpton, or the "Shrimp," as she came to be called, had slightly rumpled hair, huge doe eyes, full lips, and arched eyebrows. She gave off the air of a privileged, innocent young woman yearning to be seduced, which endowed those pictures, especially Bailey's, with a sexual vibrancy that spoke to both the high fashion–minded and the masses alike. Under Bailey's influence—they became a couple soon after they started working together—Jean's career took off quickly. She landed major magazine covers in her first few years, refraining from advertising work to give her more exclusivity and power (though in later years she worked for major companies like Revlon, Max Factor, and Yardley of London). The Shrimp and Bailey—photographed at nightclubs, hanging out with their friends the Rolling Stones—were the pair of the moment, never mind that until 1963, he was still married to someone else. That same year Jean was named "Model of the Year" by *Glamour* magazine, and became the poster girl of swinging London, the combustible meeting point of changing sexual mores, the lifting of Britain's postwar austerity, accessible youth fashion, and rock and roll. Sadly for Bailey, 1963, just after he and his wife finally parted, was also the year that Jean finally left him for the screen

Opposite: Photograph by David Bailey, British *Vogue*, 1965.

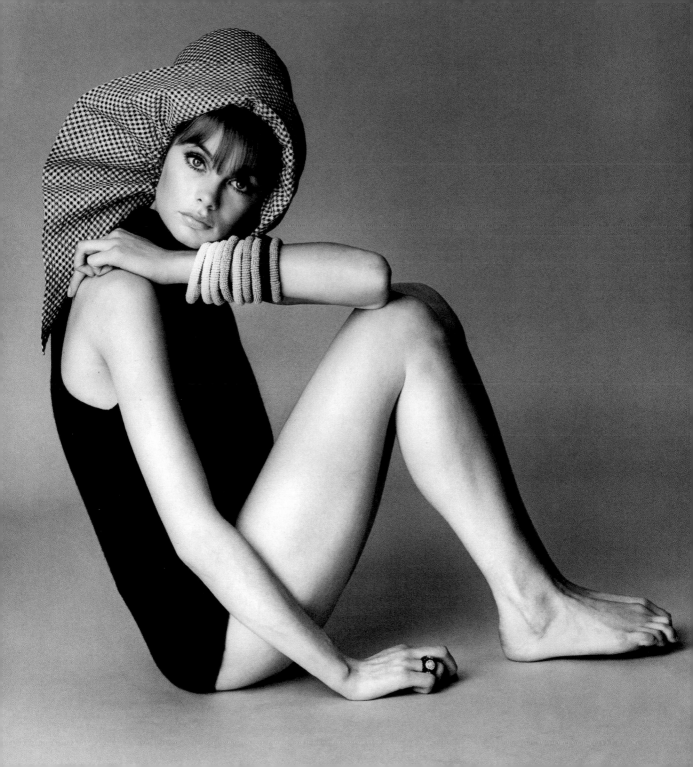

"WHAT ATTRACTED ME TO HER WAS THAT SHE GENUINELY DIDN'T CARE HOW SHE LOOKED. SHE HONESTLY NEVER UNDERSTOOD WHAT ALL THE FUSS WAS ABOUT."

—DAVID BAILEY, from "The Shrimpton Story," by Jessica Bumpus, British *Vogue*, March 2010

idol Terence Stamp, which only made her more famous.

When Jean crossed the Atlantic to work more regularly in the larger American market, also in 1963, she was the highest-paid model in the business at the time, earning $120 an hour. Diana Vreeland put her on the cover of *Vogue* nineteen times. Jean's cultural power was such that, the following year, when she appeared at the Victoria Derby in Melbourne, Australia, wearing a minidress because a local designer hadn't had enough fabric to fashion something longer, she captured headlines. Jean had assumed no one would notice the shorter skirt, or the fact that she opted to forgo tights, a hat, and gloves, and that she wore a men's watch. But then she always underestimated her own impact, which was part of her charm. No one else made that mistake: the "Shrimpton Incident," as it became known, was the first verifiable moment that miniskirts became a craze; Jean went on to design a few with Mary Quant, who became known for the style as well. At the same time, department-store mannequins were being modeled after Jean's features,

particularly her sporty bangs and pouty lips. And to this day, the freshness and charm and bewitching mix of innocence and adventure that Jean brought to fashion photography are still referenced constantly, especially by designers like Marc Jacobs and Burberry's Christopher Bailey, whose casually elegant vision for the storied English house is like a master class in Shrimptonism. During the early to mid-1960s, you couldn't get away from Jean if you wanted to. And no one wanted to.

Well, no one except Jean. Even though she volunteered to become a model, enrolling in the Lucie Clayton Grooming and Modeling School the year before she made it big, fame and posing were never really her cup of tea. Tired of this work, Jean tried her hand at acting in 1965, with little success. Uncomfortable with being so well known and feeling, as she said, slightly guilty for having earned so well, she retired from the industry in 1971. A few years later, she moved to Cornwall and opened an antiques shop, and soon bought a hotel there. She has said that she only decided to pen the story of her life, called *An Autobiography*, in 1990, when she needed the money to redo the roof.

Opposite: Photograph by David Bailey, British *Vogue*, 1964.

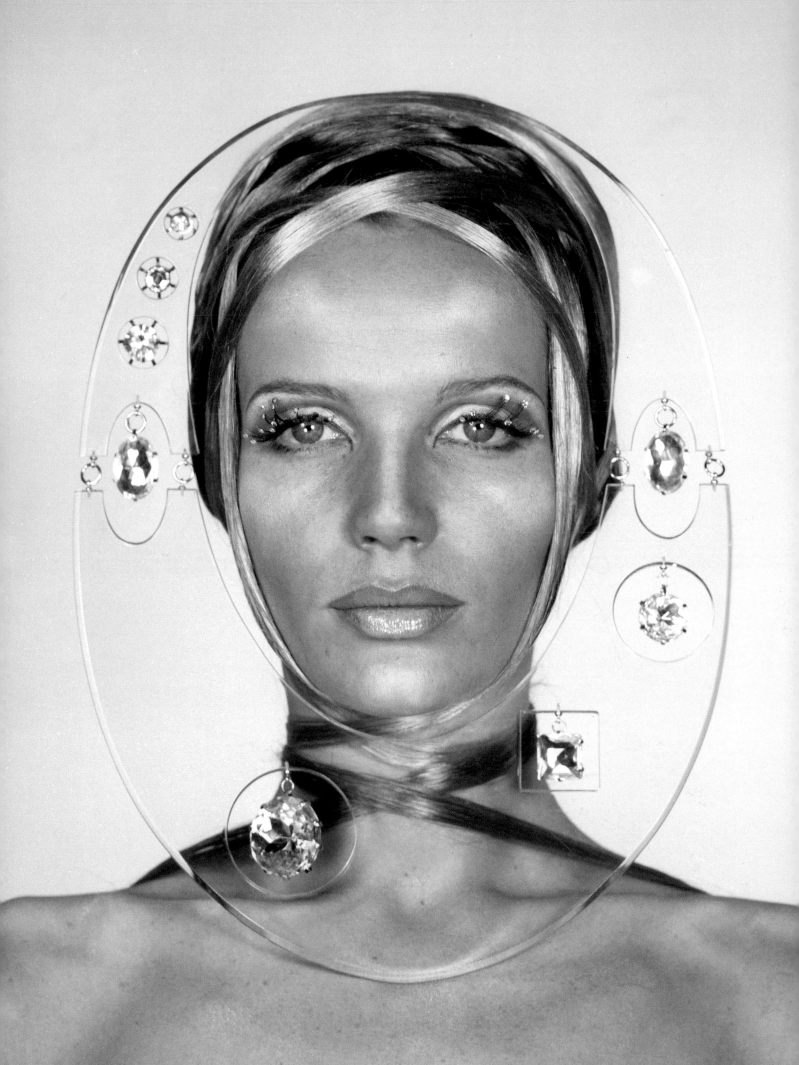

Veruschka

Veruschka stormed into mass consciousness in 1966 thanks to a five-minute film-stealing cameo in Michelangelo Antonioni's *Blow-Up*. The movie's lead character, played by David Hemmings, was a composite of photographers David Bailey and Terence Donovan, and early in the film, he strolls into his studio, where this otherworldly creature, clad in a beaded shift that barely covers her impossibly thin frame, writhes around and crawls on the floor. Hemmings, doing his best Bailey imitation, grabs his camera and alternates between shouting encouragement and discouragement, and practically mauling the model. When Antonioni's movie first came out, every hip young lad in London was suddenly carrying a Hasselblad, trying to have a go as a photographer. Who wouldn't want to do that for a living?

Veruschka became a household name after that feline performance, but in the fashion world she had already been a top model for three years, since landing her first *Vogue* cover in 1963. Born Countess Vera Gottliebe Anna Grafin von Lehndorff-Steinort, Veruschka enjoyed a life of consummate privilege in her earliest years. Her family lived in a one-hundred-room house on an enormous estate in East Prussia, now Germany. Things went sour for them, as they did for so many others, during World War II: in Vera's case, her father participated in the failed Valkyrie coup to assassinate Hitler, and was executed as a result. The von Lehndorff family's life

of luxury vanished seemingly overnight. The family ended up homeless for a time, and Vera attended thirteen different schools before enrolling in art school in Hamburg.

At the age of twenty, now living in Florence, she was discovered by the portrait photographer Ugo Mulas, though she would have been hard to miss. Extraordinarily slim, standing more than six feet tall, with razor-sharp cheekbones and voluptuous lips, she had a pantherlike quality and a fearlessness that must have been born from her difficult life. Despite her striking looks, she was considered almost too tall to model, and initially too bony and gawky as well. But she was interested in giving it a go and moved to Paris in 1960, where Dorian Leigh represented her. Through Dorian, Eileen Ford encouraged Vera to come to New York City, but in the following year, when she arrived, she was ignored by the fashion establishment there. And so it was back to Paris once more, where Vera finally landed upon the magic formula that would make her career take off. She went exotic. She changed her name to Veruschka and gave herself an au courant, beatnik edge, dressing entirely in black to accentuate her spindly frame.

She went back to New York once again, in 1961, and this time, Veruschka shook up the fashion scene and landed her first *Vogue* cover. It was her willingness to own her body, to submerge herself in this invented character, that made people

Opposite:
Photograph by Franco Rubartelli, *Vogue,* 1968.

Page 51:
Photograph by Franco Rubartelli, *Vogue,* 1968.

"FASHION ISN'T ABOUT BEING BEAUTIFUL. IT'S ABOUT NEVER BEING FORGOTTEN ONCE A PHOTOGRAPHER HAS SEEN YOU."

—VERUSCHKA, from "Her Bold Looks Made Her a Standout in the '60s, but Now Veruschka Paints Herself into the Background," by Michael Small, *People*, February 16, 1987

see her as otherworldly, not scrawny. Not only daring in her sexiness, Veruschka also became known for being willing to do just about anything for a photograph, including posing in the most extreme locations, even under sometimes treacherous conditions. She was an adventuress at a time when the birth of the mass media first gave the world a sense of its own smallness. And in the height of the Cold War, this girl from the East was like forbidden fruit. The exotic Bond girl archetype that arose with the success of those films borrowed much from Veruschka's profile.

By 1975, Veruschka had tired of sitting for artists and yearned to become one herself. She retired from modeling, changed her name back to Vera Lehndorff, and partnered with the German photographer

Holger Trulzsch to create eerie portraits in which she camouflaged herself with body paint to become essentially invisible. She had already been experimenting with body painting on the pages of *Vogue* in the late 1960s (models in those days still did their own hair and makeup on set). But Vera's efforts to go deeper, to the point where she herself disappeared in the context of the work, are both ironic and daring since her face and body were the basis of her success up until then. The book she released with Trulzsch, *Veruschka: Trans-figurations*, in 1986, was an art-world hit. She currently creates video installations that have been displayed at the Art Institute of Chicago and PS1 in New York, and occasionally pops up on catwalks and in photographs under the name that first made her famous.

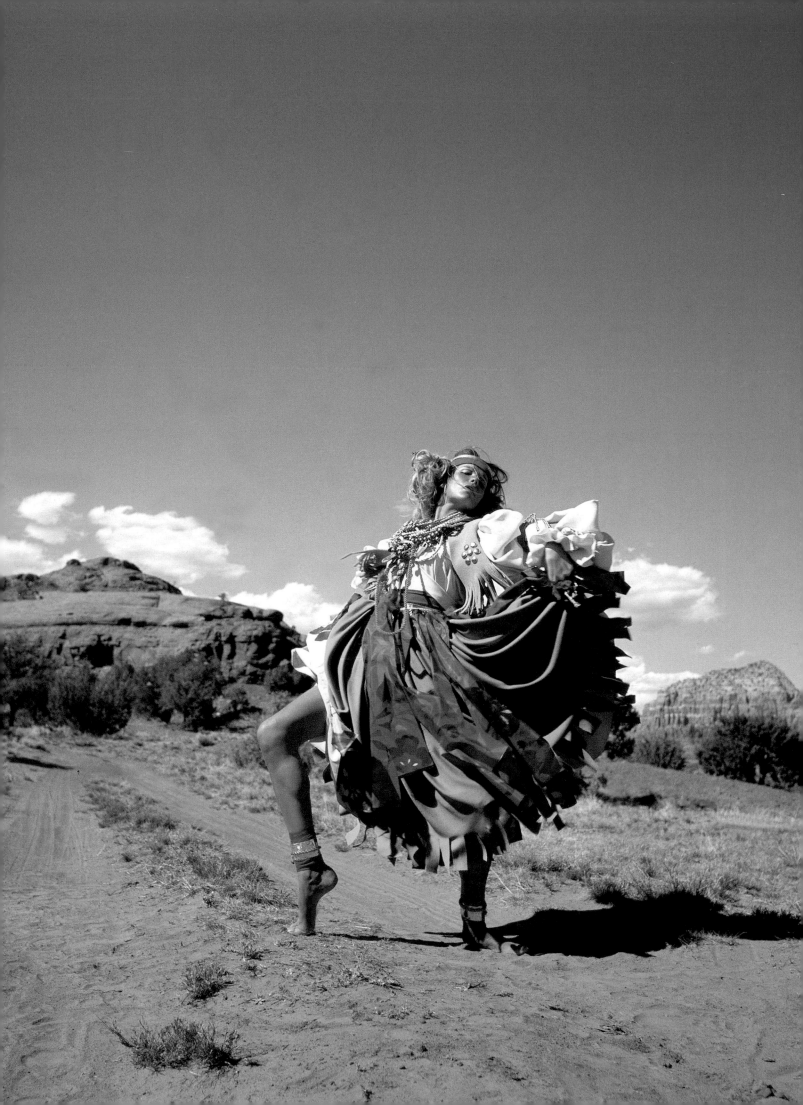

Peggy Moffitt

Trained in theater arts, Peggy Moffitt landed small acting parts in Hollywood before turning to modeling in the late 1950s, while she was still in her late teens. In 1959 she married the photographer William Claxton, who was making a name for himself as a portraitist of jazz musicians, and the pair became very close to the Los Angeles–based designer Rudi Gernreich. Gernreich, who had once worked for costumer Edith Head and was long an admirer of modern dance, was making inroads into fashion with less structured, highly graphic, and more affordable designs, like knit tube dresses and dramatic color-blocked swimwear. He relied on Peggy and Claxton, who photographed all his look books, as sources of ideas and inspiration.

As a model, Peggy put her great intelligence and dance training toward creating an angular new style of posing that called to mind the work of choreographer Martha Graham, which she complemented with Kabuki-esque makeup. She was daring, seeing herself more as an artist than a creature of commerce. Unafraid to look strange or unpretty, she would bug out her eyes and make faces that exaggerated her long, drawn-out features—whatever it took to express herself and portray a persona she thought the clothes would support. During shoots, Peggy created elaborate characters and backstories for herself, constantly dancing while the camera was on. Her pictures were crystallizations of the rising mod aesthetic; they had a sculptural, graphic, and also distant effect, as if she were lost in her own world.

By 1964, with Claxton and Peggy working on every collection with him, Gernreich decided that the time had come to take a risk. Eager to make a comment on the hypocrisy of fashion—which the trio saw as aiming to titillate while remaining essentially prudish—Gernreich proposed a topless bathing suit. He rendered it in simple black, held up by V-straps that started just below the breast. When he presented the design to Peggy, she agreed to pose in it, but under certain conditions: Claxton had to shoot the picture; she would have final say on where it would run, specifying that it could not be featured in *Playboy* or *Esquire* or in any other exploitative context; and she would never be expected to wear it on the runway.

Opposite:
Photograph by William Claxton, 1971.

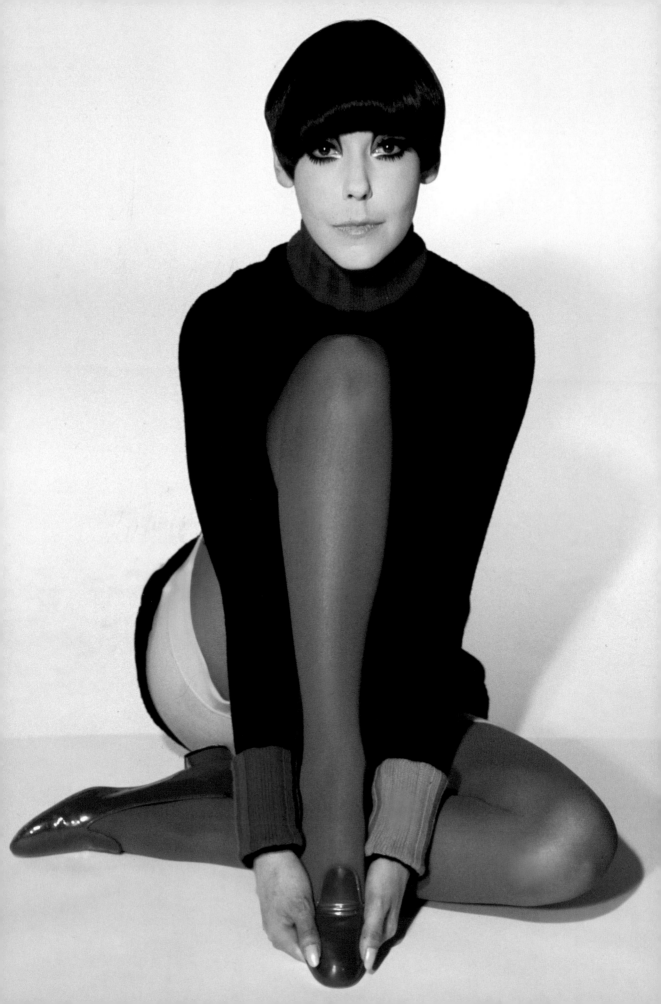

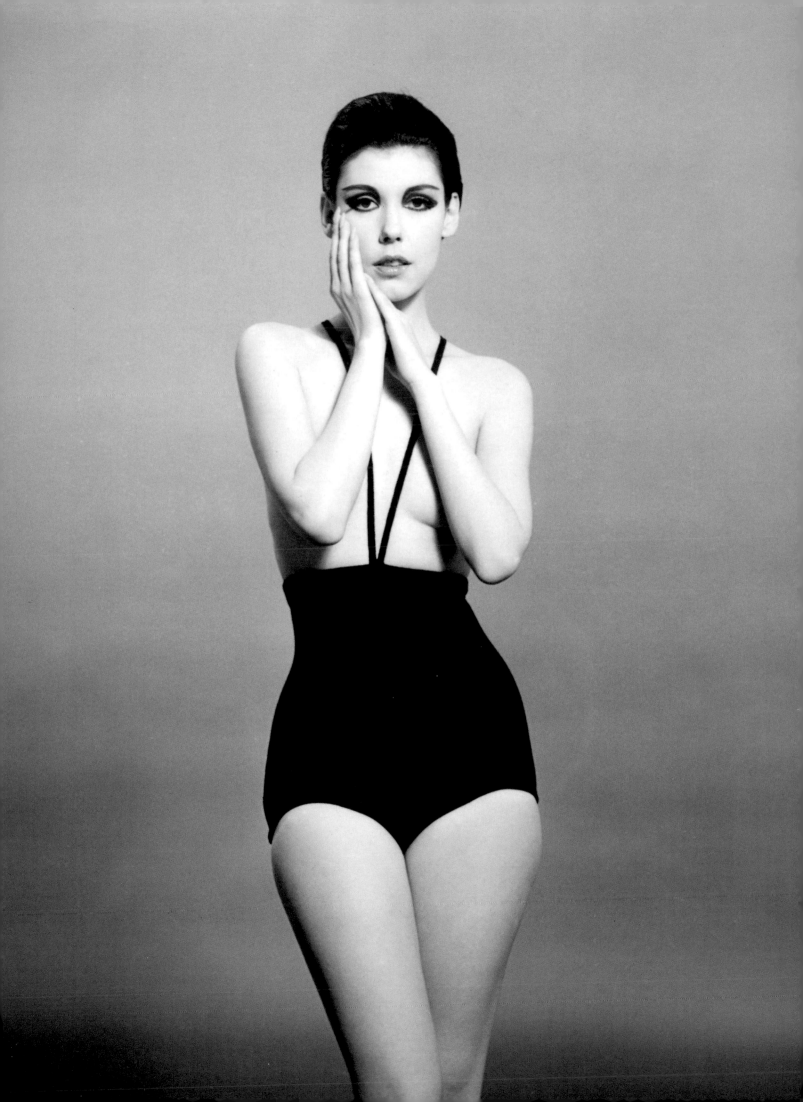

The eventual picture, in which Peggy is dripping wet, her willowy limbs settled gracefully against her body, went out to the fashion press and caused a sensation. Even as popular culture was beginning to loosen up and women's fashion started leaving girdles behind, nudity was still very much taboo, and the monokini was denounced by everyone from the Vatican to the Soviet Union to Republican politicians. Peggy's ensuing work, with its freedom of movement and expression and willingness to bare flesh, especially wearing Gernreich's ahead-of-their-time designs, helped to change that.

A year later, while on a shoot with Richard Avedon, modeling the sheer No-Bra, another Gernreich design, Peggy met Vidal Sassoon. Later that year, at a demonstration for his fellow hairdressers in Los Angeles, he gave her his now famous five-point bob, a strict, angular short haircut that he invented on his then hair model, Grace Coddington, the future creative director of American *Vogue*. As all eyes were already on Peggy thanks to the monokini, she helped turn the style into a beauty craze. With this trailblazing and much-copied look, she appeared in two seminal fashion films, *Blow-Up* and *Qui Êtes-Vous, Polly Maggoo?*, a withering fashion satire by fashion photographer William Klein.

Peggy remained on the cutting edge behind the camera, too. In 1967, she conceived the script for "Basic Black," the first-ever fashion film, a wordless, seven-minute short video directed by Claxton.

At the time, photographers were starting to break into filming television commercials, and Claxton wanted a reel, so Peggy got Gernreich to loan out some of his more dramatic pieces, set down the ideas, and once again steered fashion history in a new direction. She also held the copyrights to Gernreich's designs, and after he died, she published *The Rudi Gernreich Book* and helped curate an exhibition on Gernreich, Claxton, and herself at the Museum of Contemporary Art, Los Angeles.

"I UNDERSTOOD THE POINT OF OVERSTATING THE CASE FOR UNRESTRICTED EXPRESSION OF FREEDOM."

—PEGGY MOFFITT, from *The Rudi Gernreich Book*, by Peggy Moffitt and Marylou Luther, 1999

Today, Peggy still possesses great energy: the feistiness that helped her forge her place in fashion history is still intact, as is the Sassoon cut and the thick fringe of false eyelashes. Peggy continues to do things her way.

Opposite:
Photograph by William Claxton, 1964.

Twiggy

Before Lesley Hornby, a.k.a. Twiggy, landed on American shores in 1967, her fame so preceded her that on the day of her arrival, there was a frenzied press conference at the airport, not unlike the one the Beatles encountered in 1964. Jean Shrimpton had certainly achieved international fame for both her beauty and her personification of the swinging London lifestyle, but her popularity was nothing compared to that of Twiggy, who was an instant and mass phenomenon at age sixteen. Within two years of her first professional photograph appearing in a London hair salon, and with her boyish, frail body and huge eyes, her name became a full-blown brand, with a dress line and a hit single, "Beautiful Dreams," for Ember Records. In short order, she followed this up with a makeup line, a doll, a board game, lunchboxes, a musicians' agency, and a boutique. Even today, when the model as mogul is more and more common, the brand categories that this tiny, birdlike girl was able to span remain wider than anyone else's.

The secret to the Twiggy phenomenon lies in two spheres: what Twiggy herself brought to bear and where popular culture was at the time. For all the rest of the Twiggy machine, she was, and is, a naturally gifted model with a rare authenticity. With her innocence and youth, and her plucked-from-obscurity story, Twiggy was visibly working class, a real girl, and fascinating for that very reason. Those

qualities gave her overwhelming appeal to her teenage peers the world over. And that appeal translated to sales for advertisers, because 1960s kids not only wanted to buy Twiggy-endorsed products but also had the spending power to do so.

Twiggy's appeal in the world of fashion has much to do with her reflecting the zeitgeist of the day. In the mid-1960s, high fashion was not necessarily becoming more androgynous in nature, but it was becoming less restrictive and less curve-accentuating, and moving toward a looser, freer, and younger look. It's not that designers and photographers were out looking for boyish teenagers to shoot, but when Twiggy came along, it was kismet. Her lightness, luminosity, and expressive, childlike face represented a certain innocence and optimism that characterized the era, and in modeling the clothes of that time, she came to symbolize the more youthful, spirited aura of her generation.

Twiggy was discovered in 1966, after a portrait of her short pixie haircut ran in a London hairdresser's shop. An editor for the *Daily Express* saw it, reached out to Twiggy, and, with all the speed and immediacy that a newspaper could bring, declared her the "Face of '66." With such an auspicious introduction, Twiggy immediately started modeling for real, posing for British *Vogue* and *Elle*, but she wasn't embraced by David Bailey and his contemporaries, who preferred more

Opposite:
Contact sheet, 1967.
Photographs by
Ronald Traeger.

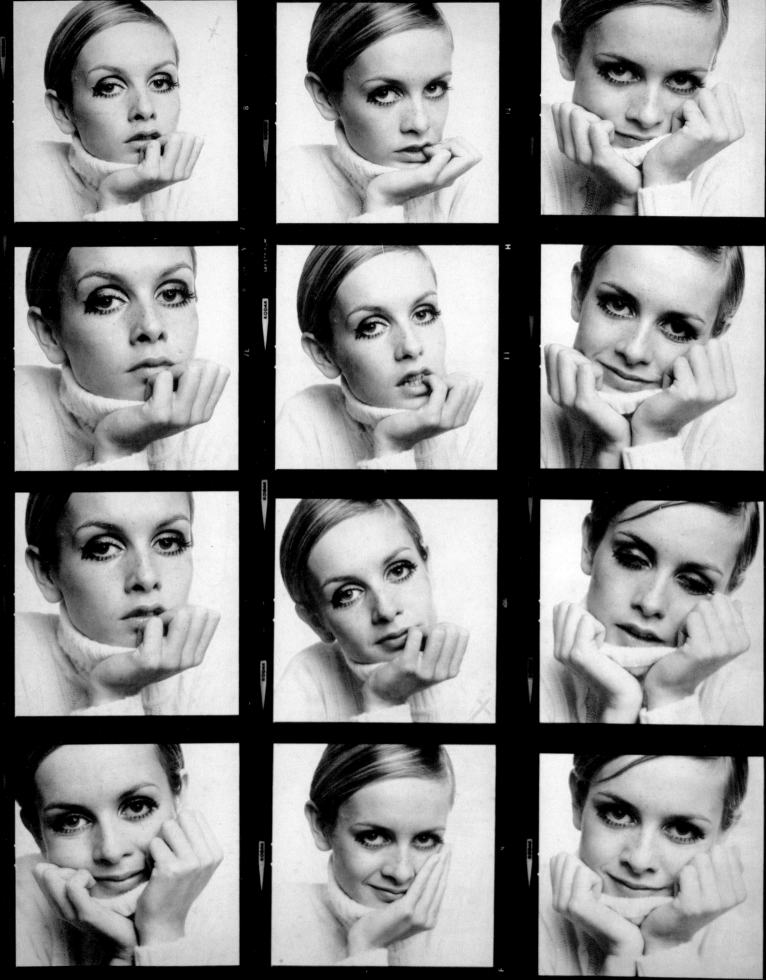

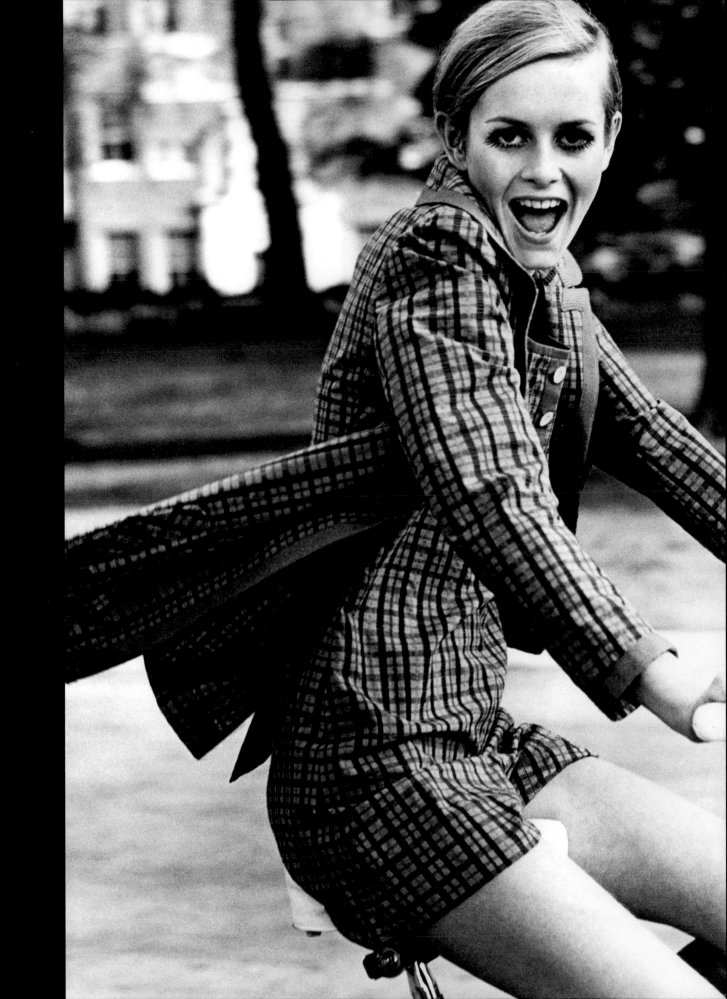

"THE WORKING-CLASS GIRL WITH MONEY IN HER POCKET CAN BE AS CHIC AS THE DEB. THAT'S WHAT TWIGGY IS ALL ABOUT."

—CECIL BEATON, from *Twiggy: A Life in Photographs*, by Terence Pepper, Robin Muir, and Melvin Sokolsky, 2009

sophisticated and womanly models. It didn't matter, though: Twiggy wasn't the face of the posh; she was the face of the people. She was the standard-bearer for the gamine girl, like a younger, poppier version of Jean Shrimpton, and as a household name across Britain, a safe way into fashion and style for kids outside of sophisticated cities like London. She herself worked a bit outside the system, without a model agent, under the guidance of her older boyfriend, a former hairdresser who assumed the name Justin de Villeneuve, who helped her to launch her early branding initiative.

Prefiguring later controversies over Kate Moss and "heroin chic," Twiggy's success was divisive from the start, and she was unfairly accused of promoting an unhealthy body image. But those who loved her loved how brilliantly she captured, and made beautiful, the newly culturally visible phase of awkward adolescence. When Twiggy came to America to promote her Twiggy dress line and pose for Diana Vreeland at *Vogue*, she was followed by the fashion photographer Bert Stern for three ABC documentaries, *Twiggy in New York*, *Twiggy in Hollywood*, and *Twiggy, Why? Newsweek* did a feature on her, and *The New Yorker* gave her fifty pages—including an extensive profile and photographs by Richard Avedon—unheard of even to this day. At the height of her modeling fame, that one sensational year,

from 1967 to 1968, she sat for other top photographers, including Cecil Beaton, Melvin Sokolsky, and Norman Parkinson. And Vreeland championed her: in 1967, Twiggy was on the cover of *Vogue* four times.

But as often happens with rapid, sensational rises to fame, the ride is short. By 1969, due to extraordinary overexposure, the Twiggy rage had fizzled out. She retired from modeling, turning her attention to acting and singing. Since the 1970s, when she started to release her own records and posed next to David Bowie on the cover of his album *Pin Ups*, she has appeared onstage and in films numerous times. In the 1990s, having proven to herself that she was a complete person and not just "a thing," Twiggy started modeling again, for the quintessentially British company Marks & Spencer, where she has become a brand ambassador. Thanks to her broad range of talent and hard work, Twiggy has risen above her sensational early branding to become a cultural mainstay in Britain. But those early images have such resonance that they've endured worldwide, not only because of the easily identifiable hairdo and giant eyelashes, or because they are such perfect exemplars of an optimistic and adventurous moment in history, but also because the spunk and innocence that Twiggy expressed, her sense of wonder, enthusiasm, and vitality, have eternal appeal.

Opposite:
Photograph by
Ronald Traeger,
British *Vogue*, 1967.

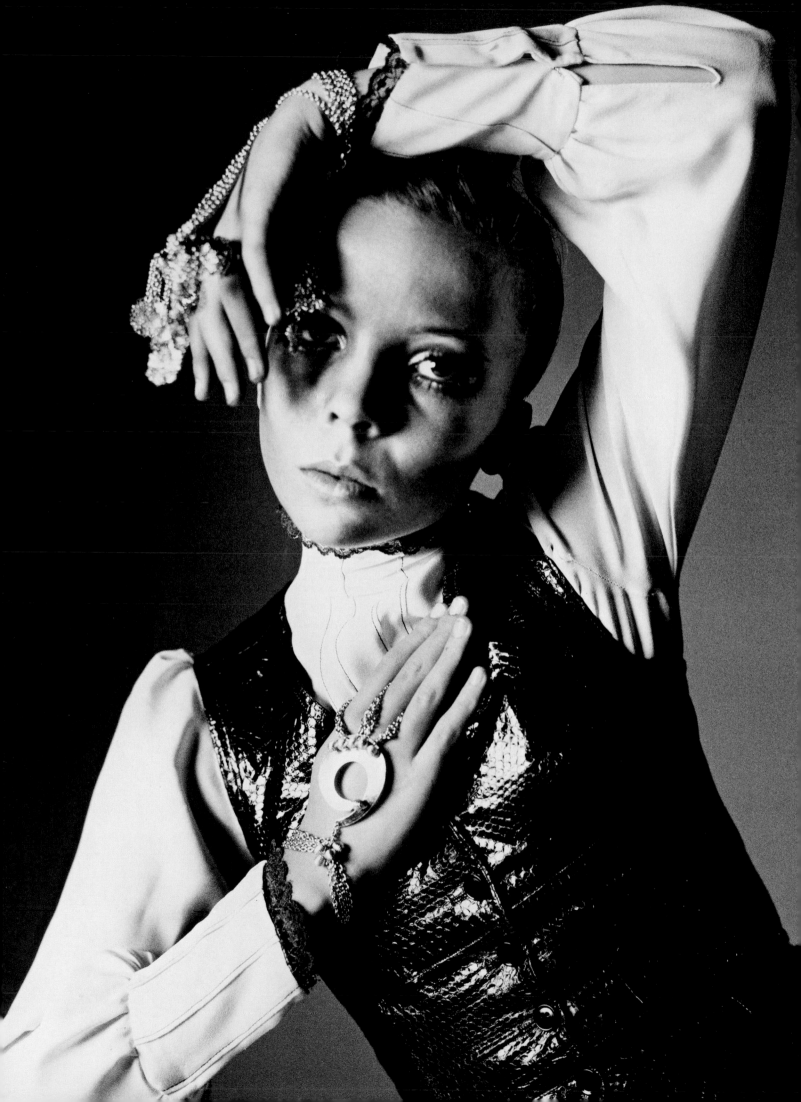

Penelope Tree

With her quirky, ethereal style and saucer-shaped eyes, Penelope Tree embodied the sense of exploration and experimentation that so many were experiencing in the latter half of the 1960s. In 1968, two years after she was first discovered at age seventeen by Diana Vreeland at Truman Capote's Black and White Ball, she was declared America's Twiggy, although Penelope was the great-granddaughter of Marshall Field and far from working class.

Penelope, who grew up in a socially connected family in New York City, was as unconventional as she looked. Diane Arbus was the first professional photographer to see something in Penelope's broad, vulnerable face, which she spied, and photographed, staring through the balustrade at a party at Penelope's family's house when Penelope was just thirteen. Arbus tried to run the picture in *Town & Country* magazine, but Penelope's family wouldn't let her. Even at that young age, she wore heavy eye makeup and the shortest possible miniskirts to rile her posh peers. Ever seeking freedom, Penelope started sneaking out at night to downtown New York, where she was a young fixture on the folk music scene. When she appeared at the Black and White Ball in an extremely revealing, mod evening dress by Betsey Johnson, with a heavy fringe setting off her gigantic eyes, Vreeland couldn't help but gravitate toward her, and her modeling

career began in a flash. She rose quickly to the pinnacle of high fashion, posing for Richard Avedon, David Bailey (with whom she had a six-year relationship), and other greats, but she soon became disillusioned with the industry, and her time in it didn't last long.

In the late 1960s, more unique-looking girls like Peggy Moffitt and Twiggy were powerful, and fashion was in the midst of its first short period of enchantment with difference, lauding the unusual-looking more than the conventionally pretty. The space race was on; the human potential movement was beginning; politics on the ground were messy and violent—it's no wonder fashion wanted to be transported. The mood Penelope conjured was romantic and otherworldly, with her tiny pointed chin and elfin physique, and oftentimes shaved eyebrows and exaggeratedly painted-on mascara. Habitually clad in miniskirts and a belt strung with foxtails, she was the poster girl for flower power, a personification of the collective longing to escape. After entering into a romantic relationship with photographer David Bailey, then thirty to her sixteen, and moving in with him in 1968, Penelope was welcomed as one of the new superstars of the swinging 1960s avant-garde, with articles on her personal style and a profile in *Life* magazine.

Sadly, Penelope's career was cut short at the end of the 1960s, when her face

Opposite:
Photograph by Bert Stern, *Vogue*, 1968.

"WHAT MAKES HER A SENSATION IS NOT HER IMPECCABLE BACKGROUND BUT THE WAY IN WHICH PHOTOGRAPHY CAN TRANSFORM HER LITTLE-GIRL-LOST APPEARANCE INTO BIZARRE HIGH-STYLE ELEGANCE."

—"67's Twig Becomes a Tree," *Life*, April 19, 1968

became marred by severe cystic acne and she stepped out of the public eye. Though the acne disappeared in a few years, her face was scarred, and her relationship with Bailey had ended as well. She moved to Los Angeles for a few years, and then to Australia, finding her way to London at the end of the 1990s. Now living in West London, she only makes appearances, such as a 2006 Burberry campaign or for Barneys New York in 2012, when they benefit her charity, Lotus Outreach, which aids girls in danger of falling into sex trafficking in Asia.

Right:
New York,
June 1, 1967.
Photograph by
Richard Avedon.

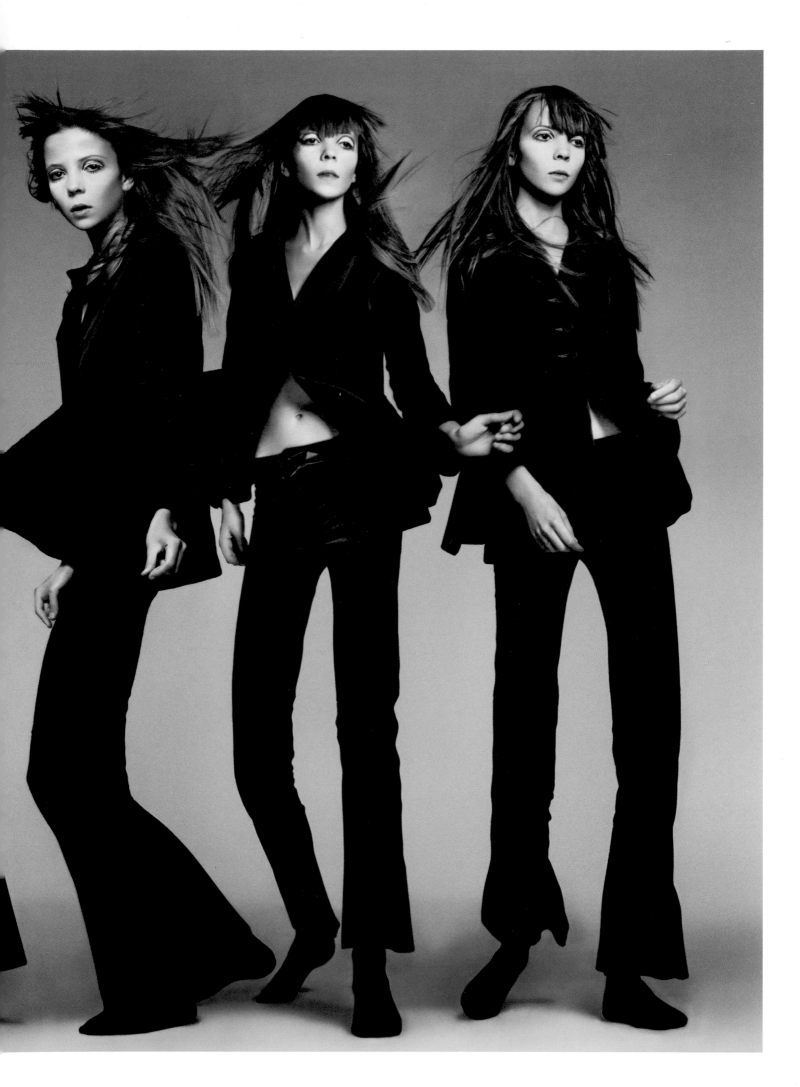

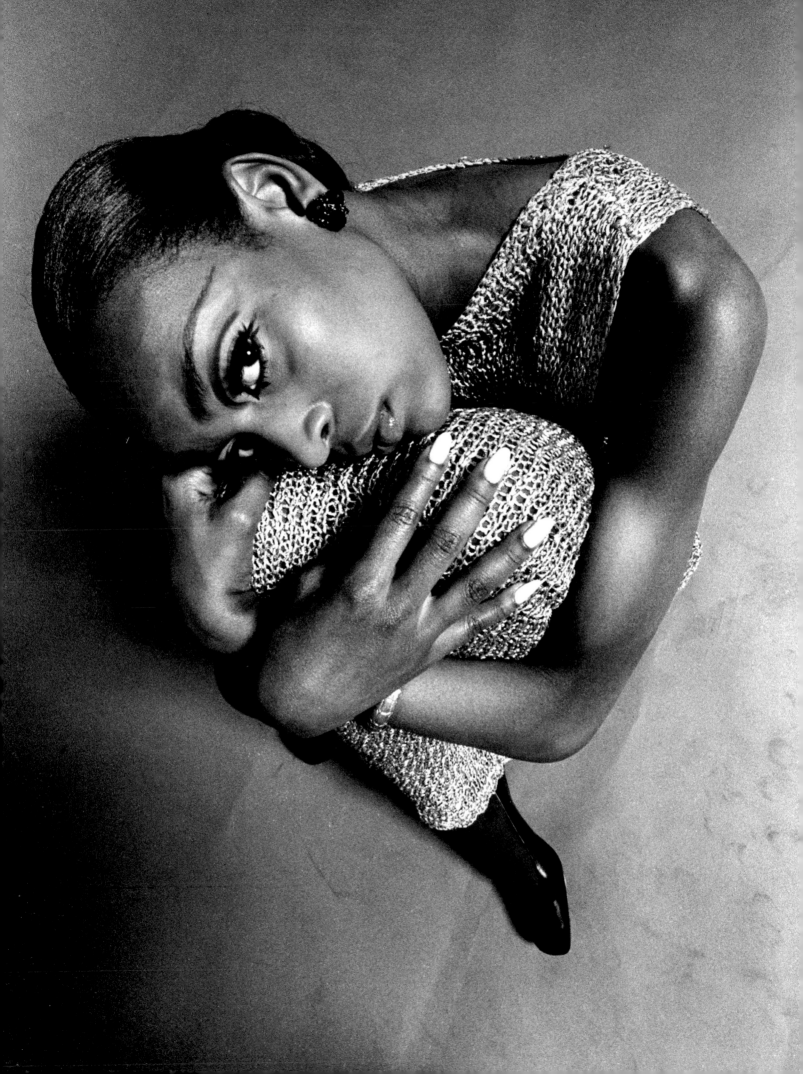

Naomi Sims

When people bring up the subject of Naomi Sims, they usually spend a lot of time talking about firsts: she was the first black model on the cover of a national magazine and the first black model to work for mainstream magazines and journals such as *Ladies' Home Journal*, *Life*, and the *New York Times* as well as for those targeted to African Americans, *Ebony* and *Jet*. Naomi was also the first black woman to appear in a national television commercial (for AT&T), and she became a successful entrepreneur in the beauty business when her time in front of the camera came to an end. The style she brought to her work—not the exoticism of her fellow breakthrough black model Donyale Luna but a singular refinement and sophistication—was the high fashion embodiment of the Black Is Beautiful movement in the 1960s. Understated and confident, she exuded a natural, regal calm and brought a palpable warmth to the glamour of her images.

Growing up as a foster child in a mostly white working-class neighborhood of Pittsburgh, Naomi was five feet, ten inches, by the age of thirteen; was teased and bullied at school; and did not have an easy adolescence. But she was determined to be a model, and she knew she had the looks and proportions to be a successful one. In 1966, when Naomi got a scholarship to the Fashion Institute of Technology in New York City—she would also study psychology on the side—there was generally very little interest in black models.

Women like Dorothea Towles Church, who walked the couture runways of Paris in the 1950s, and Luna, British *Vogue*'s model of the year in 1966, were extreme exceptions to a very white rule. In fact, every time Naomi approached a New York agency, she was turned away and told she was too dark. So she helped pay her bills by modeling for fashion illustrators, who could, one imagines, make her any color they wanted her to be.

Nonetheless, Naomi was resilient: she wasn't the type to give up her dream. The timing was right, too: with the civil rights movement in full force, along with black Americans' increasing voice in politics and presence in popular culture, Naomi saw an opportunity for black women to make inroads in fashion. She bypassed the agencies and went straight to the fashion photographers, who understood her appeal in a more instinctive and aesthetic way. Gosta Peterson, who worked for *Harper's Bazaar* and the *New York Times*'s fashion magazine supplements, was the first, shooting her solo in a black hat and cape for the August 1967 cover of *Fashions of the Times*.

The *New York Times* was a fantastic score, but it wasn't *Vogue*, and Naomi had to earn a living. Finally realizing that she couldn't survive outside the agency system any longer, and still being turned away from the big agencies like Ford, she approached Wilhelmina Cooper, a top model who had just opened her own agency with a mandate to represent more diverse girls, both in shape and ethnicity. But Wilhelmina wasn't

Opposite:
Test shoot, late
1960s. Photograph
by Stan Shaffer.

"SHE WAS THAT ELEGANT, BEAUTIFUL, CLASSIC, DARK-SKINNED BEAUTY THAT WE REALLY NEEDED AT THAT TIME."

—BETHANN HARDISON, from "Naomi Sims, Model, Dies," *Women's Wear Daily*, August 4, 2009

ready to commit to her either. So Naomi made her a proposition: she would send out her *New York Times* cover herself to advertising agencies, not fashion magazines, with Wilhelmina's number attached to it. If Naomi booked herself a job, Wilhelmina would get the commission.

At the time, advertising agencies had a mandate for proportional representation of people of color, whereas fashion did not. Even if the client was General Electric and not Christian Dior, they paid, and the ads put your face in the public eye. After Naomi's first round of mailings, the bookings came in very quickly. When she landed a television commercial for AT&T—she appeared clad in Bill Blass, alongside a Caucasian and an Asian woman—she got her big break, for television's newfound omnipotence as a medium forever put lie to the question of a black woman's "appropriateness" for the big leagues.

Soon Naomi was making $1,000 a week. She sat for Irving Penn at *Vogue*, and walked the runway for Halston, Bill Blass, and Giorgio di Sant'Angelo, designers who were just beginning to establish the identity for American high fashion as elegant, confident, and breezy—all qualities that Naomi had in abundance. In October 1969, she was chosen for the cover of *Life* magazine, which ran a feature story on rising black

models. Black Is Beautiful was now finally a reality for the mainstream masses, and Naomi was its ambassador. Stars like Diana Ross were copying her signature ballerina bun. By 1972, Hollywood came calling, and Naomi was offered the title role in the blaxploitation movie *Cleopatra Jones*, but when she read the script, she was turned off and turned it down.

Cosmopolitan magazine—she appeared on the August 1973 cover—was much more her speed than a B-list crime flick. But Naomi was tired of modeling, and that same year, she left it behind for a new adventure. After spending many hours in the studio doing her own hair and makeup for fashion shoots, she was aware of the lack of beauty and hair-care products available to black women. So she created a wig collection of straightened black hair, and a makeup and perfume line that went on to earn millions. She also wrote books on health, beauty, and success for black women, and a column for teenage girls in *Right On!* magazine. In the 1980s, she expanded her business to include several beauty salons, though when she pulled back from management in the 1990s, they faltered.

Naomi passed away from cancer at the age of sixty-one, in 2009, but for her trailblazing, radiant work, she'll be remembered forever.

Opposite:
Yves Saint Laurent, couture runway presentation, fall/ winter 1983–84. Photograph by Loomis Dean.

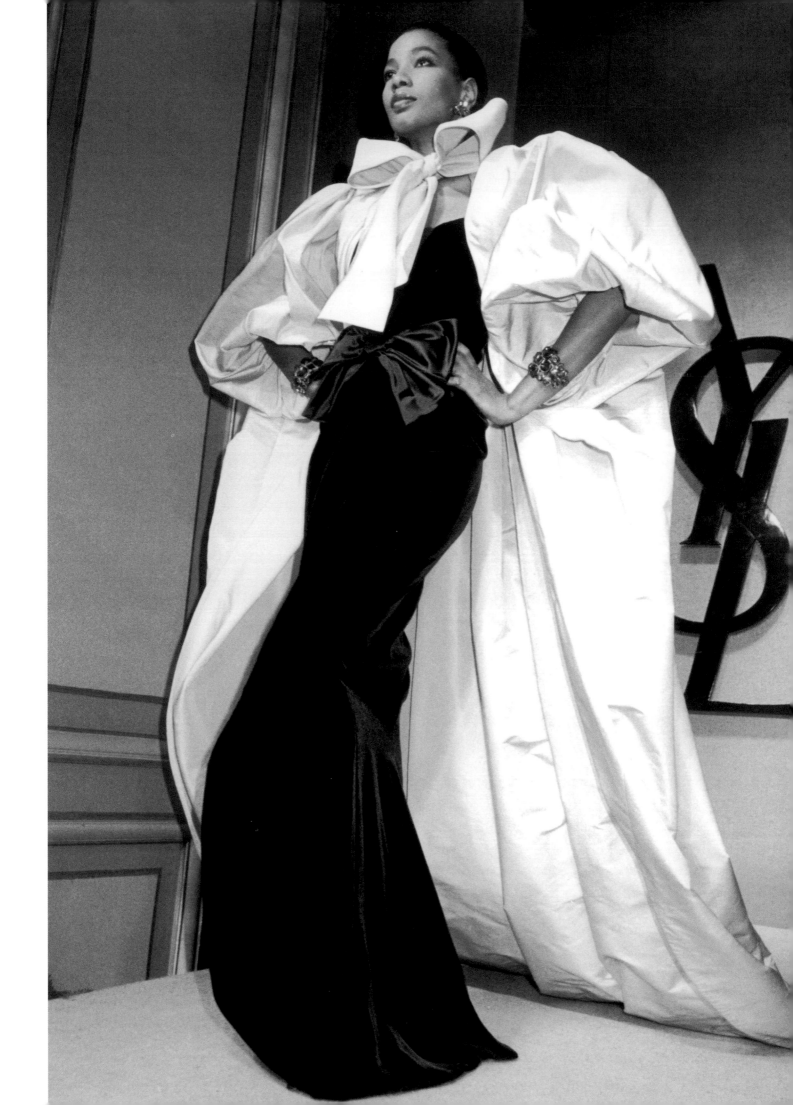

THE BEAUTY REVOLUTION

THE 1960S SAW THE BIRTH OF

individualism in fashion and advertising, and in the 1970s, that individualism was given a highly successful, sexy gloss. Though the decade began with a small recession, the advertising industry truly took off shortly afterward, with spots in television and in magazines taking on a new visibility and iconicity. In 1976, the J. Walter Thompson agency became the first shop to surpass $1 billion in volume, with its American billings tripling over the decade. In fashion, American sportswear was gaining a new power and respect as well, which meant the audience for fashion and models was growing rapidly. While the artistic centers of the industry remained in Paris and Milan, emerging New York designers like Halston, Calvin Klein, Anne Klein, and Liz Claiborne were dressing American women in a way that supported their visibly growing power in society.

With so much new business to be done, modeling agencies consolidated, building international and regional channels that ultimately led to New York, where the highest advertising budgets were—and remain. The most artistic photography was still happening in Europe, where there was a high number of fashion magazines per capita. These magazines had lower budgets, which incentivized photographers to take chances on new girls. Sensing opportunity, models

routinely started to go overseas to break into the business. Meanwhile, in America, lighthearted and self-assured images reigned supreme, setting the stage for models who possessed a more straightforward prettiness that ultimately became the look of the day. The sought-after model conveyed freshness and was quite often a blonde, although there were inspiring examples of women who broke that convention, too.

As the rest of the world reached new heights of decadence and sensuality, so did the modeling industry, and in a very big and unapologetic way. Unfortunately, the atmosphere became exploitative for some girls, especially less experienced, younger ones, who were starting to come into the business in much greater numbers. At the same time, models continued their steady climb in earning power and importance. Now frequently on the arms of famous rock stars and actors, they started making noteworthy deals with large corporations, achieving the first exclusive, million-dollar cosmetics contracts. Hair and makeup artists started working on sets to do the work that models once had done themselves. This allowed for better working conditions, and let the girls concentrate more on the task of posing. Signature wall calendars became a big side business, which helped models to continue cementing their popular identities in their own right, separate from the designers or Svengali photographers who helped make their careers in the first place. Models of this period were still a long way from being the global superstars we know today, but this era marked their first real steps down that road.

Pages 68–69:
Roy Halston with
Pat Cleveland
(standing on table)
and other models
wearing designs
from his fall 1977
ready-to-wear
collection.
Photograph by
Sal Traina.

Lauren Hutton

Lauren Hutton's rise to the top of the modeling industry, world renown, and enduring appeal is a prime example of the power of charisma over surface prettiness. Lauren had a great vitality that was fully emblematic of the late 1960s and 1970s, when women were rising to new positions of power in society. Before Diana Vreeland discovered Lauren—who would go on to book twenty-six covers of *Vogue*, more than any other model—she had been struggling to make it in the business for two years. Lauren's problems, which got her turned away from most of the New York agencies, were a bump in her nose and a gap between her front teeth. And she had a wide-set mouth and a strong brow, too.

Unfortunately, even as unusual looks were gaining ground for aspiring models in the 1960s, it was still difficult for someone unconventional-looking to break into the business. Lauren was told she had to fix her nose and teeth before she could get big jobs, so she did small-time ones, filling in the gap between her teeth with mortician's wax, which she often knocked loose and swallowed while talking or laughing. Considering the incredible impact Lauren went on to have in the fashion and beauty industries, clearly her strong sense of self and good humor were major contributing elements to her success and helped pave the way for other unusual-looking models, too.

In 1966, Lauren was working as a part-time fit model at *Vogue*. One afternoon, she was trying on dresses with other models for a run-through to help the editors visualize the clothes on real women, not hangers, before planning their shoots. As Lauren was taking a time-out among the racks, Diana Vreeland spotted her and called her out, saying, "You! You've got quite a presence!" Lauren did have a presence: she was athletic and tomboyish, and had an adventurous spirit; even at that age all she really wanted to do was travel and see the world. Modeling was a good way for her to earn money to satisfy her wanderlust, so she was willing to do whatever it took. Vreeland sent Lauren over to see Richard Avedon the next day, as she did with so many of the women who would go on to become great models under her direction. Avedon became an important collaborator of Lauren's, though she would also shoot frequently with Irving Penn and later, in her most influential years in the 1970s, with Francesco Scavullo.

Opposite:
Photograph by
Archive Photos, 1974.

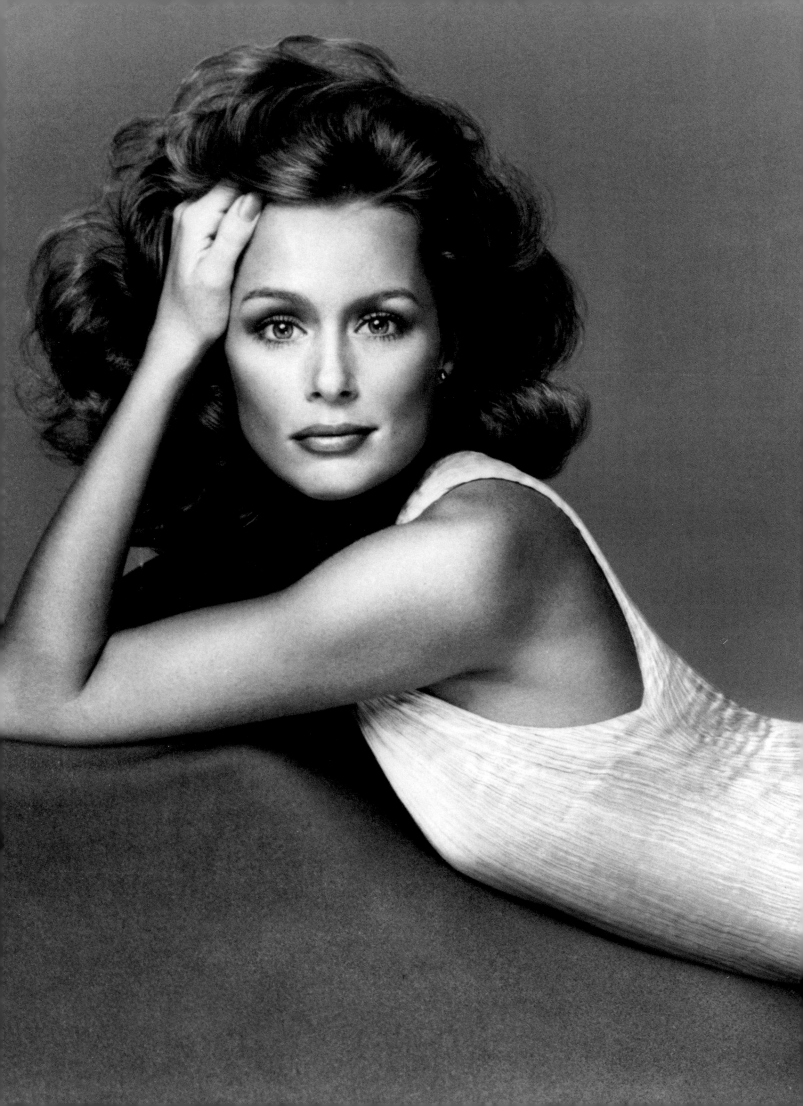

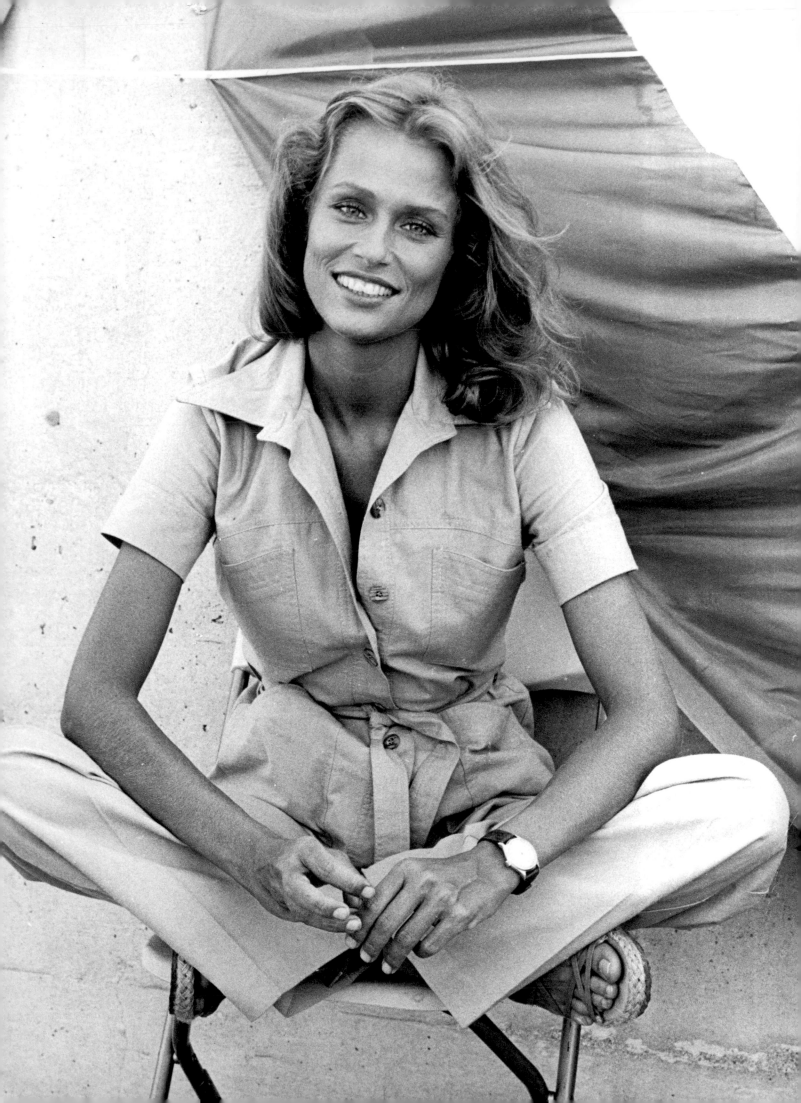

From then on, Lauren's ascent was rapid and seemingly knew no bounds. She worked steadily in magazines and acted in films and on television as well. In 1973, by then a well-established modeling star, she was tapped as the face of Revlon's Ultima brand of cosmetics, with Avedon set to shoot the campaign. Eager to stop working by the hour, as most models still did back then, and to graduate to longer-term and higher-paying bookings, Lauren held out for an exclusive contract, with Avedon's support. She won it, and earned $1 million over three years for just twenty days of work a year.

The money and the commitment were groundbreaking and brought models over-all greater power, as well as exposure for the industry in the media coverage that accompanied Revlon's announcement. Hourly bookings were suddenly a thing of the past. Exclusive cosmetics contracts became the new golden ring. Women in society were echoing this rise, too, which only made it that much more resonant. *Ms.* magazine had launched as a stand-alone publication in 1972, just a year before Lauren made her deal. The feminist movement was in full swing, and with her headline-making paycheck, Lauren was an alluring embodiment of its values.

Lauren continued to develop her acting career throughout the 1970s, although it peaked in 1980, when she starred in *American Gigolo*, a cold, stylish film by Paul Schrader with a wardrobe furnished by Giorgio Armani. Then in 1983, when she was forty years old, her contract with Revlon was cut. No matter how radiant she looked, Revlon saw her age as advanced, and was convinced that women her age didn't even buy makeup. Nonetheless, she continued to work on and off in Hollywood, nourishing her life by making art, riding motorcycles, and continuing her global travels.

In the late 1980s, when Lauren was forty-six, Steven Meisel asked her to appear in an advertisement for Barneys New York. She would later say of working with Meisel that, for the first time, a photographer wasn't obsessed with trying to make her look younger but let her be herself.

"I UNDERSTOOD THAT [MODELING] COULD CHANGE MY LIFE. . . . IT WAS AS SIMPLE AS THAT. I HAD A DESPERATE NEED TO GET OUT AND SEE THE WORLD, AND I COULDN'T SEE IT ANY OTHER WAY."

—LAUREN HUTTON, from "The Iconoclast: Lauren Hutton," by Jenna Lyons, *Interview*, September 2013

Inspired by the experience, Lauren returned to modeling with a vengeance, imbued with a mission to show the world that older women could be a force in beauty. She also launched Lauren Hutton Cosmetics to give women over forty products that are tailor-made for their skin. Now in her seventies, Lauren still poses with the same zeal and sexiness that first made her a star.

Opposite:
Photographer unknown, c. 1976.

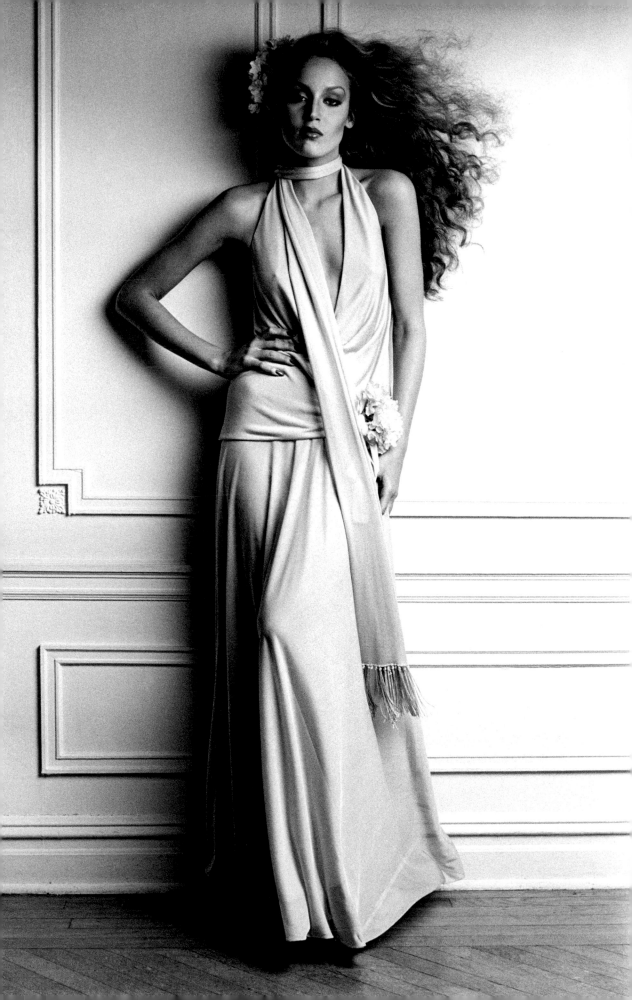

Jerry Hall

By the early 1970s, many large New York–based modeling agencies were sharing their girls with satellite booking offices all over the world. As a result, Paris and Milan were becoming training grounds for American models. The girls went abroad in search of a look that would distinguish them from others, to learn the ropes on the runway, and to make connections with magazine photographers and designer clients who paid less for bookings but often took more artistic chances and gave aspiring models an incredible education in the business. Houses such as Yves Saint Laurent and Emanuel Ungaro were on the rise, making colorful clothes that accentuated the female form, and with provocative photographers like Helmut Newton and Guy Bourdin shooting them, leggy bombshells were in demand.

Enter Jerry Hall, a six-foot-tall Amazon from Mesquite, Texas, with mile-long legs, a wide mouth that was either smiling or snarling, corn-blond hair styled like film vixen Veronica Lake's trademark tresses, and fearless composure. Jerry and her twin sister, Terry, were raised by a mother who had wanted to model herself, so in 1974, when Jerry decided her forceful looks and personality would have better luck in Paris than at provincial Dallas modeling agencies, her mother suggested her seventeen-year-old daughter go first to Saint-Tropez, where the fashion beau monde vacationed en masse, and where her stunning physique and personality could work their magic on the beach and possibly get her results even faster.

When Jerry arrived in Saint-Tropez, that's exactly what happened. The moment she hit the beach in a pink crocheted bikini she was discovered by model agent Claude Haddad, whose Euro Planning agency was starting to give the dominant Paris shop, Elite Model Management, a run for its money. Jerry's sexy confidence, can't-look-away charisma, athletic flexibility, and high-flying energy—all accented with a big, booming belly laugh—were irresistible. She moved straightaway to Paris, where she shared an apartment with Grace Jones, who was also modeling at the time. Jerry quickly gained a reputation as a model who would do whatever it took to get a shot: pose in bondage gear for Helmut Newton, sprawl on a bed in Marie Antoinette–style costume at Versailles for Norman Parkinson, jump up on an oil rig in the hostile territory of the USSR after British *Vogue* got special dispensation for Parkinson to shoot her there. Not surprisingly, she began to secure covers, appearing on *Vogue* Paris and French *Elle* in 1974, and on British *Vogue* twice in 1975. Jerry also quickly became an enfant terrible on the Parisian club scene, running with a crowd that included Antonio Lopez, Paloma Picasso, and Pat Cleveland.

With her success so rapidly and firmly established, Jerry came to New York in 1975, where she started to work with fashion photography giants like Richard Avedon, Irving Penn, and Deborah Turbeville.

Opposite:
Photograph by Stan Shaffer for John Anthony, 1974.

Pages 78–79:
Jerry Hall and Helmut Newton, Cannes, 1973. Photograph by David Bailey.

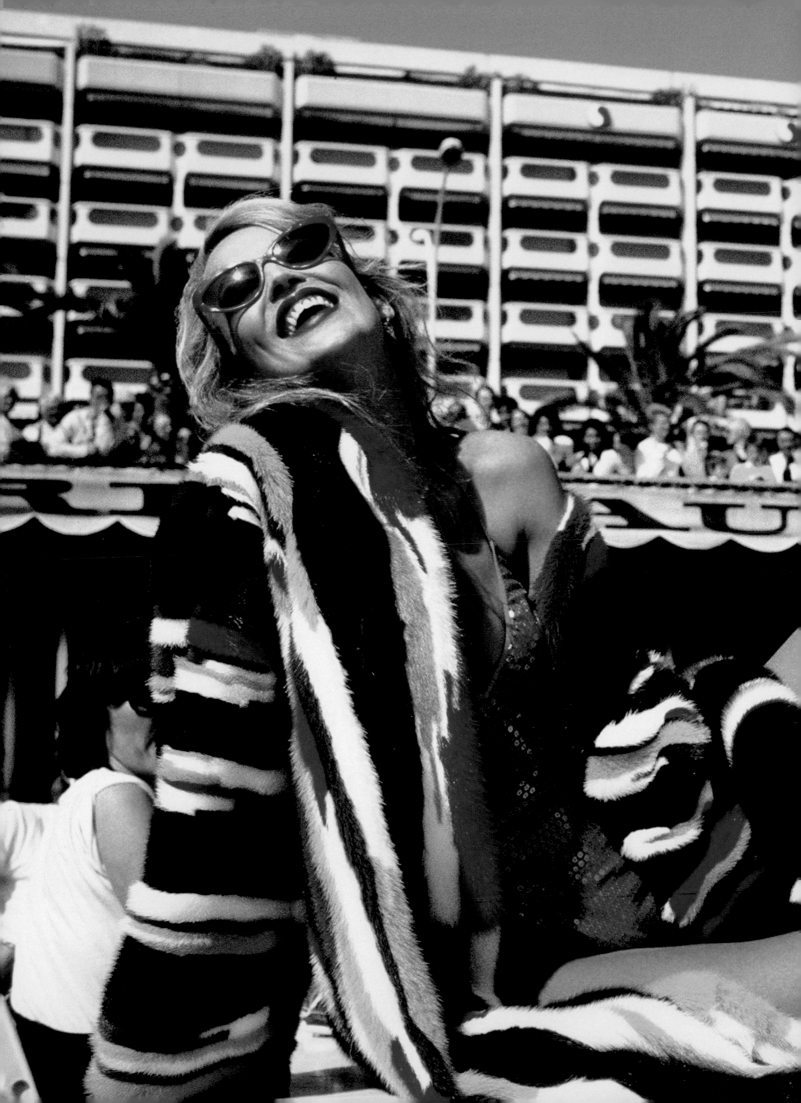

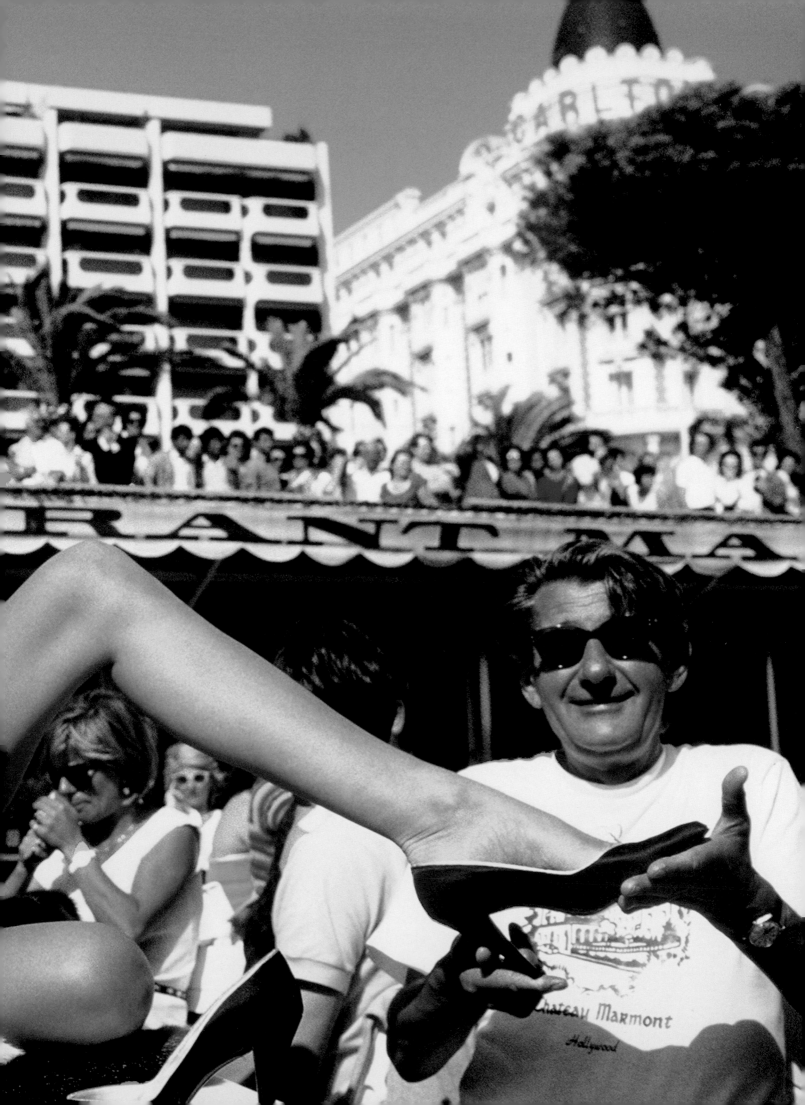

"THE MORE FLESH YOU SHOW, THE HIGHER UP THE LADDER YOU GO."

—JERRY HALL, from "Jerry Hall Turns 57!," by Lucy Buckland, *Daily Mirror*, July 2, 2013

But it was only when she appeared on the cover of Roxy Music's fifth album, *Siren*, that Jerry dipped her toe into the pool of mainstream celebrity. The band's singer, Bryan Ferry, more than ten years her senior, first saw her on the pages of British *Vogue*, and on the Roxy Music shoot, where Jerry played the part of the siren as Greek mythology intended—beautiful, feral, and deadly—Ferry fell hard. Soon they were engaged. His devotion was such that he wrote "Let's Stick Together" for her—Jerry is also in the video, camping it up in magnificent Serge Lutens–style makeup, her hair in giant curls.

But in the end, the more staid Ferry lost Jerry to Mick Jagger, who was a better match for her ebullient personality. Jagger won her over gradually, while he was still married himself, to Bianca Jagger, though he wouldn't be for long. Around this time, in 1977, Jerry booked the inaugural ad for Yves Saint Laurent's decadent, oriental Opium perfume, setting the template for the famous campaigns: pouting, louche, almost impossibly sultry. Even though Bianca Jagger was prominent in Saint Laurent's entourage, when news of Jerry and Mick's relationship broke in 1979, Jerry kept the campaign for eight years. Her brand of smoldering sold.

Because she was constantly photographed with Mick Jagger and accompanied him on his tours with the Rolling Stones, Jerry gained an even greater level of visibility there than in her prolific modeling career, where she was earning more than $1,000 a day. But that work continued to make waves, too, as when she posed with Helmut Newton at the Cannes Film Festival in 1983, for David Bailey, wearing nothing but a bathing suit and fur coat. Her vampy iconicity was so established by the early 1980s that in 1985, when she appeared on the cover of *Cosmopolitan*, the cover line read, "Jerry Hall and other Scarlett [sic] women." Andy Warhol, who became a close friend, did six portraits of her. She also posed for painters Lucian Freud and Francesco Clemente.

A couple for twenty-three years, Jagger and Jerry had four children, and increasingly it was they who got most of her attention. Once the kids grew older, Jerry focused more on acting on the London stage and on television. Proving that she has more fun with her outsize persona than anyone, after her split from Jagger she did a campy reality television show, *Kept*, a competition to groom and train her perfect boy toy. And though she famously backed out of writing a tell-all book about Jagger in 2010, she did pen two autobiographies, *Jerry Hall's Tall Tales* and *Jerry Hall: My Life in Pictures*, which are full of saucy stories and memories. Today, she continues to pose when the mood strikes—both with and without her model daughters, Lizzy and Georgia May. And she continues to make fashion headlines—*Harper's Bazaar* treated her cutting her hair into a shoulder-length bob in 2014 as breaking news. But Jerry is clear that her life is meant to be enjoyed, and she is at her happiest gardening and cooking, spending long seasons at her house in the south of France.

Opposite:
Photograph by
Ronnie Hertz, 1976.

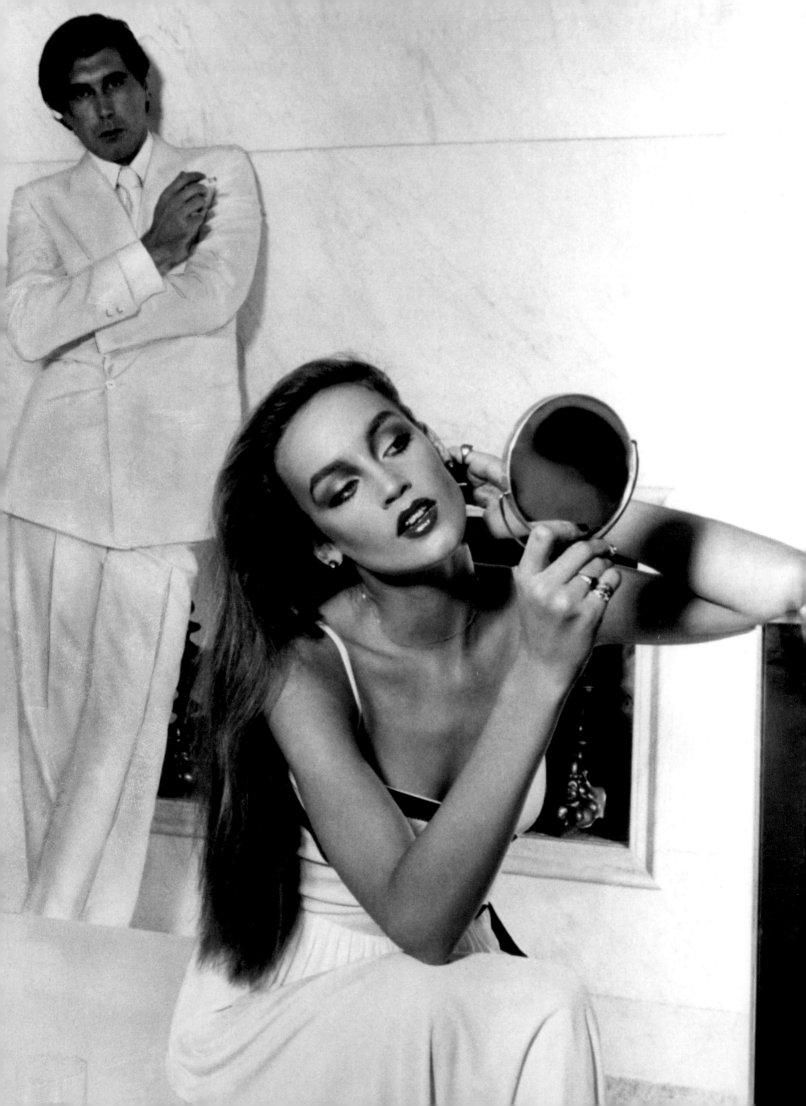

Margaux Hemingway

Margaux Hemingway may have borne a famous name—her grandfather was Ernest Hemingway—but she grew up in Idaho, far from the glitzy New York City that became her home during her most prolific modeling years. Six feet tall, with bedroom eyes framed by thick eyebrows, and a sumptuous mouth that looked as if it was about to kiss you, Margaux was a magnificent all-American beauty who became one of the biggest successes of the 1970s.

Margaux was discovered while having tea at the Plaza Hotel during a visit to New York City by Errol Wetson, a socially connected heir to the Wetson's hamburger chain who was fourteen years her senior. He introduced her to the beau monde of 1970s New York, and Margaux soon learned that the high life—evenings out at Studio 54, in the company of Halston and Liza Minnelli—suited her. Modeling was an obvious next step.

By the time Margaux got into the industry, in 1974, it was becoming more predatory, with male agents, photographers, and hangers-on gravitating toward the business for its access to beautiful, impressionable young girls. Of course, there were plenty of professionals working in fashion, too, but the sexual revolution was in full swing, and drugs were becoming a factor on many sets. Off hours, in the international playboy circles that many models were part of, drugs were ever present. A lot of young, inexperienced girls got caught up in the moment, and Margaux—who already had her struggles with dyslexia, epilepsy, and bulimia—ended up one of them, developing a taste for heavy drinking and drugs that fueled rather than mollified her natural tendency to insecurity.

But however much Margaux may have been experiencing inner turmoil, she was a

Opposite: Photograph by Helmut Newton, cover, *Vogue* Paris, 1976.

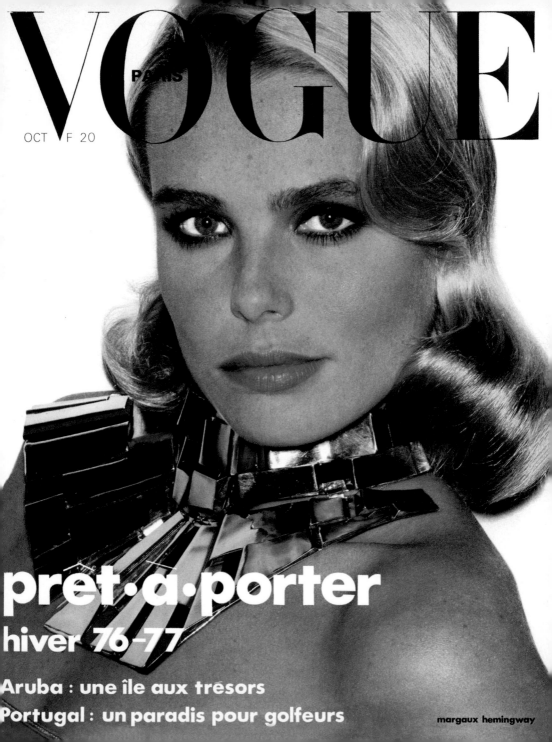

VOGUE

PARIS

OCT · F 20

pret·a·porter
hiver 76-77

Aruba : une île aux trésors
Portugal : un paradis pour golfeurs

margaux hemingway

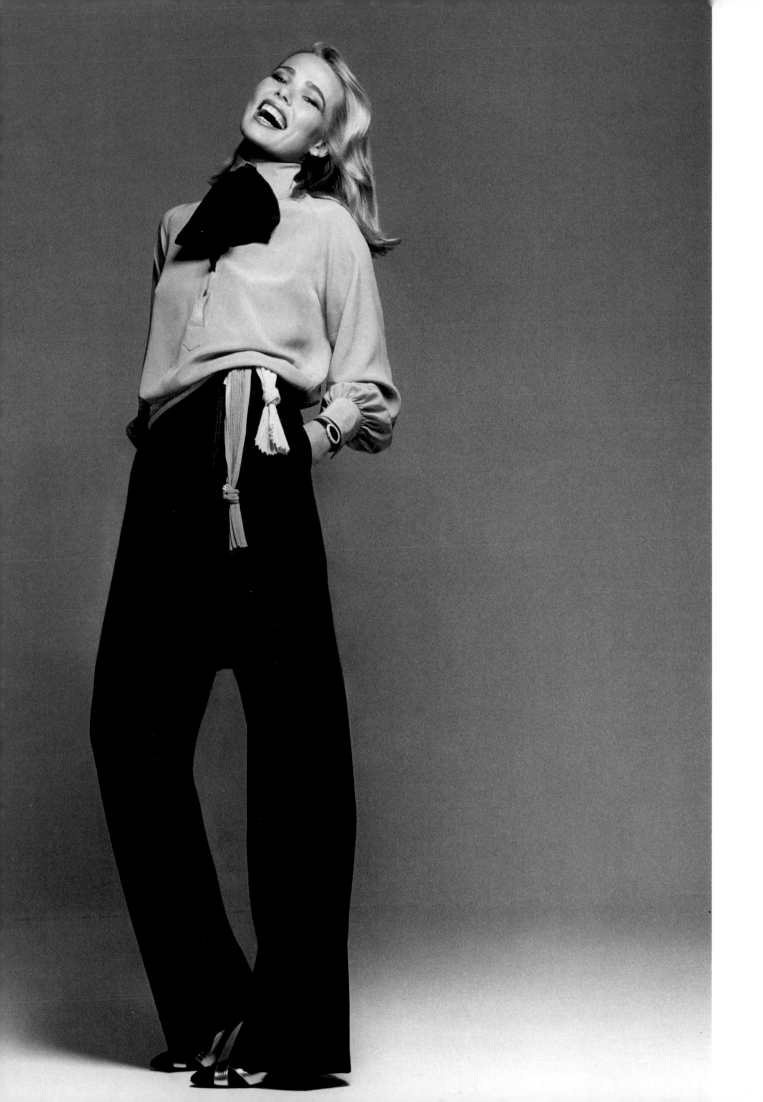

golden girl on set. She worked frequently with Francesco Scavullo, who helped iconize the sirenlike hair and glossy lips that became the style of that era. She appeared on the covers of *Cosmopolitan*, *Vogue*, *Elle*, *Harper's Bazaar*, and even *Time*, which named her one of the "new beauties" in 1975. That same year, Margaux made history when she signed a $1 million contract with Fabergé to be the face of the brand's Babe fragrance and cosmetics lines. In one of Babe's television commercials, the opening tagline went, "You're the Babe I want to journey through life with." That was a key to Margaux's appeal: she wasn't a throwaway girl; she was a thoroughbred. She was the kind of woman you would want to be with forever.

In photographs or commercials, as for Freixenet sparkling wine, she projected sophistication, clad in Halston and sequins. But she also projected a hint of innocence along with her worldliness. Today, hindsight lends the images of her 1970s apex an air of sadness, but they're also monuments to a moment of unique personal freedom in society at large, when women were invested with new hopes of finding their own place in the world, of achieving their own success. Margaux was the epitome of disco glamour, and the images she helped to create are suffused with the confidence of a woman who looked like she could go anywhere and do anything.

Unfortunately that wasn't the case in Margaux's real life. Soon after she became a star, she made an unsuccessful shift to acting—critics attacked her

performance in her first film, 1976's *Lipstick*, though they would praise the performance by her younger sister, Mariel, whose part in the film was actually Margaux's doing. Mariel's huge success in later years was hard for Margaux to handle. After a ski injury in 1984, she gained seventy-five pounds and went through a long depressive phase that only ended when she sought help for alcoholism in 1987.

"YOU COULD PUT HER OUT IN THE SUNLIGHT IN THE MIDDLE OF THE DAY AND SHE LOOKED LIKE AN ANGEL."

—FRANCESCO SCAVULLO, from "It Hurts So Much," by Kim Masters, *Time*, July 15, 1996

After completing treatment, Margaux became more focused on spirituality and healthy living. She attempted a comeback and was paid $900,000 to pose for *Playboy* in 1990, but unfortunately other work did not follow. She started appearing in infomercials and straight-to-video films, and struggled financially. In 1996, at the age of forty-one, she took her own life in her Santa Monica home, a day before the anniversary of the same act by her famous grandfather.

Opposite:
Photograph by
Francesco Scavullo,
Vogue, 1976.

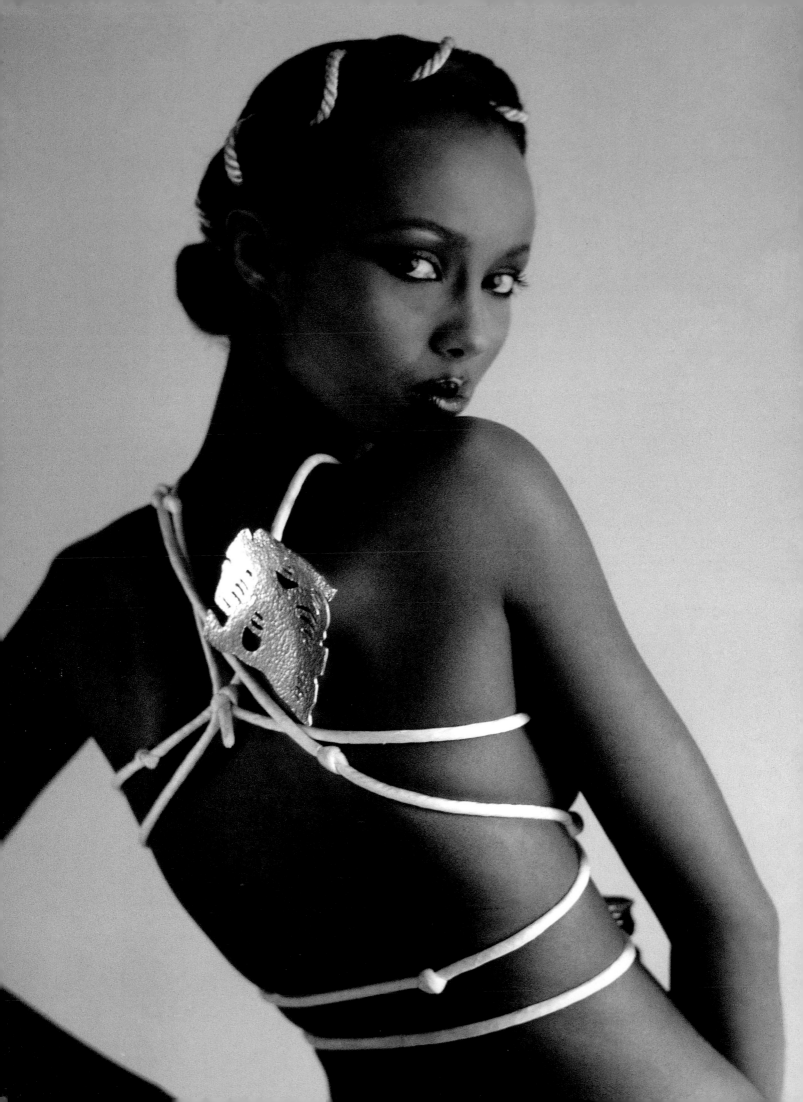

Iman

Although Iman has said that she looks like every other Somali woman, her beauty was unique in the West in its time. It's not just the way a person looks, anyway, but who they are and how they move, gesture, and make others feel that make the difference in modeling. And Iman has always been commanding. Since 1975, when she first appeared to the fashion world at a press conference with photographer Peter Beard, she's been a figure of public fascination, and she remains so today. Her time at the top has given her the opportunity to do a lot of other good work, but turning those opportunities into the incredible successes they have become is due entirely to her canny and enterprising nature, her penchant for big ideas, her generous heart, and her extra-large dose of life energy. The woman is a force. Like everything else she has put on, she wears her authority well.

Contrary to Iman's famous origin story that she was a tribal princess who spoke no English and was discovered in the African bush, Iman Abdulmajid was born to a progressive Muslim family in Mogadishu, Somalia, in 1955. Her father was a diplomat and her mother was a gynecologist; they named her Iman, a gender-neutral name that translates as "faith," hoping to arm their daughter with more clout in a male-centric African country. They also had her educated at a private school for girls rather than at the local schools, where she

Opposite:
Photograph by Ishimuro, *Vogue*, 1977.

excelled and mastered five languages. When she was eighteen, still never having worn makeup or heels, working part-time as a translator and majoring in political science at Kenya's University of Nairobi, Iman was spotted by Beard on the street. He was alternating between shooting fashion and nature and art photography, which he did mostly in Africa, from his home base there. When Beard approached her, Iman immediately assumed he had bad intentions because she was wary of men coming up to her in the street. But when he offered to pay her to take her photograph, the latent businesswoman in her kicked in. Her price: a year's tuition bill, paid in full.

Beard shot hundreds of photographs of Iman in Nairobi before returning to New York City. He tried for months to get her to follow him to the United States, where he knew she would find success. When she finally did, even though she was offended by the fiction spun about her, Iman was no fool. She realized she had just received a golden opportunity, so she didn't press the point. Regardless of her private dismay, the world ate up the invention.

Fashion has always been a business that thrives on the new and loves a good discovery story, especially one cloaked in exoticism and mystery, however exaggerated or baseless it may turn out to be. Iman also happened to be stunning, with a long, aristocratic neck and delicate features,

"IT JUST TAKES A WHILE FOR THE WORLD TO CATCH UP WITH IMAN."

—BETHANN HARDISON, from "Iman: Not Just Another Pretty Face," by Teri Agins, *New York Times*, June 4, 2010

a powerful grace of movement, and an ability to channel her energy into very impactful moments in front of the camera. She quickly signed with Wilhelmina, which, among all the agencies, had the best track record in terms of representing black women, and became a hit right away: her first job was a *Vogue* shoot with Richard Avedon in 1976. Designers went wild for her: Calvin Klein found that the coppery tone of her skin seemed to electrify his subdued clothes; Halston's draped dresses were perfect for her long, lean proportions. Thierry Mugler, who once sent Iman down the runway walking a tiger, could always count on her to bring an almost otherworldly presence to his shows. In 1985, still working regularly with photographers like Bruce Weber and Helmut Newton, Iman inspired Yves Saint Laurent to create an entire collection around her called "The African Queen."

In the late 1970s, Iman married the basketball star Spencer Haywood, with whom she had a daughter, Zulekha; the couple divorced in 1987. In 1992, she married David Bowie—their union is one of the most enduring love affairs between

megastars—and they also have a daughter. In 1994, Iman stepped back from modeling and delved into the business world, parlaying her fame, smarts, and outsize ambition into a $25-million-a-year global cosmetics brand for women of color. Today Iman models occasionally, for friends like Donna Karan. She's also dabbled in reality television and, in 2007, launched an instantly successful line of caftans, sportswear, and accessories with Home Shopping Network that is now one of the top sellers among HSN's hundreds of brands.

The energy it takes to create, launch, maintain, and serve as the face of two large-scale businesses is daunting, but Iman also is an outspoken advocate for models of color, works with numerous charities on behalf of children the world over, and has campaigned vocally against the spread of blood diamonds, publicly severing a contract with De Beers over the issue. Iman has said that if she never went into fashion, she would have become a politician. The skill with which she wields her power demonstrates that she would have been a very good one.

Opposite:
Photograph by
Michael Ochs
Archives, 1979.

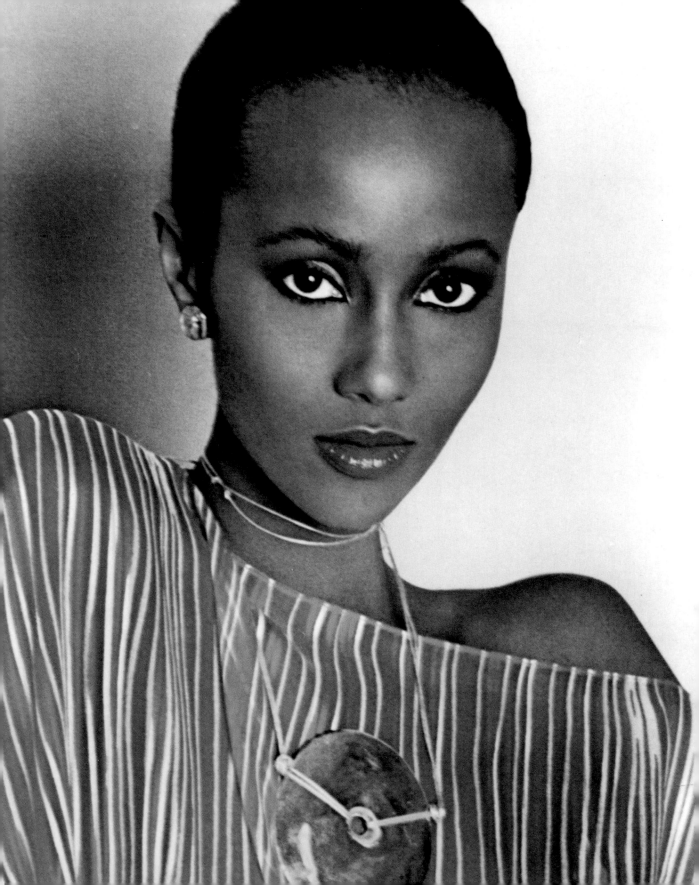

Janice Dickinson

The 1970s saw greater diversity in models, but it was still a challenging time, not only for girls who were black but even for those who looked vaguely ethnic. At that time, Eileen Ford, the leading model agent of the era, preferred blondes, initially turning away many of the women of color discussed in this chapter who would go on to have successful careers in modeling and other pursuits. With swarthy skin and smoky eyes, the half-Polish, half-Scots-Irish Janice Dickinson was another nonblonde whom Ford passed on. Janice had the last laugh, though, as she went on to become one of the great faces of modeling in the 1970s and 1980s, appearing on the cover of French *Elle*, which runs weekly in France, seven times in a row.

Janice was born in Brooklyn, New York, but raised in Hollywood, Florida, a town

she was only too eager to escape. In 1972, at seventeen, she won the John Robert Powers modeling school's Miss High Fashion Model contest at a convention in New York, but her look, with her wide, hungry mouth and dark eyes, baffled the agents there. So Jacques Silberstein, a photographer, and Wilhelmina Cooper sent Janice to work in Europe, where exotic looks were more at home, and that's where the fun began.

Janice's moody, raw energy, penetrating gaze, and often-parted lips created pictures that pulsated with sexiness. And her unpredictability made shooting her a thrill. Janice was really the first of the bad-girl models, untamable, with no shyness whatsoever. She was prone to taking off her clothes on the streets of Paris, loving to get a rise out of people. Photographers

Opposite:
Photograph by
Alice Springs, cover,
Elle France, 1975.

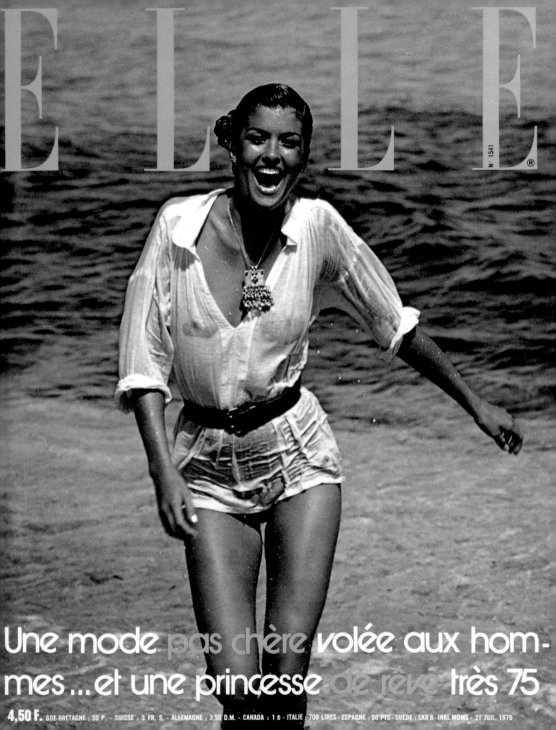

ELLE

N° 1541

Une mode pas chère volée aux hom-
mes... et une princesse de rêve très 75

4,50 F. GDE-BRETAGNE : 50 P. · SUISSE : 3 FR. S. · ALLEMAGNE : 3,50 D.M. · CANADA : 1 $ · ITALIE : 700 LIRES · ESPAGNE : 60 PTS · SUEDE : SKR 6 INKL MOMS · 21 JUIL. 1975

PHOTO

LES MODES EROTIQUES D'HELMUT NEWTON

MENSUEL N° 201/12 F·BELGIQUE 97 FB·CANADA 2,75 $·HOLLANDE 5 FL·ITALIE 4300 L·ESPAGNE 200 PTAS·SUISSE 5.50 FS·U.S.A 2,75 $

"EVERY PLAYBOY, EVERY SHAH OF IRAN, EVERY MOVIE STAR, EVERY ROCK AND ROLL STAR, THEY ALL WANTED ME."

—JANICE DICKINSON, from *Model: The Ugly Business of Beautiful Women*, by Michael Gross, 1995

like Guy Bourdin, Mike Reinhardt, and Jean-Paul Goude loved her, and Janice became a regular on the covers of all the major French fashion magazines. Soon after returning to New York in 1978, she signed up at Elite Model Management, which represented a new breed of model in the industry, with a business plan intended to turn their girls into personalities. Elite's parties were legendarily decadent, and sex was very much on the table. With her outsize personality and wild reputation, Janice was a perfect fit. Elite's owner, John Casablancas, didn't even take a commission from her, and would forward Janice the 20 percent of the client fee that he typically would have taken, too. She helped his agency merely by being associated with it, and his direction helped put her over the top of success.

For the next twenty years, Janice worked for every major magazine, with multiple covers for *Vogue*, *Elle*, *Harper's Bazaar*, and *Cosmopolitan*, and from brands such as Balmain and Christian Dior to Orbit Gum, Hush Puppies, Revlon, and Virginia Slims, all the while having colorful affairs with major Hollywood players like Warren Beatty, Jack Nicholson, and Sylvester Stallone. Her various exploits were frequently covered in gossip columns, and those experiences gave her plenty of fodder for her two very successful, very funny autobiographies, *No Lifeguard on Duty* and *Everything About Me Is Fake— And I'm Perfect*. She also pursued fashion photography for a time, but it is in front of the camera that Janice is really in her element. She is a born entertainer: great models have a kind of inner fire, and on a quiet day, Janice's is a five-alarm one.

Opposite: Photograph by Mike Reinhardt, cover, *Photo*, June 1984.

Gia Carangi

It's rare that an aspiring model's trajectory goes straight from the bottom to the top in a flash, but that was the case for Gia Carangi. Coltish yet seductive, tough yet childlike, she was a natural in front of the camera. Even in the simplest-seeming, most straightforward photographs, she had an ability to reach out with her eyes and grab your heart. And during her short career, she made some truly memorable pictures, such as Chris von Wangenheim's January 1979 editorial for *Vogue*, where Gia was photographed in a series of industrial-looking settings, in front of a chain-link fence, and on a platform at a municipal-looking swimming pool. The clothes were quite refined—high-end sportswear, nothing too avant-garde—but Gia's laserlike ability to engage the camera, with that extra edge provided by the choice of sets, made the pictures unforgettable. They had that combination of tough and pretty that Gia perfectly embodied.

In Gia's case, the toughness was as genuine as the pretty, though it covered her deep emotional vulnerability. Her childhood and adolescence in Philadelphia were troubled. Gia's mother left home when Gia was still quite young, and Gia ran wild as a young teenager, shoplifting, staying out all night, and getting into trouble at school. Even though she liked to dress like David Bowie and play up her androgynous looks, Gia started working as a model at Gimbels department store when she was fourteen.

While she was introverted and shy off camera, she snapped to vibrant life when a photographer started shooting. In 1978, pictures she had made with a local Philadelphia photographer came to the attention of Wilhelmina Cooper, who made a huge play for this dark-skinned girl with soulful eyes and a velvety mouth.

Gia didn't have the time to learn basic poses, nor develop personal resilience in a tough business, nor even really decide if she wanted to become a modeling superstar, because things moved so quickly for her. She bristled at the process of go-sees, taking what little rejection that did come her way very hard. Wearing torn-up jeans and a biker jacket long before that look found its way onto the pages of *Vogue*, she very quickly earned go-sees with the best photographers, who found her look and manner captivating. She charmed Francesco Scavullo, who loved how raw and unschooled she was and her original, improvisational way of posing; he said her photos were so fresh they felt like candids. She was in high demand with Richard Avedon and Arthur Elgort, too. By the time she was eighteen, in 1979, a year after being discovered, Gia was making $100,000 a year—and appearing in *Vogue* editorials, on the covers of *Harper's Bazaar* and *Cosmopolitan*, and in advertisements for Christian Dior, Diane von Furstenberg, Yves Saint Laurent, and Gianni Versace.

Opposite: Photograph by Mike Reinhardt, *Vogue*, 1979.

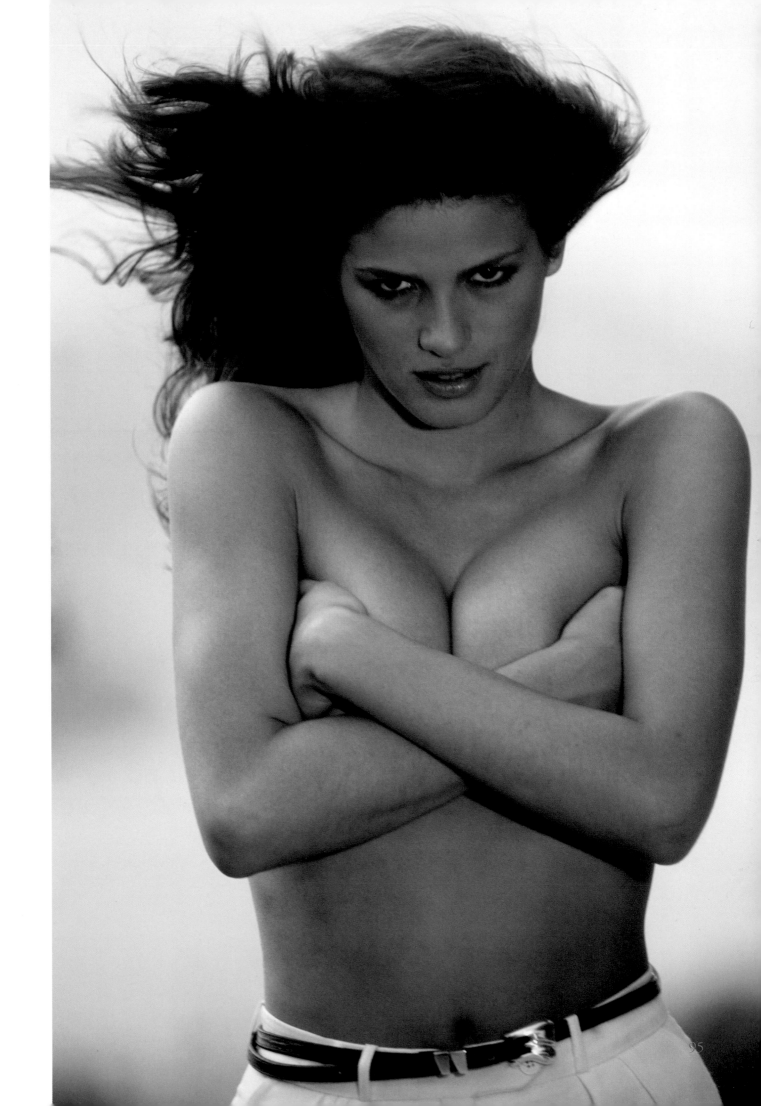

95

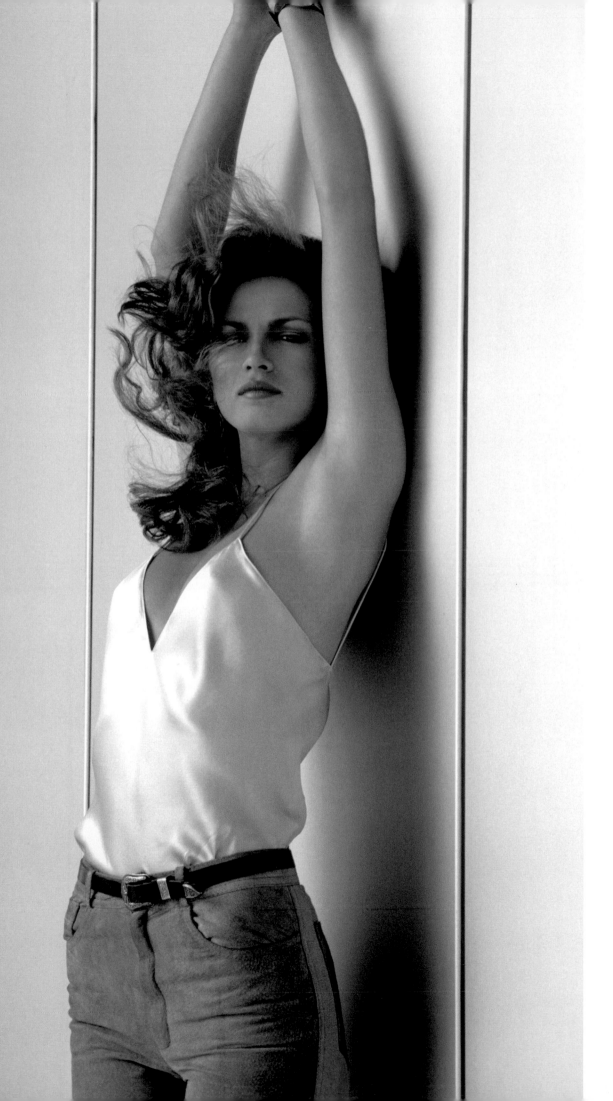

"SHE WAS SUCH A VULNERABLE GIRL. IT'S PART OF THE BEAUTY OF HER PHOTOGRAPHS. SHE ALWAYS GAVE YOU BACK SOMETHING WONDERFUL."

—POLLY ALLEN MELLEN, from *Thing of Beauty: The Tragedy of Supermodel Gia*, by Stephen Fried, 1994

Gia had begun using drugs and alcohol at a relatively young age, and she turned to them more and more as she became more famous, perhaps to cover up or cope with her innate shyness, or to manage the pressure of expectation on set. She never really tried to fit in with the fashion crowd, preferring to do her partying in downtown venues like the Mudd Club, not Studio 54. According to those who knew her well, she was bisexual, and she didn't really try to hide her relationships with women. Although she worked in a business that tended toward permissiveness and lack of judgment with regards to sexual preferences, her bisexuality probably didn't help her career much, as at the time, the fashion business was very much about men wielding power over very young women.

In 1980, when Wilhelmina Cooper, who was as much a mother figure as an agent to Gia, died of lung cancer, Gia spiraled out of control. She moved from using marijuana and Quaaludes to cocaine and heroin, and her behavior on shoots became increasingly difficult and erratic. The stories are many, and they are all sad: how Gia would sneak off to the bathroom in between takes to shoot heroin; how she nodded off on a shoot with a needle in her arm and bled all over her couture dress; how she refused to wear bathing suit bottoms on an outdoor shoot for *Vogue*; how she told Avedon while shooting a Versace advertisement that she was going out to buy cigarettes and never came back. During one of her final shoots for *Vogue*, the crew could see the red track marks on her arms, and not all of them were airbrushed out.

With her dangerous and unreliable behavior escalating, Gia's career declined almost as quickly as it had risen. Clients didn't want to take the risk of working with her, and photographers were finding that she was incapable of producing the level of work she once had. She would try to get clean and then attempt comebacks, but she kept slipping up.

Having all but disappeared from the fashion scene, Gia moved back to Philadelphia and entered rehab in 1985. The following year, when she was just twenty-six, Gia was diagnosed with AIDS and died of complications from the disease that October; she was buried quietly, with little attention. Once her former colleagues and friends in the fashion world realized what had happened, there was a genuine outpouring of regret. Of course, no one could have saved her: Gia was clearly her own undoing. Still, it didn't make her loss any less sad for those who loved her and admired her work.

Opposite:
Photograph by
Stan Malinowski,
Vogue, 1978.

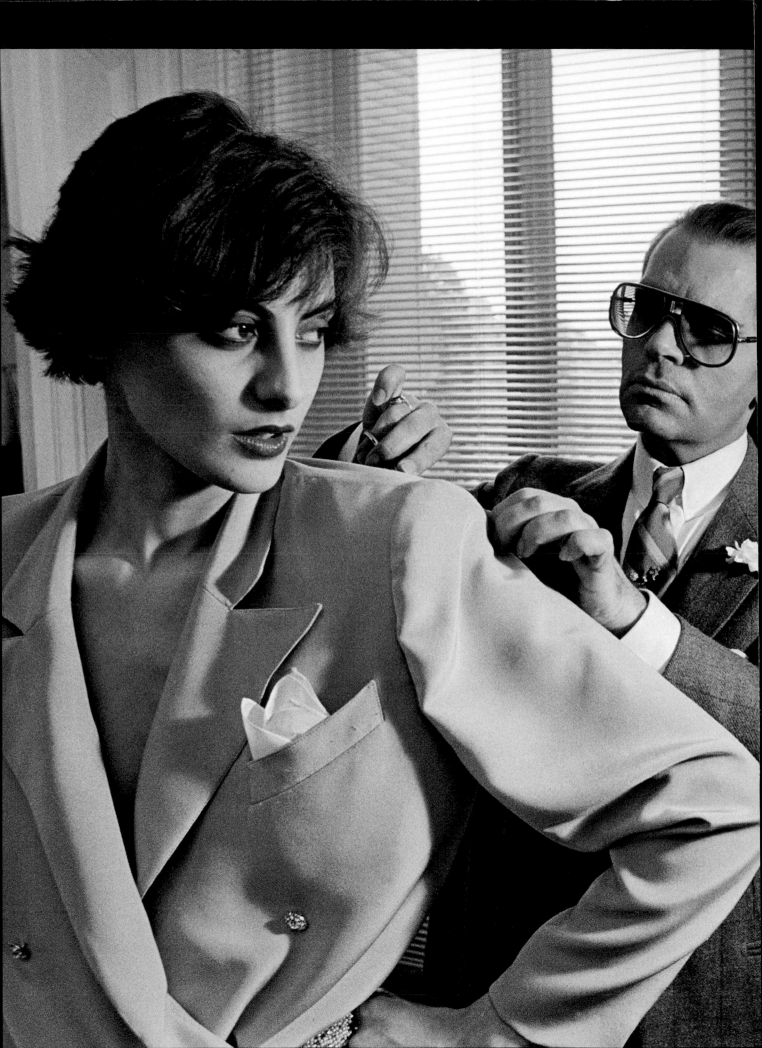

D

URING THE EARLY AND
mid-1980s, the enormous financial boom in the
West and westernized Japan brought designer
fashion back with a vengeance. Runway shows,
which were becoming more elaborately and glam-
orously designed, were covered by the media, even
appearing on television in fashion capitals like Paris
and Milan. High fashion was going through a creative,
maximalist phase, and European designers like Giorgio Armani,
Christian Lacroix, and Karl Lagerfeld were embedding themselves in
mass consciousness for the first time. But that cultural breakthrough was not
only about the economic boom but also a result of the houses' expansion of their newer licensing
arms, which included widespread development of perfume and cosmetics businesses. These
new brand avenues needed models to sell them to consumers, and as modeling agencies had
established elaborate global scouting networks by then, the high fashion houses found those
models in steady supply.

At the same time, after sexual liberation in the 1960s and the over-the-top decadent social
behavior of the 1970s, the 1980s' version of sexy took a turn toward a coquettish, newly
conservative innocence with an emphasis on fitness. Models—if the images of them were
neither deviant nor threatening—could make an impact posing in just a swimsuit, or even

lingerie, without being perceived as approaching pornographic. With aerobics classes and videos the new craze, human bodies were now more visible in the mainstream as well as in high fashion.

The obsession with a fit, lean body led to a whole subindustry of posters and calendars built around images of celebrities and models. A big catalyst of this trend was the rising importance of *Sports Illustrated*'s swimsuit issue, which, first published in the mid-1970s and still thriving today, not only brought models to the attention of everyday men and women but also ensured them public notoriety and, in some cases, longer and bigger success than ever before. The same models who became swimsuit and poster stars also found a home toward the end of the decade with a burgeoning catalog company called Victoria's Secret. The women who worked lingerie and swimsuit were built differently—they were generally larger-framed and bustier, and had more wholesome-looking faces than high fashion models. But in some cases, models would cross over from one category into the other, working both sides of the business. What was a rare double-track success then has become a template for modeling stardom that persists to this day, beginning with Christie Brinkley, who paved the way for Paulina Porizkova, Elle Macpherson, Tyra Banks, and, more recently, Gisele Bündchen and Karlie Kloss.

With new markets opening internationally, the advertising business grew ever more powerful, and models responded by dropping the bad-girl antics of the 1970s and getting down to business. Exclusive brand representation became the order of the day. More women were entering the workforce worldwide, and more models realized the potential for lucrative superstardom on and off the runway.

Pages 98–99:
Karl Lagerfeld and
Inès de la Fressange
at Chloé, Paris,
1983. Photograph by
Pierre Vauthey.

Christie Brinkley

With her sunny good looks and buoyant personality, Christie Brinkley epitomized an American ideal of beauty: blond, athletic, friendly, unassuming, and seemingly ready for anything—like a high school cheerleader whose good looks and energy actually improved after graduation. So thoroughly did she embody this upbeat American spirit in her heyday that major brands as diverse as Noxzema, Revlon, Clairol, Breck, Diet Coke, and Anheuser-Busch made her the face of their products.

Christie is in that small group of models who have appeared on more than five hundred magazine covers, and hers range from American *Vogue* to *Rolling Stone* to the bestselling issue of *Life* of all time. The list also includes *Sports Illustrated*'s swimsuit issue, which featured Christie on the cover three years consecutively (1979 to 1981), during the time when the magazine's popularity was rising precipitously. Its growth was catalyzed by the 1978 photograph of Cheryl Tiegs in a nipple-baring fishnet suit that catapulted the swimsuit issue into a thrilling, controversial, and much-anticipated annual event. So firm did its cultural footprint become that even now, Christie, in her sixties, is ranked sixteenth on *Men's Health*'s list of the "100 Hottest Women of All Time," beating out Gisele

Bündchen, Cindy Crawford, Beyoncé, and Jayne Mansfield. Clearly, men have always loved her, but with her approachable, warm look, Christie has also been able to inspire and sell to women. With an agreement with CoverGirl that was renewed for twenty years, she once held the record for the longest contract with a cosmetics company. (Christie even broke that record herself, signing back on in 2005 to tout a line for aging skin for five years, though Andie MacDowell, for L'Oréal, has since edged her out.)

Christie's career began in 1973, in Paris. She was there studying art, and the story goes that she was talked into posing by a photographer who spotted her on the street. Christie thought models were skinny snobs, and she didn't really care about fashion, but she needed money—working part-time as an illustrator wasn't paying the bills. Her pictures landed at Elite Model Management, which saw in her all-American looks greater potential on her native turf than in Europe and urged her to pursue her career back in the United States. By this time, Christie was homesick and happy to go along with the plan. Once home in California, she had lunch in Los Angeles with a US-based affiliate of Ford Models, and left the restaurant that day having booked three national advertising campaigns, one of them Noxzema, after

Opposite:
Photograph by Mike Reinhardt, cover, *Photo*, June 1983.

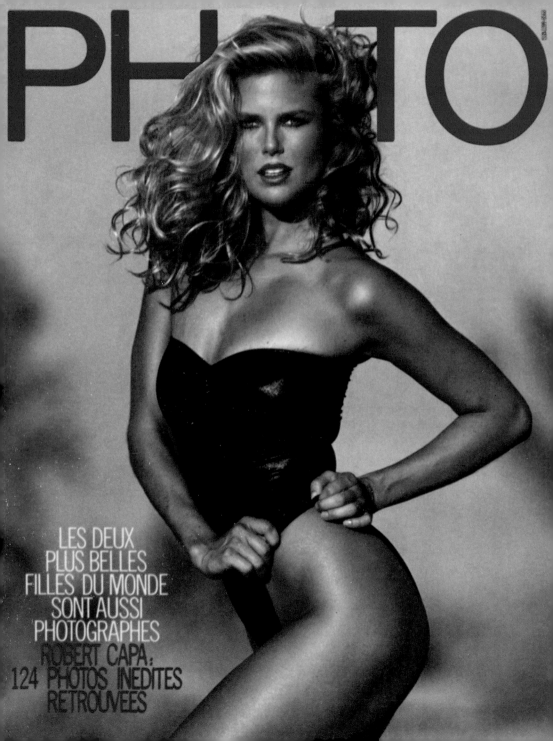

PH TO

LES DEUX
PLUS BELLES
FILLES DU MONDE
SONT AUSSI
PHOTOGRAPHES
ROBERT CAPA:
124 PHOTOS INEDITES
RETROUVEES

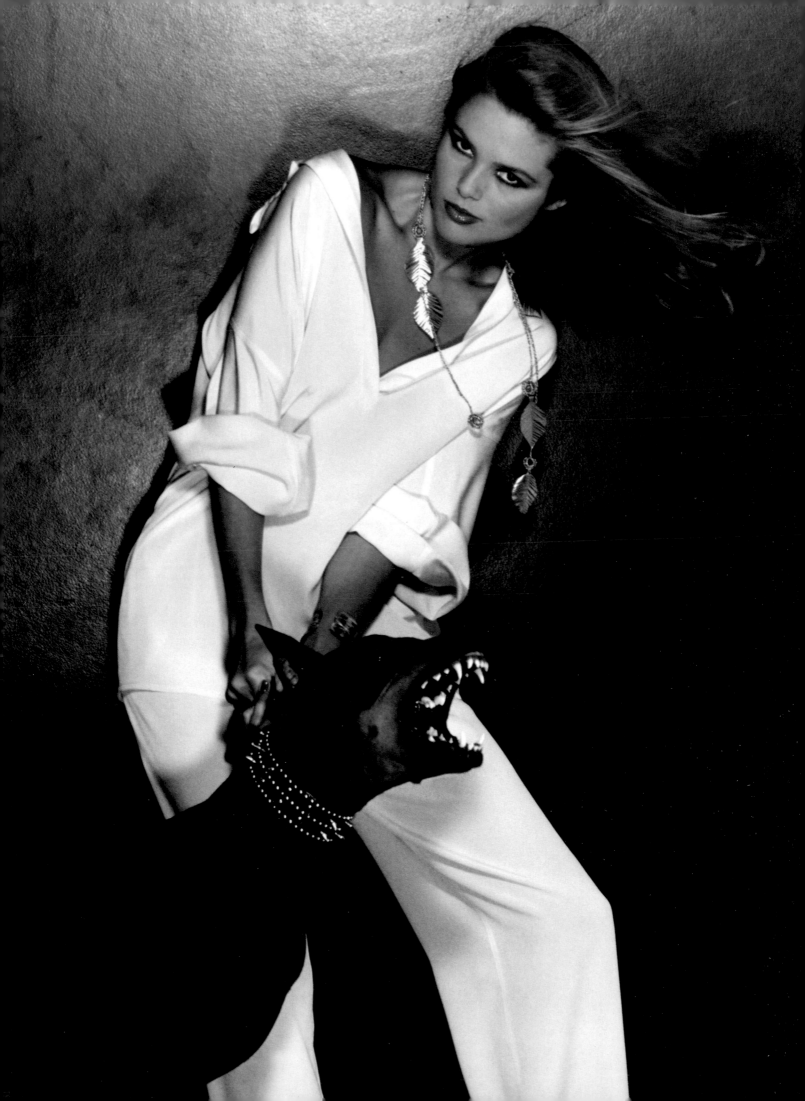

executives at those companies, who were also in the dining room at the time, dropped by their table.

In the mid-1970s, when Christie began her rise to the top of the modeling industry, America was in turmoil: the economy was poor, there was a severe energy crisis, and there was ongoing social unrest, which all had people yearning for simpler, easier times. The same impulse that ushered in Ronald Reagan's presidency—a wish for optimism in politics to assure a better daily life for Americans—was reinforced by Christie's wholesome, all-American visage. Hers was the look of the moment—and she was smart and ambitious enough to capitalize on it.

Christie is noteworthy because she's achieved an unprecedented level of entrepreneurial success as a model. By the early 1980s, already a hit with major advertisers and mainstream fashion magazines with huge circulations, Christie was one of the first to transcend representing other brands by becoming a brand herself—one that she developed carefully and managed personally. She was the first model to produce her own calendar, and she wrote a beauty and fitness book that became a *New York Times* bestseller. Though she never considered herself part of the fashion industry, Christie had—and continues to have—such a universal appeal that in the mid-1980s, she did what many would consider unthinkable; she posed for two vastly different audiences without confusing people about her image, appearing on the covers of *Playboy* and *Harper's Bazaar* in the same month. Other models, including Cindy Crawford and Stephanie Seymour, would later follow this path, but Christie was the originator.

Christie has gone on to dabble in acting, but her real focus now is activism, where she

has proven once again that being a sunny blonde with an easy smile can be a powerful thing. Thanks to her unique ability to reach people and her tenaciousness, she hasn't just been a voice for nuclear safety; she's addressed the United Nations and the US Senate on the subject. She's won humanitarian awards from the March of Dimes and American Heart Association, special recognition from the United Service Organizations for the tours she did throughout the former Yugoslavia and Kosovo, and a Merit Award from the Make-A-Wish Foundation.

"WHEN WE STARTED OUT WE WERE CLOTHES HANGERS AND WE WERE TOLD THAT BY THE TIME WE TURNED 30 WE WOULD BE CHEWED UP AND SPAT OUT. I'M AMAZED AT HOW LUCKY I'VE BEEN."

—CHRISTIE BRINKLEY, from "Christie Brinkley: My Uptown Whirl," by Helena de Bertodano, *Telegraph*, July 10, 2011

Though Christie's appeal and power as a model was always in her approachability and wholesomeness, making deceptively simple images for a mass audience, her acumen and intelligence, on full display for more than thirty years, have put lie to the once dominant idea that a model is just a pretty face.

Opposite:
Photograph by Chris von Wangenheim, *Vogue*, 1977.

Brooke Shields

Brooke Shields broke into modeling when she was just eleven months old. Thanks to her ambitious mother, Teri, who was her longtime manager, she appeared in an advertising campaign for Ivory Soap, which was shot by Francesco Scavullo. With Teri carving out the way, Brooke went on to become one of the world's most successful child models, with Eileen Ford expanding her business to include models under age seventeen just so that she could represent Brooke. By age thirteen, Brooke had already been featured as one of *People* magazine's twenty-five most interesting people. By the age of fourteen, she had appeared three times on the cover of *Vogue* and was the youngest person to have done so; in 1981, a *Time* magazine cover story listed her day rate as $10,000.

At the same time she was modeling, Brooke began to appear in movies, which is where her image took on a sexually provocative edge that shadowed her throughout her early career. Teri Shields had a bold sensibility and started early, pushing to get Brooke, then twelve years old, the title role of a child prostitute in Louis Malle's 1978 film, *Pretty Baby*. At the time, movies in which girls played roles far beyond their years were almost commonplace as well as a winning strategy for acclaim, as exemplified by Jodie Foster (*Taxi Driver*) and Tatum O'Neal (*Paper Moon*). In *Pretty Baby*, Brooke turned in a solid performance. There are nude scenes in the film, but the exaggerated controversy around them makes the actual film seem chaste by comparison. *Pretty Baby* resulted in Brooke entering her most visible years with an aura of scandal about her—which Teri fueled by helping her secure other racy roles, like *The Blue Lagoon*, which Brooke did at the age of fourteen, with a body double.

All the while, Teri did everything possible to present her daughter as a normal teenager to the media. But there was no getting around the fact that even if teenage Brooke roller-skated, rode horses, and received a five-dollar-a-week allowance like other kids, she was extraordinary, not just because of her penetrating beauty but also because of her precocious ability to express allure, sensuality, and innocence all at once. There's no better example of this than the series of advertisements Brooke did for Calvin Klein Jeans in 1980, in which she would quote scientific theories or read the dictionary, or writhe on the floor, or ask the viewers, while her knees were open quite wide, if they wanted to know what came between her and her Calvins. (Answer: nothing.)

Brooke seemed to take the fast track of fashion and entertainment in stride, continuing to rack up one success after another, whether as a model, where her magazine and advertising work continued, or as an actor, where she won the People's Choice Award for favorite young performer four years in a row, from 1981 to 1984.

In its double-headed nature, Brooke's career is important because it represents a shift in the cultural view of modeling. In the

Opposite:
Photograph by
Bruce Weber,
British *Vogue*, 1991.

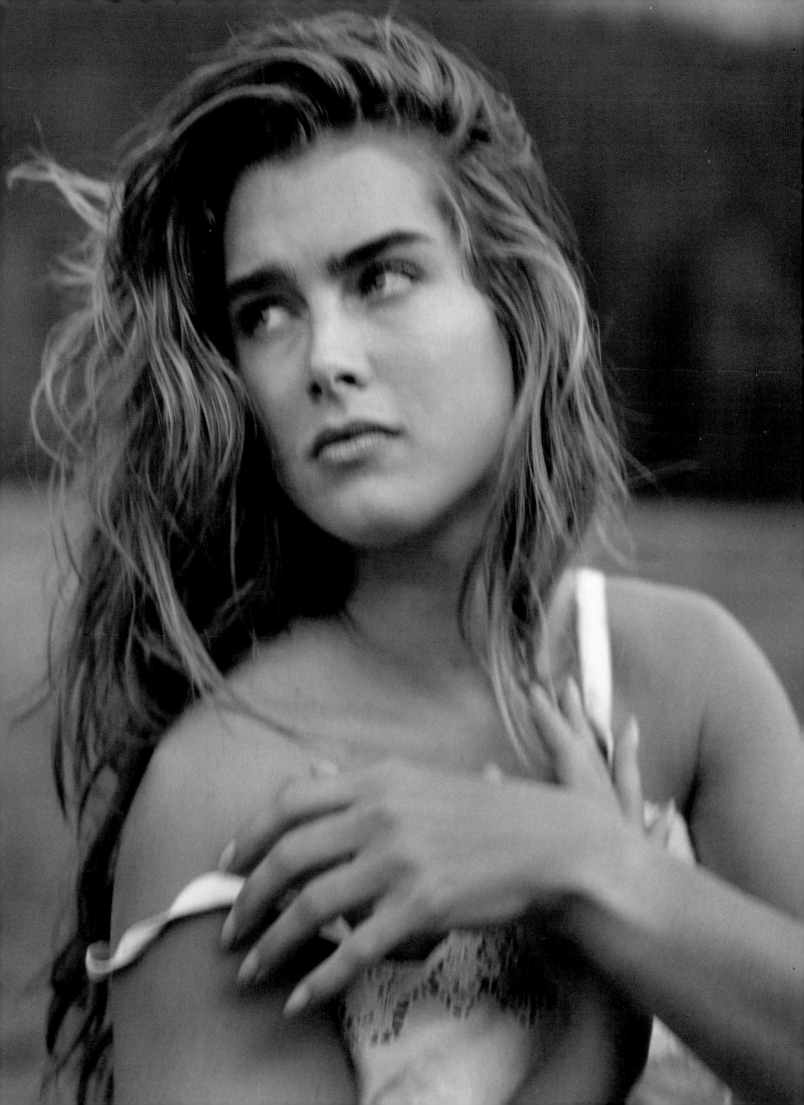

"I'M JUST A KID WHO HAS DONE THINGS THAT SOME KIDS HAVEN'T."

—BROOKE SHIELDS, from "Pretty Baby at 13: One Horse, Three Movies, Beaucoup Bucks, but No Beau," *People*, December 25, 1978

past, models who hit it big outside of the fashion world generally stopped posing for fashion magazines or in designer advertising, as evidenced by the careers of models like Lorraine Bracco, Ali MacGraw, and Cybill Shepherd. But by the 1980s, modeling itself had become a big enough business to retain girls after they had become celebrities, like Andie MacDowell. It was no longer a stepping-stone to something bigger—it was big enough on its own.

So even while Brooke was a household name, even when she scaled back on her acting work to attend Princeton University in 1983, she never stopped posing. Throughout the 1980s, she was on the covers of international editions of both *Vogue* and *Harper's Bazaar*. She was popular at *Seventeen, Cosmopolitan, Mademoiselle,* and *Glamour.* In 1989, *Vogue* declared her the face of the decade, and *People* and *Time* covered her film work, despite the fact that she didn't maintain her early success as an actor.

Nonetheless, Brooke concentrated mostly on acting in the ensuing years, working hard onstage and on television to live down the critical drubbings that had accompanied her early box-office successes. She starred in a popular sitcom in the 1990s, *Suddenly Susan,* but she only broke the curse of being

underestimated as an actress in 2003 when she took over the lead role in *Wonderful Town* from Broadway heavyweight Donna Murphy and won rave reviews. In 2013, she directed a three-day run of *Chicago* at the Hollywood Bowl, which earned critical plaudits as well.

Brooke has also gone through her personal—yet very public—ups and downs, which makes her later success so satisfying. She has for so long attracted outsize attention, and sometimes ire, that it feels like she's been with us, and we've been worried about her, forever. Her brief marriage to Andre Agassi, which ended in divorce in 1999, coincided with the first real downward slide of his career, earning her the unfair animosity of tennis fans the world over. When she wrote her 2005 autobiography, *Down Came the Rain: My Journey Through Postpartum Depression,* she ended up the target of bizarre public attacks from as unusual a source as Tom Cruise. So now that she's once again being lauded for things she's worked incredibly hard to achieve, it's a victory that feels especially sweet. She has faced multiple moments in her career when she could have just faded away, but Brooke has continued to prove that it will never pay to count her out.

Opposite:
Calvin Klein jeans advertisement, 1980.
Photograph by
Richard Avedon.

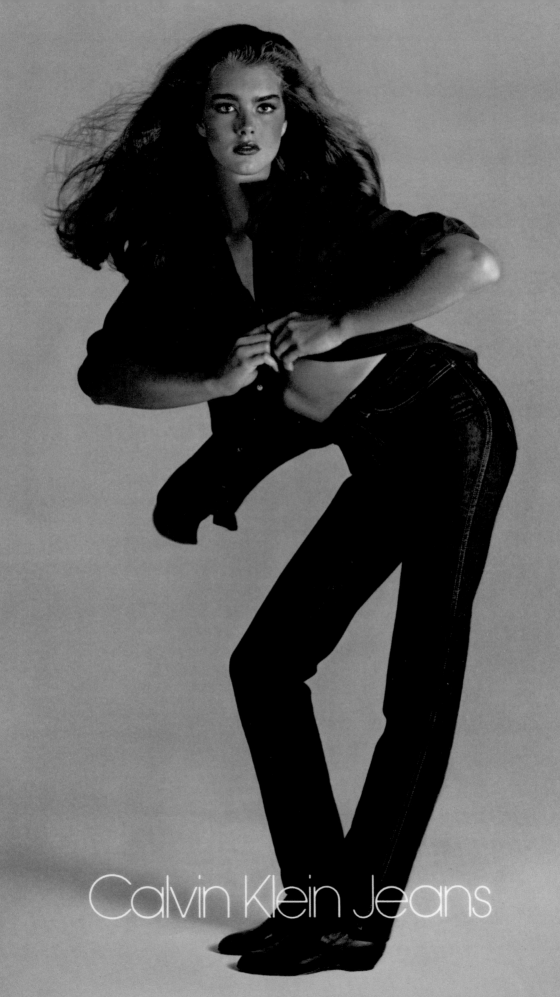

Calvin Klein Jeans

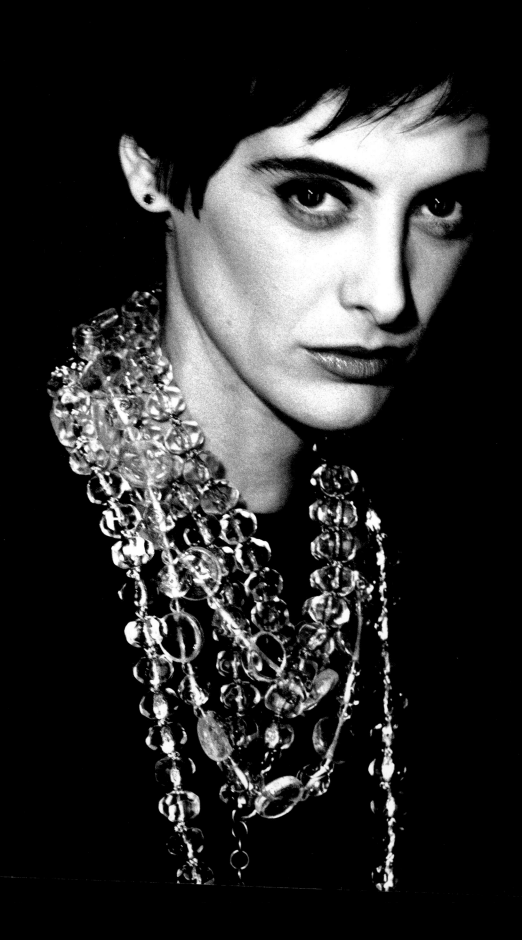

Inès de la Fressange

While Christie Brinkley and Brooke Shields were changing what it meant to be a model for a mainstream American audience, across the Atlantic Ocean, in her home country of France, Inès de la Fressange became a national treasure very much inside of fashion. For the role she played in helping to revive Chanel, a house that would stand like no other for French values and taste, the "swarthy asparagus," as she likes to call herself, is more than just a model. On her skinny, impossibly stylish shoulders sits no less than the image of French chic itself. Since Inès became a star at the outset of the 1980s, she has helped export it across Europe, into newly affluent Japan as well as to America, and then later—in her work as a brand ambassador for Roger Vivier, with her own brands, and as the author of a wildly successful Parisian style guide—to the world at large.

Inès, who grew up just outside of Paris, comes from a family of aristocrats and banking heirs, with a mother who was an Argentine model. With her tall, gangly, and angular frame, at five feet, eleven inches, and just 110 pounds, she was genetically predisposed to posing for a living, which was a good thing, because her parents were not terrific money managers, and she needed to earn a living for herself. She tried modeling twice as a teenager, on the suggestion of boyfriends, and it was only the second time,

when she was seventeen, that it stuck. Inès wasn't an immediate success; it took Kenzo Takada booking her for his hugely successful label Kenzo to bring her to the attention of the right people. Soon she was working regularly for French *Elle*, and that's when Karl Lagerfeld took notice of her.

The year was 1983, and Lagerfeld had just assumed the head designer and creative director position at Chanel. To make a big splash with his potentially controversial, updated take on the brand, he needed a woman who could mythologize Coco Chanel, the founder of the house, without coming off as retro. In Inès he found a knockout who could call the designer to mind visually—she was a dark-skinned brunette, after all, with a strong brow and a bit of the *garçonne* insouciance always associated with Chanel. Inès, who has always been confident, witty, and carefree, also shared Chanel's opinionated, articulate nature. Lagerfeld realized he had struck gold and signed Inès to an exclusive contract, the first time a fashion house had ever made such a commitment, especially with such potentially big stakes. She would appear in all of Chanel's ads, be the face of its new perfumes, walk its runways, and appear at Lagerfeld's side for numerous media appearances.

Inès's innate elegance and good breeding were the perfect vehicle through which

Opposite:
Photograph by Gilles Bensimon, *Elle*, 1985.

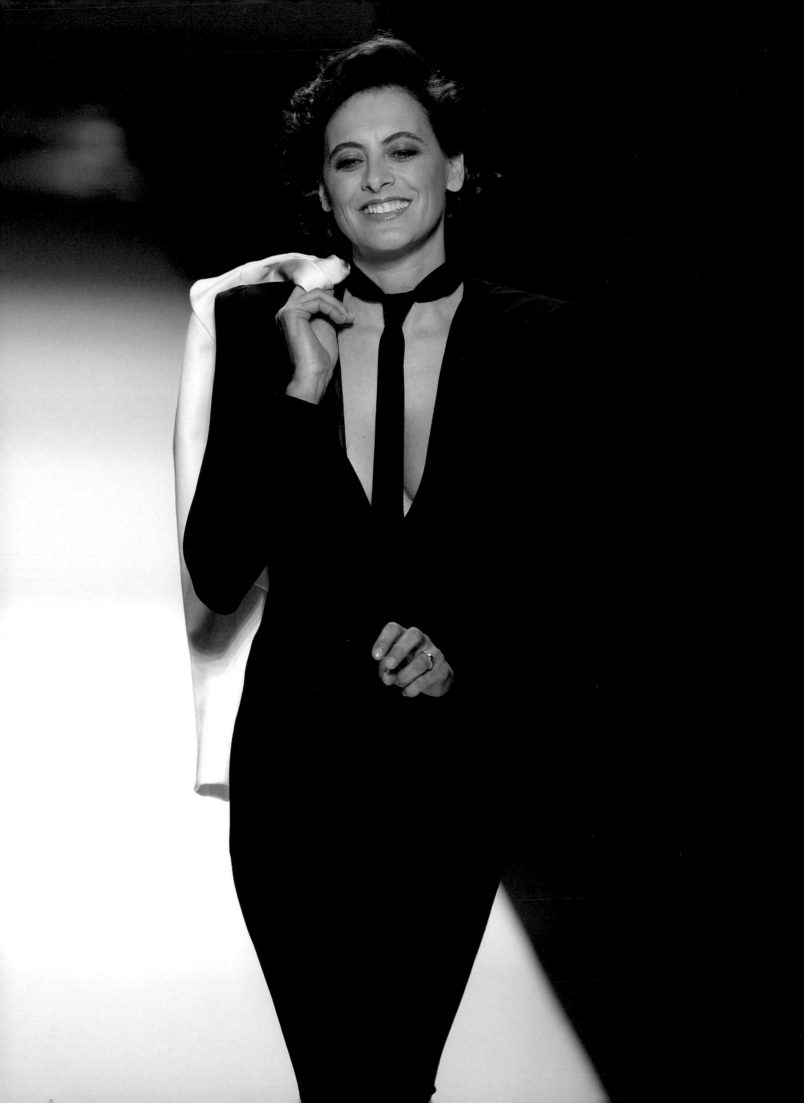

Lagerfeld could propose new ideas and push his vision for Chanel into the direction the times saw fit—more baroque, more pop, more elaborate. On the runway, she was like a panther, albeit a perfectly soigné French one, making direct eye contact with the audience, flirting, twirling, playing the coquette or the gamine or the snob, whatever the clothes needed.

So successful was Inès's embodiment of this important French brand that she soon became an easily identifiable shorthand for French chic itself. So it was no surprise that when the French government, under President François Mitterrand, went looking for its latest Marianne, they chose her. Marianne is the historic symbol of postrevolutionary France, and her toga-clad guise has appeared on postage stamps and official busts since 1969, when the government started casting well-known French women to use as a likeness. The honor had previously been held by such icons as Brigitte Bardot and Catherine Deneuve, but in 1989, when Inès said yes, it went to a model for the first time. The only problem was that Lagerfeld considered the very idea boring and bourgeois. He threatened to send Inès down the runway wearing a dress covered in fleurs-de-lis, the symbol of the monarchy, just to poke the government in the eye. When she refused to wear the dress, their falling-out was too much for the relationship to survive, and her enormously impactful time at Chanel came to an end.

Inès then decided that working on the other side of fashion was more interesting than continuing to model full-time. She launched her own sportswear label in 1991 and gave it her all, but her stake in the brand was too low for her to be able to fight when her investors decided to close it down in 1999. Inès learned a lot through the experience,

though, and so when Diego Della Valle was looking for someone to revive the storied Roger Vivier shoe company in 2002, he knew she had the energy, passion, and contacts to bring it back to life. Inès still works for Vivier today as brand ambassador.

"PERFECTION IS A NIGHTMARE. A GREAT FRENCH WINE WOULD BE NOTHING WITHOUT THE TASTE OF THE OAK BARREL OR A TOUCH OF DUST."

—INÈS DE LA FRESSANGE, from "This Is What 'Parisienne' Looks Like," by Elaine Sciolino, *New York Times*, April 20, 2011

Her book, *Parisian Chic: A Style Guide*, was a *New York Times* bestseller. She then launched a collection of smartly tailored casual clothes with Uniqlo in 2013, and finally bought back her name in 2014 to relaunch her own stand-alone line. Still with the same willowy frame and beautiful cheekbones, and already posing frequently to promote her own brands, she recently became a face of L'Oréal. In her early fifties, she appeared topless on the cover of *Madame Figaro*, the widely circulated fashion insert of the French national daily newspaper *Le Figaro*. And she has popped back onto runways occasionally, too, once for Jean Paul Gaultier in 2009 and then again in 2010, in one of the happier full circles in fashion history, for Karl Lagerfeld at Chanel.

Opposite:
Jean Paul Gaultier, runway presentation, spring/summer 2009. Photograph by Patrick Kovarik.

Isabella Rossellini

While a great many models are discovered by others, it's rare for that to happen to one as relatively old as Isabella Rossellini, who started posing for pictures professionally at twenty-eight. The daughter of Ingrid Bergman and Roberto Rossellini, and the then wife of Martin Scorsese, Isabella was not exactly unknown in elite circles. But it took a portrait of her shot in 1980 by the photographer Bruce Weber in British *Vogue* for her to come to the attention of the fashion industry. The dreamy, faraway look in her eyes; the noble face so like her mother's; the air of refined intelligence; the maturity that her "older" years brought even to her still images—all added up to a seductive, sophisticated antidote to the cheerful blond brigade that still dominated the big-money modeling world, even in the wake of the successes of Beverly Johnson, Janice Dickinson, and Gia Carangi. With a dark, educated air similar to that of Inès de la Fressange, Isabella was the thinking woman's model, the anti-bimbo.

Isabella was raised in Rome and Paris, and when she was eleven, a scoliosis diagnosis resulted in her undergoing eighteen months of painful surgeries and wearing body casts to correct her growth. None of

this could have given her much of a sense of her own beauty during her impressionable early adolescence, though no one who saw the girl could deny it was there. Isabella appeared in a few Italian movies and, when she was nineteen, came to New York to attend college, working as a translator and then as a part-time foreign correspondent on a comedic Italian news program presented by Roberto Benigni. In 1979, at twenty-seven, she married Martin Scorsese; they remained together for three years.

When Isabella appeared in the Weber photograph, which came about because the two were friends and he simply asked, there was a subsequent avalanche of interest in her from both fine art and fashion photographers. Richard Avedon, Helmut Newton, Annie Leibovitz, Francesco Scavullo, Robert Mapplethorpe, and Steven Meisel all lined up to photograph her. Isabella, who found modeling to be interesting work, less invasive and demanding than acting, dove in, soon racking up a string of covers on American and international editions of *Vogue*, *Harper's Bazaar*, *Vanity Fair*, and *Cosmopolitan*. In 1981, the French cosmetics giant Lancôme, looking to dust off its fusty image, signed Isabella

Opposite:
Photograph by
Michael Thompson,
Allure, 1994.

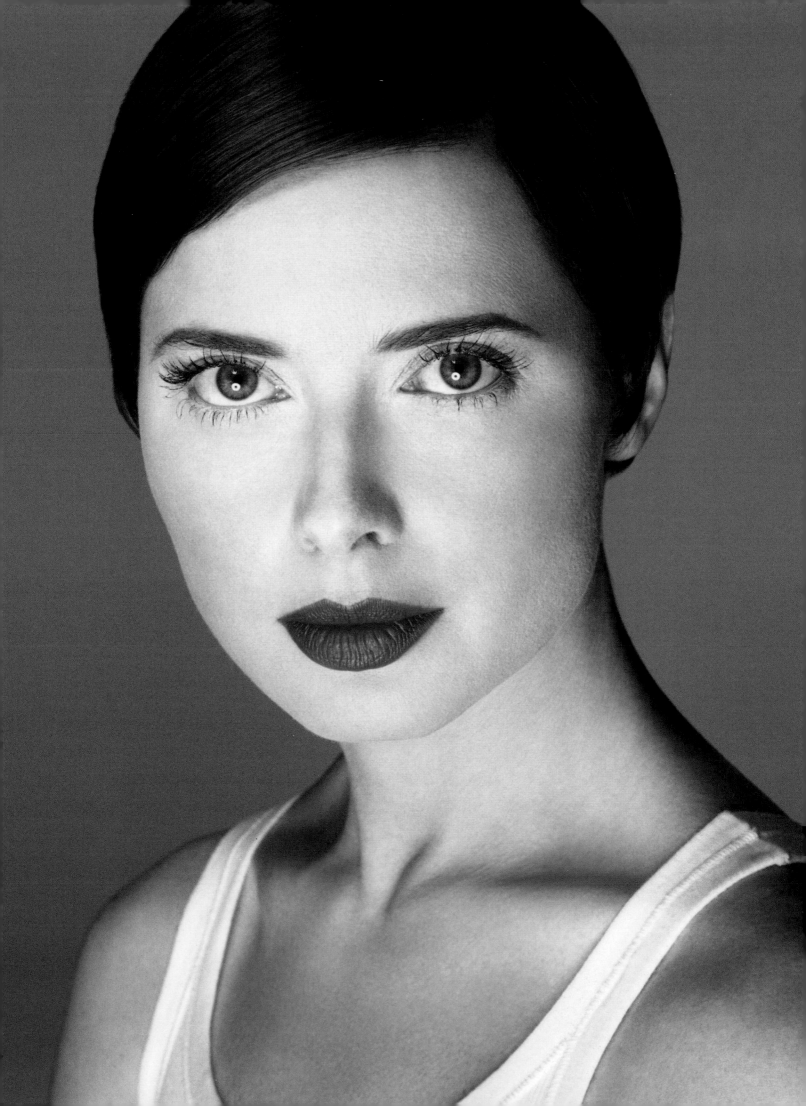

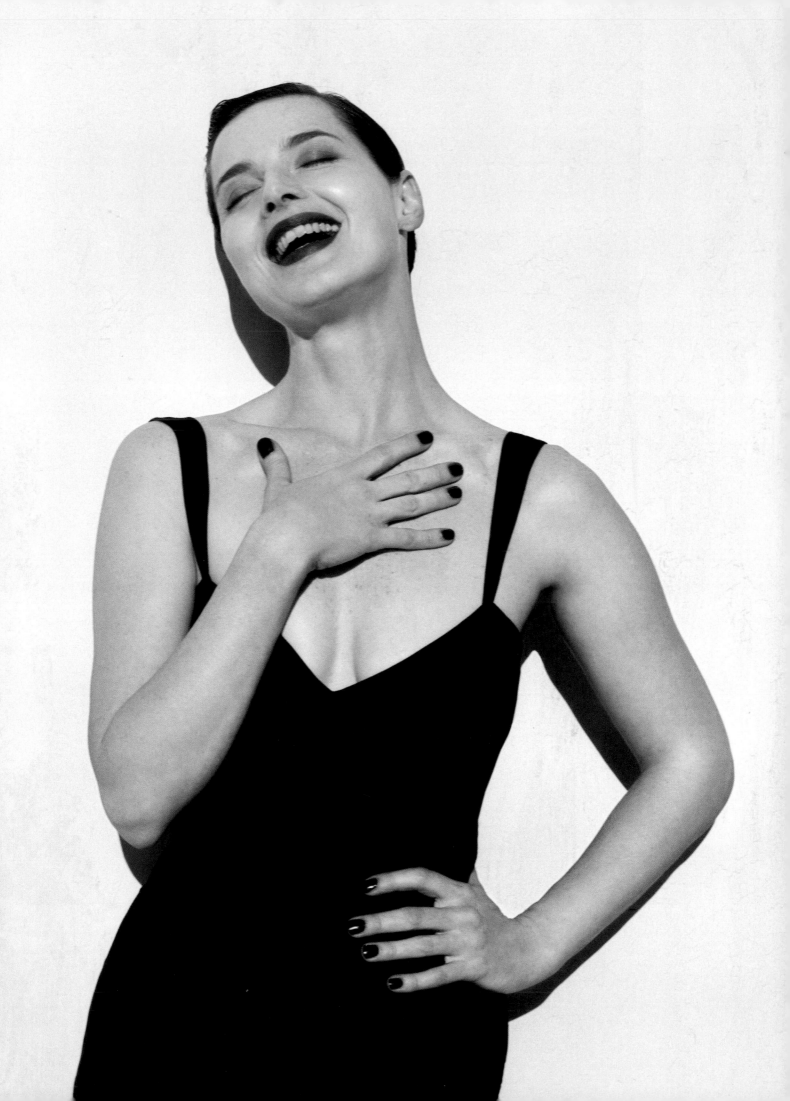

"NOBODY ASKED ME HOW OLD I WAS. BY THE TIME I WAS SUCCESSFUL WITH COVERS OF *VOGUE* AND *HARPER'S BAZAAR* AND *VANITY FAIR* AND THE LANCÔME CONTRACT, SOMEONE ASKED HOW OLD I WAS. THEY ALMOST FAINTED WHEN I SAID 33."

—ISABELLA ROSSELLINI, from "The Inheritance," by Rachel Baker, *New York*, August 14, 2011

to a $2 million annual contract, the highest in the business at the time. Two years later, *Time* magazine reported her modeling salary to be $9,000 a day.

Though Isabella would stay with Lancôme for fourteen years, she turned her energy toward acting, where she developed an eccentric résumé, eschewing obvious pretty-lady parts for more counterintuitive, distinctive roles. Her breakout performance was in her then partner David Lynch's 1986 film, *Blue Velvet*, and she has continued to work in film and television to the present day—and was named by *People* magazine as one of the fifty most beautiful people in the world in both 1990 and 1991. After Lancôme controversially terminated her contract when she turned forty-two—a nefarious trend that prevailed at cosmetics companies throughout the 1980s and 1990s—she countered by starting Manifesto, her own makeup and perfume company, in 1999.

Though Isabella has remained candid about her career as a model—she enjoyed posing but always rued the career's generally short lifespan—she continues to work at it now and again, appearing in a campaign for Bulgari in 2012 to promote a line of handbags she created for the brand. But she spends much of her time now working on a bizarre and humorous series of short films about the sex lives of animals, Green Porno, informed by her decision in her midfifties to go back to school to study animal behavior. The series first appeared on the Sundance Channel, and she recently brought it to the stage at the Brooklyn Academy of Music.

The worlds that Isabella has worked in—fashion and film—tend to valorize pretty young women who smile and don't make waves. But Isabella's maturity and insightfulness, her outspokenness and originality, combined with her beauty, have given her lasting relevance, both as a model and an artist.

Opposite:
Donna Karan advertising campaign, 1994. Photograph by Herb Ritts.

Paulina Porizkova

Despite her strong, soulful face, with its sharp cheekbones and perfect symmetry, and her ability to project equal measures of warmth and *froideur*, Paulina Porizkova is uncomfortable with the idea of being beautiful. Not that you'd know it from her pictures, in which Paulina poses with a grace and confidence that make shooting her a great pleasure. But the unusual journey of her earliest years made her innately suspicious of media hype, and she has always seen through the modeling industry's tendency to flattery.

Paulina was born in Olomouc in what was then Czechoslovakia, but when she was a toddler, her parents fled to nearby Sweden, and she spent her remaining childhood years living with her grandmother in Prostějov, looking after her younger brother. Her parents made a

public bid to have their children join them, which turned Paulina into a cause célèbre in Sweden and the focus of an intense political pressure campaign against her native country. She and her brother were eventually allowed to join their parents, but the unwanted media fame made Paulina feel awkward in her new school, a fact that wasn't helped by her tall, skinny stature. Feeling like an ugly outcast, she focused on developing her mind, working hard in school and studying classical piano.

When she was fifteen, Paulina had a friend who was hoping to start a career as a photographer and convinced her to let him take some pictures of her. She agreed, and when the pictures arrived at Elite Model Management in Paris, the photographer's work didn't stand out so much as did the model in the pictures. Elite courted

Opposite:
Estée Lauder advertising campaign, 1988.
Photograph by
Victor Skrebneski.

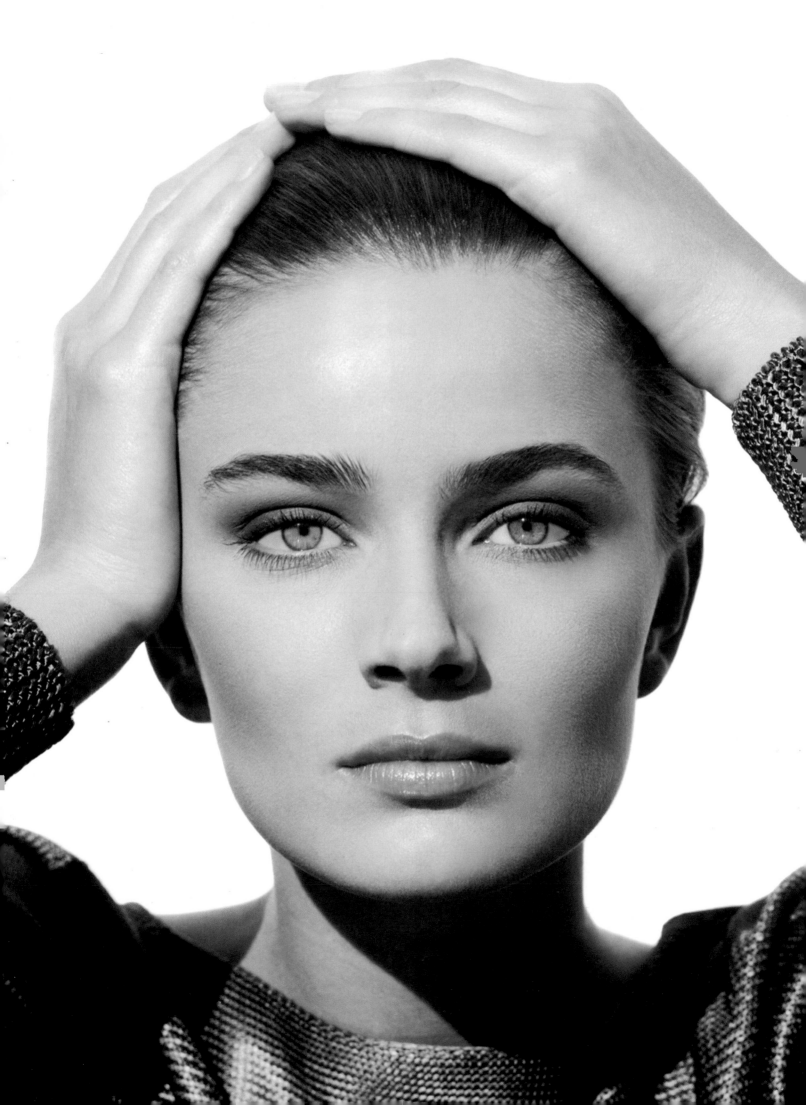

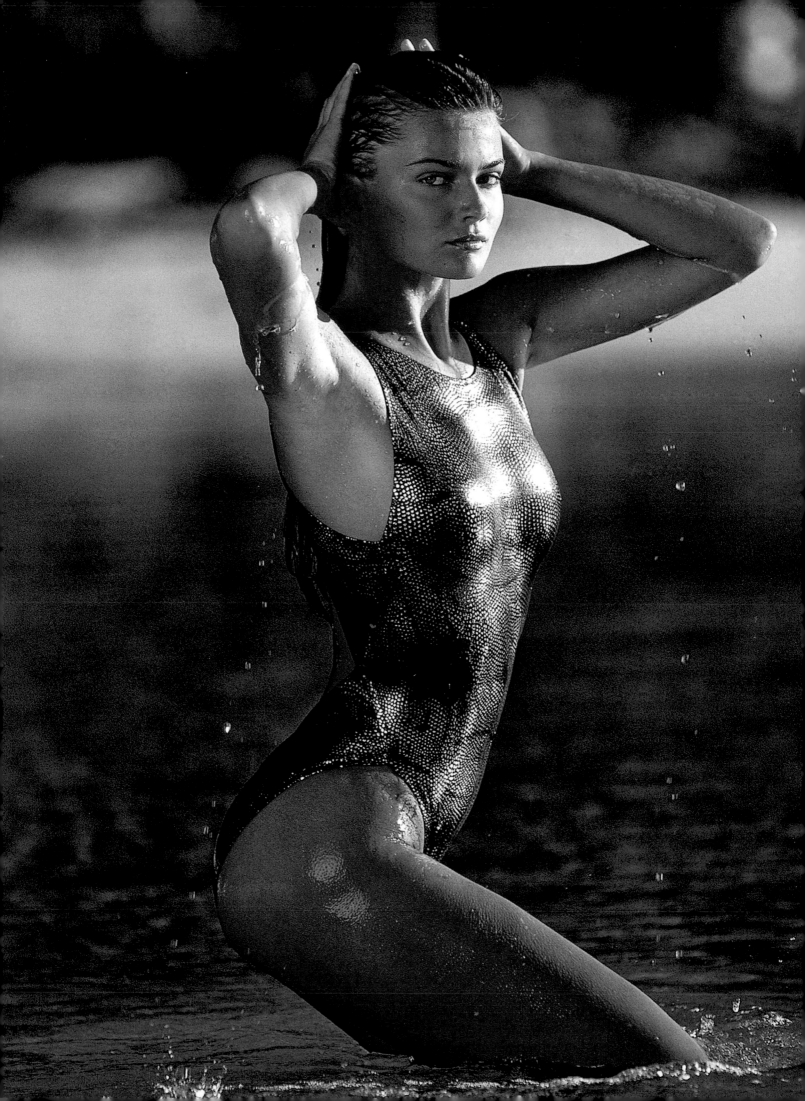

"HAD YOU PLUNKED ME DOWN A CENTURY EARLIER, I WOULD HAVE BEEN A SALLOW, FORBIDDINGLY TALL AND ANGULAR CHICK WITH FEW MARRIAGEABLE PROSPECTS."

—PAULINA PORIZKOVA, "Modeling Is a Great Job and a Sh*tty Career," *Huffington Post*, February 16, 2011

Paulina eagerly, sending her an airline ticket to France. With her newly developed curves and brash personality—smoking, drinking, swearing, quoting Dostoyevsky—she was an overnight sensation. *Sports Illustrated* selected her for the cover of the 1984 swimsuit issue when she was just eighteen. When they chose her again for the cover in 1985, it was only the second time that a model would have consecutive covers since Christie Brinkley in the late 1970s.

With her wide-set, feline eyes, strong bone structure, and slender limbs, Paulina had the kind of look that could cross over from the more commercial world of swimsuit modeling to high fashion, something that was rare at the time. Models like Christie Brinkley were straddling both worlds, but mostly the direction went from fashion to mass, not the other way around. However, Paulina's ability to convey mystery and sophistication was too good a fit for the fashion of the late 1980s, which was swooning over exotic, worldly Europeans who seemed beamed directly from crumbling palaces and James Bond–worthy casinos. Soon Paulina started to appear frequently on the pages and covers of *Vogue, Harper's Bazaar, Cosmopolitan, Glamour*, and *Self*. By 1988, Estée Lauder had made her the face of the brand for $6 million a year, breaking Isabella Rossellini's previous record of $2 million with Lancôme. Paulina remained the face of Estée Lauder until 1993, when the cosmetics giant, citing the now familiar refrain that she had grown too old at age forty, let her go. By then Paulina had already made *Harper's Bazaar*'s list of the ten most beautiful women, and *People* magazine's list of the fifty most beautiful people twice.

Paulina's second act has seen her exploring acting in the 1990s, and writing a column for the *Huffington Post*, a novel that came out in 2008, and a children's book, illustrated by her stepson with Ric Ocasek, whom she married in 1989 and to whom she remains happily married today.

Opposite: Photograph by Brian Lanker, *Sports Illustrated* swimsuit issue, 1986.

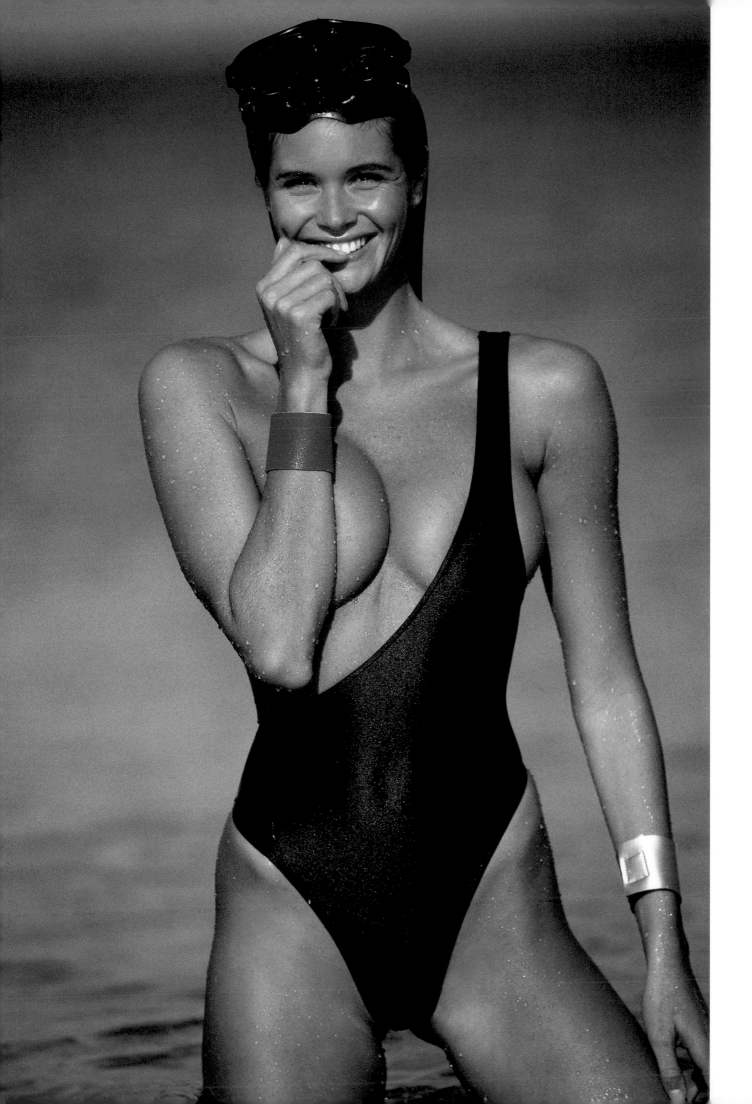

Elle Macpherson

Elle Macpherson earned her nickname, "The Body," for two reasons. To begin with, quite simply, she has a stunning physique. Broad-shouldered like a swimmer, she's six feet tall and lean, with strong legs and feminine curves. Second, the name stuck because Elle began her modeling career feeling self-conscious about facing the camera head-on. She was more at ease emphasizing her body, so her body became her calling card and greatest strength. Nowadays Elle has figured out successful new ways to keep the Body relevant, with a massive lingerie business, a skin-care line, and a line of wellness products. But she didn't start out with such ambitions.

The daughter of an engineer and the stepdaughter of a lawyer, Elle grew up in a Sydney suburb, and wanted to study law. At age seventeen, in 1981, she went to New York, looking for work during the year she took off between high school and Sydney University, and signed up for a short stint at Click Models. Her big break, which introduced her as a girl-next-door type, was being cast in a television commercial for the diet soft drink Tab, which aired in 1982. In the advertisement, she strolls on the beach in a bikini, a big, wide smile on her face,

prompting other girls to rib their drooling boyfriends. The ad made Elle a star back home and a hot property in America. By 1984 she was working frequently for *Elle*, with its creative director, photographer Gilles Bensimon, whom she eventually married. (They stayed together for seven years.) Her nonstop work with Bensimon—she had a six-year run in which she appeared in every issue of *Elle*—spurred covers for *Vogue*, *Harper's Bazaar*, *Cosmopolitan*, and *GQ*, and, in 1986, *Sports Illustrated*'s swimsuit issue. *Sports Illustrated* was a perfect venue for athletic, earthy Elle, and she went on to dominate the magazine, appearing on its cover five times; she remains the record holder for covers to date. In 1989, *Time* put her on its cover, too, accompanied by a profile about her career. "The Big Elle," they called her, presciently, as she went on to make even bigger moves in the ensuing years, always in the interest of running her own business.

After a few good years of being paid well as a model, Elle realized her top-earning years would be of relatively short duration and started to make a point of taking controlling positions in her endeavors. In 1989, when she was approached by a

Opposite:
Photograph by
Robert Huntzinger,
Sports Illustrated
swimsuit issue, 1990.

New Zealand–based lingerie company, Bendon, to represent its products, she suggested instead a licensing agreement and the creation of a whole new company together. Such an approach is common now for celebrities, but it wasn't at the time, and it still isn't for models. As part of the deal, Elle volunteered to give up her work for Victoria's Secret, and she even deferred her salary for a share in the profits. It might have seemed like a gamble at the time, but the company that was born the following year out of that risk, Elle Macpherson Intimates, has since grown into an internationally distributed brand. It's one of the bestselling lingerie lines in the world, generating more than $60 million in sales per year. At the same time, Elle set up her own parent company, forgoing an agent to handle her modeling, which was revolutionary.

Similarly, Elle is very much in command when it comes to producing her own images. After putting out a series of very successful calendars in the 1990s, in 1993 Elle played a small but memorable part in the film *Sirens*, in which she appeared fully nude. The film's success set the tabloids on a furious hunt for existing naked pictures of her, and, realizing the extent of the interest in her naked body—it shouldn't have been much of a news flash!—she decided to take matters into her own hands and pose for *Playboy*, enlisting Herb Ritts to take the pictures. When Elle began to host *Britain and Ireland's Next Top Model* in 2010, she also became an executive producer, as she did for the first season of NBC's *Fashion Star* in 2012. Again, she took greater risks, which paid off for her.

Elle has made other on-screen appearances, notably a five-episode arc on *Friends* in 1999 and 2000, but her businesses have remained her main focus—and she has spent her time and energy there wisely. After creating her skin-care company, The Body, with the British megapharmacy Boots, she cofounded Welleco, a nutrition company, on the eve of her fiftieth birthday.

> "I HONESTLY DON'T LOOK IN THE MIRROR, EXCEPT FOR WHEN I AM WORKING, AND THEN I SEE AN IMAGE THAT SUPPORTS MY BRAND."
>
> —ELLE MACPHERSON, from "My Secret Life: Elle Macpherson, Model & Businesswoman, 47," by Charlotte Philby, *Independent*, June 5, 2010

And yet, proving she could have it both ways, Elle also signed a three-year contract as a global ambassador for Revlon, which she renewed for another three years in 2010. Though she calls herself the "accidental executive," Elle has earned numerous awards for entrepreneurship and design, even as she's returned to the catwalk for Marc Jacobs at Louis Vuitton and continued appearing on major magazine covers.

Opposite:
Photograph by
Gilles Bensimon,
cover, *Elle*, 1986.

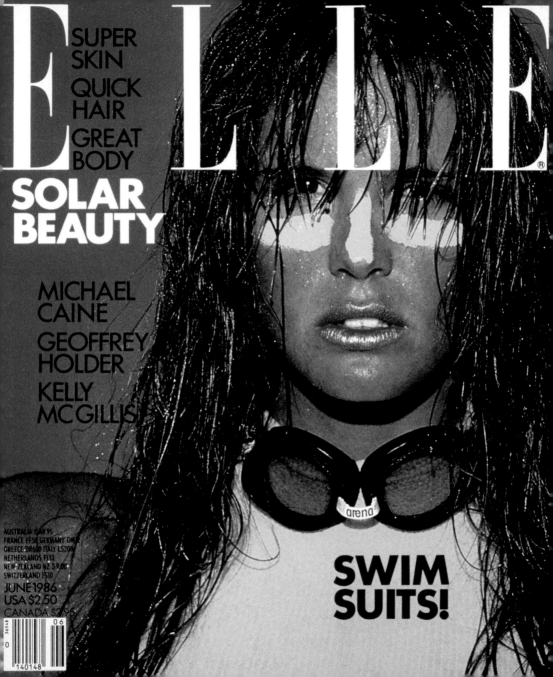

V.

THE SUPERMODELS

B

Y THE MIDDLE OF THE 1980S, THE new rich were competing to outspend one another with abandon and wanted look-at-me clothes in which to do it. Karl Lagerfeld, who took over as Chanel's creative director and head designer in 1983, remade what had become a conservative and dowdy brand into an opulent, sexy one. The other bold, bright high fashion houses, like Versace and Christian Lacroix, were candy for conspicuous consumers as well.

At the same time, high fashion started trickling down to a larger, more mass audience. European fashion imports were beginning to flood the newly wealthy American and Japanese markets, which meant that at the end of any given season, markdowns were deeper, racks were fuller, and more people could afford to buy into the dream. Some European houses started to consolidate, under moguls such as Bernard Arnault, who created the LVMH conglomerate in 1987, giving powerful new backing to iconic French companies like Louis Vuitton and Christian Dior. Designer licenses were also proliferating throughout Europe, the United States, and Asia. These lower-priced, lesser-value products affiliated with European houses were sanctioned by the mother companies, but instead of being manufactured in countries like France or Italy with age-old traditions, they were made more cheaply overseas.

At the same time, some high-end designers, like Donna Karan, Calvin Klein, and Ralph Lauren, were launching diffusion, denim, and underwear lines under their own creative direction, building new customers on lower levels of the socioeconomic spectrum. The profit windfalls from the broadening and diversification of brands were most often directed back into marketing, which meant bigger budgets for advertising and fashion shows, and more opportunities for models to make an impact. Meanwhile, the same factories in China that captured all this legitimate business were also beginning to produce more faithful knockoffs on the side, at a faster pace, for immediate delivery to major cities all over the world for a public hungry for designer names and logos.

The tentacles of a rapidly advancing mass media reached ever further into the world, so well primed for fashion information. Both high fashion and street style were lionized on MTV, which turned what used to be regional trends into national and international ones, and even launched its own weekly magazine show, *House of Style*, hosted by the rising model Cindy Crawford, to appeal to young audiences hungry to know more. Designers were energized by what they

saw and started to take their cues from the street rather than merely the other way around. This led to a fruitful exchange between high and low, between elite designers and expressive youth, that hasn't stopped since. Mass media has energized fashion, making what used to sit in an ivory tower relevant to a much larger audience.

With more people paying greater attention to fashion, curiosity and fascination could only grow around the models who walked the runway. Model superstardom was now not just for the bikini babes in *Sports Illustrated* but also for the girls who worked with designers and photographers in a more artistic and creative way—bringing strong personalities into the equation. With more money to be made from cosmetics and fashion contracts, and the modeling agencies now fully at war with one another to obtain the best talent, rising girls such as Christy Turlington, Linda Evangelista, and Naomi Campbell—all muses of prominent photographers and designers—were able to take advantage of what was becoming a frenzy, pitting clients against one another and making enormous demands regarding fees and working conditions. Magazines were complicit in the star-making effort, routinely running models' names in the credits and giving promising newcomers written profiles of a depth that was once reserved for established stars. Soon the top fashion models were bigger than their clients, and with the public fully aware of the fees they could command, their appearance in advertisements could make a young designer look like he or she had arrived simply by booking them.

When the major models of this era—Christy, Linda, and Naomi, as well as Cindy Crawford, Stephanie Seymour, and Claudia Schiffer—were at the peak of their power, they were ubiquitous: they worked in both advertising and editorial, and they had the power to select the photographers and designers they wanted to work with. But by the mid-1990s, there was a backlash against the fees, the egos, and the antics that such stardom can enable. Fashion magazines of the time started to put actresses on their covers—the same actresses who were once too shy or purist in terms of their public image to consider endorsing products. This started a movement that would only grow stronger as the decades wore on, to the point that today, models are only rarely on the covers of major fashion monthlies, as editors are seeking the larger audiences that movie stars attract. But at the dawn of the 1980s and into the early 1990s, the cover girl was still a model.

Models will likely never again have the same power they did during the 1980s and early 1990s. Even though it cost designers huge sums of money to work with these unbridled superstars, they are now often openly nostalgic for a time when models with intoxicating power and individuality brought sizzle and excitement to fashion at a level that is hard to imagine today.

Pages 126–127:
Linda Evangelista,
Naomi Campbell,
and Christy
Turlington, 1989.
Photograph by
Roxanne Lowit.

Christy Turlington

Christy Turlington is one of the best models ever—and it's almost impossible to find a photographer or editor to disagree with that assertion. A sublime combination of exotic and down-home, regal and approachable, enigmatic and familiar, and greater than the sum of her parts, Christy brings grace, intelligence, and serenity to almost every picture. With modeling skills, intelligence, and a strong sense of self, Christy has enjoyed a career of impressive longevity. From when she first started up to the present day, when overexposure is the norm, Christy has preserved her mystery and allure. When assessing her legacy and her ongoing modeling work—in 1992, the Costume Institute at the Metropolitan Museum of Art not only called her the "Face of the 20th Century" but also used her as the model for its own mannequins the following year—it's impossible not to gush.

Discovered at age thirteen while riding horses in Miami by a local fashion photographer, Christy was uninterested in fashion at the beginning of her career. But anyone who saw her early pictures—taken when she still had braces on her teeth—knew she had something special. With feline eyes, a refined, upturned nose, and full lips, her perfectly balanced features were delicate but strong. Her mother's Salvadoran heritage gave Christy a hint of exoticism, which, following the domination of blond, blue-eyed models in the 1970s, was no longer a curse. Her look was at once contemporary and evocative of a certain nostalgia. In Christy's poise and elegance, photographers like Steven Meisel, who loved to restage iconic vintage images into contemporary homages, saw a throwback to the great couture models of the 1950s. But she could also pour on the glitz and personify the very 1980s exuberance and excess, as she did in countless Versace campaigns.

When she was fifteen, Christy decided to pursue modeling seriously and took exploratory trips to Paris and New York with her mother, followed by a summer stay the next year at the Ford Models Manhattan townhouse, one of the original "model apartments," where agents would house and try to babysit their youngest new talent. During that summer, Christy landed a go-see with the photographer Arthur Elgort, a regular contributor to *Vogue*. The meeting went so well that suddenly Christy was working for *Vogue* almost exclusively. Her big break, though, came in 1986, when she was seventeen, upon meeting Steven Meisel. He had already built a reputation as a star maker, both through his playful, spectacular work, which really let girls perform, and his tendency to take young models under his wing and mentor and groom them for stardom. Christy met Meisel on a shoot for British *Vogue*, where Anna Wintour was editor in chief at the time, that teamed Meisel for the first time with hairstylist Oribe and makeup artist François Nars— a trio who would go on to work together

Opposite:
Photograph by Herb Ritts, *LA Style*, 1998.

"CHRISTY TURLINGTON IS THE MODEL OF OUR TIME."

—*Arthur Elgort's Models Manual*, 1993

constantly in the following years, helping to define beauty trends. The story, "Delicious Black Dressing," in the August issue, sent Christy's career soaring to the top. In it, she wore simple black dresses with very natural, almost nude, makeup, yet her range of dynamic poses brought so much life and variety of expression to the pictures that the industry took notice.

Meisel was smitten; soon other influential photographers, such as Peter Lindbergh and Irving Penn, were, too. With her ability to portray everything from a Hindu goddess to a harried mom, always with the utmost professionalism, Christy became very much in demand with advertisers including Revlon, Missoni, and Versace, who knew they would get exactly what they needed from her, and were more than happy to pay top dollar for her level of work. The most impactful of them all was Calvin Klein, who signed Christy to an exclusive contract in 1988, and made her the face not just of his Eternity fragrance but also, not long after, of ready-to-wear and lingerie, too. Klein knew that Christy's look could speak to diverse ethnic groups, which was starting to become important at the end of the 1980s, and her timeless quality and quiet confidence had universal appeal.

Around the time that Christy first signed with Calvin Klein, she became close friends with fellow models Linda Evangelista and Naomi Campbell. Though she was famous before the other two, by the dawn of the 1990s, the three together had become a media phenomenon called "The Trinity"

that changed modeling forever. The Trinity not only posed together on shoots, but also went to nightclubs, walked the runway, and were snapped by paparazzi together. This threesome increased media attention for fashion shows and made the general public more aware of and curious about designers showing their wares in real time.

Though Christy, Naomi, and Linda were legitimately close friends, after a few years of the Trinity phenomenon Christy began to chafe at being part of what she saw as a prepackaged marketing gimmick. In 1994, she took a step back from the business, enrolling at New York University to study Eastern religion and philosophy, and doing some advertising work for Gianni Versace and Calvin Klein. By 2000, she had become a vocal advocate for the practice of yoga, launching a line of activewear with Puma. And year by year, she has turned her energy more and more to activism, especially on behalf of maternal health issues, releasing the documentary *No Woman, No Cry*, which she directed, and creating her own foundation, Every Mother Counts, in 2010. She has come back to modeling on a part-time basis throughout all of this, and today she still holds lucrative and highly visible contracts as a face of Maybelline and once again with Calvin Klein, as well as seasonal campaigns for such impactful brands as Prada and H&M. They all know, as does everyone else, that after all these years, after all these memorable editorials and campaigns, that Christy still has the power to inspire like almost no one else.

Opposite: Photograph by Patrick Demarchelier, *Vogue*, 1991.

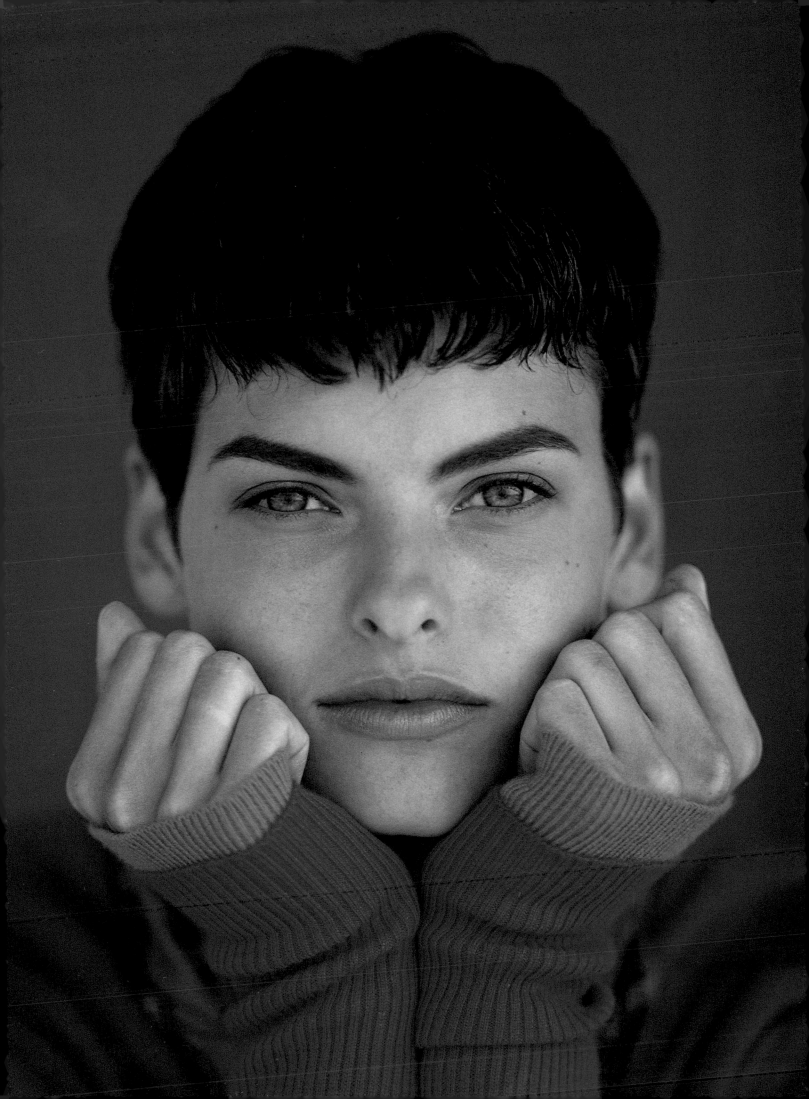

Linda Evangelista

Of all of the supermodels of the late 1980s and 1990s, none was as pure a creature of fashion as Linda Evangelista. Linda has never wanted to do—and has never done—anything else professionally. There have been no skin-care lines, no acting, no television shows, no tell-all books. Her focus, insatiable desire, raw talent, and incredible, unmatchable skill all go to modeling. This drive has made her every photographer's dream, never mind that at the height of her fame, she could be a handful. No one who has worked with Linda begrudges her that quality for long because she loves and understands fashion with a consuming passion, and she does what it takes to make indelible images, which is, after all, what the business is about. Linda is more than a model; she's an inspiration and a muse, a role she has played for such era-defining designers as Karl Lagerfeld, Azzedine Alaïa, and Domenico Dolce and Stefano Gabbana, as well as photographers like Peter Lindbergh and, especially, Steven Meisel. When the stakes were very high, she took consistent risks with her appearance and, in so doing, changed how women approached beauty forever.

Opposite:
Photograph by Gilles Bensimon, *Elle*, 1989.

Linda was attuned to fashion as a teenager and first tried modeling at age sixteen in Japan, but when she was asked to pose nude, she smartly ran back home to Canada. Pressed by her agency there, she entered the Miss Teen Niagara contest the same year, in 1981. She didn't win, but she was scouted by Elite Model Management and asked to come to New York, though she took years to follow up with the agency. When Linda finally did make the trip to New York, her book didn't catch fire, so in 1984 Elite sent her to Paris, where she spent the next three years doing catalog and some editorial work.

Gradually things picked up for her. Arthur Elgort booked her for *Vogue* Paris, and she then started to work regularly for the magazine. In 1987, she married Gerald Marie, who ran the Paris branch of Elite Model Management, and Linda benefited greatly from his sharp negotiating skills and ability to set up the right girls with the right photographers.

There would be many right photographers for Linda, but the most right one was Steven Meisel, whose dramatic, over-the-top, concept-driven shoots required

"SHE'S A KIND OF STRADIVARIUS. YOU CAN PLAY HER LIKE YOU CAN PLAY NO OTHER INSTRUMENT. SHE'S STRONG AND AT THE SAME TIME FLEXIBLE. SHE'S TOUGH AND VERY TOUCHING, AND THAT'S THE SECRET OF HER SUCCESS."

—KARL LAGERFELD, from "She's Back," by
Jonathan Van Meter, *Vogue*, September 2001

Opposite:
Photograph by Arthur
Elgort, *Vogue*, 1991.

a girl who could transform herself easily and play a part. Linda first worked for Meisel in 1987, the year that she, Christy Turlington, and Naomi Campbell started walking the runways together—something they'd reprise over and over in the ensuing few years.

Meisel didn't have a hand in Linda's most fateful career decision, but he reaped the rewards of it for years afterward. At a 1988 shoot, the photographer Peter Lindbergh asked hairdresser Julien d'Ys to crop Linda's hair into a short, boyish cut. She was worried it would mean the end of her career but made the sacrifice anyway.

Because of her drastic new hairstyle, Linda was dropped from a dozen runway shows that season, which was especially hard on her because she loved walking during fashion week and she, more than any other editorial model of her time, helped make shows de rigueur for models with ambition. But she would have the last laugh. Within a year she landed covers for all the major *Vogue*s: American, French, British, and Italian.

Now rocketing to the top, instinctively geared to stoke the flames of nonstop change that fuel fashion's evolution, Linda started changing her haircut and color constantly. In that moment in time, outside of subcultures like punks and ravers, the only person who had anywhere near the craving to reinvent herself like Linda did was Madonna. But Linda changed even faster, going short, long, streaked, red, black, platinum—whatever moved her and her hair guru, Garren, who guided her through many of these transitions. As Linda's changing 'dos became something subscribers to *Vogue* and *Harper's Bazaar* looked forward to with every issue, high fashion let go of its don't-ask, don't-tell attitude toward beauty, giving up the pretense that good looks should be natural. This opened up the space of experimentation for all women. Hair color for the chic and stylish no longer needed to look like one was born with it, and it hasn't ever since.

By early 1990, Linda had been on sixty magazine covers and had just been named the face of Revlon's Charlie perfume, when singer George Michael spied a cover of British *Vogue* featuring her, Cindy Crawford, Christy Turlington, Tatjana Patitz, and Naomi Campbell. Suddenly the cast of the video for his

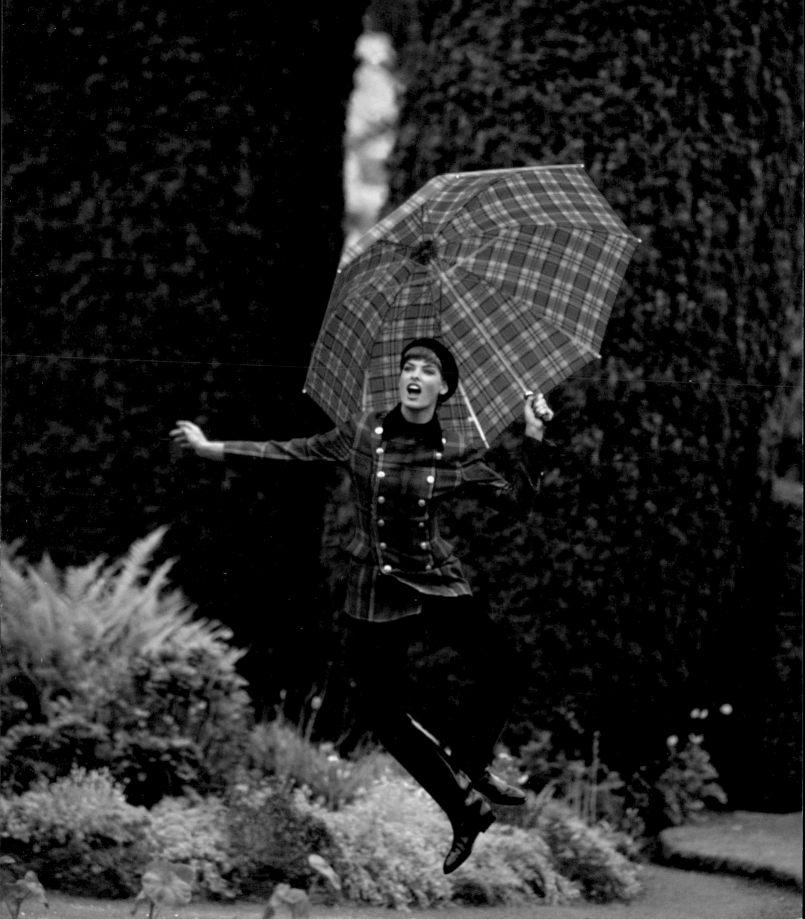

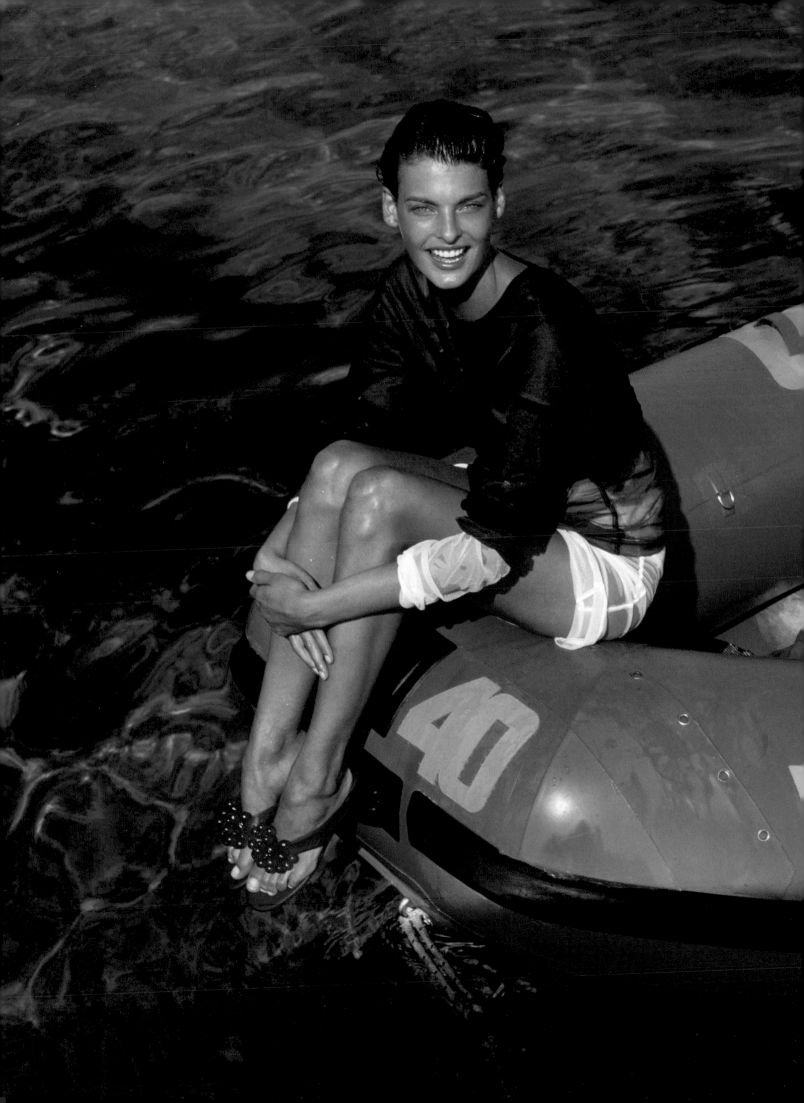

"LINDA PROBABLY LOVES MODELING MORE THAN ANYONE I KNOW. THAT'S WHY WE ALL LOVE LOOKING AT PICTURES OF HER."

—AMBER VALLETTA, from "She's Back," by Jonathan Van Meter, *Vogue*, September 2001

megahit "Freedom '90" was assembled. Linda arrived on set having bleached her hair platinum blond for the first time the night before, and with her indelible new look and the dreamy mystery she projects in the clip, she stole the video from the rest of the cast, which was no mean feat. "Freedom '90" was what really launched the media phenomenon known as the "supermodels," as this group of girls that included the famous Christy-Naomi-Linda Trinity was now routinely called. A year later, Gianni Versace hired the Trinity and Cindy Crawford to walk his runway arm in arm, mouthing the words to the song—yet another of the perfect fashion moments that seemed to trail these girls wherever they went.

Nothing lasts forever, and that same year, Linda was also at the center of the inevitable backlash. In an article for the October 1990 issue of *Vogue*, Linda told the journalist Jonathan Van Meter, "We have this expression, Christy and I. We don't wake up for less than $10,000 a day." She has always protested that she was kidding, and would go on to apologize countless times, but the image of the models as spoiled princesses who did nothing but show up and look beautiful was too much for a lot of people to take—never mind that modeling is actually very hard work, and to

hold down a top model's schedule requires an iron constitution. That was their Marie Antoinette moment, when public adoration turned into jealousy and judgment.

Linda kept working steadily, though. She posed constantly in magazines and signed a lucrative deal for Clairol hair color, an appropriate client if ever there was one. Linda kept up a breakneck pace until the end of the 1990s, when a breakup with a famous French soccer star and a devastating miscarriage pushed her into self-imposed isolation. She stayed at her home in the south of France for three years, eating what she wanted, growing out her hair, and doing as little as possible. Finally, sick of seeing what she has described as unflattering tabloid pictures of herself, she put herself back together and made a stunning comeback, accompanied by a thirty-page feature in *Vogue*'s September 2001 issue.

Linda hasn't stopped working since, although she has kept a much saner pace, especially since the birth of her son, Augustin, in 2006. In recent years, she has landed covers of *W*, *Interview*, *Harper's Bazaar*, and several international *Vogue*s, as well as advertising campaigns for L'Oréal, Loewe, Chanel, Barneys, and Prada. Though the heady era of Linda's dominance has come and gone, she is still doing exactly what she feels she was put on this earth to do.

Opposite:
Photograph by Gilles Bensimon, *Elle*, 1991.

Naomi Campbell

As important as Naomi Campbell has been to the modeling industry, and beyond it too, words simply fail when you look at her. The verve and grace of her runway walk—taught to her by Pat Cleveland—has blown away all other models since 1986, when she was scouted at age fifteen while window-shopping in Covent Garden. Even her still images appear to be undulating, practically shimmying off the page. Those images didn't take long to reach the public, either; Naomi landed the cover of British *Elle* less than a year after starting out.

Then there's her personal might, which can make the weak quiver. I met her in the mid-1990s, when I was booked to model for a Chanel show in Paris, and I will never forget first seeing her backstage, talking to Karl Lagerfeld. She wasn't the tallest or the shapeliest model there, but when she turned

to walk away from the designer, with that thoroughbred stride, it was like there was no one else in the room. Walking the runway alongside her that day, I was equal parts terrified and thrilled.

In her almost thirty-year career—with more than five hundred magazine covers, thousands of editorials and advertising campaigns, and some dabbling in perfume, music, novel-writing, and now TV—she is the only model of her generation who hasn't taken a time-out. The daughter of a single mother from South London, she worked her way up, day by day, to become one of the most famous and successful models in fashion history; Naomi owns both the glory and the drama that trails in her wake. But her ability to adapt and evolve, while her beauty remains as if untouched, is a source of strength for her and amazement for those

Opposite: Photograph by Herb Ritts, *Interview*, 1991.

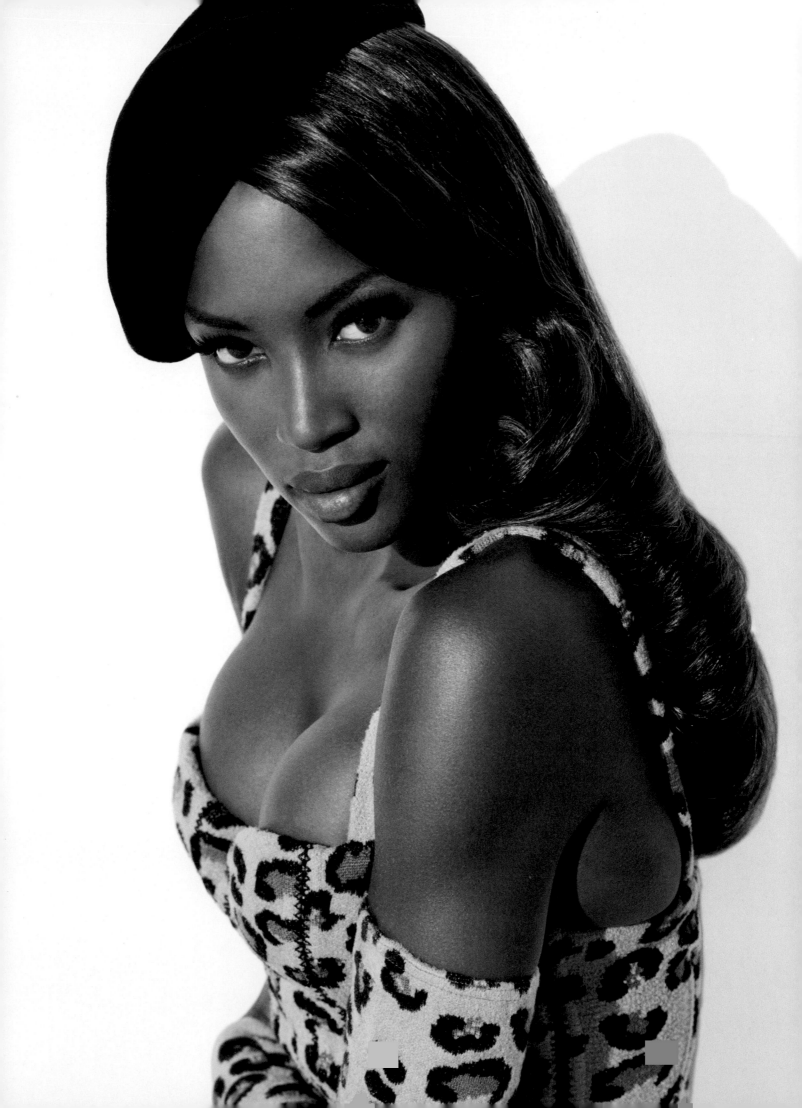

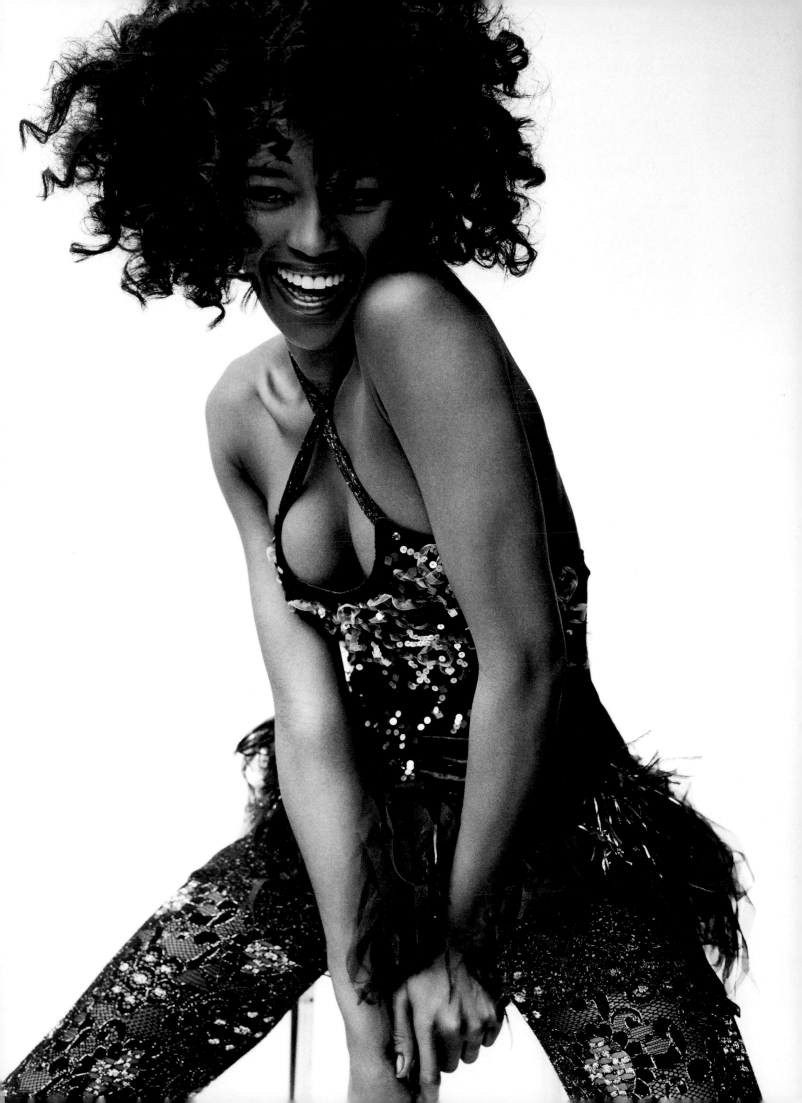

who know her. It's not just the ever-changing hairdos but also the seemingly endless poses, moves, and feelings she evokes. No one else could steal a pas de deux from Michael Jackson, as she did in his 1992 video "In the Closet," directed by Herb Ritts.

As is so often the case with someone who helps to define an era, Naomi was the right model for a moment when fashion was intoxicating and glamorous—and she's remained so ever since. Her avatar status was first recognized by designers as dissimilar as Gianni Versace and Azzedine Alaïa, for both of whom she has served as a muse. Naomi's piercing gaze, dancer's fluidity, Amazonian stature, and incredible fire in the belly were also right for a time when women were storming the barricades of the workplace. Power was in.

Power wasn't necessarily to be easily claimed by everyone in equal measure, however. In 1986, race was very much a barrier—an even bigger one then than it is today. There is a famous story about how Christy Turlington threatened to withhold her own services on an important advertising campaign for Dolce & Gabbana unless her friend Naomi was booked, too. (It's ironic, then, that Naomi is still starring in campaigns for D&G today.) Naomi herself has been a leader against racism in the industry since she first became famous, raising her voice for decades against the relative invisibility of models of color. She, with Iman and the agent Bethann Hardison, was a cofounder of the Diversity Coalition, a watchdog organization that has confronted fashion's international governing bodies and media for white-washing runways. Fashion for Relief, an organization she founded in 2005 to raise funds for rebuilding after Hurricane Katrina, has now gone global, raising many millions for victims of such other disasters as the 2010 earthquake in Haiti.

> ## "I LIKE WORDS LIKE TRANSFORMATION, REINVENTION, AND CHAMELEON. ONE WORD I DON'T LIKE IS PREDICTABLE."
>
> —NAOMI CAMPBELL, from "Naomi Knows It All," by Derek Blasberg, *Harper's Bazaar*, February 2012

UNESCO recognized her charity work in 2011, and she has not slowed down. Naomi may have earned a diva-esque reputation over the years, both fairly and unfairly, but her friends, who include everyone from Kate Moss to the late Nelson Mandela, have remained at her side for a reason. She is fiercely loyal and supportive of the people she is closest to, and will do whatever it takes to help them out.

In work and in life, Naomi does everything on her own terms, which is why you can bet that she won't stop modeling until she's good and ready. Let's hope that day is a long, long way off.

Opposite:
Photograph by Mario Testino, *Allure*, 1994.

Cindy Crawford

The world has been on a first-name basis with Cindy Crawford since the early 1990s, and her success is entirely self-made. She owes her impressive career to her talent, enormous ambition, and ability to deliver on it time and again. Soon after she was discovered by a local photographer at age sixteen in an Illinois cornfield in 1982, Cindy started working for Chicago-based photographers. She enrolled in an Elite Model Management Look of the Year contest the following year and won runner-up, but as valedictorian of her high school class, she considered academics important. She had been accepted to Harvard, MIT, and Northwestern University, and did enroll at Northwestern with the hopes of becoming a nuclear physicist, as she wasn't sure modeling could compete. Yet she worked regularly in Chicago while she was in school, for the photographer Victor Skrebneski. Posing for department stores and other local clients and walking the runways in Paris, even based in a second-tier market like Chicago she was on track to earning $200,000 a year.

Ultimately school didn't have a chance. In 1985, she was discovered on Azzedine Alaïa's runway by a top booker at Elite, who finally convinced her to move to New York the next year. Nicknamed "Baby Gia"

for how much her olive skin, heavy brows, and impressive cleavage made her resemble model Gia Carangi, Cindy went to work right away with photographers who had championed Gia, like Albert Watson and Francesco Scavullo. Cindy had that perfect combination of approachability and a touch of spice, and with world-class photographers amping up the glamour, she started going places very quickly. But even when she did her first *Vogue* cover, shot by Richard Avedon, in 1986, artists were still habitually retouching the mole she always refused to have removed.

The following year, Cindy booked three more covers at *Vogue*, and by then, the mole was out in full force. Unlike in Lauren Hutton's day, when the gap in her teeth was an anomaly, the late 1980s and early 1990s were a time when society and pop culture were starting to consciously, even if sometimes awkwardly, celebrate diversity. That you could really tell all the big models of Cindy's era apart only aided their efforts to brand themselves, as Cindy's mole, in her case, ended up helping to do.

Cindy's first step outside of the conventional realm of posing for magazines and advertisements was when MTV, capitalizing on the growing interest in fashion and models, launched *House of Style*, with Cindy

Opposite:
Pirelli calendar, 1993. Photograph by Herb Ritts.

144

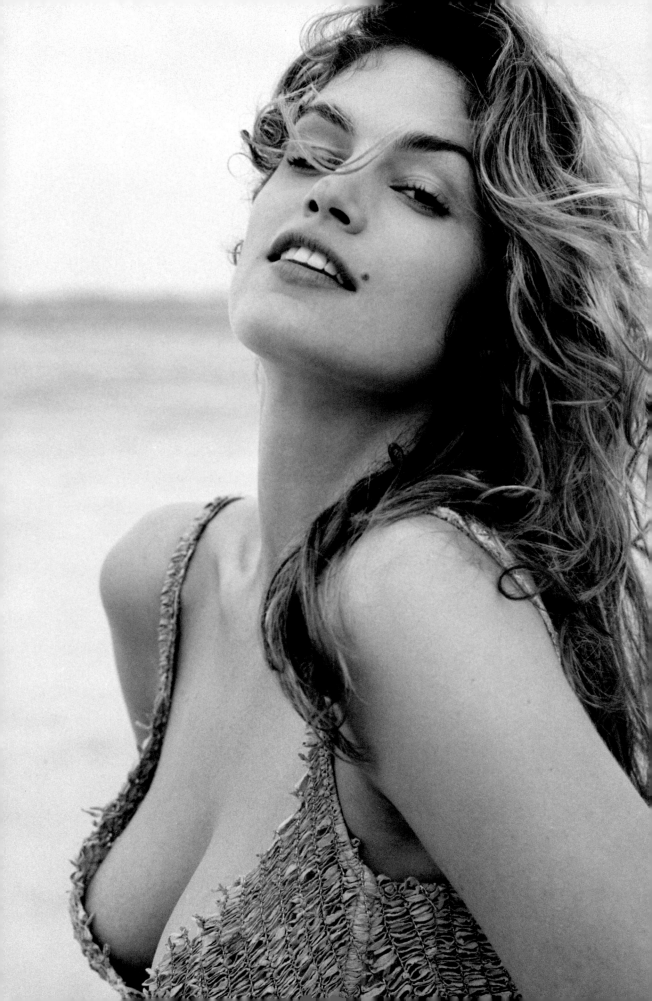

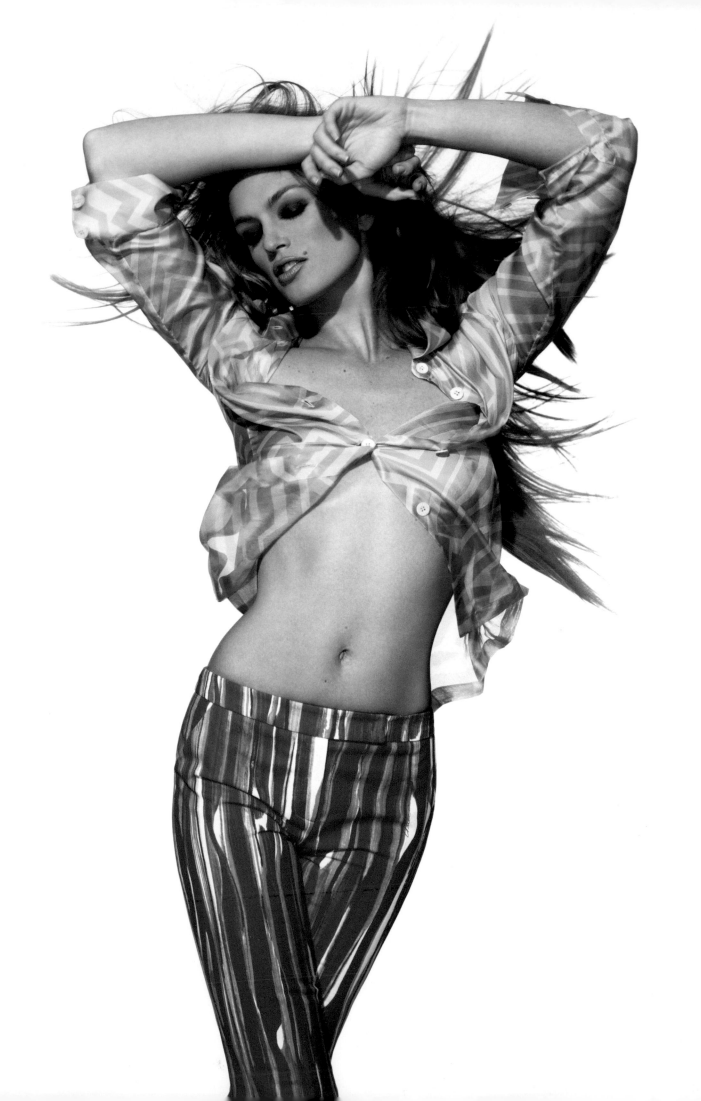

as its host, in 1989. In the same year, now dating Richard Gere, whose career was on fire, and already having posed for *Playboy* for Herb Ritts, she even became the subject of a song by Prince, "Cindy C.," on his notorious *Black Album*, which circulated widely as a bootleg at the end of the decade and cemented her pop cultural appeal.

In 1989, Cindy also landed the Revlon account, for which she served as one of the company's pivotal spokeswomen for eleven years. Cindy was photographed plenty in couture and became the face of Halston in 1990, the same year George Michael released "Freedom '90," but thanks to the broad choices she made—MTV and *Playboy* especially—she gained a truly mass appeal and, unlike the Trinity, started to transcend fashion. Cindy started signing bigger and bigger deals, like Pepsi, whose Super Bowl commercial featuring her in a red Lamborghini has been ranked time and time again by popular men's magazines as one of the sexiest ever. The fashion world tends to mistrust mass taste, and yet at the same time that Cindy started putting out successful workout tapes as well as posters and calendars featuring her image, she was a muse to Gianni Versace. She was the first model to really have her cake and eat it, too: that is, work at the top of the high fashion world while becoming an internationally recognized star to people across just about every socioeconomic, national, and cultural spectrum.

Other than Christy Turlington and Gisele Bündchen, there hasn't really been a model since Cindy who has been able to capture such a broad audience in such diverse categories of taste. Cindy was a top earner and constant worker until the late 1990s when, married to the nightlife

impresario Rande Gerber, she started to focus on her family life, raising two children, one of whom, Kaia, has already modeled for Young Versace. Today Cindy is more attuned to her business life than modeling. With the celebrity dermatologist Jean-Louis Sebagh and the manufacturer Guthy-Renker, the maker of Proactiv, she created Meaningful Beauty, an accessibly priced research-based skin-care line. She's launched a jewelry line, several fragrances, and a home furnishings and accessories line, Cindy Crawford Style. But she is still posing in avenues both mainstream, like *Redbook*, and avant-garde, like *V*, where the same sexiness and energy we've seen since the 1980s are still very much on display.

"I WAS BABYSITTING, THEN WORKING IN A STORE, THEN CLEANING HOUSES, THEN WORKING IN THE CORNFIELDS, AND THEN WHEN I STARTED MODELING I TREATED IT LIKE A JOB, NOT A LIFE-STYLE. I WAS SERIOUS ABOUT THAT."

—CINDY CRAWFORD, from "When Piers Met Cindy Crawford," by Piers Morgan, British *GQ*, May 2011

Opposite:
Photograph by
Gilles Bensimon,
cover, *Elle*, 1996.

Tatjana Patitz

Among her supermodel peers, Tatjana Patitz was probably the least obviously commercial. Even if the star models of this era all looked very different from one another, there was something exotic about Tatjana that set her even further apart from them. She was physically unusual, with dark circles under piercing blue eyes, which often made her look like she had just woken up. Usually, such imperfections would send a makeup artist running for the concealer. And yet as important a figure in beauty as François Nars, known for glamorous makeup and bright colors, has said that when he worked on Tatjana, he preferred to keep her face as bare as possible, lest he reduce the delicate balance that nature created.

A great model is most often a blank canvas, transformable. Tatjana could play the siren or the surfer, and she expressed a broad range of emotions, but the most lasting images of her are when she was really looking like herself, with a minimum of theme or concept, almost like a palate cleanser from the high camp and artifice of the late 1980s. With her womanly body—at five foot eleven, she's a relatively curvaceous size eight—Tatjana can project feline sensuality, but also fragility and softness. Those qualities are as evident in her 1980s advertisements for Revlon and Calvin Klein as they are on the February 2013 cover of *Numéro China*. That cover line simply reads, "Woman," and there stands Tatjana, in all her voluptuousness, still mysterious and just a little remote. It's the same wistful beauty she's always had. She may not have stayed in the spotlight to the same degree as her cohorts, but the soft vulnerability she projected makes her work during the 1980s and 1990s stand

Opposite:
Photograph by
Herb Ritts,
Rolling Stone, 1989.

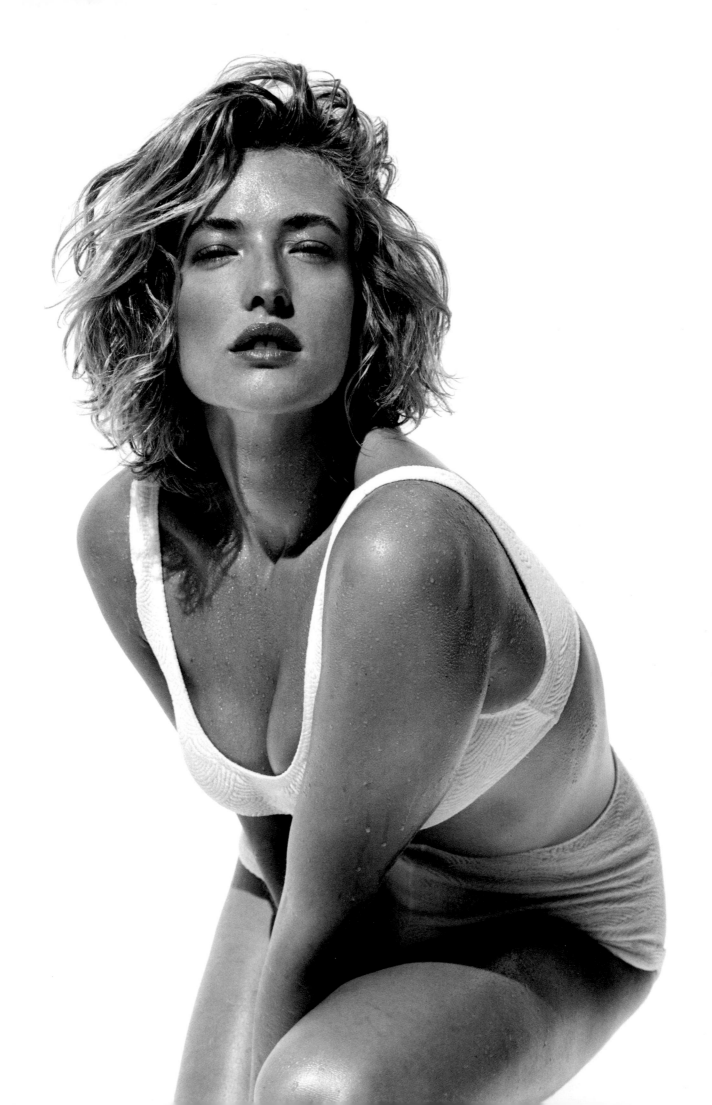

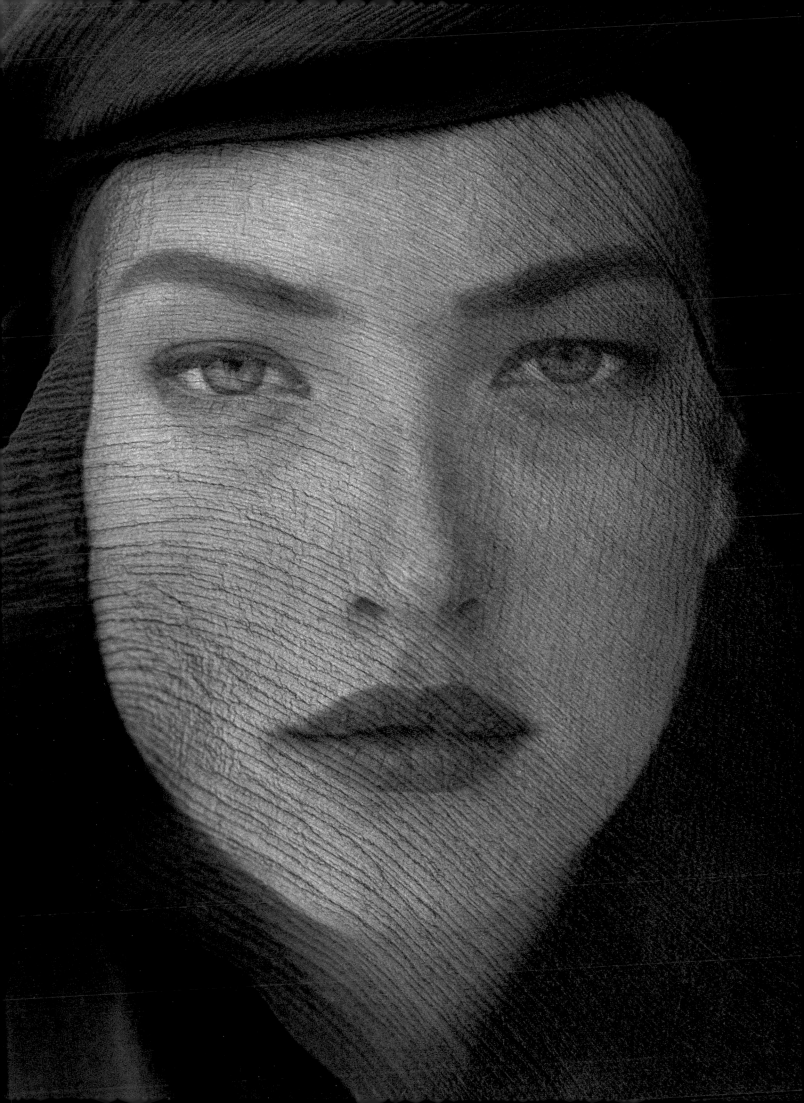

out as unusual during that more exhibitionistic period.

Tatjana was born in Germany but grew up in a quiet seaside resort town in Sweden. Tomboyish, sporty, and tall for her age, she swam and rode horses competitively. When she turned seventeen, she came in third in an Elite Model contest in Stockholm and won a contract with the agency and a trip to Paris. She wasn't an immediate success, and spent most of her first year knocking on doors and getting no reply. Finally, in 1985, after Robert Mapplethorpe shot her for a beauty story in the February issue of *Vogue*, Tatjana was noticed by star makers like Peter Lindbergh, Herb Ritts, Bruce Weber, and, soon after, Steven Meisel. By 1987, she was working for Richard Avedon at *Vogue* and posing in advertisements for Revlon, Calvin Klein, and Perry Ellis. She also started to work frequently in music videos, a venue of growing importance, including George Michael's famous "Freedom '90" and Duran Duran's "Skin Trade."

Over the course of her career, Tatjana has been featured on more than two hundred magazine covers, including *Vogue*, *Elle*, *Marie Claire*, *Glamour*, and *Cosmopolitan*. She also appeared on the cover of *Vogue*'s centennial issue in 1992, alongside nine other superstars of the time, including Naomi Campbell, Christy Turlington, Linda Evangelista, Yasmeen Ghauri, Claudia Schiffer, and Cindy Crawford.

"IN PICTURES, HER SENSITIVITY IS WHAT COMES THROUGH: SOMETHING DELICATE, FRAGILE, EXCITING. IT'S A STRANGE MIXTURE OF LAZY SENSUALITY AND MOMENTS OF INTENSE EMOTION."

—JOHN CASABLANCAS, from "Tatjana: Million-Dollar Beauty," *Vogue*, June 1988

Though Tatjana became best known for projecting serenity in her work, at the height of her career she was known to be a bit of a wild child. She moved to Los Angeles at the end of the 1980s, seeking some tranquility, which, as the years have worn on, she has truly found. She still models intermittently today, for Uniqlo, Shiseido, and Chantelle lingerie. But her life now, in Malibu, is far more focused on her son, Jonah, her horses, yoga, and environmental causes, such as her work with PETA, the Cousteau Society, and Greenpeace.

Opposite:
Photograph by
Herb Ritts, British
Vogue, 1988.

Stephanie Seymour

In the 1980s and 1990s, a time of strutting, swaggering, sexy models, Stephanie Seymour was among the sexiest, and like Cindy Crawford before her, she bridged the gap from commercial work to high fashion modeling seamlessly—which was very unusual at the time. Like Cindy, she was proof that a model could work both sides of the business. With her intensity, strength, and real feel for fashion, Stephanie transcended what could have been a more anonymous career as a body model, even though her graceful and curvaceous figure is one of her biggest strengths.

Born in San Diego, California, in 1968, Stephanie's career began at fourteen, when she was photographed as part of a beauty story for *Cosmopolitan*. She modeled for local department stores and newspapers for another year until she entered the Elite Model Management Look of the Year contest in 1983. She didn't win, and neither did Cindy Crawford—they both lost to Lisa Hollenbeck. Nonetheless, Stephanie went straight to New York anyway and signed with Elite, and the following year, she took the familiar route through Europe, where two auspicious relationships mixing business and pleasure would change the course of her life. First, in Paris, at just sixteen years old, she started seeing Elite's owner, John Casablancas, who was twice her age and married. The relationship didn't last long, but when the news first came out, it cloaked

Stephanie in notoriety and controversy, and garnered quite a bit of press, even if it was mostly negative.

As Brooke Shields had already demonstrated, a whiff of scandal can be an effective way for a model to get a break—though she'll have to back up the notoriety with good work to make sure it lasts. Stephanie had caught her break, and doing good work was not a problem for her, as she had real ambition, talent, and love of modeling. She also has a penetrating gaze, which she wields to perfection in front of a camera, grounding any scenario, no matter how outlandish or racy.

Stephanie's second important connection in Paris was Azzedine Alaïa, a leading figure in fashion at the time, who took her under his wing. Even now, she calls him "papa," and says that she wears something of his every day. Stephanie credits her "kind of bubbly rear end" for that meeting, and Alaïa's sophisticated, curve-enhancing knits were certainly the better for it.

That rear end was also a big factor in attracting the attention of Jule Campbell, director of *Sports Illustrated*'s swimsuit issue, who asked Stephanie to pose for the magazine in 1988, which she did, the first of many occasions. At the same time that she went fully commercial, Stephanie still fascinated high fashion photographers like Richard Avedon, who adored her and shot her for the cover of *Vogue* in 1988. One of Avedon's most famous photos, taken as

Opposite: Photograph by Herb Ritts, British *Vogue*, 1990.

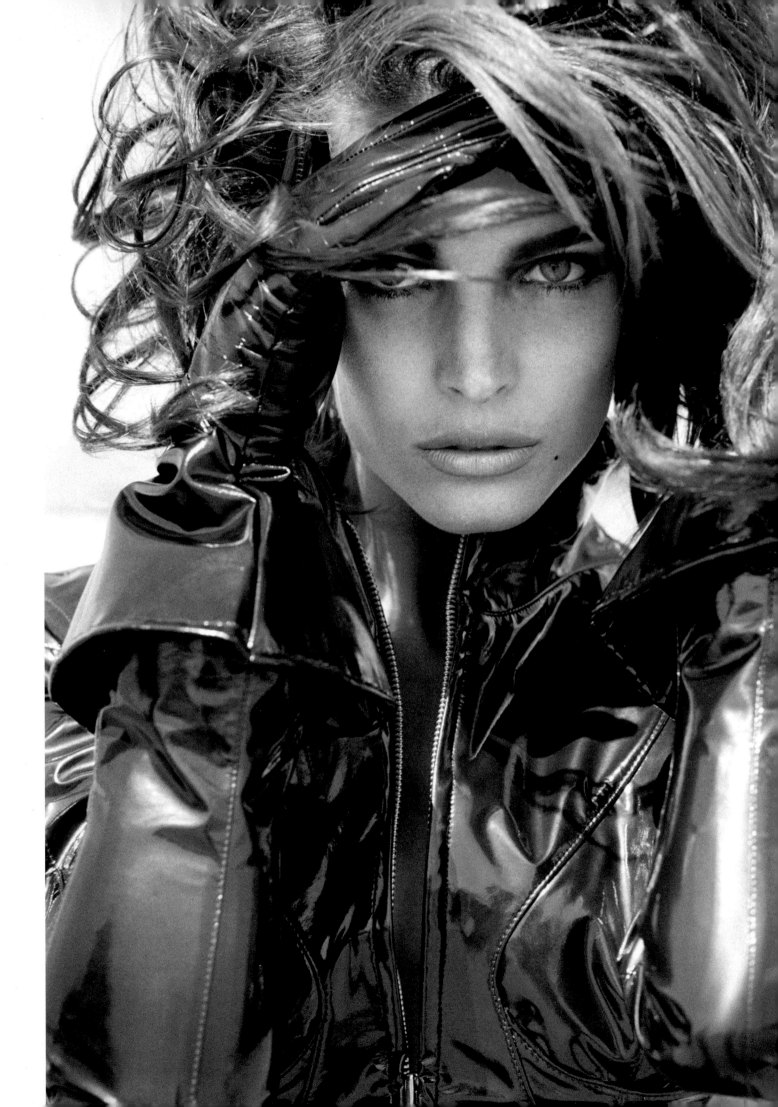

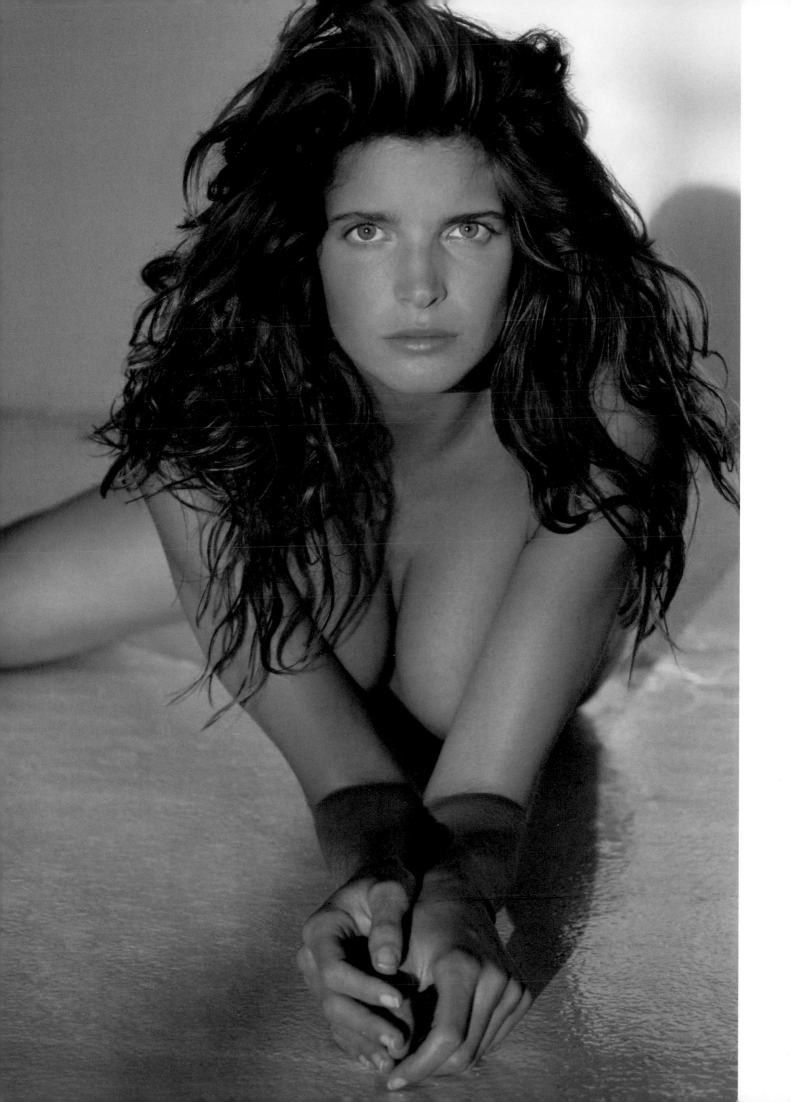

part of a photography course he taught, is of Stephanie wearing a see-through, long-sleeved black dress without bra or underwear; she's pulled up the dress to flash perfectly landscaped pubic hair, with a neutral, almost blasé, facial expression, as if doing such a thing was as normal as going grocery shopping. The image shocked a seemingly unshockable public, which had been awash in racy imagery since the 1970s.

With her bold personality, Stephanie was a natural for colorful, ostentatious designers like Gianni Versace, too. In 1991, the same year that she became a face of Dior, Stephanie did her first *Playboy* shoot, and she continued to work frequently for *Harper's Bazaar*, *Vogue*, *Elle*, the newly launched *Allure* magazine, *Cosmopolitan*, and *Mademoiselle*. While Stephanie was posing up a storm, her personal life was equally active, making her a continued object of public fascination. An admitted wild child, she had a short marriage to the surfer and guitarist Tommy Andrews, which produced a son, as well as relationships with Warren Beatty and Guns N' Roses front man Axl Rose, who put her in two of his big-budget music videos, "Don't Cry" and "November Rain." Shortly after breaking up with Rose, Stephanie became involved with publisher and art collector Peter Brant; in 1993, she bore the first of their three children. The couple married in 1995.

Brant was a very wealthy man when Stephanie married him, but she didn't need his money, having already signed a multimillion-dollar deal in 1992 with Victoria's Secret, whose catalogs were becoming increasingly important vehicles for rising stars, just as *Sports Illustrated*'s swimsuit issue had been in the previous decade.

Throughout the 1990s, Stephanie remained at the top, booking major campaigns for Chanel, Yves Saint Laurent, the Gap, and Marc Jacobs, and a multiyear deal with L'Oréal; she became a serious collector of vintage haute couture and fine art along the way. She isn't working with the same frequency she used to, but the list of photographers she inspires has only gotten longer and more diverse over time. Very few models can claim to have been muses for such vastly different artists as Helmut Newton, Arthur Elgort, and Juergen Teller. In 2008, the influential

"I DON'T HAVE THE PERFECT BARBIE-DOLL FACE, BUT I DID GET FAMOUS FOR THIS BODY."

—STEPHANIE SEYMOUR, from "Stephanie's Secret," *Playboy*, February 1993

editor Katie Grand dedicated an entire issue of her *Pop* magazine to Stephanie, so universally is her sexy, noirish brand of cool admired. Other more recent covers have included *Vogue* Paris, *i-D*, the *London Sunday Times* style magazine, and *Interview*. Even as she has become a new face of Estée Lauder, Stephanie remains relevant for young designers like Jason Wu, who put her in a spring 2013 campaign featuring sheer lace looks combined with ladylike flourishes that are a perfect encapsulation of the balance of elegance and edginess she has long embodied.

Opposite: Photograph by Herb Ritts, *Playboy*, 1991.

Claudia Schiffer

The daughter of a prominent lawyer from North Rhine-Westphalia, Claudia Schiffer was discovered in 1987, at the age of seventeen, in a Düsseldorf disco by an agent with Metropolitan Models. She left for Paris soon after, landing the cover of French *Elle* the following year as the epitome of natural, wholesome beauty. But this would not remain her calling card for long. In 1989, photographer Ellen von Unwerth, who had already shot Claudia for *Interview* magazine, brought her to Guess founder Paul Marciano's attention for an advertisement for its jeans. In her photos, von Unwerth often conjures up very playful sexuality, something that naturally shy, straitlaced Claudia turned out to be expert at bringing out in front of the camera, as von Unwerth knew. In that first string of black-and-white ads for Guess, Claudia is a kittenish bombshell, all wavy blond hair and kissable lips, spilling out of her bustier. The campaign was so popular that Marciano has credited it for giving his upstart directional denim company its first real global exposure. Thanks to Claudia, and Marciano's good

eye for talent, Guess has since turned that eureka moment into a longtime formula, finding a relatively unknown model and, through a string of epic black-and-white narrative pictorials, turning her into a star.

Karl Lagerfeld was the next power-house to embrace Claudia. He saw her on the cover of British *Vogue*, photographed by Herb Ritts, and simply said, "Who is this girl? I want to meet her." When he signed her as the face of Chanel in 1990, first introducing her to the runway in the spring haute couture show, it was his first really grand gesture towards a model after Inès de la Fressange had been his muse, and the world took notice. Overnight, Claudia became a household name and was able to bridge the worlds of high fashion and commercial modeling.

In 1990 *People* magazine named her one of its "50 Most Beautiful People," even though she had only a smattering of covers under her belt at the time. In 1992 a coveted Revlon contract, for a reported $20 million for three years, was hers, as was a spot in a Versace campaign shot by Richard Avedon, alongside Linda

Opposite:
Photograph by
Herb Ritts, 1989.

Pages 158–59:
Photograph by
Ellen von Unwerth,
Vogue, 1991.

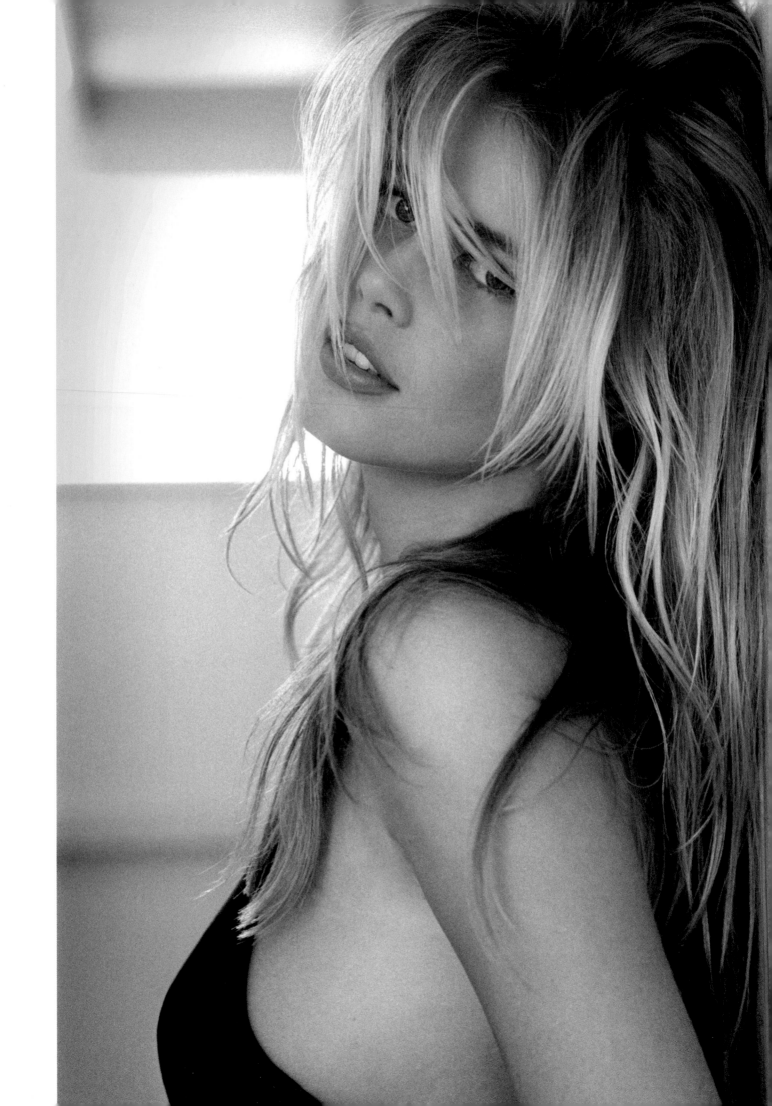

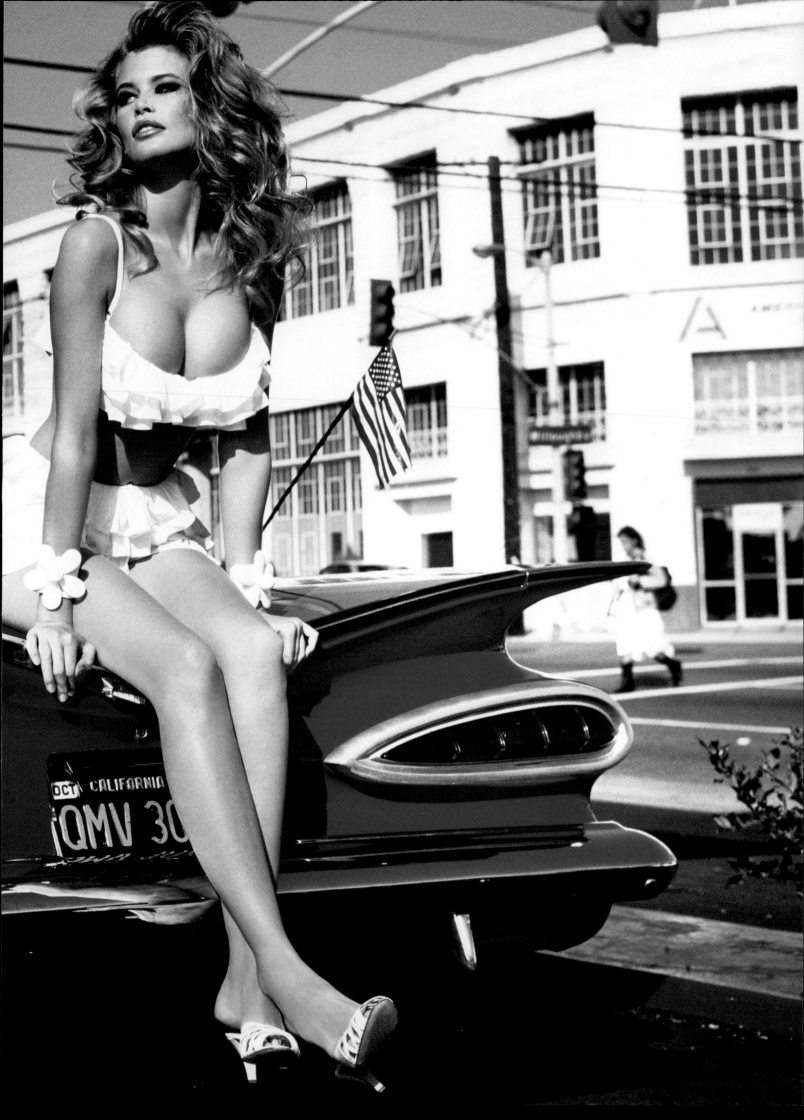

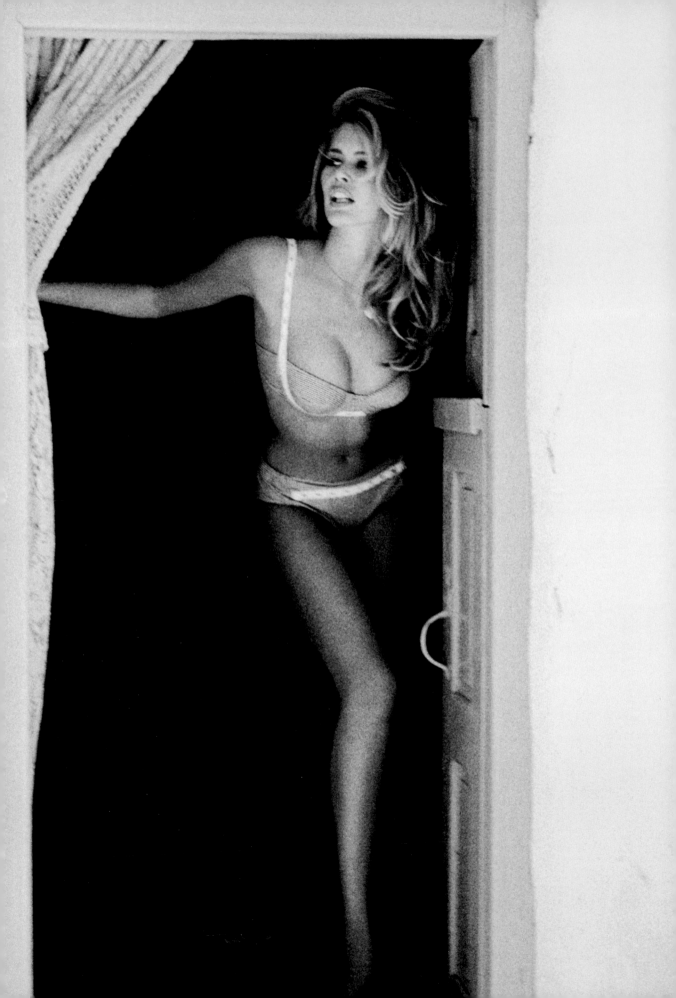

Evangelista, Naomi Campbell, Christy Turlington, and Cindy Crawford, whose famous ranks she joined in seemingly record time.

Claudia came along at a time when fashion fell hard for retro homages. Her uncanny resemblance to Brigitte Bardot, noticed in those first Guess ads, was played up by many a photographer. Over the course of what has been, on and off, a more-than-twenty-five-year collaboration with Chanel, Lagerfeld has shot her in a stunning array of moods, from wistful to romantic to snarling, for numerous campaigns, including watches, fragrance, and sunglasses. She's also been the face of Dolce & Gabbana, Guess, Alberta Ferretti perfumes, Yves Saint Laurent, Salvatore Ferragamo, Ralph Lauren, Louis Vuitton, Valentino, and had a fourteen-year contract with L'Oréal.

Throughout her long career, Claudia has had ongoing editorial work, posing for magazines from *Self Service* to all the major editions of *Vogue*. She has appeared on more than one thousand magazine covers, including *Elle*, *Time*, *W*, *Harper's Bazaar*, *Vanity Fair*, the *New York Times*, *Rolling Stone*, *People*, sixteen for American *Vogue*, and many more. She has been

"IT WAS ONLY ONCE I WAS IN FRONT OF THE CAMERA THAT I WOULD CROSS THE LINE AND BECOME SEXY. WHEN I'M ON A PHOTO SHOOT, I'M NOT SHY AT ALL."

—CLAUDIA SCHIFFER, from "Claudia Schiffer," by Carola Long, *Independent*, October 24, 2009

listed in the *Guinness Book of World Records* for having the highest annual earnings of a model (1999) and the most magazine covers (2004).

Most recently, Claudia has turned to business endeavors, with a successful hair care and hair color line in collaboration with Schwarzkopf called Essence Ultime; a line of sunglasses with the German optical company Rodenstock; and a successful cashmere collection, Claudia Schiffer Cashmere, which has been carried at Harvey Nichols, Colette, and netaporter.com. Today she lives in the English countryside with her husband, British director and film producer Matthew Vaughn, and their three children.

Opposite:
Guess advertising campaign, 1990. Photograph by Ellen von Unwerth.

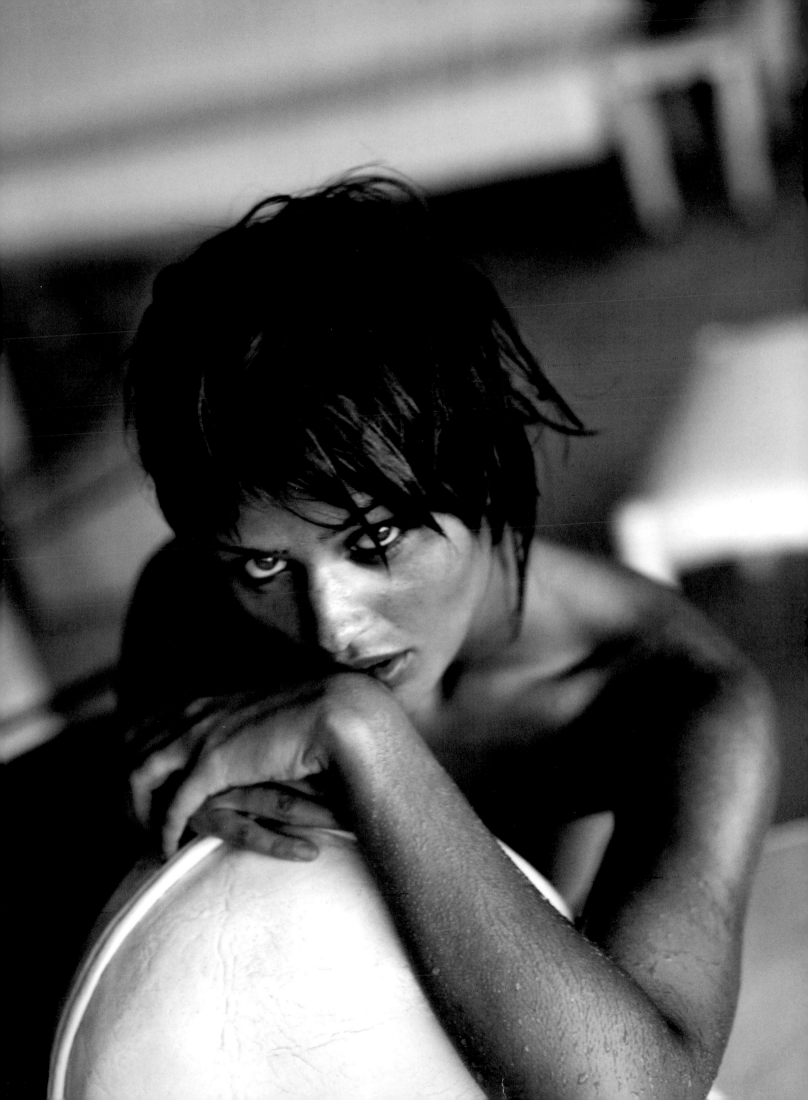

Helena Christensen

Had Helena Christensen come around ten years earlier, before the fashion industry of the 1990s started to go searching for more exotic and unusual models, her unconventional looks —part Inca, part Viking, due to a Peruvian mother and Danish father— might not have found the same enormous audience. But the tawny girl with the athletic shoulders, wide-open face, and piercing light-green eyes has always brought such soul and mystery to her work that even if the cultural moment wasn't right, she would have conquered anyway.

The masses first became aware of Helena in 1991, when she appeared in the much-aired video for Chris Isaak's hit song "Wicked Game," directed by Herb Ritts. With the clip seemingly on a tape loop on MTV, suddenly everyone was talking about this kittenish, retro-modern girl, like a rockabilly pinup—a little bit naughty, a little bit nice, covered in sand with chipped nails, who could pout and tease like nobody else. Whether it was growing up in sexually liberated Copenhagen or simply an innate comfort in her own skin, it's hard to say, but Helena's ease with her body makes her potentially scandalous work, evident not just in the Ritts video but in the countless editorials and advertisements in which she's appeared, feel like a pure and simple celebration of human beauty.

Helena modeled as a child but didn't want to continue into her teens. After finishing school at age nineteen, she traveled around the world and took up photography along the way. Upon her return to Copenhagen she was scouted by a French model agent, who sent her to Paris for a week. Appealing to her love of travel, the trip went so well that within those seven days of go-sees she booked a job walking for Valentino. French *Elle* was the first magazine to hire her, and she went on to work for *Elle* extensively throughout her career. In 1990 she landed her first cover, by Peter Lindbergh for British *Vogue*—a feat she repeated five more times. And the following year she got the call for "Wicked Games," which to this day is one of the sexiest music videos in history.

After her big break, she started appearing on cover after cover—especially for *Elle*, where she now holds the record number of covers, but also international and American *Vogue, Marie Claire, Cosmopolitan,* and *GQ*—and numerous campaigns for Versace, Karl Lagerfeld, Neiman Marcus, Valentino, Revlon, Chanel, Victoria's Secret, and many others. By the time Victoria's Secret was ready to launch the iconic Angels campaign in 1997, there was no question that Helena would be one of its stars. Nonetheless, Helena has a wonderfully relaxed attitude about fashion, with the air of being able to take or leave the drama that can come with the industry.

Once she retired from the catwalk in 1999, rather than sit still and catch her breath, she turned around and co-founded

Opposite:
Photograph by Sante D'Orazio, 1994.

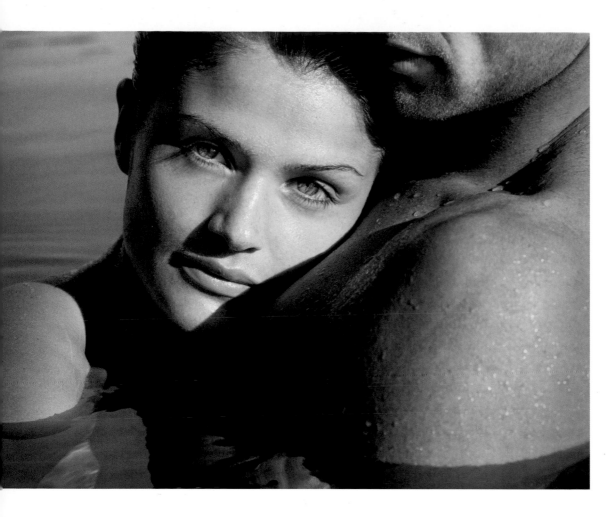

Left:
Malibu, 1993.
Photograph by
Herb Ritts.

Opposite:
Photograph by
Mikael Jansson,
British *Vogue*, 1994.

"SHE LOOKS AS THOUGH SHE WOULD HAPPILY SPEND THE DAY IN BED EATING CHOCOLATE. THAT'S OUR KIND OF SUPERMODEL."

—ANNABEL MEGGESON, "Helena Christensen,"
Red, September 2013

Nylon magazine, which is still on newsstands today. She has also used her years of travel to cultivate her photography, which is now a true passion and has earned her such clients as Nike, *Dazed & Confused*, *World of Interiors*, and Oxfam, where she is a global ambassador documenting climate change, as well as solo shows in Tokyo, London, and Copenhagen.

Helena has myriad other interests as well. She has opened an antiques and clothing shop in New York City called BUTIK, designed products for Habitat, and collaborated for many years with the British lingerie giant Triumph, not just as its face and body but also with a capsule series she designed herself. Now, with her friend Camilla Staerk, she is at work on the clothing line Staerk & Christensen. Helena still poses often, too, with recent covers for *Elle* Spain—which ran an extensive beauty feature on her—*i-D*, and *Madame Figaro*.

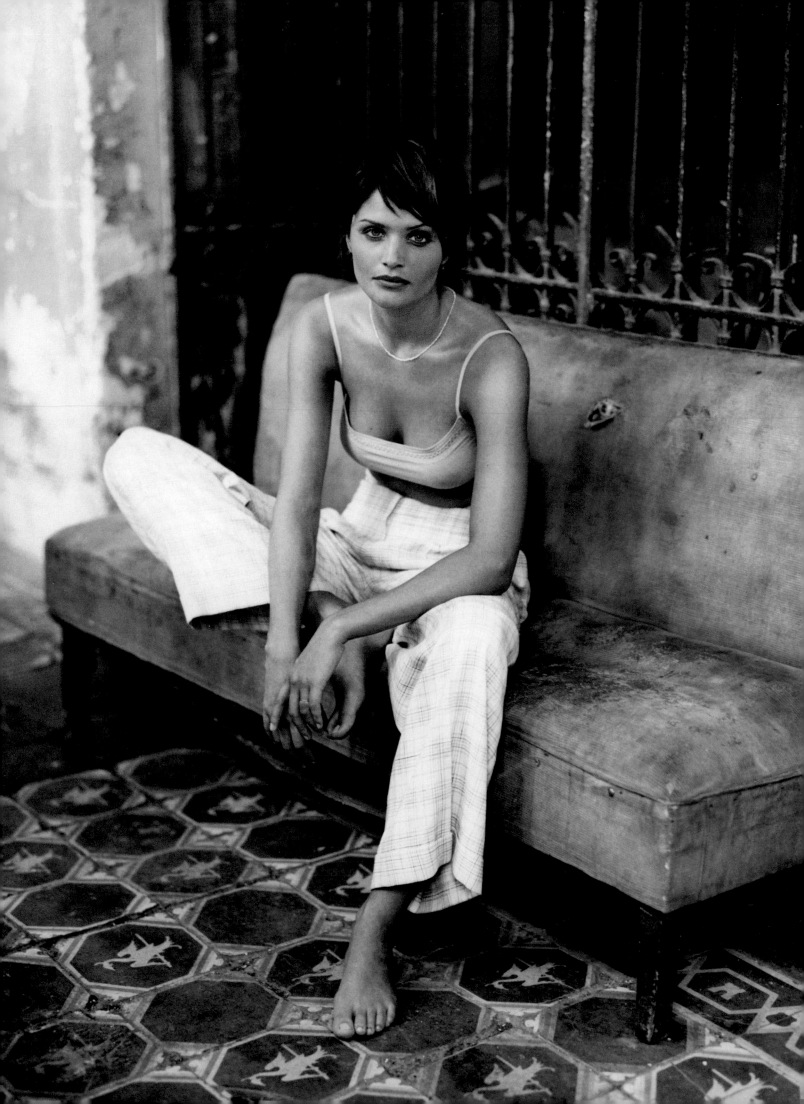

Tyra Banks

Unmatchable drive, determination, and confidence: that's Tyra Banks. The strengths that have made her a great model continue to guide her as she moves from one success to the next in her television career. A natural show person, she was the first black model to appear on the covers of *Sports Illustrated*'s swimsuit issue, *GQ*, and the Victoria's Secret catalog, in many ways doing for mass-appeal glamour modeling what Naomi Sims and Beverly Johnson did for fashion.

Like many models, Tyra went through a painfully awkward phase, growing three inches and losing thirty pounds in the space of three months when she was eleven. Her newly thin face—emphasizing her broad, high forehead and delicate, narrow chin—prompted some of the kids at school to call her "lightbulb head." In the end, though, the alienation she felt from her changing body and the rejection of her peers only strengthened Tyra's character.

When she was fifteen and more settled in her long limbs and burgeoning curves, Tyra decided to give modeling a try. At first she was turned down by four agencies that either didn't want a black model or already had one lone face and weren't looking for more. The fifth, L.A. Models, was the charm, and within a year, in 1990, Tyra had moved on to power broker Elite Model Management to really kick-start her career. Elite sent her to Europe, where in her first season in Paris and Milan she walked the runways for twenty-five houses, including Fendi, Valentino, and Chanel. On the catwalk, it was impossible not to notice her bouncy, swingy strut, with twirls

Opposite:
Photograph by
Patrick Demarchelier,
Vogue, 1992.

and pivot kicks that felt almost like a return to the age of Pat Cleveland. When she posed in pictures, she had a dramatic style as well—when she smoldered, she really smoldered; when she played innocent, there was no doubt what she was trying to convey. Soon she was on the cover of German *Cosmopolitan*, *Harper's Bazaar*, Spanish *Vogue*, and American *Elle*; appeared in advertisements for Dolce & Gabbana, Yves Saint Laurent, and Ralph Lauren; and, in 1995, signed a coveted contract with CoverGirl.

Though in the early 1990s models were nowhere near as thin as they have become today, Tyra was still more curvaceous than most of the other girls working in high fashion. Tired of years of constant dieting, she returned to America to seek work in the mainstream fashion world, with its swimsuit and lingerie focus, and it was there that she became a superstar. Tyra's voluptuous body, coupled with her natural energy and enthusiasm, made her perfect for *Sports Illustrated*'s swimsuit issue. She appeared on its cover in 1996, a first for a black model, and again in 1997, the same year she won Supermodel of the Year at the VH1 Fashion Awards.

People quickly discovered that when they put Tyra on covers, they sold. And so in 1997, Victoria's Secret asked her to be one of its five inaugural Angels, along with Helena Christensen, Stephanie Seymour, Daniela Pestova, and Karen Mulder. This was the lingerie giant's highest-profile branding effort at the time, and according to Tyra, Victoria's Secret sold more units when she modeled them than when anyone else did. As the

Victoria's Secret shows morphed into televised spectaculars with record-breaking ratings, she rose to every occasion, shimmying, shaking, and waving her hands in the air to get audience members out of their seats.

Tyra's love of entertaining made her perfect for television, too. In 2003, with her editorial work slowing down, Tyra took what she knew best and turned it into the on-air television model search, *America's Next Top Model*. Inspired by her own quest for success at the outset of her career, she broke down the mechanics of posing, the rigors of shoots, and the stresses of rejection, and sated the world's natural curiosity about a business that has minted so many superstars. Initially the show ran on a smaller network and had very few commercial sponsors, but as the ratings rose to become the network's best, Tyra worked tirelessly to secure higher-level partners, booking then *Vogue* columnist and fashion historian André Leon Talley as a judge and winning sponsorship from *Vogue* Italia.

Tyra has also used her celebrity to become an outspoken advocate for models of color, speaking out regularly on her television shows, in interviews and profiles, and through her TZONE foundation, which started as a sleepaway camp for girls struggling with self-esteem issues and now has a permanent outpost at the Lower Eastside Girls Club in downtown New York City. Having struggled with her own weight off and on, she's also brought body issues into the national conversation time and again. It's for this that *Time* magazine named her one of the world's most influential people in 2007, alongside Barack Obama and the pope. Anyone who knows Tyra was not surprised by this honor. Most of us were just wondering what took them so long.

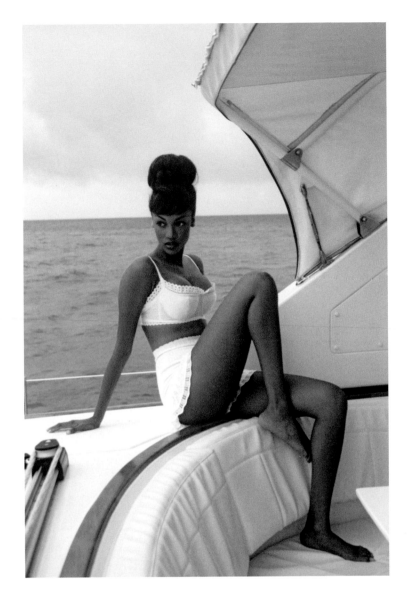

"WHEN SOMEONE TELLS ME THAT I CAN'T DO SOMETHING, I BECOME OBSESSED WITH PROVING THEM WRONG."

—TYRA BANKS, from "Model to Mogul and Beyond," by Ty-Ron Mayes, *WestEast*, October 27, 2012

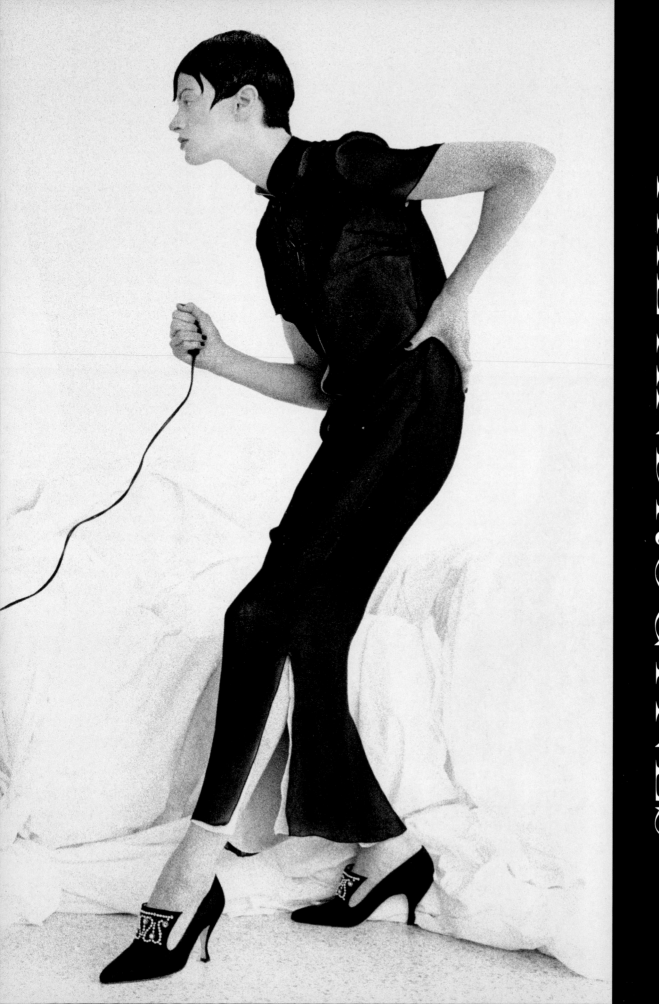

A

S THE HIGH-FLYING 1980S WANED,
all the artifice and glitz of the decade's bombshell supermodels
lip-synching pop hits on the runway started to feel contrived—and
old. MTV's content acknowledged that popular shift in perception,
too: the network that launched *House of Style* with Cindy
Crawford was also a catalyst for the seemingly oxymoronic
mainstreaming of alternative culture. A new sensibility was
arising that prized authenticity and idiosyncrasy over
bombast, slickness, and stardom. Musicians like Kurt
Cobain made fame chasing and commercialism feel
empty and unimportant.

Fashion, now hyperalert to changes in youth
culture, responded with a new wave of designers, including Marc Jacobs and Anna Sui, who cham-
pioned an anti-fashion aesthetic, as if the looks they presented were assembled from a thrift store.
The big European houses were still powerful, but they, too, were starting to quiet down and embrace
more subdued minimalism. As the culture wars raged on in politics, which brought soft subjects like
pop music into the halls of Congress, and the toll from the AIDS crisis became too overwhelming
to ignore, political statements began to enter into the fashion conversation more and more.

Designers like Jean Paul Gaultier and the stylish mass chain Benetton—whose challenging, provocative advertisements and brand magazine, *COLORS*, featured images of male religious figures kissing, mixed-race couples, and a photograph of Queen Elizabeth II that had been manipulated to make her look black—gave a new sense of purpose to the otherwise hedonistic fashion business.

At the same time, cultural norms were shifting to give alternative sexualities and lifestyles more visibility. Models who could be said to represent a radically different way of life than the usual fantasy trappings of fashion—whether working class, naive, plucked straight from war-torn countries, or even aristocratic if the girl was rebellious enough—became the rage in the early to mid-1990s. Lifestyle magazines out of London like *The Face* and *i-D* were ascending in influence because of the raw, strange, and unvarnished images they promoted. This "grunge" aesthetic even infiltrated the pages of *Vogue*, an otherwise totally unlikely outlet. Suddenly the exuberant supermodels were swapped out for a group of anti-models who hunched, rather than strutted, on the runway, and who entered the fashion industry almost in spite of its glamour, not because of it. These girls were often very thin, which prompted overblown hand-wringing on the part of the more conservative news media, which didn't much like fashion's new interest in androgyny either. The trend didn't last long, but many of the models who rose to prominence as part of this wave have remained relevant even today because of their flexible attitude and a willingness to transform themselves to whatever the job requires.

Pages 168–69:
Kristen McMenamy,
Vogue Paris, 1993.
Photograph by
Max Vadukul.

Kate Moss

There are models who represent the times, and then there are the extremely rare ones who change them, stopping the fashion world in full stride and turning it in a completely different direction. Kate Moss is one of the latter, whose initial impact was such that most of us actually remember where we were the first time we saw those wide-set eyes and that precocious combination of innocence and wisdom, so new yet seemingly eternal. The first time I saw Kate was on the tube in London. We were both going to a booking at *i-D* magazine. While I was fully conscious of and nervous about what a big deal it was, Kate was just sitting there without a care in the world, drinking milk through a straw, as if going on this go-see were the most normal thing in the world. Her nonchalance is ironic— she really did change everything, after all— and is one of the secrets to her success. Kate's innate good style—she was inducted into the International Best-Dressed Hall of Fame in 2006—and her unapologetic joie de vivre are as powerful as they are because she never seems to fuss over any of it. She is the epitome of effortless excellence, and is admired and emulated the world over for it.

Kate, with her snaggletooth and knock knees, who stands many inches under the standard model height, at five foot seven with a gamine frame, ultimately brought an end to the industry domination of curvaceous supermodels. She went on to command the same astronomical fees as Linda Evangelista and Naomi Campbell, of course, but when she first appeared on the scene, almost like a baby bird, she represented authenticity, not artifice; fragility, not fierceness. There are echoes of Twiggy in Kate's profile—young, extremely thin, with big bright eyes and roots in the working class—but even from the start of her career, there has been nothing nostalgic about her. The Calvin Klein jeans and perfume advertisements in print and on television that launched her into the stratosphere were the perfect vehicle for her unique balance of seduction and innocence. As her long career both in front of the camera and elsewhere in the fashion business has proven, with rarely a down moment, the unique appeal that first made her a star is enduring. She has a power and longevity only seen once or twice before in the history of the modeling business with models such as Lauren Hutton and Christy Turlington.

Born in 1974, in Croydon, a working-class suburb of South London, Kate was fourteen when she was discovered at JFK Airport by Sarah Doukas, the founder of Storm Model Agency. The photographers Corinne Day and Juergen Teller, who were working for the influential British culture bible *The Face* at the time, were the first to embrace her. When they started posing Kate in stripped-down black-and-white

Opposite:
Photograph by
Tesh, *i-D*, 2005.

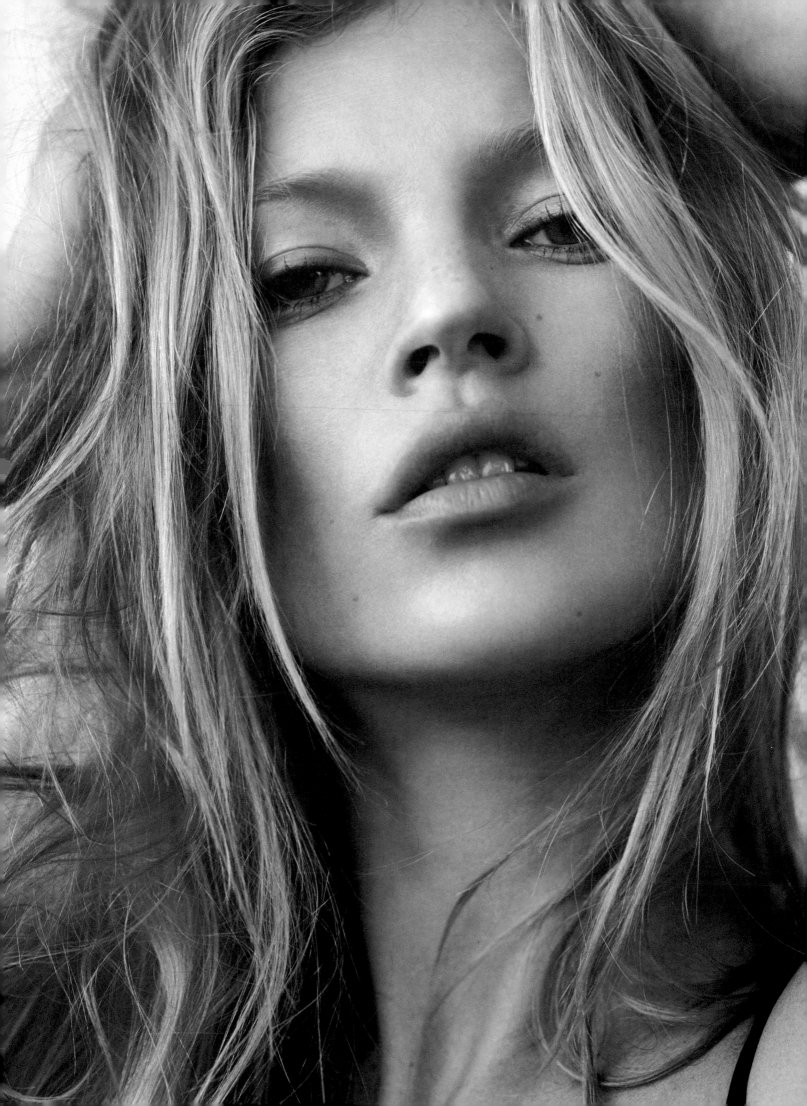

images, with tangly, windswept hair and no makeup, her apparent naïveté struck a chord. The art director Fabien Baron, who worked with Calvin Klein throughout the 1990s, saw Kate in *The Face* and was so taken with her look and her embodiment of the brand's embrace of a new, stripped-down, youth-culture-led authenticity that he brought her to Klein's attention. Not long after, Moss signed a lucrative contract to represent the brand in a series of advertisements for jeans, underwear, and fragrances, most notably Obsession. The Calvin Klein contract, which lasted for eight years, made her a superstar.

Klein posed Kate in crumbling buildings, or lounging on what looked like dirty old pieces of furniture, modeling in the sorts of settings now commonly regarded as industrial-glamorous, though they were considered raw and radical at the time. These advertisements, setting the waif with the hungry-looking eyes within these environmental contexts, caused a furor. Conservative types reacted against what they perceived to be glamorizing the abject, and the media campaign against

"heroin chic" was launched. Kate was heckled by the press, who insisted she was anorexic. She wasn't, but this experience planted the seeds for her ongoing credo of keeping the media at a distance. In ensuing years, through much-publicized relationships, breakups, and even a stint in rehab, Kate has only done press in relation to fashion projects, and even then under very strict conditions. As she herself has said, "The more visible they make me, the more invisible I become."

Grunge may have been Kate's entrée to modeling, but she soon proved herself to be far more than the embodiment of the zeitgeist of that era. She can convey looks that are on trend as much as she can deliver ones that deftly transcend them. Though she is very much a part of her age, she is also timeless, and she's a true chameleon. She can play coy or honest, young and surprised or canny and wise, overtly sexy or completely gamine. The diversity of what she can express is so great that when she walked the runway for Marc Jacobs's landmark grunge collection at Perry Ellis, so embodying the spirit of that moment,

"WE LOVE HER FOR TAKING THE SNOBBISHNESS OUT OF FASHION. WITH HER EVER-PRESENT NAUGHTY LAUGH AND EVEN NAUGHTIER CIGARETTE, THE ULTIMATE PARTY GIRL DOESN'T TAKE HERSELF TOO SERIOUSLY."

—ANGELA BUTTOLPH, "How Kate Moss Has Influenced Fashion Forever," *New York Post*, January 18, 2014

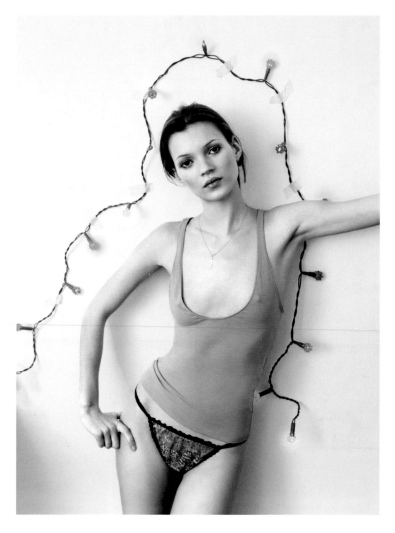

she also became the face of Yves Saint Laurent's womanly Opium perfume. Dolce & Gabbana, Gucci, Chanel, Bulgari, Rag & Bone, and a host of other major brands have featured her in their campaigns, where she's played everything from rocker girl to sophisticate. This is due to what is simply an inborn talent for projecting emotion without saying a word— something artists like Lucian Freud, Chuck Close, and Marc Quinn have immortalized in their work. In her many guises, she's been on the cover of every major fashion magazine, including some thirty times for British *Vogue*, where she also has become a contributing fashion editor.

Despite the great talent for playing the part that she has displayed throughout her twenty-five-year career, Kate has remained unapologetically herself, cultivating a mystery around herself that enhances her allure. Even in the face of tabloid bruisings and constant hounding by the paparazzi, when others more desperate to be liked would try to explain themselves, Kate keeps her own counsel. In her romantic relationships, in her group of high-living rock-star friends, in her business ventures— like her successful line of clothing for Topshop, which people have waited in line for hours to buy, or her handbags for Longchamp, or her lipstick line for Rimmel—Kate lives her life on her terms. The fact that she lets the rest of us look, but only rarely deigns to explain a thing, only keeps us all wanting more.

Above:
Photograph by
Corinne Day,
British *Vogue*, 1993.

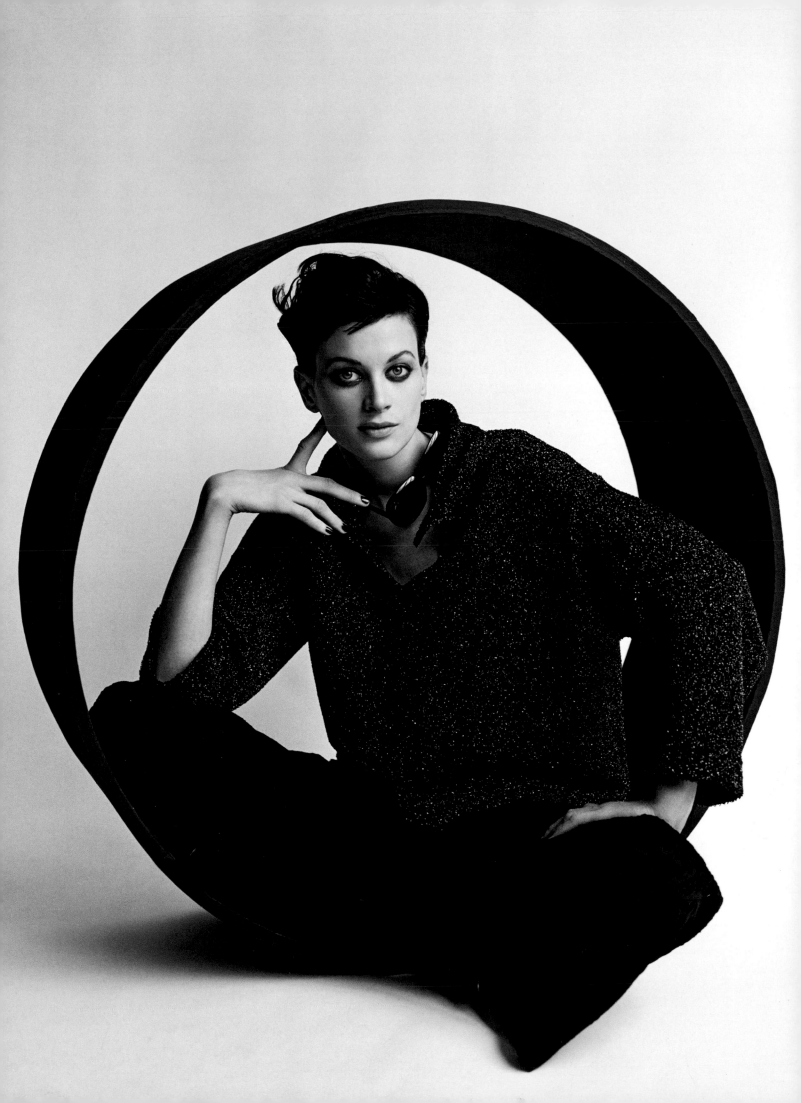

Kristen McMenamy

Striking, shocking, ferally sexy, sometimes pretty and always inspiring, Kristen McMenamy had actually been working as a model for almost a decade before 1991, when she cut her naturally curly, long red hair into the severe black crop that transformed her facial features from slightly off to sculptural, and gained her membership in the androgyne club. When she did that, and a year later when the makeup artist François Nars shaved off her eyebrows, she became a star in the fashion world, although by then it was already known that this alien-looking, lanky extrovert would do anything for a picture. Her dramatic posing, exaggerated grimace, willingness to work nude—or covered in graffiti, or with wild animals—and keen understanding of how to skate the line between evocative and over-the-top are all reasons that Kristen is still working constantly and still pushing the envelope more than twenty years later. Her willingness to use her body as an instrument, no matter how strange or alien it may look—and her willingness to embrace her age as she has grown older—has put her on a different register than perfectly pretty faces that can sometimes be forgettable.

She has also proven that physical features are far less important than what you do with them.

Before she came to modeling, Kristen's life followed a similar course to those of many of her peers: awkward, skinny, and tall (and, in her case, a straight-A student to boot), she was teased and bullied. In 1983, when she was a senior in high school and already a serious fashion fan, Kristen enrolled in a two-month modeling course, then entered a contest held by *Cosmopolitan* magazine and lost miserably. Undaunted—Kristen has pluck like almost no other—she went to New York City and made the rounds of modeling agencies, but was shut out there, too. Her downturned, somewhat bulging eyes, prominent mouth and brow, and wide, round nose were not selling in the early 1980s. In fact, Kristen has said that Eileen Ford told her she needed eyelid surgery if she was ever going to work. Kristen got a job in a fast-food restaurant to survive and was still looking for modeling work when her pictures were discovered at the bottom of the *Cosmopolitan* reject pile by an agent who saw something in her and gave her a one-way ticket to Paris.

Opposite:
Photograph by
Mario Testino,
French *Glamour*, 1993.

"I AM CONSTANTLY TRYING TO PROVE SOMETHING. IF YOU THINK, 'I'M GREAT AND I HAVE NOTHING ELSE TO PROVE,' THEN YOU HAVE NOTHING ELSE TO PROVE. YOU JUST GO AWAY."

—KRISTEN McMENAMY, from "It Was Always Kristen,"
by Jo-Ann Furniss, Style.com/Print 04, Fall 2013

Opposite:
Photograph by
Mario Testino,
British *Vogue*, 1995.

Kristen stayed in Europe, and in about a year's time she started to have success, especially with Peter Lindbergh, a master at capturing spontaneity and dynamic facial expressions, who recognized the performer in her. Her career was respectable, as she appeared in advertisements for Byblos and in *Vogue* Italia and French *Elle* editorials, but she didn't reach the top tier until one day in 1991, frustrated at her lack of traction in a business that was still very much in thrall to curves and bombshells, she chopped off her hair into a monastic-looking crop and dyed it black, deciding to "go weirdo," as she has said. Avant-garde Japanese designers like Yohji Yamamoto and Rei Kawakubo, whose intellectual, unconventional clothes were by now a respectable undercurrent in fashion,

as well as Karl Lagerfeld, were among the first to respond to her look. When Kristen went even further and let François Nars shave off her eyebrows in 1992, her career skyrocketed, and she became one of the favorites of the rapidly rising anti-fashion crowd. Thanks to high-profile editorials such as Steven Meisel's influential "Grunge and Glory" shoot for *Vogue* that same year, Kristen was suddenly in high demand.

Tales of Kristen's derring-do on set are legendary, with her sustaining bruises, getting tossed into a water tank in full bondage, once even breaking her collarbone, if it meant getting a shot with a chance at immortality. It's no wonder that photographers with more otherworldly tendencies like Mert and Marcus, Tim Walker, and Nick Knight adore her, as does Juergen Teller, whose big strobe flashes capture so evocatively the extreme planes and hollows of her face.

Since that fateful haircut, Kristen has given vent to her own eccentricities, and she's reinvented herself constantly, experimenting with endless hair colors and playing the camp pinup girl, the frosty aristocrat, the space alien. In 2004 Kristen made another prescient decision, simply because she thought it would make for a good picture: to let her natural hair, by then all-over gray, grow out all the way to her waist. With her body still in sinewy, toned form and her alabaster face as expressive as ever, in this second phase of her career she has continued to work constantly, on the runways, in editorials for *Vogue* Italia, *W*, and *i-D*, and in advertisements for Lanvin, Balenciaga, and Saint Laurent.

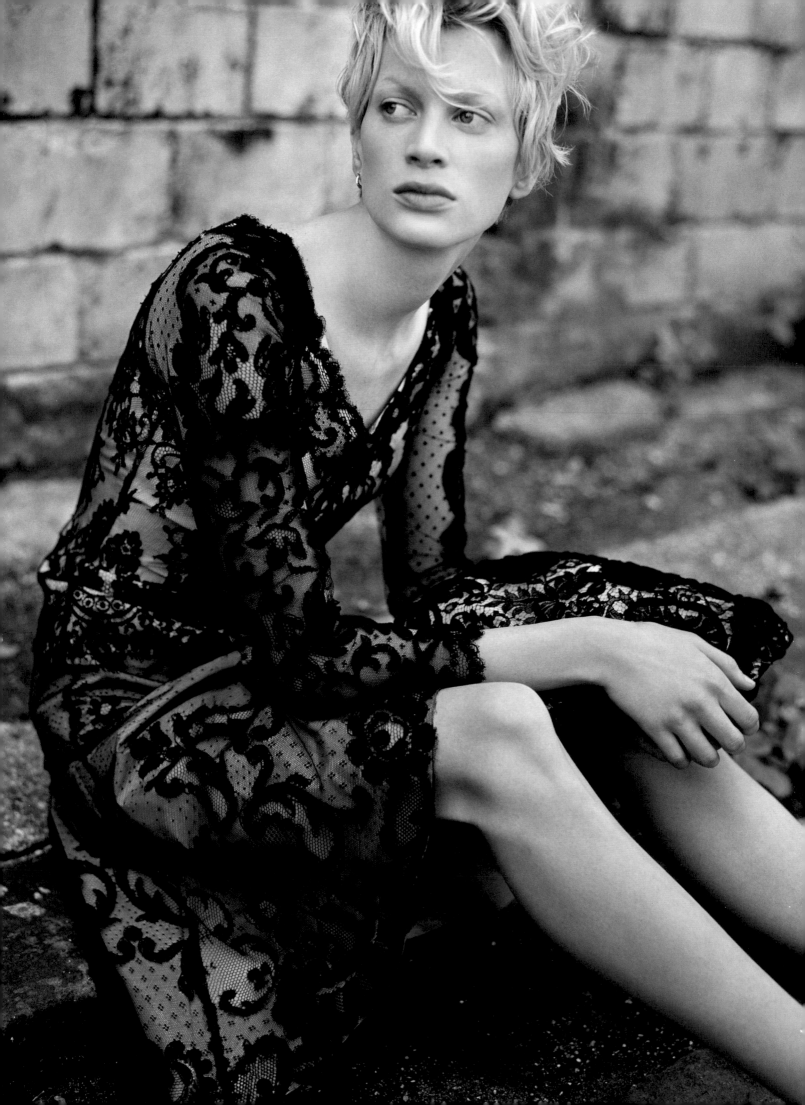

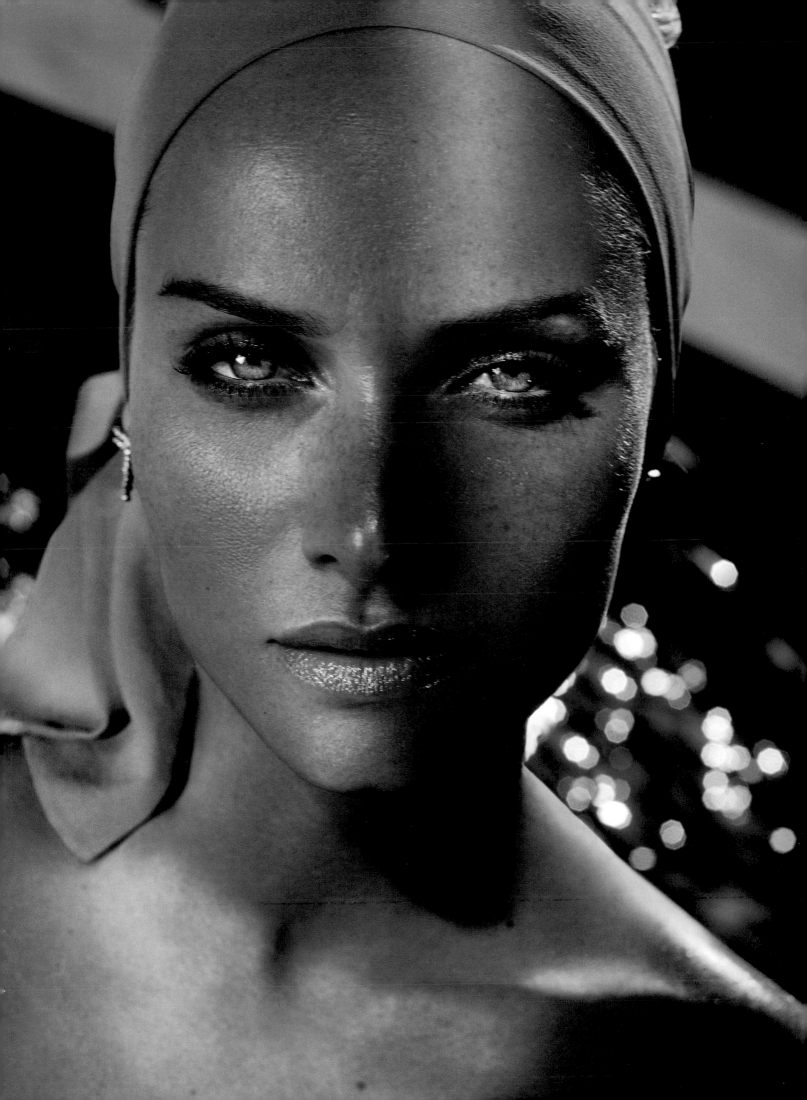

Amber Valletta

Amber Valletta emerged onto the modeling scene in the early 1990s, offering a middle ground between the Amazonian supermodels of the 1980s and the slender androgynes who were starting to steal the limelight. Even though Amber had the height, curves, and strong bone structure of the supermodels, her huge, Twiggy-like green eyes, high forehead, and soft demeanor gave her the potential to look like a waif, too. Although Amber was emblematic of the delicate, childlike beauty that was in favor when she first became successful in 1993, her versatility and soulfulness have always differentiated her, resulting in work with lasting impact. If you've ever doubted that modeling requires the skills of an actress, look at Amber's indelible Prada ads from 1997, shot by Glen Luchford. In them, she looks moody and faraway, and the loneliness and melancholy of her expression burn through the mist and fog on the page.

There was little doubt Amber had the raw material to give modeling a try while she was growing up in Tulsa, Oklahoma. She was more interested in acting, but with her mother's encouragement she enrolled in a local modeling school at seventeen, where she was scouted and, like so many before her, sent to Europe to build her portfolio. She worked from the start, but wasn't getting the kind of groundbreaking editorials that would secure major campaigns and

covers until she decided to cut her hair into a wispy pixie cut in 1993. Perhaps it was a combination of her grown-up figure and the new haircut that suggested a more accessible way into the androgyny craze, but along with Kate Moss, Amber became one of the most visible models representing the waif trend.

After the haircut, Steven Meisel came calling, and never stopped—the two worked together constantly into the next decade, with Amber giving vent to an astonishing range of expression. But in 1993, before anyone had seen all that, all they knew was that they had to have this girl, and Amber went on to book almost every runway show in Milan and Paris, shooting her first *Vogue* cover right after. The following year she was picked as the face of Calvin Klein's Escape fragrance. With Klein's ability to make cutting-edge images appeal to the masses, in that effortlessly sexy, intimate campaign, like Christy Turlington, Amber became a new kind of pinup girl, one who starred in fashion images, not swimsuit calendars, and still held major male appeal. Amber's profile continued to grow, particularly in 1996, when she became the cohost of MTV's *House of Style* with her best friend and frequent posing partner, Shalom Harlow.

By then Amber had graduated from her waif incarnation, and she was beginning to wonder if there wasn't more to life

Opposite:
Photograph by
Vincent Peters,
Vogue Italy, 2005.

"IF WE WERE LIVING IN PREHISTORIC CLANS, I'D PROBABLY BE SITTING BY THE CAMPFIRE TAKING TWO STONES AND SHOWING YOU HOW DINOSAURS WERE CHASING US. I'D BE THE ONE FINDING A WAY TO COMMUNICATE AND PERFORM."

—AMBER VALLETTA, from "Amber Valletta,"
Interview, September 2013

Right:
Photograph by
Herb Ritts,
Vogue, 1997.

than modeling. In 2000 she gave birth to a son and started to focus primarily on acting, which she has approached with intelligence and humility, turning down babe roles in mediocre films to take smaller roles in productions with more visibility, like *Hitch*, *Perfume*, and a hilariously campy recurring role on the ABC series *Revenge*. Today, when she steps in front of a still camera, it's either for a very special editorial, usually for Meisel, or to front a cause she believes in, like Master and Muse, the ethical shopping portal she launched with yoox.com.

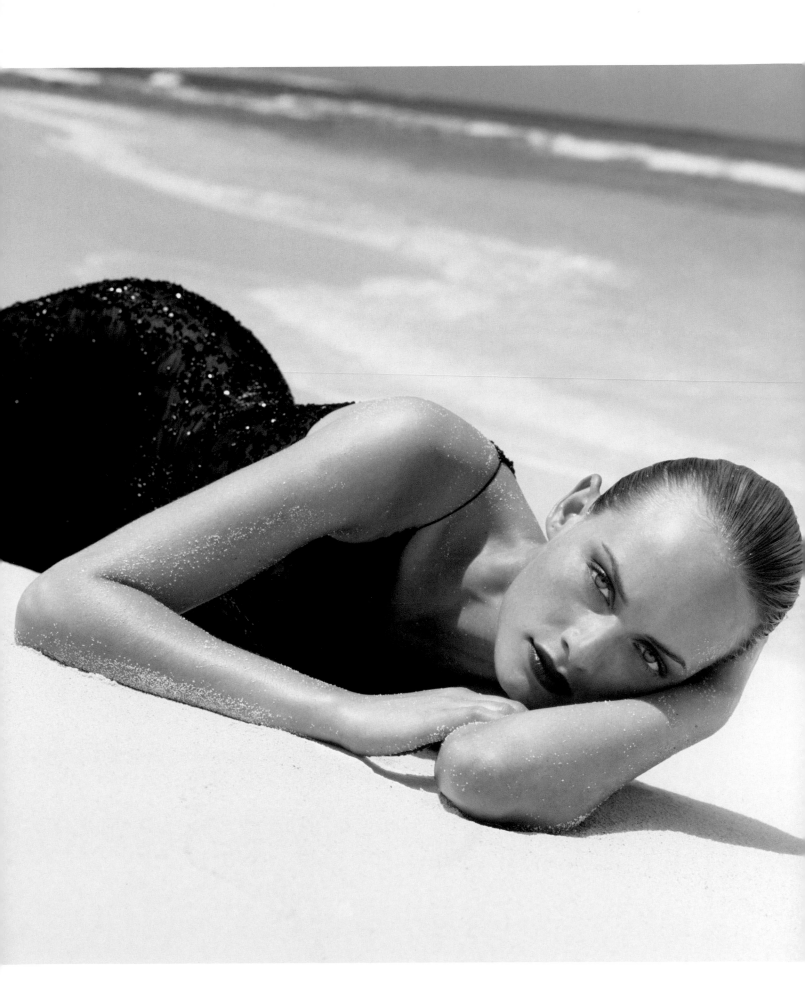

Stella Tennant

By 1993, the modeling industry had become institutionalized and thoroughly self-perpetuating, especially after the supermodels had attracted so many international young strivers to the profession. And so fashion, as it always does, was seeking another source of inspiration. Not that it would ever let go of stunning professional posers, but in influential campaigns like Calvin Klein's early ads for CK One and "real people" magazine stories like Steven Meisel's "Anglo-Saxon Attitude" for British *Vogue*, designers, creative directors, and photographers were starting to become fascinated by extreme-looking young women plucked from other walks of life.

When Stella Tennant—the granddaughter of the Duchess of Devonshire, who is also the youngest of the Mitford sisters—was cast by Isabella Blow in "Anglo-Saxon Attitude," she was an art student with a large ring through her septum. With her delicately aristocratic features bisected by graphic, perfectly horizontal eyebrows, and her mysterious unwillingness to smile, she had a powerful presence in that casually no-frills shoot, inexplicably the most expensive ever for British *Vogue*. But alongside the socialite and *Vogue* fashion assistant Plum Sykes and the designer Bella Freud, daughter of the painter Lucian, Stella was treated more as a personality, not a model. That was fine with her, as she had no intention of pursuing a career posing for a living; she wanted to be

a sculptor after she finished school. Steven Meisel had other ideas, though, and within a few weeks, he had put this pin-thin, lanky androgyne, who at first didn't even have an agent, into a Versace advertisement with Linda Evangelista, and on the cover of *Vogue* Italia.

As it turned out, Stella was a natural at what soon became her new job. In her demeanor, she is utterly unpretentious and relaxed, yet she's capable of creating an evocative range of personalities and images, from believably vintage to unsettlingly futuristic. In sepia-toned pictures by Paolo Roversi, like in his "Hotchpotch" editorial for *Vogue* Italia in November 2001 and many other editorials through the years, Stella looks like a ghost from another age burning through the ether, yet she could also color-block her face and do neomod. Equally convincing as a lady, m'lady, or punk, Stella held real appeal for Karl Lagerfeld, who, especially in his work for Chanel, so often mines the crossroads between retro and cutting edge. In 1996, he rather unceremoniously elbowed Claudia Schiffer aside to make way for this "totally modern" new muse, paying her a rumored $1 million per year.

Only two years later, Stella announced her retirement from modeling, but it has never really stuck. Even now that she's relocated to the Scottish Borders to raise her four children, she's reappeared time and again in campaigns for Burberry, Louis

Opposite:
Photograph by Rennio Maifredi, *Marie Claire* Italy, 2003.

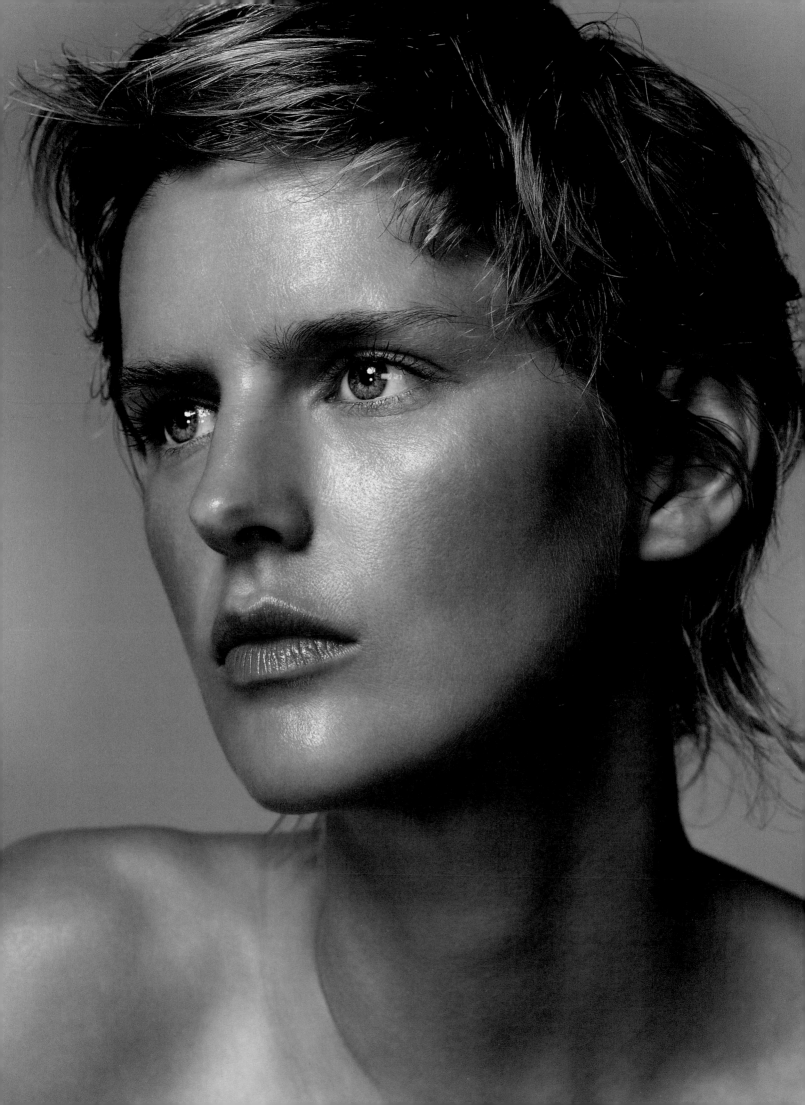

"IN THE FASHION WORLD, TENNANT HAS ALWAYS STOOD FOR INDIVIDUALITY AND AUTHENTICITY, AND THE SUBSTANCE OF HER LIFE—WHOLESOME AND CREATIVE—PROVES THAT SOMETIMES AN IMAGE CAN BE FOUNDED IN REALITY."

—ANNA WINTOUR, Letter from the Editor, *Vogue*, October 2005

Vuitton, Givenchy, and Céline; on the runways for every major designer; and on covers for *i-D* and British *Vogue*. The contentment of her country life has been featured in countless magazine profiles, and since the early 2000s, images of her, shod in her Wellies, with her dogs, have circulated almost as much as those of her dressed up in ladylike Dior. It's as if, in the totality of Stella's long and rich body of work, the old way of thinking about women in society—that one can be either a lady or a tramp, a duchess or a dog walker, but never both—goes right out the window.

Right:
Photograph by
Arthur Elgort,
Vogue, 2004.

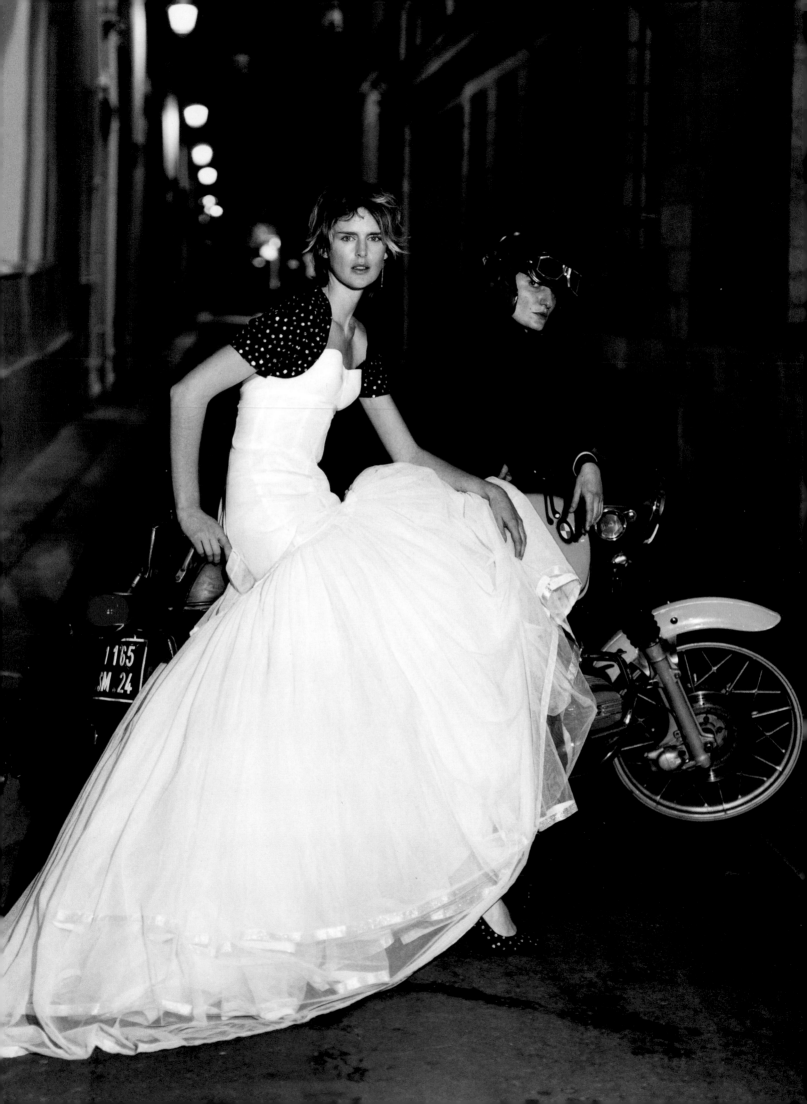

Alek Wek

Even though fashion history is strewn with breakthroughs, social convention is incredibly tenacious and, by definition, often lacks imagination. Even after periods of upheaval like the 1960s, it tends to resettle itself into safe and comfortable norms. As radical as the impact of models like Iman, Beverly Johnson, and Naomi Campbell has been, it took Alek Wek in the mid-1990s to show the world that a dark-skinned model with strong sub-Saharan African features had what it took to do high fashion and commercial work—not just any work but cheerful, fierce, and explosive work that has gone on to inspire a generation, both in and outside of the world of fashion. Fashion was experimenting with androgyny and grunge when Alek appeared, but she was a much harder slap in the face to the industry, reminding it of how narrow its vision of beauty still remained.

After the famine in Ethiopia in the 1980s led the MTV generation to its first globally televised activism in Live Aid, and with the African AIDS crisis and numerous bloody civil wars appearing on the twenty-four-hour cable news networks that were changing news consumption, the Western world was getting used to visually associating Africa with gut-wrenching hardship. The rich world's media diet did not contain many images of African women other than Iman, in glamorous guise, especially not women like Alek, who, with broad noses, ebony skin, and short Afros, were usually seen as figures of tragedy,

the recipients of charity, or subjects of anthropology—and certainly not as aspirational figures who helped sell designer fashion. That Alek herself was a refugee from South Sudan made her story compelling, but the fashion work she has done since breaking through sensationally in the mid-1990s has been a celebration of beauty, strength, and the global potential of style.

When Alek was scouted in South London's Crystal Palace Park in 1995, she was eighteen and had only been in England for four years after fleeing her native South Sudan during its brutal second civil war. Alek and her parents and eight brothers and sisters had lived in a small town in South Sudan, where they were barricaded in their home for days on end. When the family fled, they walked for weeks and had to survive on what they could find in the bush. Alek's father was a professional man, but there was no culture of fashion magazines in Sudan for anyone of any means, and the South Sudanese, with their dark skin, broad faces, and Dinka language, suffered ethnic discrimination at the hands of the Arab-speaking Muslim majority.

All of this is to say that even though Alek and her four sisters loved to talk about makeup, growing up, she never imagined a life for herself in the fashion industry in the West, and at first she thought that the agent from Models One, a top London firm, who spotted her that afternoon was joking. But of course she

Opposite: Photograph by Gilles Bensimon, cover, *Elle*, 1997.

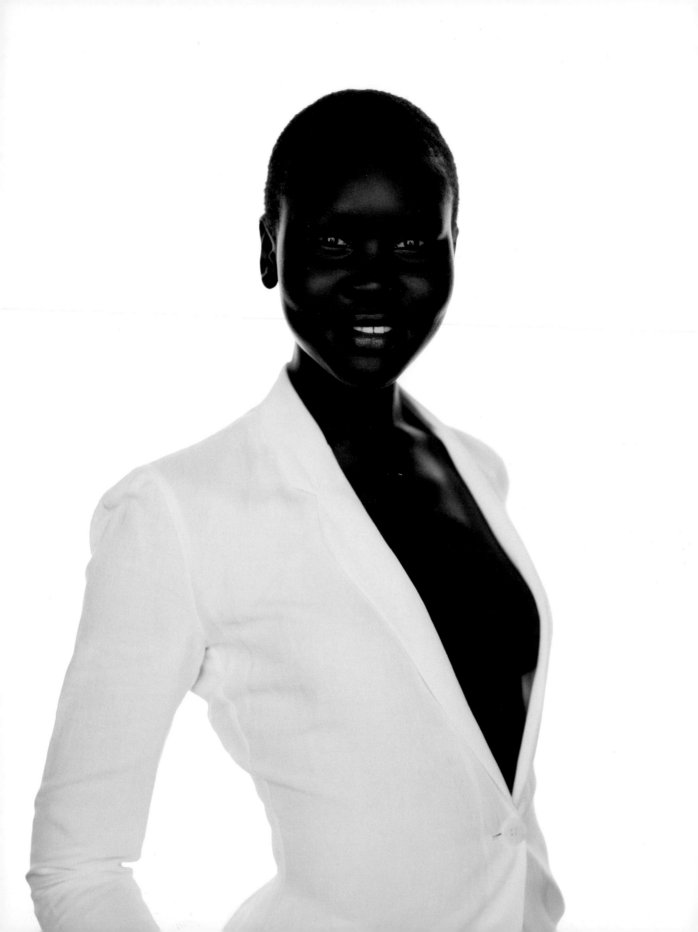

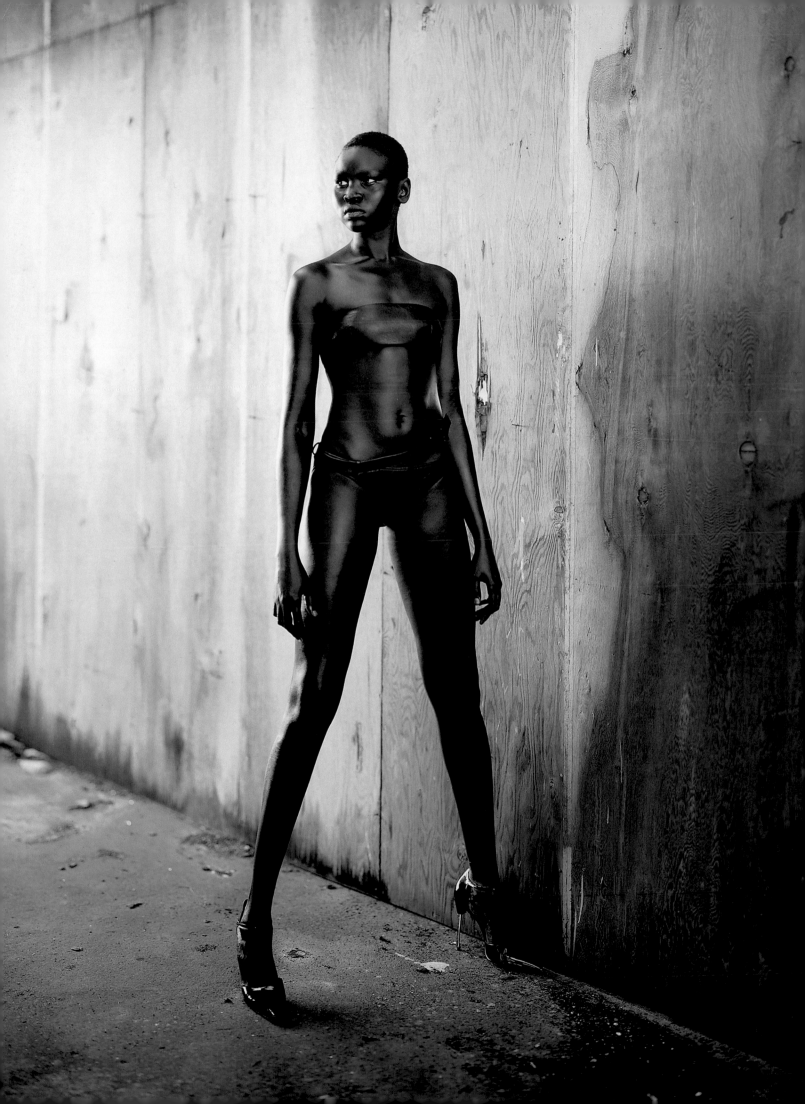

> "WHEN I SAW ALEK, I INADVERTENTLY SAW A REFLECTION OF MYSELF THAT I COULD NOT DENY. NOW I HAD A SPRING IN MY STEP BECAUSE I FELT MORE SEEN, MORE APPRECIATED, BY THE FARAWAY GATEKEEPERS OF BEAUTY."

—LUPITA NYONG'O, from a speech at the 2014 Essence Black Women in Hollywood Luncheon

wasn't, and that same year Alek landed a spot in Tina Turner's video for the Bond film *GoldenEye*, which led to a contract at Ford Models and a spot in Mark Romanek's award-winning video for Janet Jackson's massive hit "Got 'til It's Gone." In that video, set in a nightclub in apartheid-era South Africa, Jackson and Q-Tip are surrounded by a visual feast of extras, including Alek, smiling ever so shyly.

Helena Christensen had already proven with Chris Isaak's "Wicked Game" that music videos can take a model straight to the top, and after those two hits Alek started to work the European runways, where her arresting face and graceful, powerful stride made her a favorite at Alexander McQueen and Vivienne Westwood. Her look, which she has said "is not easy," was nevertheless so resonant that in 1997, when Gilles Bensimon put her on the cover of *Elle*, stunning in a glowing white suit and mile-wide smile, the reader response was impossible to ignore. The magazine received thousands of letters of gratitude for using this vibrant dark-skinned beauty at long last. Covers for *i-D*, *Vogue*, *Glamour*, and *Cosmopolitan*

followed, as did campaigns for Calvin Klein, Donna Karan, John Galliano, and Chanel. Oprah told her on an episode of her show that if Alek had been on magazine covers when she was growing up, it would have changed her entire sense of herself. While Alek's presence may have announced change, her personality is so upbeat and her walk so fierce that more mainstream and commercial brands like Victoria's Secret, XOXO, and Clinique came calling, too.

Arguably, however, Alek's greatest impact in the world of fashion photography has always been inside the pages of magazines, where she could do more challenging, dramatic work than what is shown on more generic covers. There her flexibility and chameleonlike range of expressions and poses are on full display. Today Alek puts more time into humanitarian work with the UN Refugee Agency and Doctors Without Borders and less into modeling, but she continues to make her presence felt in high-visibility work like the Pirelli Calendar's fiftieth anniversary edition and campaigns for H&M and Benetton.

Opposite:
Photograph by Gilles Bensimon, *Elle*, 2003.

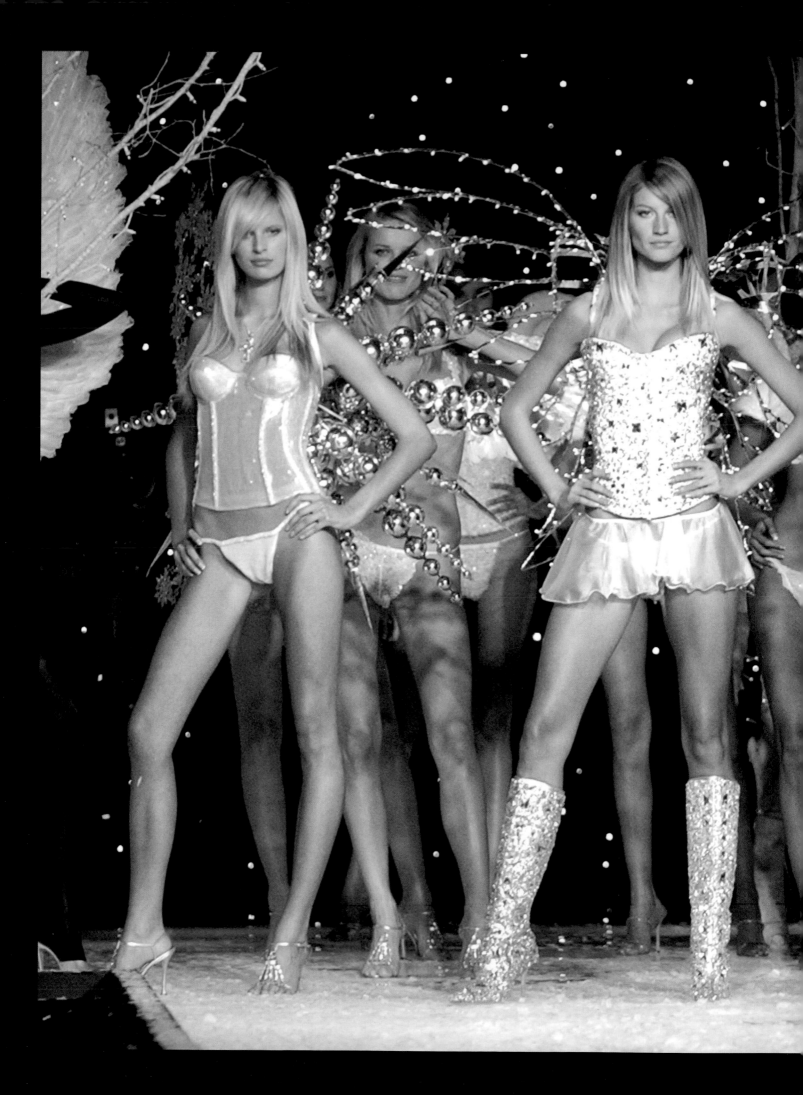

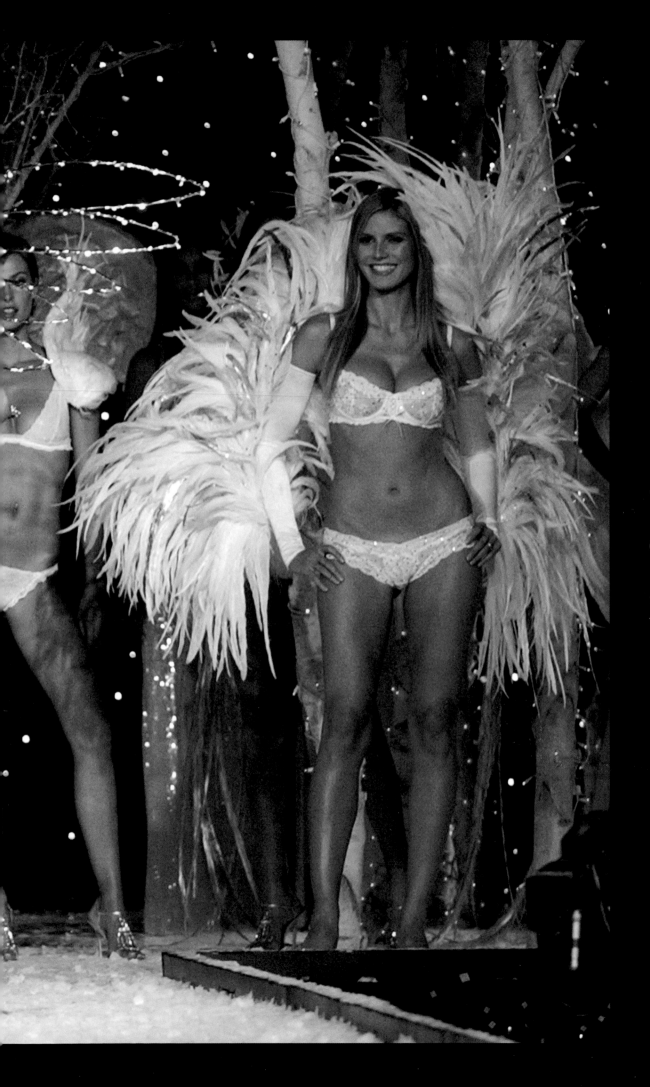

THE NOUGHTIES

B

Y 2000, WITH NONSTOP CABLE

news and the rising power of the Internet, we really were becoming a global village, with an almost universal curiosity about the world as it exists outside our daily experience. By this time, the Soviet Union had fallen, and dictators around the world were following suit, which meant that areas once ignored by fashion—Latin America and Eastern Europe, especially—were becoming accessible, as both new customer bases and new sources of modeling talent. Difference, exoticism, and uniqueness in models started to be calling cards, and increasingly, the ranks of the very top girls began to reflect the diversity of the audience—though we still have a long way to go. At the dawn of the twenty-first century, thanks to all of this opening up, there was less room for cynicism in both popular culture and fashion, and more of a desire to simply celebrate beauty and the optimism that it represents.

The rapid spread of technology, including the first Internet boom at the end of the 1990s, meant that fashion images could penetrate anywhere there was computer access. Thanks to the pioneering website Style.com, which went live in 2000, fashion shows were now not only running on a half-hour news magazine show on a cable channel but also visible in real time, with new depths of information, including tags identifying each model who walked the runway. But even if models were invading people's computers and gaining a new level of ubiquity, and

though the top girls could always name their price, the exaggerated fees and diva behavior of the supermodels were distinctly out of style. Anna Wintour, by then comfortably ensconced at American *Vogue*, started to almost entirely replace models with known celebrities as cover subjects.

Even as designers like Alexander McQueen were creating elaborate spectacles on the runway, and Dolce & Gabbana and Tom Ford at Gucci were turning up the sex appeal to nearly impossible levels, designers were producing more accessories and fragrances—all more affordable than ready-to-wear—than ever before. The cycle of deliveries of goods to stores sped up, which meant designers were sending more and more messages per year, and giving more opportunities for models. Brand logos became ubiquitous, in both the moneyed West and Asia, which had the effect of making fashion less elite.

As just-in-time production and the immediacy of runway photos became the norm, fast fashion—barely concealed knockoffs that hit the retail floor with astonishing speed—became a phenomenon. First sold in Europe at stores like H&M, Zara, and Topshop, fast fashion started moving to the United States, where these stores became a force of their own. With more access to trendy clothes, even if they weren't original designs, and with more people around the world creating their own mix-and-match looks out of this less expensive clothing, the realm of fashion, once ensconced in an ivory tower accessed only by the wealthiest few, became a spectator sport for all social classes as well as an important new player on the pop-culture landscape. This meant that the models who sold it became part of the conversation on a still-more mass level.

Pages 192–193: Victoria's Secret show finale, 2001. From left to right: Karolina Kurkova, Eva Herzigova, Gisele Bündchen, Aurelie Claudel, and Heidi Klum. Photograph by Kevin Mazur.

Gisele Bündchen

By the late 1990s, in Latin America, far from the centers of power in fashion, dictatorships were being overthrown and once lagging economies, like that of Brazil, were gaining momentum and opening up. Brazil had operated like a closed system for generations, but a series of market reforms meant that by the time Gisele Bündchen came of age in a southern province, Rio Grande do Sul, designer fashion was becoming more widely available in the country, and more and more girls were inspired to give modeling a try.

Statuesque, vibrant, with a powerful body and natural grace, Gisele has a way of making both men and women comfortable. Partly it's because she's naturally cheerful, a bit goofy, and unself-conscious. It's why no one should have a hard time picturing the moment when Gisele was first discovered, at age thirteen, in the food court of a São Paulo mall. She is the proverbial Brazilian ideal, tall, tan, young, and lovely, with a prominent nose bringing just enough offbeat character to her face to make it interesting. When Gisele hit it big at the end of the 1990s, she pulled modeling out of a somewhat apathetic, contrarian, too-cool-for-school phase, embodying the sexiness and glitz that were coming back

into fashion with her fierce warrior goddess comportment. She also put Brazil on the map as a prime target for model scouts, which helped the rest of the world get to know girls like Raquel Zimmermann, Isabeli Fontana, Alessandra Ambrosio, Adriana Lima, and Caroline Trentini, all of whom have gone on to their own forms of greatness.

Gisele's story is not one of overnight success. It took almost three years of go-sees and auditions before her career took off, on the runway of Alexander McQueen's spring 1998 "Yellow Rain" show, in which she strode like a race horse in impossibly high heels on a slippery, water-soaked runway. McQueen, who never designed for will-o'-the-wisps, loved Gisele's strength, poise, and dynamism—and to see her walk the runway is to witness a bouncy prance with a jiggle and sizzle that can't be beat. With McQueen's vocal endorsement, Gisele's bookings surged, and the following year she appeared on the cover of British *Vogue*, the first of her now 120 (and counting) covers across the magazine's American and international editions.

In 1999, with campaigns for Missoni, Dolce & Gabbana, Versace, Valentino, and

Opposite:
Photograph by Matt
Jones, *i-D*, 2006.

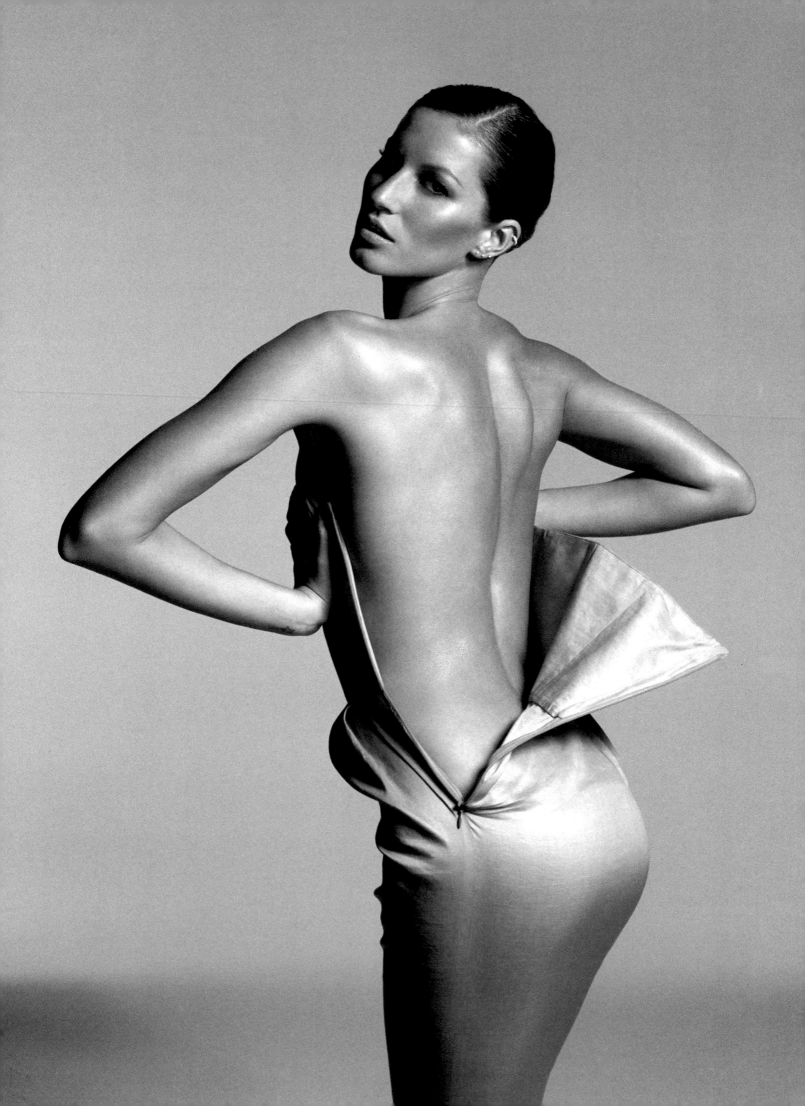

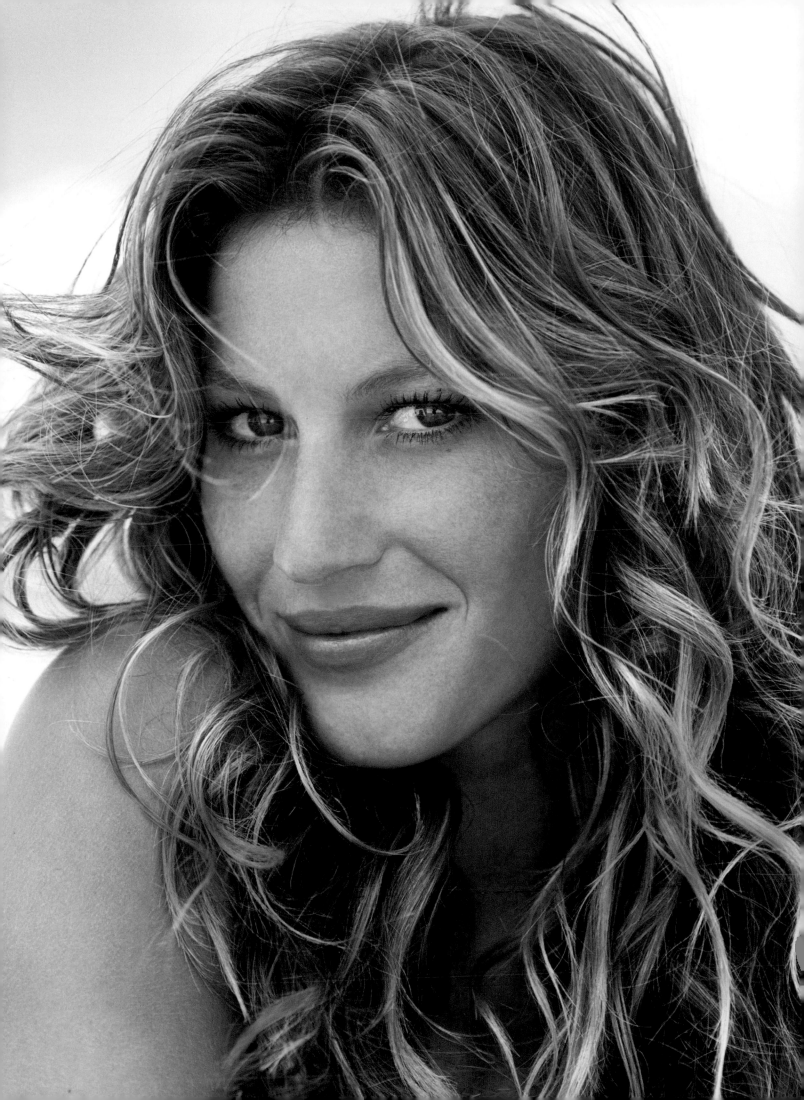

> **"I HAD HEARD ABOUT GISELE, BUT WHEN SHE WALKED IN THE ROOM I FELT LIKE MY FINGERS HAD BEEN PUT INTO THE ELECTRICAL SOCKET, LIKE, PWOAH! PURE ELECTRICITY."**
>
> —JOHN GALLIANO, from "Gisele: Supermodel Muse," by Anamaria Wilson, *Harper's Bazaar*, April 2009

Ralph Lauren under her belt, Gisele starred in a *Vogue* feature called "The Return of the Sexy Model," becoming the poster girl for the sea change in modeling that she helped bring about, as curves and sensuality were now in again. Not long after that story ran, you couldn't open up a magazine without seeing at least ten pictures of Gisele—Gisele steamy, Gisele laughing, Gisele punching and kicking, Gisele flirty, Gisele nude. She managed to make all of it look easy, which it really isn't. Anna Wintour called her the "model of the millennium," and Gisele would prove totally up to the endorsement.

Taking a page from moguls like Christie Brinkley and Cindy Crawford, as Gisele became the dominant model of her time, she signed contracts where she could turn on the sex in a supremely fashionable way, posing in ambitious, fleshy ads for Dior and becoming an important ongoing face of Dolce & Gabbana. These ads resulted in a five-year contract with Victoria's Secret, which, coupled with her budding relationship with actor Leonardo DiCaprio, made Gisele a bona fide superstar. She was ready for all of it.

Maintaining strong ties to her native Brazil, in 2001 Gisele started a sandals company to rival Havaianas, called Ipanema,

which helped catapult her onto the *Forbes* list of highest-earning supermodels for the first time in 2004—she holds the number-one spot today. Gisele has a seemingly endless energy for work; two years after she first topped *Forbes*, *Women's Wear Daily* claimed that she was second only to Princess Diana in the number of magazine covers worldwide she'd appeared on in her lifetime. As a model, she defines "bankable," to the extent that an American stock analyst created an index to compare the performance of the products she pitches to the rest of the Dow Jones Industrial Average. Not surprisingly, the products she endorses have come out ahead.

Gisele built a great career at a time when opportunities for models were shrinking. Now that she has two young children with the football star Tom Brady, she has slowed down her editorial work. But Gisele remains exciting to designers and cosmetics companies alike, across the high and mass spectrum, most recently starring in advertisements as disparate as Pantene and Louis Vuitton, H&M and Chanel. If there is a corner of the world that she has not dominated with her throaty laugh and disarming smile, then we simply haven't discovered it yet.

Opposite:
Photograph by
Patrick Demarchelier,
Vanity Fair, 2004.

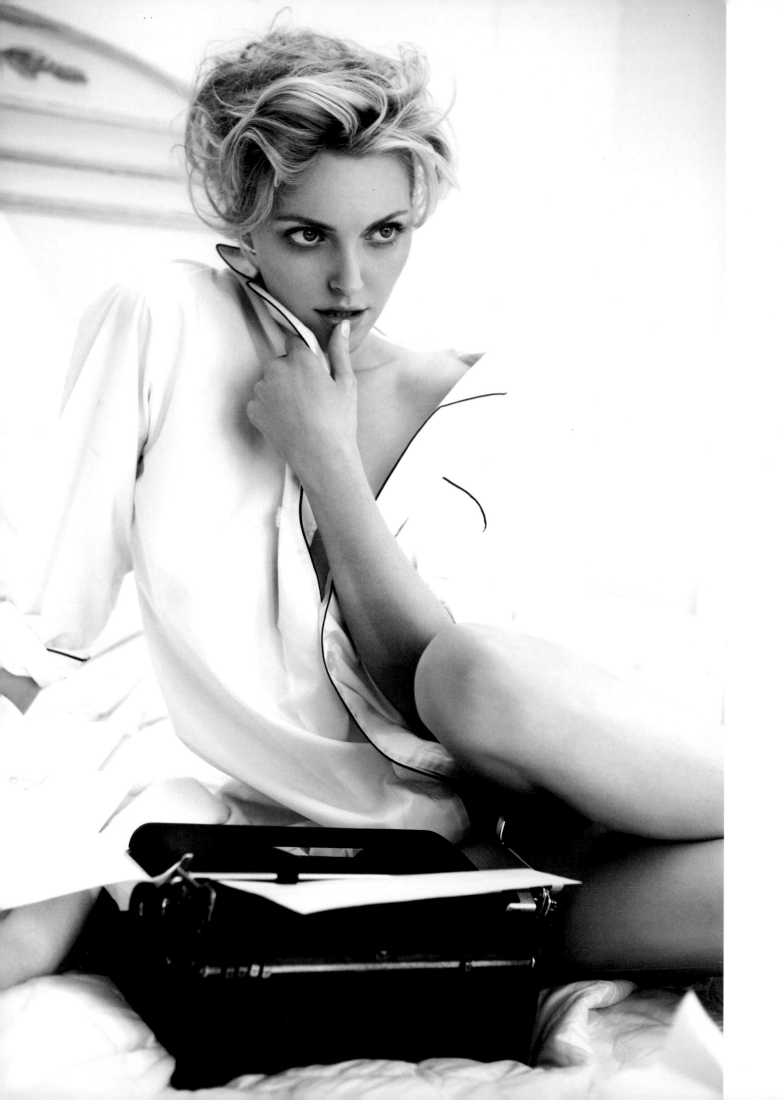

Sophie Dahl

By the late 1990s, the fashion world had overdosed on "heroin chic," and the industry could only play grunge's anti-fashion card for so long before it went looking for new inspiration. It found it in Sophie Dahl. At a British size 14, the equivalent to a US 10, Sophie did not have the kind of proportions that designers and photographers were used to, but she had a laundry list of irresistible qualities: luminous sexiness, refined facial features, enormous eyes, and a rank fearlessness, which in her case was born of a peripatetic childhood and an unstable mother. She also had an impressive pedigree: Sophie came from a prominent family—her grandfather was the author Roald Dahl; her father, the actor Julian Holloway; and her mother, the writer, and girl about town, Tessa Dahl—so she knew to take the fashion industry's posh glamour in stride. Because her family's fortune was self-made, Sophie also understood what it meant to work hard.

Sophie was nineteen when she met the woman who was to become her fashion fairy godmother, the maverick stylist Isabella Blow. After a fight with her mother on Belgravia's Elizabeth Street, Sophie had run off, and sat on a doorstep, crying. A vision wearing a Galleon ship on her head stepped out of a cab and asked Sophie who she was, why she was crying, and what she was doing on her doorstep. Then she asked whether she wanted to be a model. It was Blow, an eccentric, and an ingenious spotter of talent. Blow took her to meet knitwear designer Lainey Keogh, who cast Sophie in her first-ever show at London Fashion Week. Sophie walked with Naomi Campbell, Helena Christensen, and Kate Moss. Among such attention-getting company, Sophie's confident sexiness and lack of self-consciousness made the headlines. Blow introduced Sophie to photographers Nick Knight and David LaChapelle, who were to shoot her for *i-D* and *Vanity Fair* respectively, on her first day of modeling. She also sent her to Sarah Doukas at Storm Model Management, who put Sophie to work in Elton John's video for "Something About the Way You Look Tonight." Cast alongside super-waif Kate Moss and a host of other international pretty people, Sophie stood out with her sass and pluck.

Though the plus-size modeling business had been operating as an adjunct to the mainstream industry since the

Opposite:
Photograph by
Patrick Demarchelier,
Vanity Fair, 2006.

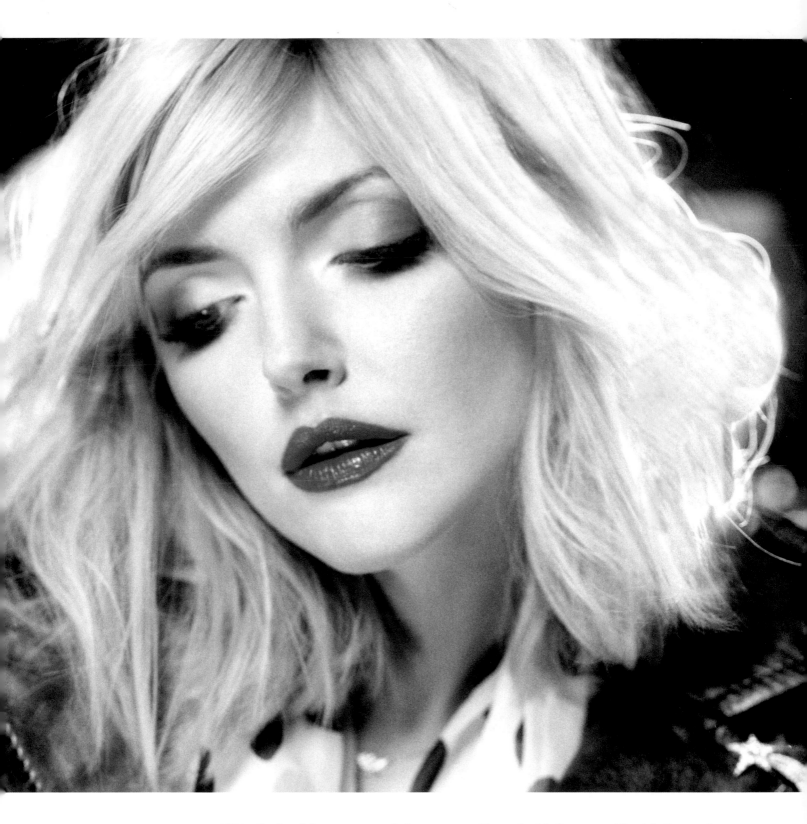

Above:
Photograph by
Regan Cameron,
British *Vogue*, 2007.

1970s, Sophie did not go to work for
its big accounts, such as the women's
wear company Lane Bryant. Instead, she
landed jobs with Richard Avedon, Karl
Lagerfeld, Peter Lindbergh, and Mario
Testino; modeled in campaigns for Versace,
Alexander McQueen, and Patrick Cox; and
appeared on the covers of Italian, French,
and British *Vogue*, *Elle*, *Harper's Bazaar*,
Visionaire, *W*, and *i-D*, among others. Her
very fashionable retro-dolly look and her
lineage gave her the edge.

"MY MODELING CAREER WAS REALLY JUST A LONG ACCIDENT—ONE THAT HAPPENED TO COINCIDE WITH MY CHOCOLATE-CAKE PHASE."

—SOPHIE DAHL, from "Sophie Dahl's Voluptuous Cooking," by Jen Murphy, *Food and Wine*, March 2010

Because fashion designers have never been in the habit of producing a range of sample sizes, Sophie ended up working nude more frequently than other girls, which, when added to her natural coquettishness, gave her a more sexy profile than many of her peers. It was only fitting, then, that Herb Ritts cast her in the 1999 Pirelli calendar, one of the modeling industry's most prestigious erotic bookings. The following year, Tom Ford, a designer who knows a thing or two about utilizing sex to sell product, put her in his retooled Yves Saint Laurent Opium campaign, shot by Steven Meisel. Wearing only a necklace and a pair of gold sandals, with flame-red hair and bright makeup, Sophie writhed on a black satin sheet. The outraged response to the overt sexuality of the advertisement was deafening. It was banned in America and the United Kingdom, where it was the subject of so many complaints for objectifying women that it ranked number eight on the Advertising Standards Authority's most-objectionable list. Meanwhile, there wasn't

a housewife north of Croydon who didn't go out and buy a bottle of Opium, my mum included. It was as if the world was waiting for this kind of generous carnality, and Sophie became a light in the darkness for fuller-figured women the world over.

Sophie slimmed down as she entered her early twenties, and went on to enjoy an equally successful second incarnation of her modeling career, shooting campaigns for the likes of The Gap, Banana Republic, Boucheron, Burberry, and DKNY. Sophie always knew modeling wouldn't last forever, and while she has continued to pick up cover work to the present day, by the turn of the 2000s, she started to explore other opportunities. She did some stage and film work before she settled on the family business of writing, which she's turned out to have a talent for, first as a contributing editor at British *Vogue* and then *Harper's Bazaar* UK, and then penning two bestselling novels. She also wrote two cookbooks, the first of which was adapted into the aptly titled *The Delicious Miss Dahl*, a six-part, primetime BBC cooking show.

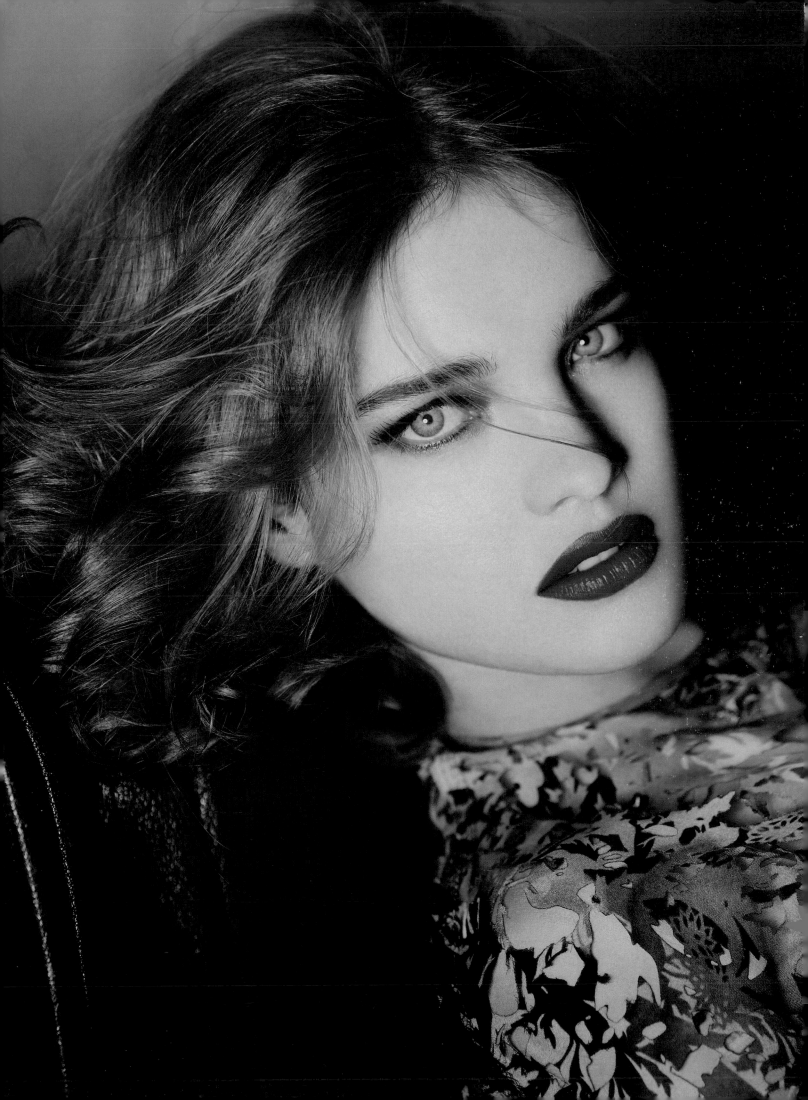

Natalia Vodianova

Opposite:
Photograph by
Guy Aroch, *WWD
Beauty Biz*, 2008.

Since Natalia Vodianova—whose delicate features and luminous skin give her the appearance of a china doll—really hit her stride as a top model at the turn of the millennium, at the age of seventeen, it's as if she has eternally hovered in that poetic, fleeting meeting point between girlhood and womanhood. In that sense, there is a bit of the waif in her. Steven Meisel nicknamed her "the Baby" for her fragile look and the tenderness it inspires, especially in an age when women are increasingly powerful and in command. The crossroads between innocence and experience is always fascinating, and in Natalia it makes for an almost throwback or storybook quality, giving rise to a romantic kind of nostalgia that may sound retrograde but—given the fact that she is a fully grown, quite powerful woman—is

harmless. That contradiction only makes her more fascinating.

Like many of her colleagues from the former Soviet Union, Natalia grew up in tough circumstances. Her mother was a fruitmonger at a Nizhni Novgorod market, and from when she was quite young, Natalia sold at her side, eventually running her own stand when she was just fifteen. There was no talk of fragility back then, and Natalia has said she only got the first inkling that she was attractive when she was wearing a new white pleather trench coat she had bought with her hard-earned money and some boys in the street called her pretty. (And then, in their inimitable teenage-boy style, they threw dirt on her.) She signed up at a local modeling school, and within a year, in 1999, she had been scouted and relocated to Paris. The following

year she was on the covers of French *Elle*, Australian *Marie Claire*, and *Teen Vogue*, her career on a fast ascent—but almost as quickly, she became pregnant with the first of her three children with Justin Portman, a real estate scion.

"AN ICE BEAUTY. LIKE SOMETHING OUT OF NARNIA."

—PHOEBE PHILO, from "In the Mood for Love," by Sarah Mower, *Vogue*, February 2003

As Portman is one of the richest men in the United Kingdom, there was momentarily some question as to whether Natalia would focus on her career or her growing family. But Natalia herself entertained no thoughts of taking it easy, and in 2001 she got to work posing for Juergen Teller for Marc Jacobs while she was still pregnant. Right after giving birth, she got back into the game in record time. The year 2002 was a banner one for her, as she headlined Tom Ford's fall show for Yves Saint Laurent, a particularly sexy collection, and became a face of Gucci and Louis Vuitton. In 2003 Natalia grabbed two major gold rings, the Pirelli swimsuit calendar, shot by Bruce Weber, and a contract with L'Oréal, signaling in no uncertain terms that she had arrived. She also appeared as Alice in a memorable and much-talked-about *Alice in Wonderland*–themed editorial for

American *Vogue*'s December 2003 issue. Shot by Annie Leibovitz and styled by Grace Coddington, the multipage editorial featured Vodianova posing in blue dresses designed by top designers of the day— John Galliano, Tom Ford, Marc Jacobs, Donatella Versace, Viktor & Rolf, and others—all of whom appeared with her in the photographs dressed like characters from the children's story. In 2005 she became the face of Calvin Klein's Euphoria fragrance and, in 2008, added Guerlain to her roster of contracts. She continues to work at a fast pace, with a substantial and growing list of *Vogue* and *Harper's Bazaar* covers across all their markets, her own lingerie line for Etam, and her charity, the Naked Heart Foundation, which aims to create safe play spaces and support families in troubled regions of Russia. In 2010, Natalia joined the short list of models to whom an entire issue has been dedicated, hers in the increasingly influential *Vogue* China.

The interplay of sweetness and wisdom in Natalia's work strikes an almost uneasy balance between the naïveté of her huge, wide-set eyes and the power of her intense gaze. She brings a real depth of feeling, expressing emotion with raw frankness, and there's something a bit forbidden about her appeal, as if she were forever just on the verge of being sullied. In an age when elixirs, potions, and surgeries are a frequent recourse for those unwilling to let go of their youth, leading the public to analyze the effects of every not-so-miracle cure, Natalia's seeming agelessness is an impossibly alluring ideal.

Opposite: Photograph by Vincent Peters, *Numéro Tokyo*, 2008.

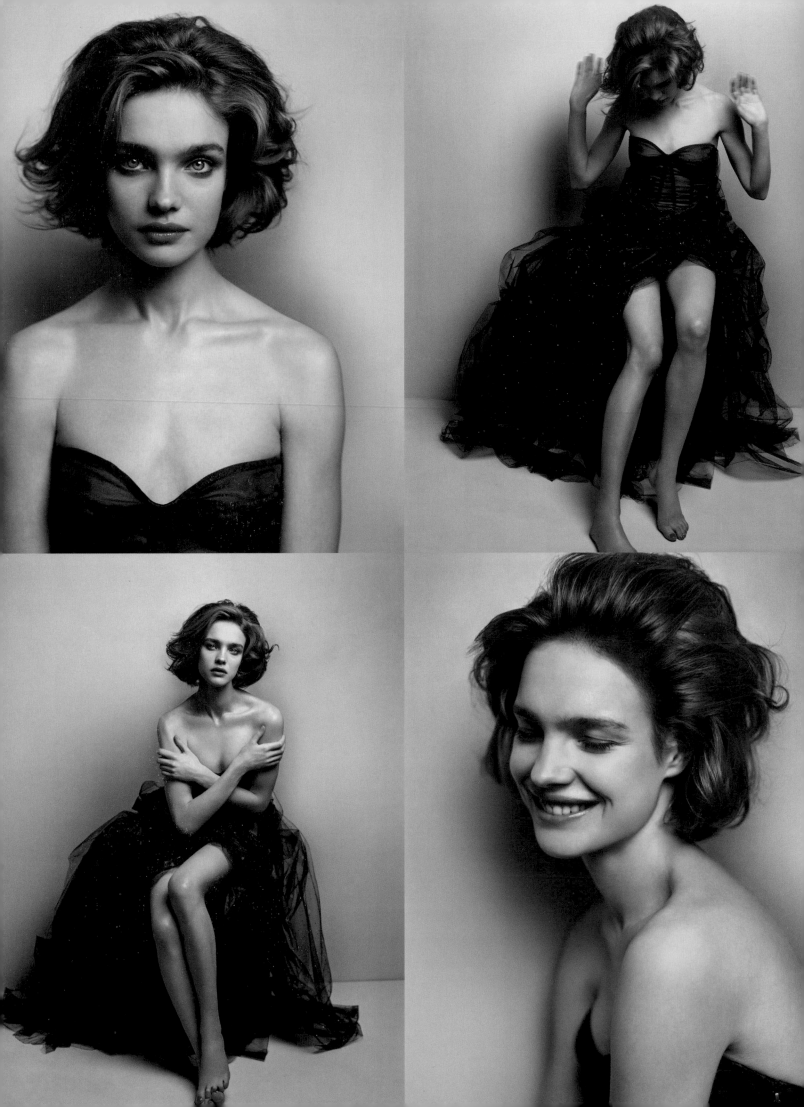

Liya Kebede

Opposite:
Photograph by Txema
Yeste, *Harper's Bazaar*,
Spain, 2012.

Above:
Photograph by
Cliff Watts, *Harper's &*
Queen, 2004.

The modeling world has always been a struggle for women of color, and when Liya Kebede first started at age twenty in 1998, after a film director spotted her in Addis Ababa and introduced her to a modeling agent, she was mostly booked for bland catalog work. She walked for Ralph Lauren and BCBG in 1999, but it was Tom Ford, in 2000, who boosted her career to a higher level, and to hear him explain the moment, it's almost as if he had no choice. "I was casting models for a show, and Liya came in," he wrote in a 2010 profile honoring her as part of *Time* magazine's *Time* 100 issue,

celebrating the most influential people in the world that year. "She looked me in the eyes, and I was quite literally stunned. . . . Later in the day, when trying to remember what she looked like, I could only remember her eyes." So the eyes had it, but so did that cool, regal bearing, surrounded as she was by bouncy Brazilians and endless streams of Eastern European blondes. Ford cast Liya with an exclusive appearance in his fall 2000 show for Gucci, so sure was he that she would capture the attention of the industry. But Liya took her auspicious debut in stride, taking downtime in the aftermath

"SHE'S AN EXOTIC GRACE KELLY.
MODELS WORK FOR YEARS
TO DEVELOP THE POISE, GRACE,
AND STYLE THAT SHE CAME
TO THE BUSINESS ALREADY
EQUIPPED WITH!"

–JAMES SCULLY, from "Casting Agent James Scully's All-Time Favorite Models,"
by Kendall Herbst, *New York's Look* fashion supplement, Spring 2009

to marry and give birth to a son, the first of her two children.

When Liya came back to work in 2001, she did it in a big way, signing on as the face of Tom Ford's Yves Saint Laurent. In 2002, she was featured not only on the May cover of *Vogue* Paris—a title the whole fashion world had locked eyes on due to its new editor, the influential former Ford muse Carine Roitfeld—but throughout most of the issue as well. The issue showed Liya in a stunning array of guises, proving that this charming girl with the soft, sweet smile could bring edge, sex, cool, and joy into high fashion, street fashion, and everything in between.

With her innate elegance and the stamp of approval of two such important power brokers, in the next couple of years Liya became the girl everyone wanted. She shot campaigns for Dolce & Gabbana, Louis Vuitton, Tiffany & Co., and the Gap; appeared on the covers of Russian, French, and American *Vogue*; and in 2003 became the first black model to sign a contract with Estée Lauder, worth $3 million. She has continued to represent brands of the moment in their moment, such as Lanvin, Balenciaga, Bottega Veneta, and Kenzo.

Her editorial work has remained impactful, with regular spreads in several international editions of *Vogue, Harper's Bazaar, W, V, Numéro,* and *i-D*. Photographers like Mario Testino and Arthur Elgort, whose work veers toward soigné, grown-up glamour, swear by her. But she is also a regular with the more outré Steven Meisel and Mert and Marcus.

Although she's been highly successful, Liya has never forgotten her roots. A vocal advocate for her native Ethiopia, she has created a line of casual contemporary sportswear, Lemlem, made by artisanal weavers back home, in an effort to keep alive an otherwise dying craft. In 2005, she became a goodwill ambassador for the World Health Organization for Maternal, Newborn, and Child Health. As she has approached acting little by little, she's made conscious choices, taking on smaller parts in political films. Her first starring role was in 2010's *Desert Flower*, based on the life story of Somalian model and survivor of genital mutilation Waris Dirie. The same year, when she had already scored spots on *Vanity Fair's* International Best-Dressed List and *Forbes's* list of highest-paid models, it was her humanitarian work that put her on the *Time* 100.

Opposite:
Photograph by Arthur Elgort, *Vogue,* 2006.

Daria Werbowy

While the longevity of a modeling career in the twenty-first century has decreased due to increased competition among models, the public's ever-diminishing attention span, and changes in the cultural climate, for some rare birds there is almost no limit to whom they can reach and for how long. One key to a long and storied reign, like that of Daria Werbowy, one of the most successful models in the last twenty years, is versatility—being able to convey almost any mood believably and embody the diversity of looks and genres in which the fashion industry now traffics. When there is no longer one reigning type, models who want enduring careers don't have the luxury of being pigeonholed: they have to continually reinvent themselves and transcend the trends. Although Daria's curves, athletic frame, and womanly, elegant face are a far cry from waifs and androgynes, recalling more the supermodels of the 1980s and 1990s, she has always been able to appeal to broad audiences.

Another key to a long career is strength of character and constitution, the ability to withstand the business's ever-faster-moving pace and growing number of media and outlets. As capable of transforming herself as Daria is, she has a strong sense of self. Since starting work at eighteen, she's taken the time, and occasionally the time-out, to develop her self-awareness. When the media writes about her, they like to mention that her last name, Werbowy, means "willow tree" in Ukrainian, her parents' native language, because it's a fitting moniker for someone so strong and supple, who can bend to the needs of the moment without breaking. Daria manifests power, both in her physique and enormous presence; she is a model whom other women feel no shame in admiring.

Born in Krakow, Poland, Daria immigrated to Toronto with her family when she was three. By fourteen, she had grown to her adult height, five foot eleven, and despite a mouthful of braces won a national modeling contest. She decided to wait to start modeling until she finished high school because she saw it simply as a means to put herself through art school. At eighteen, Daria signed with Elmer Olsen, a former scout for Elite Model Management, and went to New York to test her luck in her first runway season. Unfortunately, her

Opposite:
Photograph by Inez and
Vinoodh, *Vogue*, 2008.

timing was in sync with the events of 9/11: that year, New York's spring Fashion Week fell on the second week of the month, which included the day of the bin Laden attacks. Everything stopped: the entire city was shut down, and the rest of the year was very quiet as the economy fell into a downswing. After eight uneventful months in New York, she returned to Canada, assuming she would pick up where she left off with local editorial work—and that would be that.

"GIRLS WANT TO LOOK LIKE HER— PERHAPS BECAUSE SHE LOOKS LIKE A WOMAN."

—LAURA BROWN, "Daria: The Face of Beauty Now," *Harper's Bazaar*, January 2014

Opposite: Photograph by Inez and Vinoodh, *Vogue* Paris, 2012.

But in early 2003, Daria decided to give New York another try. Almost upon her arrival, she was booked by the star-making Steven Meisel for the first of three Prada campaigns. This booking triggered an avalanche of high-visibility work, including three *Vogue* Italia covers, also shot by Meisel, and editorials for *Vogue* Japan, *Vogue* Paris, *i-D*, *W*, *Numéro*, and *The Face*. In September 2004, American

Vogue put her in a prime position of their gatefold cover, next to Gisele Bündchen and Natalia Vodianova, calling her one of the models of the moment.

American *Vogue* was being too tentative, for Daria has been a model of many moments. In 2005, after Karl Lagerfeld signed her to the first of five Chanel campaigns, she landed one of the most prestigious jobs in the business, becoming the main face of Lancôme—a job she has held for a decade. In 2006 she slowed down a bit to clear her head, and she did so again in 2012, when she took some personal time to travel and relocate to Ireland. But over the years, Daria has amassed contracts with Yves Saint Laurent, Valentino, Missoni, Versace, Isabel Marant, Diane von Furstenberg, David Yurman, Rag & Bone, Roberto Cavalli, Christian Dior, Balmain, Céline, H&M, and Salvatore Ferragamo. On the runway, she is also the model with whom many designers want to make their most lasting impression: she holds the record for opening and closing more fashion shows than any other model in history.

Despite having a low-key personality, favoring blue jeans, and playing basketball and snowboarding in her off time, Daria has become such a force within the modeling world that she is often bigger than the designers and magazines she works for, a status rarely seen since the 1990s, when supermodels of the decade ruled the runways—but without the attitude that toppled them.

THE CONTEMPORARIES

VIII.

T

HE FORCE STOKING THE FIRE OF change in the fashion industry more than any other today is the Internet, particularly social media, which has been shaping the online, and even off-line, lives of the world since the first decade of this century. Fashion reality TV launched with great success, and by now bloggers with eccentric taste and digital cameras have started to turn themselves into fashion stars, too, earning the front-row seats at Fashion Week that were once reserved only for A-list celebrities, the most important buyers, and editors in chief. Street style photography—or candid snaps of people both in and outside the fashion establishment, dressed to the nines— became influential with the *Sartorialist* blog, which launched in 2005; the venues for street style photography have since expanded outward exponentially. The rise in paparazzi and tabloids already meant that actresses couldn't leave their houses to get coffee without the help of a stylist. Thanks to street style cameras, which go into overdrive during Fashion Week, models' off-duty looks and lives have become prime-time entertainment, too.

Alluring images still sell product in ad campaigns and make for intriguing editorials, but today models with an instinct and talent for self-expression as well as the energy to share digital self-portraits on Instagram and Tumblr around the clock have a very big edge over models who don't. Though professional photographers can still be crucial at giving up-and-coming girls important bookings, models themselves have partially wrested that power away from them. In addition, magazines and designers have a newfound respect for crowd sourcing, seeking out models with a built-in following on social media.

Social media has also made designers and magazines more accountable to the public's desire to see models who look like them. Debates about body image, ageism, and racism are waged more fervently and openly now. And while the large majority of models are still Caucasian, teenage, and slim, the tier of top models today reflects a diversity of ethnicity and body type unseen since the era of the supermodels, as well as a new openness to aging beauty. This trend is partially due to the need to appeal to aging baby boomers, a powerful and demanding demographic. And it's partially due to advancements in retouching, which now is routinely extending top models' careers, longer than ever before. But it's also due to cultural evolution, a more open embrace of the beauty that can be found in people of all ethnicities, sexualities, genders, and ages.

Pages 216–217:
Cara Delevingne,
Burberry Prorsum
spring/summer
presentation, 2014.
Photograph by
Gareth Cattermole.

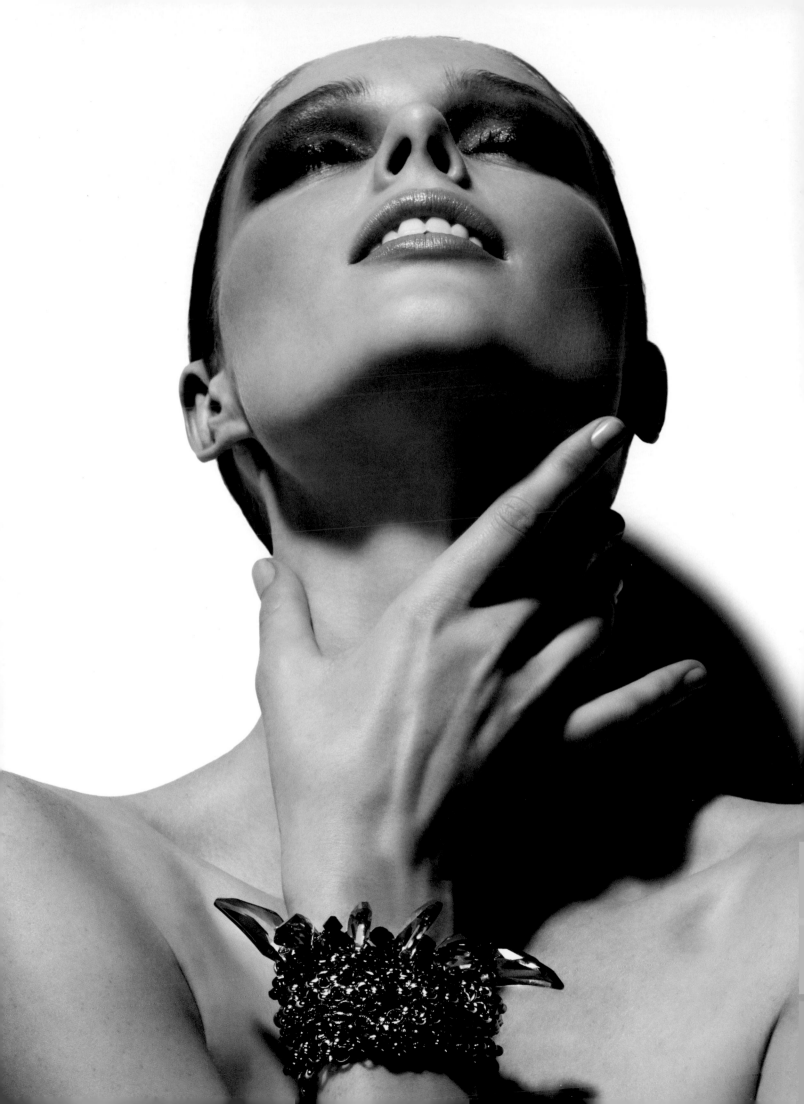

Coco Rocha

Opposite:
Senhoa advertising
campaign, 2012.
Photograph by
Nigel Barker.

Pages 222–23:
Zac Posen advertising
campaign, fall/winter
2009. Photograph by
Ellen von Unwerth.

Known industry-wide as the "Queen of Posing," Coco's energy is explosive in front of the camera. It's not just because she stays incredibly alert to the moment while she's working, but, as one of the industry's leading social media figures, with thirteen million followers across numerous platforms, she absolutely appreciates and uses her success to affect and inspire her fans.

Coco claims to hold the Guinness World Record for the highest number of usable poses in a minute. Okay, she's exaggerating, but not by much. With the flexibility and grace of a talented dancer—Coco was discovered at an Irish dancing contest in Canada at fourteen—she positively spreads her wings on set, kicking higher, jumping farther, and using her distinctive, elastic face to create myriad expressions. That face of hers is unusual by modeling standards: she's angular, with relatively thin lips, a turned-up nose, and a kind of elfin appearance. It's how she animates what she's got that sets her apart. Her theatricality is universally admired: she has a developed sense of creating a character for a photographer. And her accomplishment at the craft of modeling—perfecting its exacting poses (her artful book, *Study of Pose*, captures her in one thousand unique positions), encapsulating its mercurial moods—calls to mind the models of the golden age of haute couture in the 1950s. Fashion wasn't Coco's world when she was discovered—she refused her first agent for a year before agreeing to sign with him—but she's turned out to be a quick study. Within two years of getting signed, she was mentored by Steven Meisel, who advised her and shot her exclusively. Meisel also put her on the cover of *Vogue* Italia, a magazine that can make

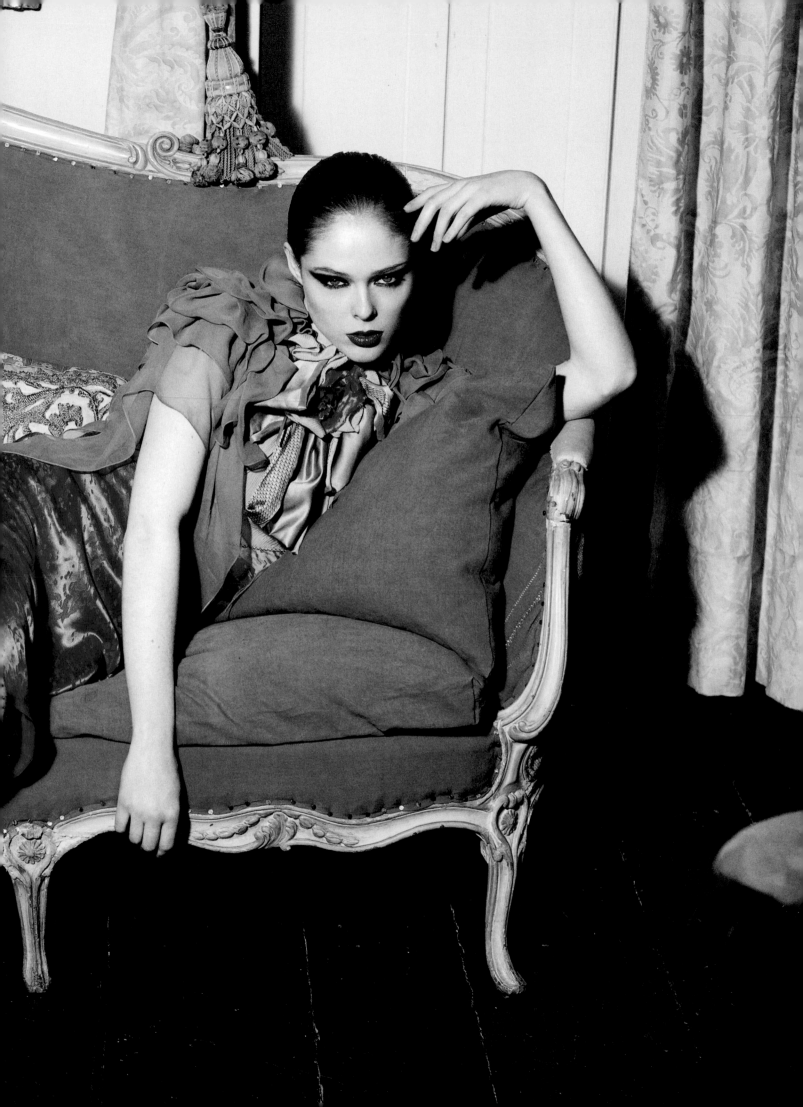

a model's career, and from there, she sky-rocketed to the top. In the process of her rapid ascent, she's quickly figured out how to turn quirks into assets. In fact, her broad appeal, intelligence, and humor are such that CNN's Piers Morgan had her cohost the 2014 Academy Awards coverage on his program.

"IT TOOK A WHILE TO GROW THE CONFIDENCE TO SAY, 'THIS IS WHO I AM. TAKE IT OR LEAVE IT.'"

—COCO ROCHA, from the CFDA Health Initiative's panel discussion "The Beauty of Health: Resizing the Sample Size," February 2010

One of the things that people both in and out of fashion admire most about Coco is that she uses the industry as a platform for bigger issues. She doesn't let it use her. It takes serious guts to go on Anderson Cooper's show *Anderson*, as she did in 2011, to advocate for set working hours and age limits in a business that can put impossible stress on very young girls. Even though by then Coco had been on dozens and dozens of covers, there's still huge pressure to toe the line in the business; speaking out is not for the faint of heart. Unusually articulate and self-possessed, she's penned open letters to the *New York Times* and the Associated Press decrying modeling's often-unhealthy body image standards. With her position on the board of directors of the Model Alliance

Opposite: Photograph by Tony Kim, *Vogue* Korea, 2009.

since 2012, Coco has been a leader of a new effort to unionize models, who are still independent contractors without the kind of representation that other creative artists, like actors and writers, enjoy. And she successfully lobbied the New York State legislature to pass a law regulating the working conditions for models under the age of eighteen: whereas before, it was really anything goes, both in terms of their working hours and how they were paid, now young models will have to have work permits and trusts set up in their names.

When Coco pushes herself to expand her skills, she does it in the service of others, too. She set out to design a capsule jewelry collection to make money not for herself but for Senhoa, a company that employs women artisans who have survived human trafficking. I shot that campaign with Coco, and she is absolutely brimming over with purpose.

Coco has the bully pulpit now, but she didn't get there by being strident. She's a natural at fan outreach, building her massive social media presence by being not just beautiful but also interesting. She was the first model to have more than a million followers on Google+. She understands intuitively the incredible curiosity out there about fashion as it happens behind the scenes. And she doesn't just report what happens; she makes things happen. Once, on a shoot with her, I put my camera down. She ran over, picked it up, and started photographing me with it. A photographer's equipment is the most delicate thing on set, human beings included. No one but the photographer or his or her assistant ever goes near it. But Coco's charm is contagious. When she dares, she pulls it off, every time.

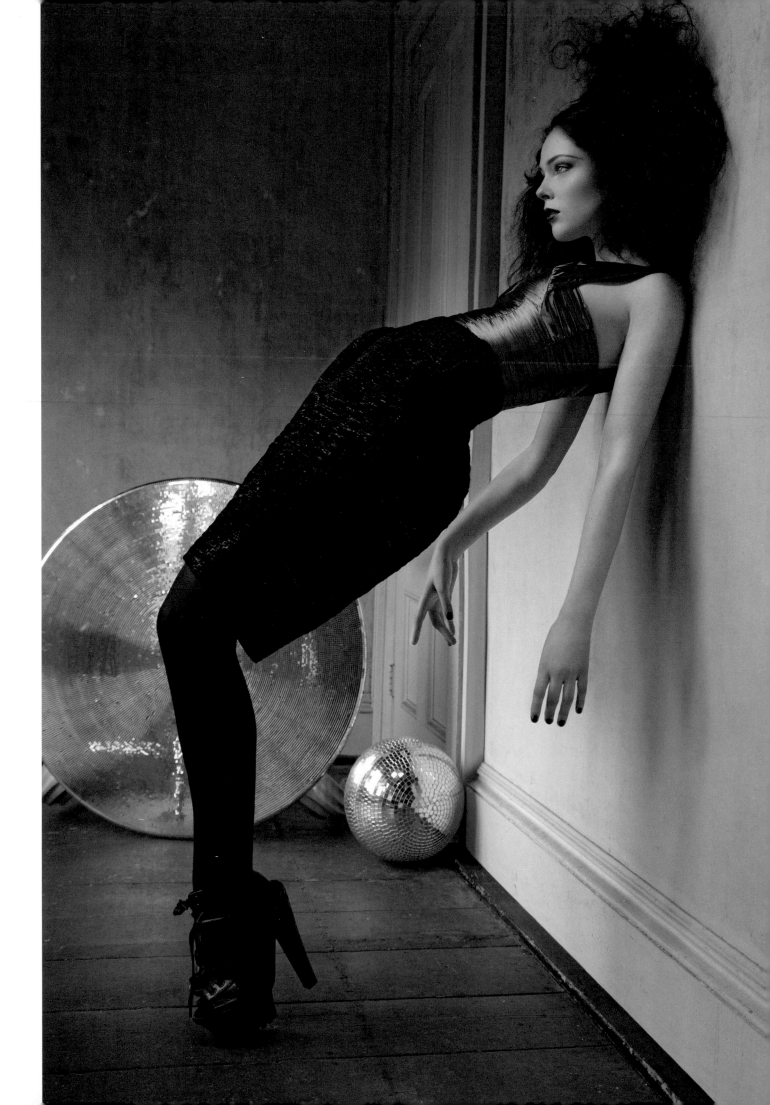

Lara Stone

Except for some rare cases, girls with real curves have not been particularly in vogue in the twenty-first century. Usually models with hips and busts gravitate to more commercial outlets like Victoria's Secret and *Sports Illustrated*'s swimsuit issue, where sex appeal is the order of the day and it's far less about the fashion itself than the bodies that wear it. But every so often, there comes a model who can tread the lucrative path of catalog and swimsuit modeling but who chooses to go in a different direction, simply because that's what inspires her. Many of these bustier, curvier girls who try high fashion are shut out of the establishment anyway because so many designers feel their clothes look and fall better on very slender, boyish bodies. But some girls do break through, and when they do, the resonance with women outside the industry is often very powerful. Never has this been truer than today, when fashion consumers have become vocal and engaged over what they perceive to be the negative effects of overly thin models.

When Lara Stone hit her stride in 2006, she was like a life raft for a public

much more ready to see different body types in high fashion images than most of the industry was ready to create. Lara's expressiveness, sultriness, and complexity were impossible to pass up—the fashion elite "got" her, and they have embraced her ever since.

Lara's proportions—she is five foot ten with D-cup breasts and a body weight that hovers in the mid-130 pounds—normally would have tracked her straight into catalogs, which in fact is where she worked at first, when she was sixteen and had just moved to Paris from a small Dutch town. Frustrated with her career path, in 2006 at twenty-two she changed agencies, and suddenly everything clicked. Lara went to meet Givenchy's creative director, Riccardo Tisci, and the minute he saw her, he has said, it was like he fell in love. He booked her on the spot for an exclusive in his 2006 spring haute couture presentation. A few months later, during the ready-to-wear shows in Paris, she walked for Ann Demeulemeester and Miu Miu. Her snarling expression and bouncy walk were

Opposite:
Photograph by Paul Bellaart, *Elle Girl*, Netherlands, 2004.

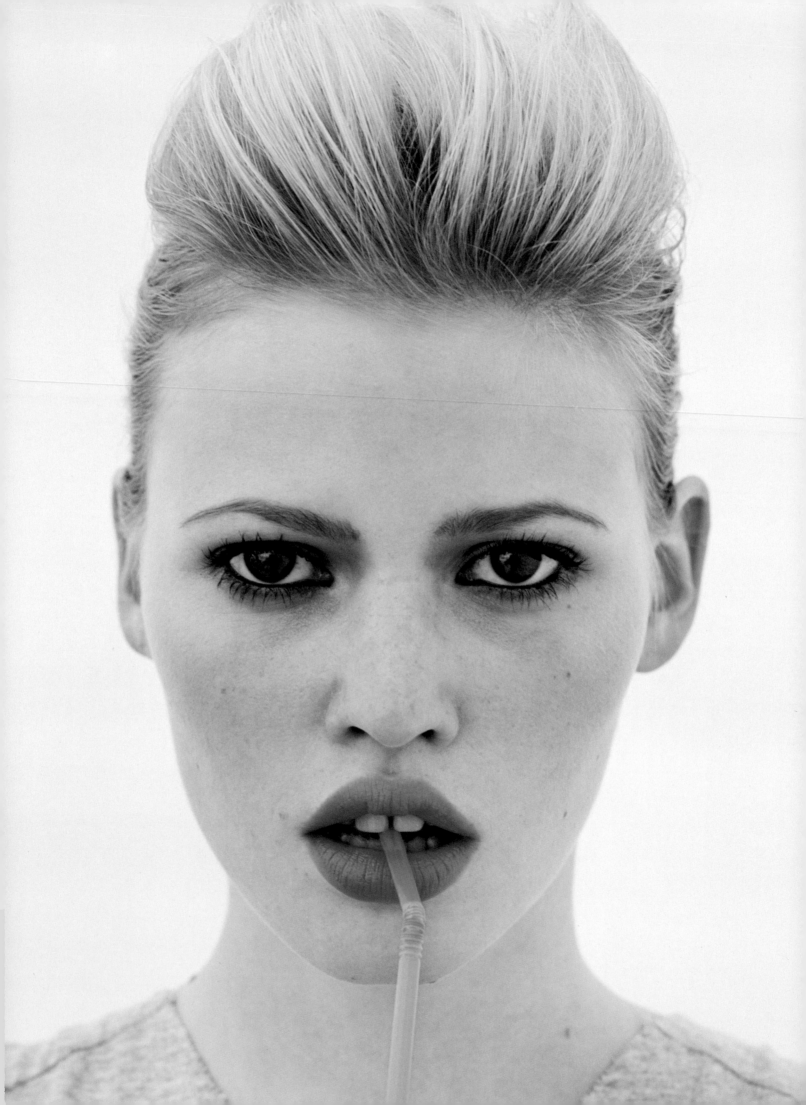

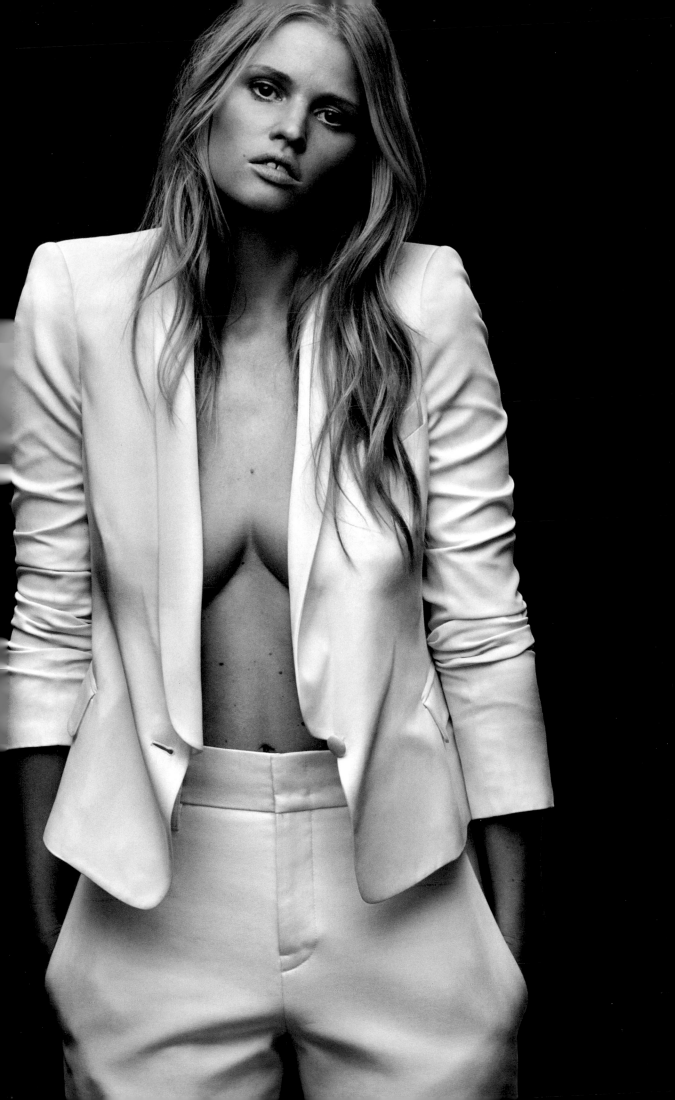

"SHE MADE SHAPE TRENDY AND INVENTED A KIND OF NEW GIRLY FEMININITY."

—KARL LAGERFELD, from "Lara Stone," by Marc Jacobs, *Interview*, March 2010

an attention-getting dichotomy that stood out from what has increasingly become a bland, less expressive norm on the runway. Terry Richardson, a photographer obsessed with raw female sexuality, produced a powerful, vampy campaign with her for Sisley, which demonstrated that even if Lara could play the siren, she could do it with an aggressive, mysterious edge; the gap between her two front teeth kept her from looking too much like a Barbie, and Lara's own talent did the rest. Carine Roitfeld at *Vogue* Paris was the next important industry figure to fall head over heels for her, and Lara started working at the magazine frequently.

Soon Lara nabbed one of the most attention-getting campaigns imaginable, replacing Kate Moss for Calvin Klein Jeans. After she secured that position, it was as if there was nothing she couldn't do. Calvin Klein signed her to an exclusive beauty campaign. Givenchy used her for three consecutive campaigns. And Prada put a semi-exclusive hold on her for spring 2008 Fashion Week, meaning she couldn't walk in any shows before she walked for them. Next came a cover of *V* magazine and, with her fashion bona fides extremely well established, a jaunt down the runway for Victoria's Secret. But by 2009, Lara was reeling. To cope with the pressure, she was drinking too much, so she took a month off to go to rehab in South Africa.

Lara's time away only made her more in demand. When she returned, newly sober, she jumped into work and hasn't stopped since, with covers for American *Vogue* and *Harper's Bazaar*, advertisements for Louis Vuitton, and—a first in the history of the brand—an exclusive contract with Calvin Klein across almost all his categories: Collection, CK, and Jeans. She has also recently been named a face of L'Oréal. In case there was any doubt left that it paid to be different, Lara's career is living proof.

Opposite:
Photograph by
Daniel Jackson,
Harper's Bazaar, 2014.

Liu Wen

One key to the steady growth of the fashion industry and its resilience to the recent economic crisis has been its expansion into Asian markets as they reach new levels of prosperity. When Liu Wen, who was born in 1988, was growing up in Hunan Province, the only Western brands there were Kentucky Fried Chicken and McDonald's; there were no fashion stores or magazines. But every year, as China's standard of living rose, its contact with the outside world expanded, to the point that in 2005 there was enough room in the market for Chinese *Elle*, Chinese *Marie Claire*, and a just-launched *Vogue* China. Today, as *Vogue* China outearns its American counterpart in advertising income, there are more than thirty-five Louis Vuitton stores on the mainland (not counting Taiwan and Hong Kong), and the Asian beauty market is growing exponentially, netting higher and higher billions a year.

Naturally, it was only a matter of time before luxury brands figured out that their important new customers had a better chance of becoming loyal ones if they saw models who looked like them in ads.

As there is no shortage of stunning women across Asia, this wasn't a hard order to fill, and a group of Asian models started to work heavily back home by the middle of the 2000s. The booming Hong Kong film industry had already introduced actresses like Zhang Ziyi and Gong Li to the Western public, too, in the 1990s. As people the world over grow more curious and outward-looking, due in great part to the Internet, and increased their appetite for different looks and ethnicities, Chinese models have followed suit, making a big splash outside of China, too—none more than Liu Wen.

Wen grew up a tomboy in a working-class family, an only girl. Her mother encouraged her to develop herself professionally, and hoped her daughter would learn posture and comportment by modeling. In 2005, at seventeen, Wen entered a local contest and didn't place, but she was discovered by an agent and soon moved to Beijing, where she taught herself to walk in stilettos for the first time. She worked as a lighting and wardrobe stand-in until a stylist for *Marie Claire* International spotted her. Wen insists that

Opposite:
Photograph by
Guy Aroch, *WWD
Beauty Biz*, 2010.

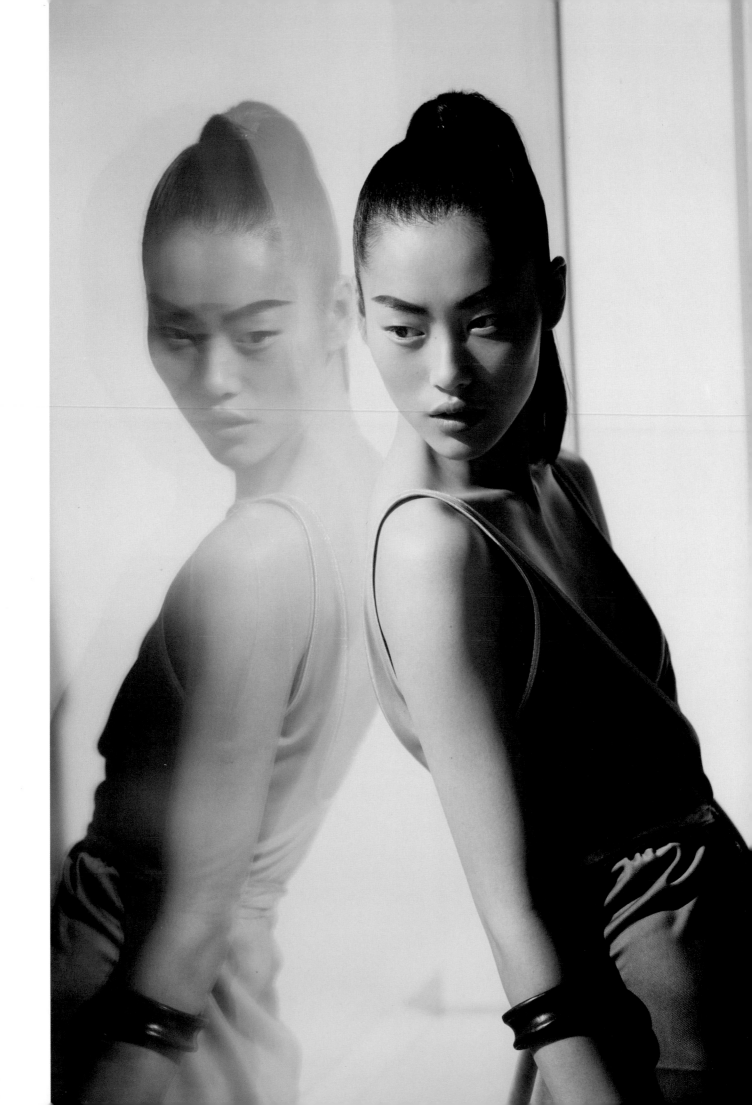

"WHEN WE MET HER IN PERSON, WE WERE SO IMPRESSED WITH HER WARMTH, BEAUTY, AND ENTHUSIASM. IT'S AMAZING TO SEE HOW CONSUMERS RESPOND TO LIU WEN—SHE HAS SO MANY FANS, NOT ONLY IN CHINA BUT AROUND THE WORLD AS WELL."

—AERIN LAUDER, from "How a Small-Town Girl Became China's First Supermodel," by Nick Parker, CNN.com, September 30, 2011

her darker skin, large eyes, and small nose and mouth are not the beauty norm back home, but once she had a chance to show her versatility and subtlety of expression, she gained a sizable number of Chinese fans, working her way up to the big leagues, shooting for *Vogue* China, *Elle* China, and *Harper's Bazaar* China.

By 2008 Wen was starting to get noticed in the West, too, and she went to Paris to walk for Chanel, Jean Paul Gaultier, and Hermès. The following year she swept the castings, walking in seventy-four shows in Milan, Paris, London, and New York— the most by anyone that season, and a record for a Chinese model. In 2009 Wen broke into advertising work, too, booking campaigns for such all-American brands as DKNY Jeans, the Gap, and Converse, as well as Alexander Wang, CK One, and Barneys New York—and this was just for the spring season. What designers, stylists, and editors saw in her was a combination of fierceness and delicacy, and the ability to express the spectrum of emotions

with strength. Victoria's Secret selected her as its first Chinese model for its globally televised fashion show that year, too. Seeing Wen cavort like a cheerleader on the runway, you can't be surprised she's kept the booking for four consecutive years as she destroys the stereotype of Chinese women as formal and stiff.

All the while, Wen has complemented her mainstream editorial work for *GQ, Allure,* and all the major editions of *Vogue* with work for the more cult titles like *i-D, W, V, Pop, Numéro,* and *Interview.* With such a well-rounded profile, Wen wasn't too big a risk for Estée Lauder when the brand named her its first Asian brand ambassador in 2010. This ambassadorship earned her the number-five spot on *Forbes's* list of highest-paid models—the first time a Chinese model even placed. The *New York Times* style magazine, *T,* may have called her China's first supermodel, but in fact Wen has transcended her origins to join a very elite group of top girls with total global appeal.

Opposite: Photograph by Andreas Laszlo Konrath, *W,* 2010.

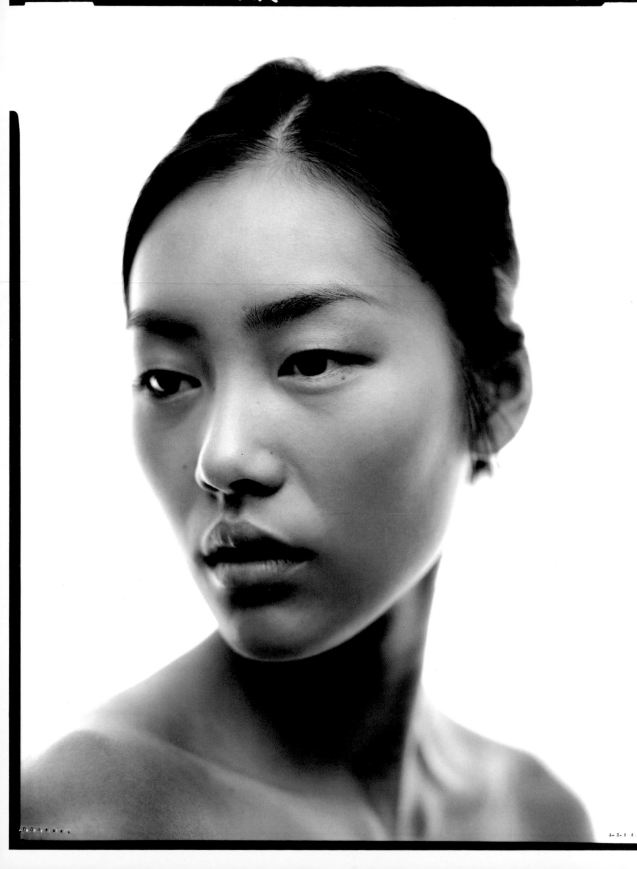

Karlie Kloss

When I met Karlie Kloss, I could feel her presence before I laid eyes on her. She was already mesmerizing everyone else in the room—that much was clear; I simply had yet to turn around. When I finally did and this otherworldly, six-foot-one beauty came walking toward me on her tiptoes like an attenuated cat, I expected her to demand a martini in an exotic accent fit for a Bond girl. Instead she gave me a big grin, sweetly shook my hand, and in her midwestern lilt told me what a pleasure it was to meet me. Karlie may have a feline look, with wide-set upturned eyes and sharply angled cheekbones that could suggest a cooler demeanor, but in fact she is ebullient, friendly, and intelligent—a combination that is one key to her success. She takes you by surprise in so many ways, with her grace, her precocious instinct for posing, her extraordinary intensity on the runway, her boundless enthusiasm, her versatility, and her down-home niceness.

Karlie started working as a model very young, at thirteen, so the fashion business has watched her grow up. With every passing year, she picks up new skills, expanding and deepening her range. Designers and fashion editors already consider her to be one of the best models around, and with the longevity her career is likely to have, it's hard not to imagine her becoming one of the most significant ever.

Karlie grew up in St. Louis, Missouri, and trained in ballet from an early age. She had ambitions of dancing professionally, but she shot up like a weed in her early teenage years and soon was too tall to consider ballet as a career. The training came in handy later on, as Karlie has said

Opposite:
Photograph by
Miguel Reveriego,
*London Sunday
Times Style,* 2013.

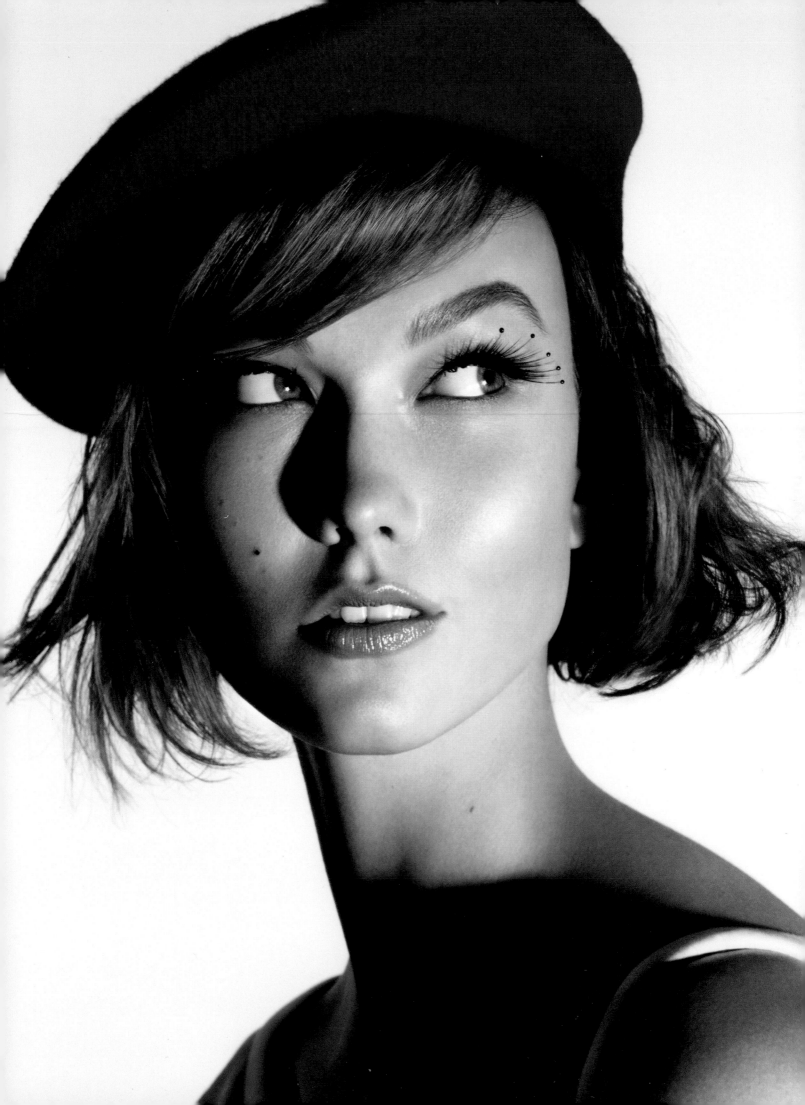

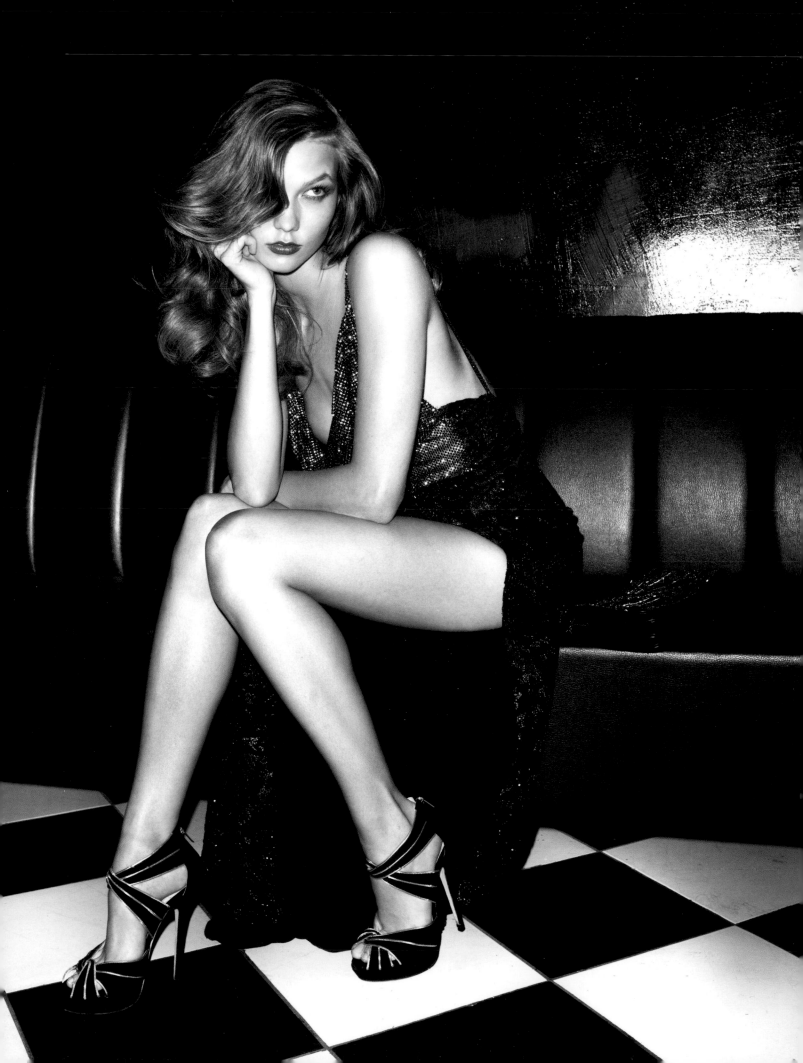

that the control over her body that ballet taught her has made the difference for her posing. When she was thirteen she was discovered at a local charity fashion show, and her first professional shoot was a year later, for Arthur Elgort, at a ballet barre. A few years after, Karlie signed with Elite Model Management and tried out for the shows. Her lanky limbs and reedy frame set off her feline eyes, but when Karlie walked, this sweet young girl became a gladiator. There was none of the Lolita air of Natalia Vodianova about her; Karlie just strode down the runway like a fully grown woman. On her first season out, she landed exclusive runway appearances at Calvin Klein in New York and Gucci in Milan, and walked for Alexander McQueen, Sonia Rykiel, and Valentino in Paris. When she tried to change agencies to Next Models the following year, at age fifteen, Elite, sensing her huge potential, sued to keep her but ultimately lost. (Karlie didn't stay long at Next either, ultimately landing at heavyweight IMG.)

At first, Karlie's gamine style and string bean shape appealed mostly to high fashion: in 2009, at age seventeen, she was American *Vogue*'s most photographed model, appeared in advertisements for Chloé and Alexander McQueen, secured a contract with Marc Jacobs's Lola perfume, and booked spots for Dior, Yves Saint Laurent,

Uniqlo, and Donna Karan for 2010—all of whom have been repeat customers. In 2011, as Karlie developed more curves, she became one of the Victoria's Secret Angels, which catapulted her to an even higher level of visibility.

"YOU CAN START A WHOLE SCRIPT JUST BY STARING INTO HER EYES."

—JOHN GALLIANO, from "Glossy Karlie . . . *Vogue* and *Lucky* Launch Partnerships . . . New Gravy Train," by Miles Socha, *Women's Wear Daily*, January 7, 2010

At her young age, Karlie is already one of the great chameleons of modeling, an electrifying presence whether she's dressed up like a co-ed or a cyberpunk. During a time of unparalleled eclecticism in fashion, it pays to be able to pull off couture and shower shoes, and because Karlie has so much emotional intensity, she is often bigger than what she's wearing anyway. One of her trademark looks is a lethal stare that can be hard to square with the truly nice person that Karlie is, but as is so often the case, it's the contradictions that hold our attention.

Opposite: Photograph by Terry Richardson, British *Vogue*, 2011.

Joan Smalls

To look at Joan Smalls on the pages of a magazine—maybe in one of her Estée Lauder or Chanel advertisements, or in editorials for American *Vogue*, *W*, or *Elle*— is to see the contemporary essence of refinement, elegance, and glamour. She has hauteur and fierceness, a mature and womanly bearing, and smoldering sexiness that is all class. With a mixed heritage— Spanish, African, Taino Indian, Irish, and South Asian—she has a face with a unique look yet universal appeal. Joan, who grew up on a farm in Hatillo, Puerto Rico, wouldn't have found her way onto those glossy pages if it weren't for one of her family's turkeys. "[It] would attack me when I was a kid," she told *Harper's Bazaar* UK in October 2012. "My father told me I had to stick up for myself, so one day I picked up a rock and hit him with it. That turkey got mean again, so eventually he went to the neighbor's house, and they ate him. That's what happens when you mess with me!"

Joan has been sucking up her courage and asserting herself, albeit on a much larger stage, ever since.

When Joan entered her first modeling competitions in Puerto Rico, she was told she was too dark, too thin, and—at five feet, ten inches—too tall to make it. Rather than accept that negative career prognosis, she moved to New York in 2007, to a market where being tall and thin was not a hindrance. Being dark, however, was. Joan's first agents didn't really push her for prestige jobs, only catalog work. When she asked why they didn't try harder on her behalf, she was told "there can only be one" woman of color in a shoot. Joan didn't internalize that vision of the business, even if casting directors still often share it. Instead she fired her agents and moved to IMG, where she was advised to take her career into her own hands and retool her image into something more chic if fashion was where she wanted to work. Off went the sneakers and on went the pumps when she went to go-sees. It made the difference.

Joan's first big break came in 2009, when Riccardo Tisci agreed to consider her for Givenchy's fall 2010 couture show. Believing in herself fully, she paid her own

Opposite:
Photograph by
Patrick Demarchelier,
Vogue, 2013.

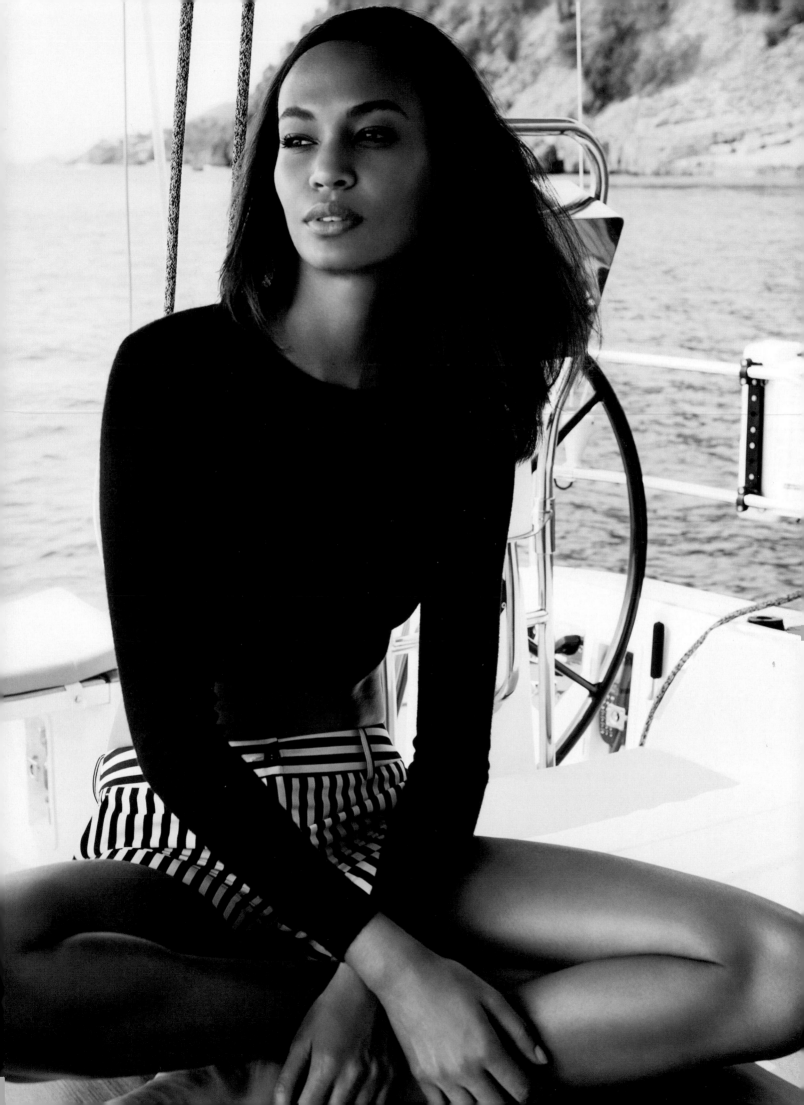

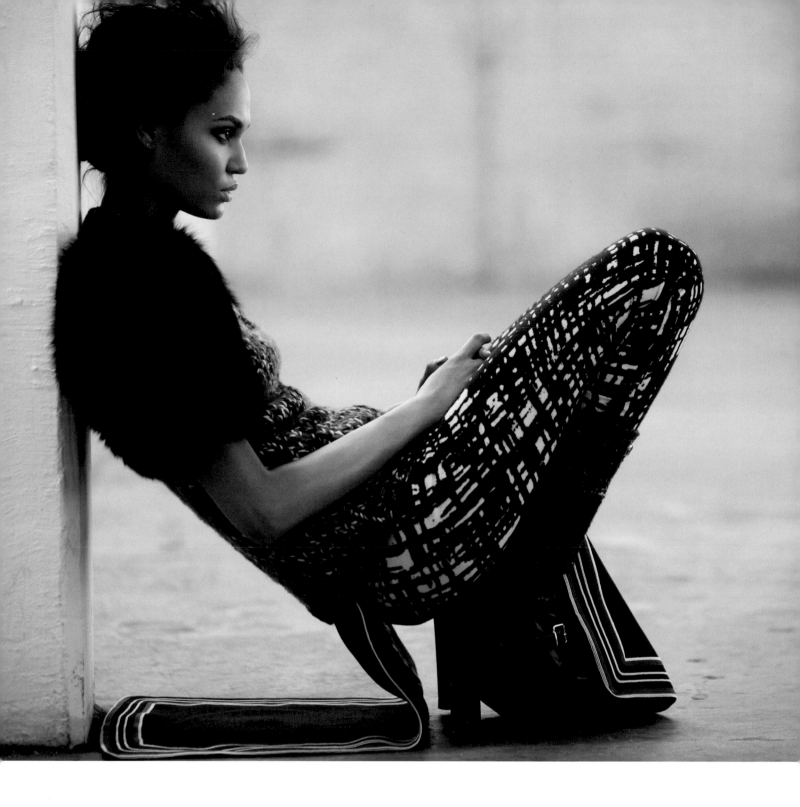

Above:
Photograph by Boo
George, *New York
Times Magazine*, 2011.

expenses to get to Paris, which turned out to be the best investment she ever made. Tisci booked Joan for Givenchy exclusively, which made all the other designers that season take notice, and the following show season, she was everywhere. Her purposeful catwalk stride was the image of determination, which inspired designers looking to appeal to female customers who were becoming increasingly comfortable with the trappings of power.

After Joan's big 2010 season, the high-ticket campaigns and covers came pouring in, starting with *i-D* and expanding to mainstream fashion magazines in 2011. She became the first Latina face for Estée Lauder, in 2011, and the first black model to appear in a Chanel advertisement, in

"I WANT TO TAKE OVER THE WORLD. I WANT PEOPLE TO LOOK AT ME AND SAY: 'OH WOW, THAT GIRL IS DOING SOMETHING.'"

—JOAN SMALLS, from "It's a Smalls World,"
by Derek Blasberg, *Harper's Bazaar* UK,
October 2012

2012. The same year, MTV relaunched its half-hour fashion show, *House of Style*, for Joan and her good friend and frequent partner in posing Karlie Kloss after the duo had debuted on the Victoria's Secret runway together. Joan's tally of ads includes Fendi, Roberto Cavalli, Gucci, Tiffany & Co., H&M, David Yurman, Stella McCartney, and many more. With editorial work in *Vogue* and *Harper's Bazaar*, both of whom have given her the feature profile treatment, and an *Elle* cover in 2014, rare nowadays for someone who is not an actress or pop star, citing her as living proof of the return of the supermodel, it's no surprise that she's now counted as one of the highest-earning and hardest-working women in the business.

Kate Upton

On the rare occasions that a successful commercial model has graduated up to high fashion, like Paulina Porizkova and Claudia Schiffer did, it usually takes the vision of a photographer, editor, or designer to make the case and get the "right" people's attention. In the case of Kate Upton, it was social media, in the form of viral videos, that made her the girl everyone had to contend with. All the fashion industry had to do was see what was right under its nose.

After Kate made a promising start on the mainstream path, going from catalogs to advertisements for Dooney & Bourke to a year's worth of work with Guess, in 2011, just after she was named "Rookie of the Year" in *Sports Illustrated*'s swimsuit issue, she posted a video of herself at a basketball game doing a dance called the Dougie. Millions of people watched and reacted, many with declarations of love and many more with lust, as this all-American pinup—five foot ten, with hips, D-cup breasts, and a heart-shaped face, recalling a young Anna Nicole Smith—swayed like a snake, bouncing and jiggling, with a huge, infectious smile.

Now signed to IMG Models, she was booked for the cover of the 2012 *Sports Illustrated* swimsuit issue, and as the attention snowballed, photographer Bruce Weber and creative directors Stephen Gan at *V* magazine and Carine Roitfeld, now the global fashion director of *Harper's Bazaar*—all of whom are known for championing models who don't fit the traditional thin, mysterious, high fashion type—started working with Kate and fell under her spell. She didn't have to look outside her established bag of tricks to capitalize on their attention. Proving that the second time can be exponentially more of a charm, a few months after the issue came out, Kate, wearing the same microscopic bikini she wore on that cover, did a far more suggestive dance, the Cat Daddy, which photographer Terry Richardson filmed for his Terry TV Internet video channel. Some twenty million hits later (and counting), Kate is now a household name worldwide.

When she appeared on the cover of the inaugural issue of Roitfeld's *CR Fashion Book* in September 2012, her presence resulted in divided opinion among the

Opposite:
Photograph by
Miguel Reveriego,
Vogue Spain, 2012.

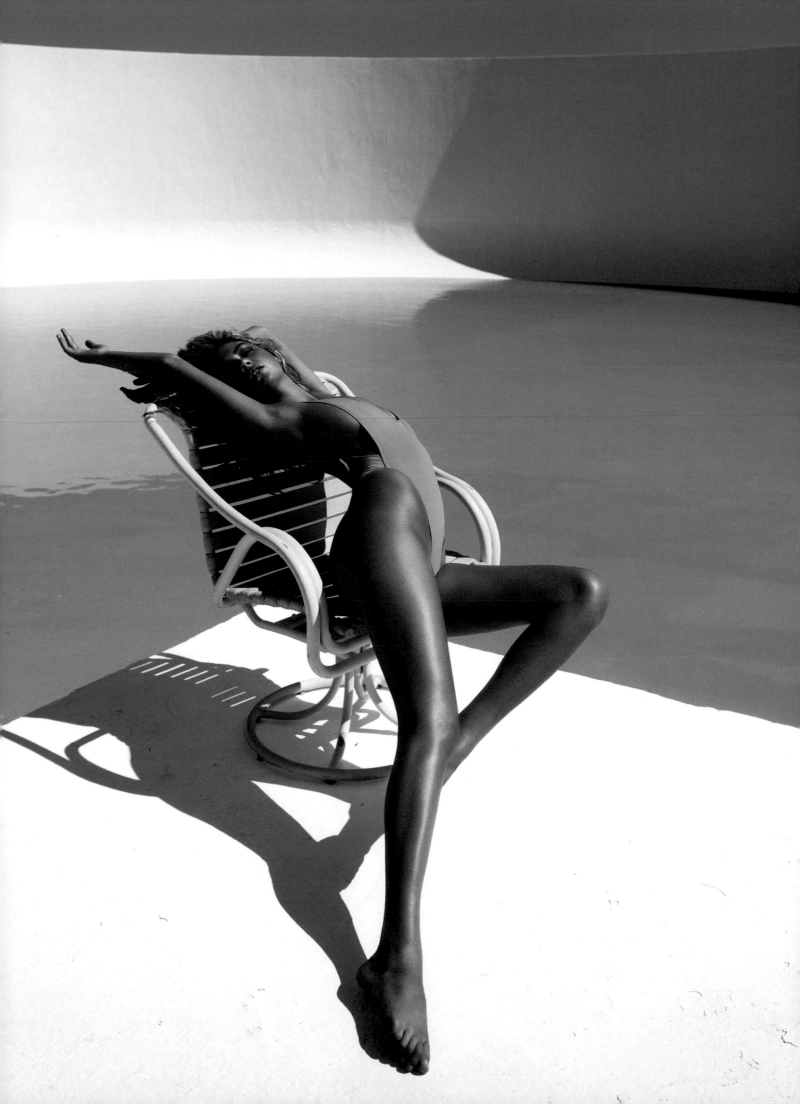

"WHEN KATE FIRST CAME IN, EVERYONE AT THE AGENCY THOUGHT I WAS CRAZY. SHE WASN'T 'FASHION' ENOUGH. KATE IS BIGGER THAN FASHION. SHE'S THE JAYNE MANSFIELD OF THE INTERNET."

—IVAN BART, from "Model Struts Path to Stardom Not on Runway, But on YouTube," by Guy Trebay, *New York Times*, February 13, 2012

fashion elite, some of whom felt she was vulgar and trashy, a flash in the pan or an example of fashion gone slumming. Kate just laughed off all the negativity as the opportunities kept heading her way. Her unpretentious, infectious charm has converted most of the doubters, as has her impressive work for *Love* magazine and every major edition of *Vogue*, including a June 2013 cover of American *Vogue*. In editorials Kate has shown a propensity to beautiful, sculptural work with her body, and the ability to project a lot more than just apple pie.

There are thousands of theories as to why Kate has been such an unexpected fashion success. Some say that her built-in Internet following is just too irresistible to pass up. Some claim that fashion is finally really ready to look outside its currently underweight norm for something new, and finally ready to embrace the masses it has

always claimed to float above—never mind that fashion has flirted with larger bodies in the past, usually to return to its preference for extreme thinness. But one has to take into account that, in addition to being quite voluptuous, Kate is the essence of joie de vivre. She's ambitious but doesn't take herself too seriously, and she revels in the camp extremes that photographers like Richardson create so well, demonstrating that she's as good-humored as she is sexy.

The world hasn't proven itself to be such a nice place to be all the time, so don't we all deserve a bit of fun and fizz? Kate has earned her rise to the top, and she's proven herself to be game for anything. Who else could you imagine going into zero gravity in a bikini, as she did for *Sports Illustrated* in 2014? She's dominated earth-bound media already; space is simply the logical next step.

Opposite: Photograph by Sebastian Faena, *Muse*, 2012.

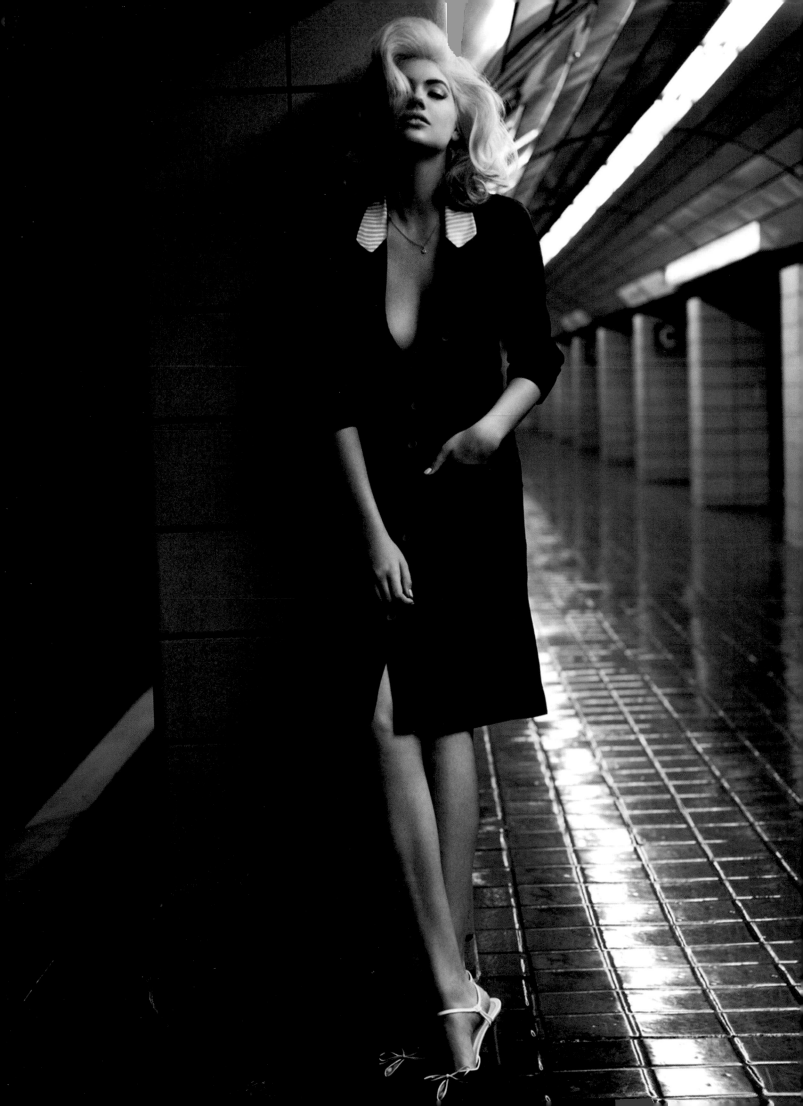

Cara Delevingne

Contrary to the widespread belief that all a model needs to do to become a success is look beautiful, a model's personality is often a key ingredient in what makes her inspiring. Today, due to unprecedented levels of curiosity about and fascination with what happens behind the scenes in fashion, and the proximity to models that social media allows, the public at large is much better able to get to know what a model is really like as she comes up through the ranks. If she's funny or charismatic, she has a much better chance to gain the followers and fans that editors and advertising clients today are desperate to tap into.

Cara Delevingne doesn't just have a great look—a waifish physique enlivened by huge, hungry eyes, finger-thick angular eyebrows, and perfect pouty lips; she also has a strong, mischievous personality and real comfort in her own skin, which is what has earned her a massive and growing Instagram and Twitter following. There she sticks her tongue out, winks, laughs, snarls, flirts, and evokes just about any emotion you can imagine. Her personality has such traction that outlets as influential as *Love* magazine and DKNY advertising campaigns have hired her to do the same thing she's been doing on her own already.

Born in London in 1992 to an aristocratic, socially connected family, Cara also capitalizes on the fascination the public has for pretty girls who were born with a silver spoon in their mouths. Educated at the bohemian private school Bedales, which is famous for educating the offspring of rock stars, actors, and royalty, Cara has always

Opposite:
Photograph by
Patrick Demarchelier,
Vogue China, 2013.

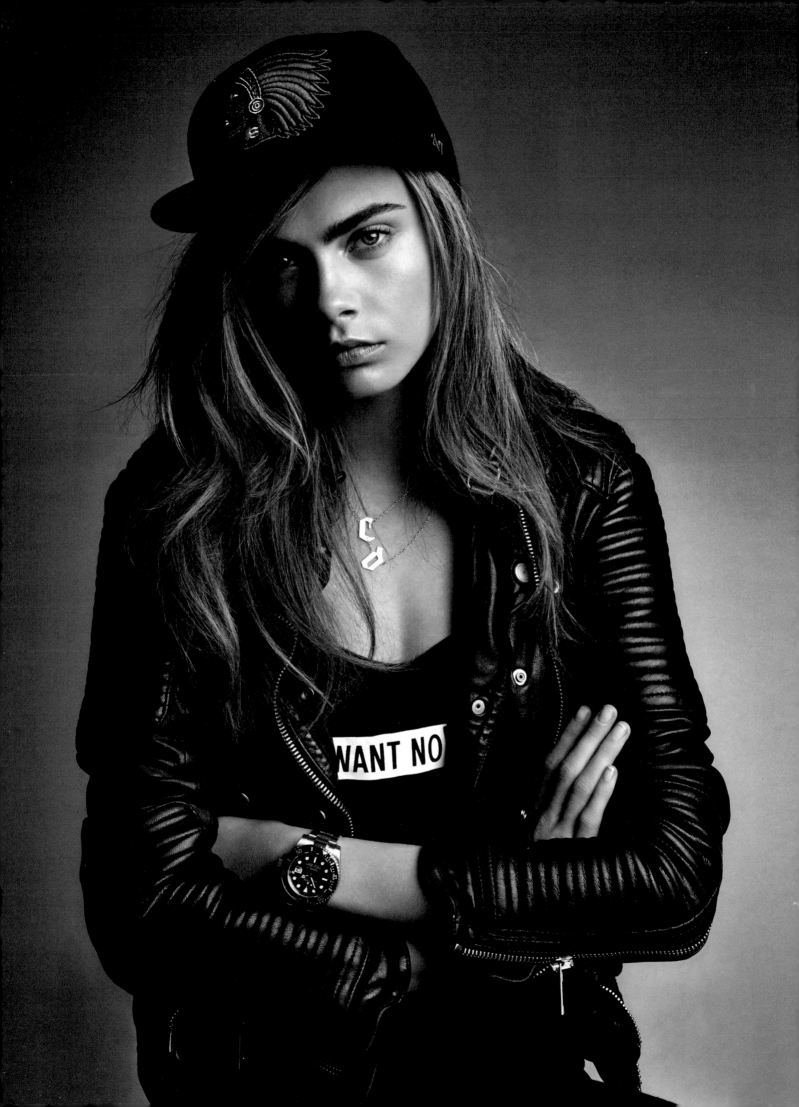

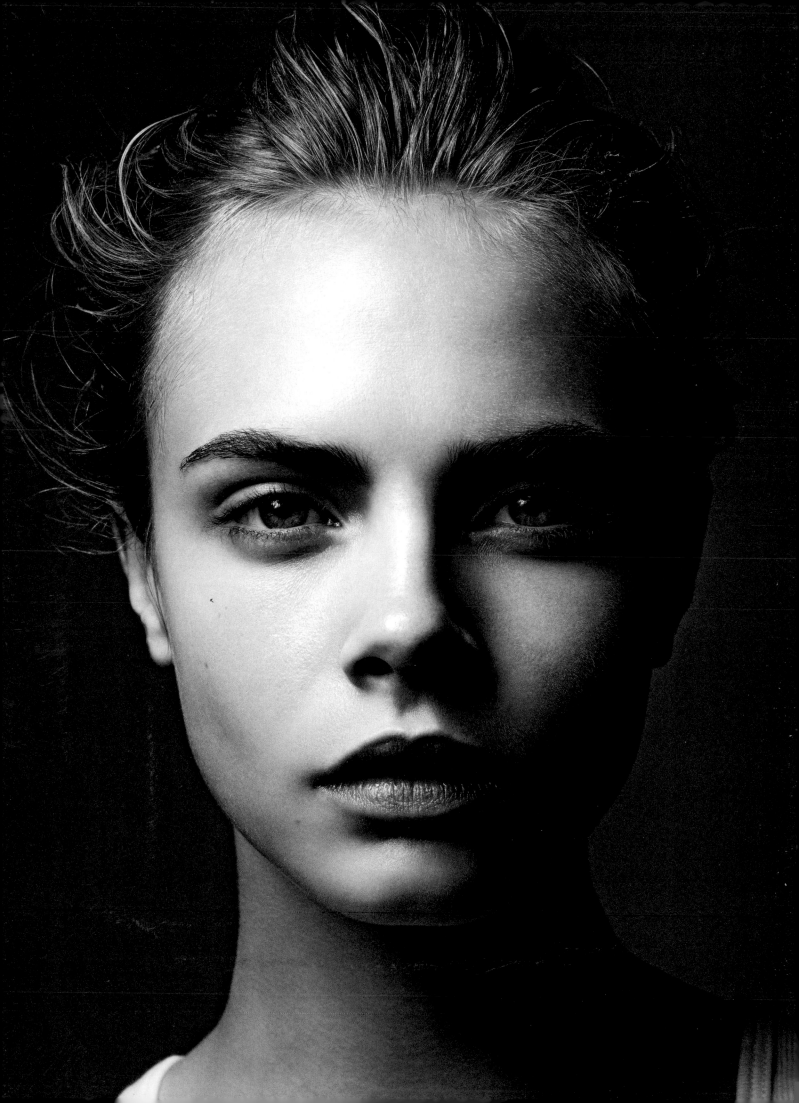

"SHE'S A CHARACTER. SHE'S THE CHARLIE CHAPLIN OF THE FASHION WORLD. GIRLS ADMIRE HER LIKE THEY USED TO KATE MOSS. THEY ALL WANT TO BE AS FREE AS HER."

—KARL LAGERFELD, from "In His Image," by Claudia Croft, *Sunday Times*, March 9, 2014

been at home with the rich and famous, so the fact that she has cultivated friendships with Rihanna, Rita Ora, and the Jagger family isn't too surprising. Her first major job was a campaign for Burberry in 2011, for whom she continues to model on a regular basis, and consequently, at lightning speed, she went on to shoot campaigns for Chanel, Blumarine, H&M, Yves Saint Laurent Beauty, and Zara, and book shows for Moschino, Jason Wu, Fendi, Dolce & Gabbana, Chanel, and Stella McCartney. Not surprisingly, British *Vogue* named her the "star face" of the fall 2012 runway season.

With backstage interviews, paparazzi video sightings, and the constant video uploads of fashion houses and bloggers,

the interest in Cara has snowballed, leading to a string of covers for *i-D*, *Numéro*, *Jalouse*, *Glamour*, *Interview*, *InStyle*, and a host of international editions of *Vogue*. In 2013, she took her first step toward major international stardom by walking the runway for Victoria's Secret, and Burberry has done its part to fuel what are now ongoing comparisons to Kate Moss by booking the two of them together to star in the campaign for its newest fragrance. Cara has already shown she has uncanny instincts and real modeling chops; whether she will prove to have as lasting a career as Kate's might well depend on whether her Twitter and Instagram friends continue to follow her.

Opposite:
Photograph by
Simon Emmett,
Wonderland, 2011.

ACKNOWLEDGMENTS

I feel very lucky that I found the fashion industry as early in my life as I did. Without all the extraordinary people who have inspired me—designers, makeup artists, hair stylists, fashion stylists, and models—I wouldn't be where I am right now.

When I was in school, I learned to sew, weave, and cut patterns while I studied mathematics and science simultaneously. And when my father asked me why I was learning about fashion design, too, I reassured him that when I became a plastic surgeon the sewing lessons would pay off! In the end, an understanding of basic fashion has served me well. As for the math and science, well. . . . So first of all, I would like to remember and thank Philippa Sayer, my fashion design teacher, who encouraged me to think outside the box.

A special thank-you to my mother, who unwittingly reset my career path from medicine to fashion, and supported me wholeheartedly nonetheless! Next, I must thank my wife, Crissy, my guiding light, whose effortless beauty, friendship, and love set an unobtainably high bar, but one that I will forever strive to reach. Of course, I'd like to thank our children, Jack and Jasmine, for their endless enthusiasm, inspiration, and creativity, which remind me daily to dream that anything is possible.

I would like to thank Tandy Anderson from Select Models, who believed in me when I was just eighteen years old and showed me the business behind modeling; Alan Piazzi, my model agent in Milan, whose joy for life was contagious and who introduced me to Crissy, for which I will be eternally grateful; and David Soloff, my agent from Click Models in New York City, who collaborated with me on my photography at the very beginning and showcased my work for the first time in New York. Thank you also to Timothy Reukauf, Nole Marin, and Rodney Hall, great stylists whose vision brought not only the clothes to life but also my photographs. Thanks to Marc Beckman, Sam Sohaili, and Nancy Chanin at DMA United for bringing opportunity after opportunity my way, including this book, of which I am very proud.

A special thank-you to Ira Schreck, who has been a close friend and confidant over the years, as well as my legal counsel, and to Julie Feldman, who worked tirelessly on this book and a hundred and one other projects for me simultaneously.

This book wouldn't be what it is without the whip-smart brilliance of my editor Elizabeth Viscott Sullivan, whose extraordinary knowledge of the fashion world was invaluable; art director Lynne Yeamans, for her creative direction and patience; and Paige Doscher, for organizing us all. I must also thank Claudia Lebenthal, my photo editor, whose image sensibility was so spot-on that it was as if I had personally dug through the numerous photography archives she plumbed for this book. And finally, my deep thanks to Alexandra Marshall, who turned my notes and thoughts into meaningful prose—not to mention that her living in Paris gives the book a truly international flavor, *ne pensez-vous?* Thank you, one and all.

—Nigel

PHOTOGRAPHY CREDITS

I: The Golden Age
Pages 12–13: Nat Farbman/The *LIFE* Picture Collection/
Getty Images. 17: Penn/*Vogue*; © Condé Nast. 18: Penn/
Vogue; © Condé Nast. 20: Photograph by Richard Avedon
© The Richard Avedon Foundation. 22: © Genevieve
Naylor/Corbis. 24: © Georges Dambier. 25: Nat Farbman/
The *LIFE* Picture Collection/Getty Images. 26: Penn/*Vogue*;
© Condé Nast. 29: Photograph by Richard Avedon © The
Richard Avedon Foundation. 30: Photograph by Richard
Avedon © The Richard Avedon Foundation. 33: Rawlings/
Vogue; © Condé Nast. 34: Tim Petersen/folio-id.com.
37: Photograph by Richard Avedon © The Richard Avedon
Foundation. 38: Jerry Schatzberg/Trunk Archive.

II: The Cult of Personality
Pages 40–41: William Klein/Trunk Archive. 44: David
Bailey/*Vogue* © The Condé Nast Publications Ltd.
46: David Bailey/*Vogue* © The Condé Nast Publications
Ltd. 48: Franco Rubartelli © Condé Nast Archive/
Corbis. 51: Franco Rubartelli © Condé Nast Archive/
Corbis. 53: William Claxton/courtesy Demont Photo
Management. 54: William Claxton/courtesy Demont
Photo Management. 57: Ronald Traeger/Trunk Archive.
58: Condé Nast Ltd/Ronald Traeger/Trunk Archive.
60: © 2014, Estate of Bert Stern/courtesy Staley-Wise
Gallery, New York. 63: Photograph by Richard Avedon
© The Richard Avedon Foundation. 64: © Stan Shaffer.
67: Loomis Dean/Camera Press/Redux.

III: The Beauty Revolution
Pages 68–69: Sal Traina © Condé Nast Archive/Corbis.
73: Archive Photos/Getty Images. 74: RexUSA. 76: © Stan
Shaffer. 78–79: Photograph © David Bailey. 81: Ronnie
Hertz/Camera Press/Redux. 83: © The Helmut Newton
Estate. 84: Scavullo/*Vogue*; © Condé Nast. 86: Ishimuro/
Vogue; © Condé Nast. 89: Michael Ochs Archives/
Getty Images. 91: Alice Springs/*Elle*/Scoop. 92: © Mike
Reinhardt/*Photo* magazine. 95: © Mike Reinhardt.
96: © Stan Malinowski.

IV: The Million-Dollar Faces
Pages 98–99: © Pierre Vauthey/Sygma/Corbis. 103:
© Mike Reinhardt/*Photo* magazine. 104: Von Wangenheim/
Vogue; © Condé Nast. 107: Bruce Weber/Trunk Archive.
109: Photograph by Richard Avedon © The Richard
Avedon Foundation. 110: Gilles Bensimon/Trunk
Archive. 112: Patrick Kovarik/AFP/Getty Images.
115: © Michael Thompson. 116: Herb Ritts/Trunk
Archive. 119: © Skrebneski Photograph. 120: Brian
Lanker/*Sports Illustrated*/Contour by Getty Images.
122: Robert Huntzinger/*Sports Illustrated*/Contour by
Getty Images. 125: Gilles Bensimon/Trunk Archive.

V: The Supermodels
Pages 126–127: Roxanne Lowit/Trunk Archive.
130: Herb Ritts/Trunk Archive. 133: Demarchelier/
Vogue; © Condé Nast. 134: Gilles Bensimon/Trunk
Archive. 137: Elgort/*Vogue*; © Condé Nast. 138: Gilles
Bensimon/Trunk Archive. 141: Herb Ritts/Trunk
Archive. 142: Mario Testino/Art Partner Licensing.
145: Herb Ritts/Trunk Archive. 146: Gilles Bensimon/
Trunk Archive. 149, 150, 152, 154, 157: Herb Ritts/
Trunk Archive. 158–159: Ellen von Unwerth/Trunk
Archive. 160: Ellen von Unwerth/Trunk Archive.
162: Sante D'Orazio/Trunk Archive. 164: Herb Ritts/
Trunk Archive. 165: Mikael Jansson/*Vogue* © The
Condé Nast Publications Ltd. 167: Demarchelier,
Vogue; © Condé Nast.

VI: The Androgynes
Pages 168–169: © Max Vadukul/August. 173: Tesh/Trunk
Archive. 175: Corinne Day/Trunk Archive. 176: Mario
Testino/Art Partner Licensing. 179: Mario Testino/Art
Partner Licensing. 180: Vincent Peters/Trunk Archive.
182–183: Herb Ritts/Trunk Archive. 185: Rennio
Maifredi/Trunk Archive. 186–187: Elgort/*Vogue*;
© Condé Nast. 189: Gilles Bensimon/Trunk Archive.
190: Gilles Bensimon/Trunk Archive.

VII: The Noughties
Page 192–193: KMazur/WireImage/Getty Images.
197: Matt Jones/Trunk Archive. 198: Demarchelier/
Vanity Fair; © Condé Nast. 200: Demarchelier/*Vanity
Fair*; © Condé Nast. 202: © Regan Cameron/Art +
Commerce. 204: Guy Aroch/Trunk Archive. 207: Vincent
Peters/Trunk Archive. 208: Txema Yeste/Trunk Archive.
209: Cliff Watts/Trunk Archive. 210: Elgort/*Vogue*;
© Condé Nast. 212: Inez and Vinoodh/Trunk Archive.
215: Inez and Vinoodh/Trunk Archive.

VIII: The Contemporaries
Pages 216–217: Gareth Cattermole/Getty Images
Entertainment. 220: © Nigel Barker. 222–223: Ellen von
Unwerth/Trunk Archive. 225: Tony Kim/Trunk Archive.
227: Paul Bellaart/Trunk Archive. 228: Daniel Jackson/
Trunk Archive. 231: Guy Aroch/Trunk Archive. 233:
Andreas Laszlo Konrath/Trunk Archive. 235: Miguel
Reveriego/Trunk Archive. 236: Terry Richardson/Art
Partner Licensing. 239: Demarchelier/*Vogue*; © Condé
Nast. 240–241: Boo George/Trunk Archive. 243: Miguel
Reveriego/Trunk Archive. 245: © Sebastian Faena.
247: Patrick Demarchelier/*Vogue* China/Trunk Archive.
248: Simon Emmett/Trunk Archive.

BIBLIOGRAPHY

ARTICLES

"67's Twig Becomes a Tree." *Life*, April 19, 1968.

"The 100 Hottest Women of All Time." *Men's Health*, November 22, 2013. www.menshealth.com/sex-women/hottest-women-all-time.

Agins, Teri. "Iman: Not Just Another Pretty Face." *New York Times*, June 6, 2010.

Alexander, Ella. "Cara Delevingne: Catwalk CV." *Vogue* UK, March 1, 2012.

"Amber Valletta." *Interview*, September 2013.

Antunes, Anderson. "Gisele Bündchen Is Still Outperforming the Dow." Forbes.com, November 17, 2011. www.forbes.com/sites/andersonantunes/2011/11/17/gisele-bundchen-is-still-outperforming-the-dow/.

Baker, Rachel. "The Inheritance." *New York*, August 14, 2011.

Barr, Naomi. "'Happy Ending, Right?'" *Slate*, October 30, 2013. www.slate.com/articles/business/when_big_businesses_were_small/2013/10/victoria_s_secret_founding_roy_raymond_had_a_great_idea_but_les_wexner_was.html.

Beker, Jeanne. "Looking Back on 27 Years of an Iconic Show." *Fashion Television*, April 13, 2012.

Bhardwaj, Vertica, and Ann Fairhurst. "Fast Fashion: Response to Changes in the Fashion Industry." *The International Review of Retail, Distribution and Consumer Research* 20, no. 1 (February 2010).

Blanchard, Tasmin. "Chanel's New Tennant." *Independent*, March 30, 1996.

———. "Inès de la Fressange Takes on Uniqlo." *Telegraph*, March 11, 2014.

Blasberg, Derek. "It's a Smalls World." *Harper's Bazaar* UK, October 2012.

———. "Linda Forever." *Harper's Bazaar*, October 2013.

———. "Naomi Knows It All." *Harper's Bazaar*, February 2012.

———. "Natalia Vodianova Moves Beyond the Runway." *WSJ. Magazine* May 16, 2013.

———. "Penelope Tree." *V*, Winter 2012/13.

Bishop, Martin. "On the Cover: Alek Wek." *Rwanda Sunday Times*, February 5, 2012.

"Black Lace and Woolen Undies." *Life*, October 16, 1944.

Boshoff, Alison. "Face It, Cindy, You're Boring, Says Revlon." *Daily Mail*, November 23, 2000.

Brown, Laura. "Daria: The Face of Beauty Now." *Harper's Bazaar*, January 2014.

Buckland, Lucy. "Jerry Hall Turns 57!" *Daily Mirror*, July 2, 2013.

Bumpus, Jessica. "The Shrimpton Story." British *Vogue*, March 2010.

Burley, Elizabeth. "Claudia Schiffer on Model Life in 1993." *Dazed & Confused*, August 2013.

Burley, Isabella. "François Nars and the Immaculate Makeover." *Dazed & Confused*, Spring 2014.

Buttolph, Angela. "How Kate Moss Has Influenced Fashion Forever." *New York Post*, January 18, 2014.

"Candid Shots: Kate Moss Opens Up." *Telegraph*, November 11, 2012.

Cardona, Tor. "Because She's Worth It: Lara Stone Unveiled as Global Spokesperson for L'Oréal Paris." *Grazia Daily* UK, October 15, 2013. www.graziadaily.co.uk/beauty/makeup/lara-stone-unveiled-as-the-new-face-of-l-oreal-paris.

Cartner-Morely, Jess. "Twiggy at 60: It's Amazing I Didn't Go Stark Raving Bonkers." *Guardian*, September 19, 2009.

"Christy Turlington." *Interview*, September 2013.

"Christy Turlington." *People*, May 3, 1993.

Colacello, Bob. "A League of Their Own." *Vanity Fair*, September 2008.

Colman, David. "Chanel's Upper-Class Face." *New York Times*, June 16, 1996.

Critchell, Samantha. "New York's Metropolitan Museum Examines the 'Model as Muse.'" Associated Press, May 5, 2009.

Croft, Claudia. "In His Image." *Sunday Times*, March 9, 2014.

"Daria Werbowy." *Interview*, September 2013.

Davidson, Andrew. "Elle Macpherson Looks Good with Intimates." *Sunday Times*, March 23, 2008.

Davison, Rebecca. "Model Behaviour: Helena Christensen's Latest Venture Is a Triumph as She Launches Third Lingerie Collection." *Daily Mail*, February 13, 2014.

de Bertodano, Helena. "Christie Brinkley: My Uptown Whirl." *Telegraph*, July 10, 2011.

de Rosee, Sophie. "Coco Rocha: The Model Interview." *Telegraph*, September 10, 2011.

Dodes, Rachel. "A Different Kind of Girl Scout." *Wall Street Journal*, February 10, 2011.

Donnally, Trish. "Have Makeup, Will Travel: Isabella Rossellini's New Line Is Compact, Convenient and Packable." *San Francisco Chronicle*, January 11, 2000.

Dorling, Danny. "Generation Peak Teen." *New Statesman*, July 25, 2013.

Earle-Levine, Julie. "Q&A: Elle Macpherson on Her New Lingerie Line, Turning 50 and More." *New York*, April 10, 2014.

Edwards, Owen. "Fashion Faux Paw." *Smithsonian*, October 2005.

"Fashion Retrospective: Gisele Bündchen—the Early Years." *Fashion TV*, February 17, 2012. www.fashiontv.com/news/fashion-retrospective-gisele-bundchen-the-early-years_599.html.

"Fashion's Familiar Faces: The Women Who Have Most Often Graced the Cover of *Vogue*." Vogue.com. www.vogue.com/magazine/article/fashions-familiar-faces-the-women-who-have-most-often-graced-the-cover-of-vogue/#1.

Fayard, Judy. "Remembering Fashion's 'Battle of Versailles.'" *Wall Street Journal*, November 21, 2013.

Ferguson, Euan. "The Supermodel Turned Spokeswoman." *Guardian*, April 15, 2007.

Fisher, Lauren. "Jerry Hall Cuts Her Iconic Hair." *Harper's Bazaar*, February 24, 2014. www.harpersbazaar.com /celebrity/news/jerry-hall-cuts-iconic-hair.

Foley, Bridget. "China Machado." *W*, March 2010.

Ford, Tom. "Liya Kebede." *Time*, April 29, 2010.

France, Louise. "People Thought I Was a Freak. I Kind of Liked That." *Observer*, August 3, 2008.

Friedman, Vanessa. "Brunch with the FT: Isabella Rossellini." *Financial Times*, August 17, 2012.

Furniss, Jo Ann. "It Was Always Kristen." Style.com/Print (Issue 4), Fall 2013.

Garced, Kristi. "Lauren Hutton on Modeling, Dating and Style." *Women's Wear Daily*, May 15, 2014.

Garnett, Daisy. "Sophie Dahl." *Red*, February 2014.

Gleick, Elizabeth. "One of a Kind." *People*, April 19, 1993.

Gliatto, Tom. "Double Fault: Done in by Dueling Careers, the Love Match between Brooke Shields and Andre Agassi Ends Abruptly in Divorce." *People*, April 26, 1999.

Grundberg, Andy. "Irving Penn, Fashion Photographer, Is Dead at 92." *New York Times*, October 8, 2009.

Haight, Sarah. "Fashion's It Girl: Lara Stone." *W*, August 2009.

Henderson, Violet. "The Unseen Veruschka." British *Vogue*, April 3, 2014. www.vogue.co.uk/news/2014/04/03 /veruschka-somerset-house-exhibition.

Herbst, Kendall. "Casting Agent James Scully's All-Time Favorite Models." *New York*, *Look* fashion supplement, Spring 2009.

"History: 1970s." *Ad Age Encyclopedia*, September 15, 2003. www.adage.com/article/adage-encyclopedia /history-1970s/98703/.

Holloway, Lynette. "Margaux Hemingway Is Dead; Actress and Model Was 41." *New York Times*, July 2, 1996.

Holson, Laura. "Brant vs. Brant: Divorce Celebrity Style." *New York Times*, August 20, 2010.

"Honeymooners Earl Wetson and Margaux Hemingway Have a Vintage Season." *People*, September 29, 1975.

Horwell, Veronica. "Dorian Leigh: Unconventional American Model and the Face of the 1940s and 50s." *Guardian*, July 12, 2008.

———. "Naomi Sims." *Guardian*, August 9, 2009.

Howe, Neil. "What Makes the Boomers the Boomers?" *Governing*, September 2012.

Hughes, Salli. "You Don't Have to Go with the Crowd." *Guardian*, March 28, 2014.

"Iman." *Into the Gloss*, November 2012. www.intothegloss.com /2012/11/iman-abdulmajid-part-1/.

Jacobs, Laura. "Everyone Fell For: Suzy." *Vanity Fair*, May 2006.

Jacobs, Marc. "Lara Stone." *Interview*, March 2010.

James, Laurie. "This Year's Model." *Harper's Bazaar*, January 1993.

"Jean Shrimpton, Famed Face of the '60s, Sits Before Her Svengali's Camera One More Time." *People*, May 30, 1977.

Keltner, Jane. "Karlie Kloss: All-American Supermodel." *Teen Vogue*, May 2010.

La Ferla, Ruth. "Fashion: Striking Poses." *New York Times*, 1991.

Larocca, Amy. "This Year's Model." *New York*, August 17, 2008.

Larson, Christina. "The Liu Wen Express." *T: The New York Times Style Magazine*, March 15, 2012.

Leitch, Luke. "Sarah Doukas of Storm Modeling Agency: The Beauty Spotter." *Telegraph*, October 17, 2012.

"Linda Evangelista." *Interview*, September 2013.

"Liu Wen: Model." *Business of Fashion*. www.businessoffashion .com/liu-wen.

"Liya Kebede: Model." *Business of Fashion*. www.businessof fashion.com/liya-kebede.

"Liya Kebede Revealed." *CNN International*, January 12, 2008. www.edition.cnn.com/CNNI/Programs/revealed /kebede/.

Llewellyn Smith, Julia. "Supermodel Daria Werbowy Is the Face You Don't Know You Know." *Telegraph*, July 5, 2009.

Lo Dico, Joy. "Moss Appeal." *Financial Review*, December 15, 2012.

Long, Carola. "Claudia Schiffer." *Independent*, October 24, 2009.

Lyons, Jenna. "The Iconoclast: Lauren Hutton." *Interview*, September 2013.

Mabrey, Vicki, Julia Bain, and Bradley Blackburn. "'The Battle of Versailles': Landmark Fashion Show Broke Racial Barriers, Showcased US Designers." *ABC News*, January 25, 2011. www.abcnews.go.com/Entertainment/battle -versailles-models-designers-reunite-celebrate-landmark -fashion/story?id=12751241.

Magee, Antonia. "Model Jean Shrimpton Recollects the Stir She Caused on Victoria Derby Day in 1965." *Herald Sun*, October 29, 2009.

Mann, Camille. "Modeling at 13? Gisele Bündchen Did It." *CBS News*, May 4, 2012. www.cbsnews.com/news /modeling-at-13-gisele-bundchen-did-it/.

Marsh, Lisa. "Gray Pride: Model, 45, Dares to Bare Her Silver Hair." *Today Style*, August 2, 2010. www.today.com /id/38520400/ns/today-today_style/t/gray-pride-model -dares-bare-her-silver-hair/.

Martin, Douglas. "Dorian Leigh, Multifaceted Cover Girl of the '40s, Dies at 91." *New York Times*, July 9, 2008.

Masters, Kim. "It Hurts So Much." *Time*, July 15, 1996.

Mau, Dhani, "Can China Save Fashion Magazines." *Fashionista*, July 25, 2012. www.fashionista.com/2012/07 /can-china-save-fashion-magazines.

Mayes, Ty-Ron. "Model to Mogul and Beyond." *WestEast*, October 27, 2012.

McCready, Louise. "Sophie Dahl on Food as Reward, Take-out Culture, and Curvy Centuries." *Huffington Post*, May 31, 2010. www.huffingtonpost.com/louise-mccready /sophie-dahl-on-food-as-re_b_595470.html.

McMurran, Kristen. "Not the Vintage Margaux." *People*, February 8, 1988.

Meggeson, Annabel. "Helena Christensen." *Red*, September 2013

Millar, Laura. "Interview: Claudia Schiffer." *Stylist*. www.stylist.co.uk/people/interviews-and-profiles/interview-claudia-schiffer.

Moore, Booth. "Vidal Sassoon Had a Style of His Own." *Los Angeles Times*, May 13, 2012.

Morgan, Piers. "When Piers Met Cindy Crawford." British *GQ*, May 2011.

Morris, Bernadine. "Dovima, a Regal Model of the 50's, Is Dead." *New York Times*, May 5, 1990.

Moss, Stephen. "Jerry Hall: Mick Served His Purpose." *Guardian*, December 11, 2010.

Mower, Sarah. "In the Mood for Love." *Vogue*, February 2003.

Mulkerrins, Jane. "Carmen Dell'Orefice, the 82-year-old Model, Reveals the Secrets to Her Lasting Success." *Daily Mail*, July 6, 2013.

"Naked Sophie Dahl Ad Banned." *BBC News*, December 18, 2000. news.bbc.co.uk/2/hi/uk_news/1077165.stm.

"Naomi Sims, Model, Dies." *Women's Wear Daily*, August 4, 2009.

Newman, Judith. ". . . And Some Call for a Voice." *New York Times*, January 19, 1992.

Norwich, William. "Ooh, That Look!" *Vanity Fair*, March 1993.

"Oral History: Porizkova, Paulina." National Czech & Slovak Museum & Library. www.ncsml.org/Oral-History/All-Interviews/20130522/301/Porizkova-Paulina.aspx.

Parker, Nick. "How a Small-Town Girl Became China's First Supermodel." CNN.com, September 30, 2011. www.edition.cnn.com/2011/09/30/living/liu-wen-supermodel/.

"Peggy Moffitt: The Total Look." *Nowness*, May 18, 2012. www.nowness.com/day/2012/5/18/2152/peggy-moffitt-the-total-look?icid=previously_2297).

Peretz, Evgenia. "Slavs of Fashion." *Vanity Fair*, April 2005.

"Perils of Paulina: Estée Lauder Remodeling." *New York*, May 3, 1993.

Philby, Charlotte. "My Secret Life: Elle Macpherson, Model & Businesswoman, 47." *Independent*, June 5, 2010.

"Pretty Baby at 13: One Horse, Three Movies, Beaucoup Bucks, but No Beau." *People*, December 25, 1978.

Prince, Dinah. "Girl Crazy." *New York*, January 25, 1988.

Porizkova, Paulina. "Modeling Is a Great Job and a Sh*tty Career." *Huffington Post*, February 16, 2011. www.huffingtonpost.com/paulina-porizkova/modeling_b_823952.html.

"Questionnaire: Bettina, Model and Muse." *Interview*, December 2008.

Rahim, Joanna. "Interview: Sophie Dahl." *Independent*, April 6, 1997.

Rapkin, Mickey. "Leave It to Diva." *Elle*, February 2013.

Reynurn, Scott. "Bardot Pouts, Poses, Hides as Art Show Charts Rise of Paparazzi." *Bloomberg News*, August 25, 2009.

Roberts, Nicola. "Norman Parkinson: Legend Behind a Lens." *FT Magazine*, March 29, 2013.

Rumbold, Judy. "Carmen Dell'Orefice: Eternal Grace." *Telegraph*, January 13, 2008.

Schiro, Anne-Marie. "Lisa Fonssagrives-Penn, 80, Artist Who Gave Up Career as Model." *New York Times*, February 6, 1992.

Schneider, Karen. "A Life Eclipsed." *People*, July 15, 1996.

Schneier, Matthew. "Riccardo Tisci: An Oral History." Style.com, June 3, 2013. www.style.com/trendsshopping/stylenotes/060313_CFDA_Riccardo_Tisci/.

Sciolino, Elaine. "This Is What 'Parisienne' Looks Like." *New York Times*, April 20, 2011.

Seidner, David. "Lisa Fonssagrives-Penn." *BOMB*, Spring 1985.

Skow, John. "Modeling the 80s Look: The Face and Fees are Fabulous." *Time*, February 9, 1981.

Small, Michael. "Her Bold Looks Made Her a Standout in the 1960s, but Now Veruschka Paints Herself into the Background." *People*, February 16, 1987.

Socha, Miles. "Chanel Brings Back Inès de la Fressange." *Women's Wear Daily*, October 1, 2010.

———. "Glossy Karlie . . . *Vogue* and *Lucky* Launch Partnerships . . . New Gravy Train." *Women's Wear Daily*, January 7, 2010.

Spector, Dina, and Vivian Giang. "The 25 Most Famous Princeton Students of All Time." *Business Insider*, December 1, 2011. www.businessinsider.com/famous-princeton-students-2011-11?op=1.

"Stephanie's Secret." *Playboy*, February 1993.

"Stephanie Seymour." *Interview*, September 2013.

"Tatjana: Million-Dollar Beauty." *Vogue*, June 1988.

Trebay, Guy. "For Hurricane Relief, Connections Count." *New York Times*, September 19, 2005.

———. "Lauren Rides Again." *Town & Country*, June/July 2013.

———. "Model Struts Path to Stardom, Not on Runway, But on YouTube." *New York Times*, February 13, 2012.

———. "Paris Diary: To Bag a Sale: Net a Writer, Cage a Model." *New York Times*, March 13, 2001.

"Tyra Banks." *People*, www.people.com/people/tyra_banks/biography.

Tyzack, Anna. "Lessons from the Stylish: Helena Christensen, 45, Model and Designer." *Telegraph*, March 1, 2014.

Van Meter, Jonathan. "She's Back." *Vogue*, September 2001.

Vodianova, Natalia. "How I Get Dressed." *Observer*, January 13, 2008.

Wade, Alex. "The Saturday Interview: Jean Shrimpton." *Guardian*, April 30, 2011.

Waldholz, Chantal. "I Know the Pain of Somebody Who's Too Thin and Too Big: Tyra Banks Opens Up about Body and Weight Battles." *Life & Style*, May 5, 2014.

Walls, Jeanette. "High Fashion's Lowest Neckline." *New York*, January 14, 2001.

Weil, Jennifer. "Inès de la Fressange Returning to Signature Label." *Women's Wear Daily*, May 31, 2013.

Wek, Alek. "Supermodel Alek Wek's Emotional Homecoming." CNN.com, September 12, 2012. www.edition.cnn.com /2012/09/11/world/africa/alek-wek-south-sudan-journey /index.html.

Whiteside, Thomas. "A Super New Thing." *New Yorker*, November 4, 1967.

Wilson, Anamaria. "Gisele: Supermodel Muse." *Harper's Bazaar*, April 2009.

Wilson, Eric. "Naomi Sims, 61, Pioneering Cover Girl, Is Dead." *New York Times*, August 3, 2009.

Wintour, Anna. "Letter from the Editor." *Vogue*, October 2005.

Wolfson, Nancy. "The Loves of Lauren Hutton." *Cigar Aficionado*, Spring 1996.

"Why Karlie Kloss Is Worth Going to Court Over." *New York*, April 18, 2008. www.nymag.com/thecut/2008/04/why _karlie_kloss_is_worth_goin.html.

Yardley, William. "Teri Shields, Mother and Manager of Brooke Shields, Dies at 79." *New York Times*, November 5, 2012.

Young, Molly. "Joan Smalls' Big Moment." *Elle*, January 2014.

Yuan, Jada. "I Didn't Think of Myself As Good-Looking at All." *New York*, August 14, 2011.

BOOKS

Dickinson, Janice. *No Lifeguard on Duty: The Accidental Life of the World's First Supermodel*. New York: HarperCollins, 2009.

Drake, Alicia. *The Beautiful Fall: Fashion, Genius, and Glorious Excess in 1970s Paris*. New York: Back Bay Books, 2007.

Elgort, Arthur. *Arthur Elgort's Models Manual*. New York: Distributed Art Publishers, 1992.

Fried, Stephen. *Thing of Beauty: The Tragedy of Supermodel Gia*. New York: Pocket Books, 1994.

Gross, Michael. *Model: The Ugly Business of Beautiful Women*. New York: William Morrow, 1995.

Hall, Jerry. *Jerry Hall's Tall Tales*. New York: Pocket Books, 1985.

———. *My Life in Pictures*. London: Quadrille Publishing, 2010.

Moffitt, Peggy, and Marylou Luther. *The Rudi Gernreich Book*. New York: Taschen, 1999.

Pepper, Terence, Robin Muir, and Melvin Sokolsky. *Twiggy: A Life in Photographs*. London: National Portrait Gallery Publications, 2009.

WEBSITES

www.christiebrinkley.com

www.ellemacpherson.com

www.johnrobertpowers.net

www.twiggylawson.co.uk

www.vogue.com/voguepedia

INTERVIEWS AND SPEECHES

Nyong'o, Lupita. 2014 Essence Black Women in Hollywood Luncheon. February 27.

Schatzberg, Jerry. Phone interview with the author, March 19, 2014.

FILM

Funny Face. Directed by Stanley Donen. Paramount Pictures, 1957.

ABOUT THE AUTHOR

Nigel Barker is an internationally renowned photographer, TV personality, brand spokesperson, and humanitarian. As a creative force in the worlds of fashion, beauty, and entertainment for more than twenty years, he has produced a diverse body of work. He has directed and produced films, documentaries, and commercials for both Hollywood clients and international charitable organizations, including the documentary *Dreams Are Not Forgotten*, which earned the Film Heals Award for Humanitarianism at the sixth annual Manhattan Film Festival in 2012.

Nigel has also been the spokesperson for numerous brands and organizations. His photography has been featured in fashion editorials and in commercials, and exhibited worldwide. The creator of his own TV show, *The Shot*, for VH1 and a longtime judge on the international hit show *America's Next Top Model*, he is now the host on Oxygen's *The Face*, with Naomi Campbell.

An ambassador for the United Nations Foundation's Girl Up campaign, Nigel is also a spokesperson and ambassador for the Make-A-Wish Foundation, the Humane Society of the United States, the Edeyo Foundation, and the Elizabeth Glaser Pediatric AIDS Foundation. He lives in New York City with his wife, Cristen, and their two children, Jack and Jasmine. www.nigelbarker.tv.